The Other Face

The Mask in the Arts

Walter Sorell

with 121 illustrations, 11 in colour

Thames and Hudson · London

For Penny West

ISBN 0 500 23197 4

Printed in Great Britain by
The Camelot Press Ltd, London and Southampton

Contents

CHAPTER I

The Mystery of the Other Face

It is man who is most fascinated by man. Since he is puzzled by his own being, he is most preoccupied with himself. His self-reflection, which he tries to penetrate, understand, and love, never quite leaves him. This is why both the primitive man and the child of the most sophisticated society instinctively attempt to recreate their own image on a wall or a piece of paper, in the sand or snow.

The new-born infant only gradually becomes aware of himself. His own face, in the light of the many other faces by which he finds himself surrounded, begins to play a major role in his growing acceptance – and partial rejection – of the world around him. It is only natural that the child should feel forced to draw faces in the image of his own face, which is, of course, a projection reduced to rudimentary forms: two short horizontal lines, the eyes, opposed or augmented by one horizontal line, the mouth, and both held together by a short vertical line, the nose, with a final line framing these four in an oval. This visualization of man's face is, at the same time, the beginning of the mask.

There is an astounding resemblance between the child's attempt to recreate a face and those in the art of early man, from drawings made during the Stone Age to the famous Cypriote terracotta group of three dancers moving around a flute-player. The faces of these dancers have a masklike expression which does not even reveal whether they are men or women. Such masklike images can be traced over thousands of years from prehistoric to historic times. Clay-modelled faces emerge from a possibly wild flight of the imagination forced to take refuge in childlike simplicity. The pressure of the forefingers and thumb creates the imprint of the eye sockets in the clay. The bridge of the nose emerges from another tweak, after which a vertical movement may bring out the protruding cheeks. Mouth and teeth were sometimes added separately. In their artless, chaste rigidity these facial images have, more often than not, the mysterious power of a mask.

Early man's desire for transformation, for losing the identity of face and shape, emerged from his seemingly contradictory need for self-repulsion as well as for total possession of his self. In order to make the charm work he felt he had to conceal his identity, to shake off his corporeal existence. Since

7

the spirit was thought of as living in the face, it was a logical act to wipe out one's countenance. To make this self-effacing act more effective, primitive man put on an artificial face and admitted with it another spirit.

In the mind of early man the border line between the concrete and the symbolic was blurred; he could not conceive of a life clearly demarcated by any determining facts of reality. He could not separate the natural from the supernatural. For him the latter was a living force with which he needed to identify. The spiritual act of taking possession of, or rather assimilating, the spirit represented by the mask – to the point of becoming possessed by it or becoming it – was the goal of such a masked man.

The variety and expressiveness of the masks grew immensely with the growing skill and artistic awareness of man. All the unrealized images he carried around with him, those many frightening visions that may have tormented him and which he could not articulate in any other form, went into the creation of masks. Afraid of demons but existing with them as seemingly living realities, man transferred demonic powers to the mask. Demon and mask were an inseparable entity in his eyes, at times – as his fear of the unknown and death led to and mingled with his escape into ecstatic joy – indistinguishable.

The demonic character of the spirits fused with man's native cruelty made him shape horror masks with which he terrorized and numbed his fellow men. Then the mask lost any sense of its sacred and elevated purpose, and in wild distortions it went to extremes of the ridiculous and grotesque. Hieronymus Bosch revived such products of the tortured mind in his surrealistic images. The grotesque mask, in its licentious, fantastic, and often frightening irrationalities, has never died. Kept alive by many tribes, it has survived as the frightfully misshapen features that can be seen at peasant mummeries and carnival festivities. The creative power of man's subconscious experiences found, in its most rudimentary form, expression in colourful and often artistically impressive masks. Their demonic character, once a living reality for early man, has become more and more a playful symbol.

We may accept that the masked person becoming the impersonated spirit of the mask truly believed himself to be in possession of the mask's demonic powers. It is more difficult for us to assume that those who watched him – not an audience in our sense of the word, but participants in a ritualistic society – believed in his mask. It is an experience we know from children, who can be afraid of a mask although fully realizing that they know the person hiding behind the mask. The total acceptance of the mask and the people's identification with it was an unwritten law among the members of the tribes. Sometimes, as with tribes in New Guinea, the enforcement of this law could put to death a person who, through contempt or denial, profaned the portrayal through the mask.

This best describes early man's sense of total identification. In his imaginative, symbolic fixation he could identify a stone pillar, ornamented or not, with a human being, or any other shape with the dwelling-place of a man's soul. In his ancestor cult he was convinced that the soul would choose the ancestral statue as its eternal seat, and for him the statue itself turned into the dead person. In the same way, the mask of an animal was endowed with the spirit and qualities of the impersonated animal.

Animal masks were most important symbols in the totemistic culture; they were among the first and most logical images and disguises for man, whose major and immediate experiences were with the animal world. The mask was undoubtedly preceded by the painting of the body, the first realization of man's sense of decoration which greatly inspired and finally led to the creation of masks. Curt Sachs has pointed out that 'masked culture, one of whose roots lies in the physical, conceives its spirits in perceptible, often in animal form'.

Rock paintings of the Paleolithic period reveal several figures, part man, part beast, which represent masked dancers. Then, of course, and for a long time thereafter, masks lacked any imaginative refinement, but even those crude images have an astounding vitality. Some scholars speak of the Mesolithic age as the beginning of the animal mask, others refer to a 'mask culture' beginning in the early Neolithic period, significant for its matriarchal system. In the beginning man would put on the skin of a slain animal, especially the skinned head of a beast, and wear it as a living mask, a sign of triumph, a disguise for use on his hunting exploits or a working charm in his fertility dances. What a long process of development it has been from the masks of those early days to the fantastically adorned masks worn in the dances in honour of the resurrected god Osiris at Abydos!

The animal mask has never lost its imaginative hold on man. It played a leading role in the festivals of Dionysus, and the Dionysian mask became its archetype, born of ecstasy and wantonness, symbol of the god's wild revelries. That the theatre emerged from them is proof of the unfathomable intricacies in man's fate and of the many unpredictable wonders of his own doing and making that have always waited for him on his way into history.

The dance was another, and probably the most extensive, form of expression for primitive man. However, it was not so much an artistic as a partly natural and partly compulsive manifestation of his way of life. His body was a ready-made instrument with which to articulate the complexities of his existence. He perceived rhythm as a constant phenomenon of nature and discovered that rhythm was also locked within him. He unlocked it on all possible opportunities, essentially on the occasion of decisive activities and stations in his life: birth and initiation, fertility and marriage, war and victory, harvest and hunting, healing the sick and exorcizing evil spirits, and

9

finally death. Dancing was an instinctive reaction of the individual within the communal spirit, it took the place of heightened communication.

In contrast to dancing, the creation of masks was a conscious act, executed in full awareness of rudimentary aesthetic principles. It was man's first attempt to give shape and meaning to his innermost visualizations, to reach beyond the ordinary for something of which he was only vaguely aware. In a life in which man's thoughts and feelings, the surrealistic world of his dreams and the realities of his waking hours, become blurred into an often frightening oneness, the mystic and magic forces gain demonic strength. All this played into the mask-makers' hands, and the mask was the first instance in the spiritual growth of man in which the synthesis of idea and matter reached an artistic form. Mask-makers were as much appreciated in former days as artists are today, and it frequently happened that chieftains would invite famous shapers of masks from other tribes and reward them richly for their work.

However abstract these early masks may appear, they became very concrete in the eyes of those who saw their world as being full of mysterious spirits and demons. Disguise and masks were also used to impersonate some of these spirits during ritualistic ceremonies. There was no disguise without a mask, which always played the most important role as the counterpart of man's face, mirroring man's soul. The lifelessness of any mask becomes strangely animated when the body moves, and in fact the dancing body instilled the mask with an overdimensional reality. Moreover, early man found in the mask the ecstatic fulfilment of his fantasy in flight from his uncertain existence and the revelation he projected on to this second face. The rhythmic movement of his body helped him to loosen his feelings and liberate him from his earth-boundness.

The mask in its innumerable forms and functions can lay claim to representing the longest chapter in primitive art. The materials used for its creation, the way it was shaped, and the manner in which it was worn varied a great deal. Some masks covered the entire face, others the whole head. Half-masks were rare among primitive men, and masks covering the eyes only were introduced by a far more sophisticated society. Sometimes the larger part of the body was covered by the mask. A figure from New Guinea displays a head mask reaching to the penis, thus underlining what for early man were the two determining features of the male. Some masks were carried on a staff or became part of an intricate head-dress, and there were masks created not to be worn as face coverings but for the purpose of exhibition as a ritualistic image. Through the millennia and centuries the mask has often changed its face with the variety of its needs and purposes, from the realistic to the fantastic to the grotesque.

The mask came into being owing to many basic instincts, such as fear or faith mainly expressed as superstition. It is most important, however, to realize that the mask emerged from a collective will which was of decisive influence on the individual artist whose hands fashioned the mask. As a work of art it had to be recognizable and identifiable by each member of the community. The early creator of masks thus combined his inner consciousness with a high degree of social awareness. He mastered with his art 'not only what the eye perceives but what it cannot see', as André Malraux said.

The mask is the earliest man-created phenomenon and man's most accomplished visual realization of our twofold existence: of day and night, wakefulness and sleep, life and death, the live and rigid face. The essentially immobile and unchangeable aspect of the mask – the face that lives without living – indicates that one of its original connotations, which early man felt strongly, was with death. But all the art of primitive man was closely linked with death.

The mask of man truly reflected the mystery of being which, to this day, is only the other side of the same coin as the mystery of death. For early man death was not a logical sequence to life, a natural biological decomposition of man's physicality. He imagined that death occurred through supernatural causes shrouded in secrecy, through the inscrutable agency of a mystic force. Nobody died a natural death except in battles with animals or in combat with man. From such limited, and yet imaginative, vision, from the earliest trauma of man, emerged the need for a second face.

The application of the mask was twofold, like the causes of its birth. At opposite ends of the spectrum of man's nature lie his barbaric instincts and his desire to transcend his ordinariness. The mask was used in both instances. When in the early beginnings of *homo sapiens* an adversary was killed, his dried and then stuffed skin was turned into an artistic trophy. Primitive man often wore the mask of his slain foe and imitated his gestures with the intent of absorbing his spirit.

At the other extreme we find the priest of early and later religious cults, who would step in front of the god's altar hiding his face behind a mask. The mask may have served to create more readily the mysterious tie between the priest and the divine spirit, but primarily it was supposed to help him shed his humanness, with all its corporeal attributes. In those early days the mask played its part in what can be considered the spiritual act of becoming possessed in order to take possession. Also, the symbolic power of the mask gave the priest a superpersonal dignity. Beyond the mere unreal expression of his second face, however, the metamorphosis was very real for him and his fellow men, as it created an imaginary power which turned into a mystic force.

In life, the mask is man's living disguise, ever-changing in its reason and reasoning, intent and intensity. It tries to hide the real man in us, to give weight and power to externalized fear, to frighten and beautify, to protect and pacify. It can grow into the grotesque image of man's distorted mirror reflection, or be man's visualization of his constant escape from himself in his anxiety as much as in his playfulness. It gives man the imaginary power to be able to manipulate his own identity. Man's masks can be beautiful and ugly, but because of their heightened expression, their dehumanized and often overemphasized humanness, they are also beautiful in their ugliness. In death, the mask of man becomes his eternally living shadow. More real and intensified than during his entire life span, the features of his soul are then magnified in the light of the sudden inner peace man is forced to make with his Maker on the threshold of his new existence of non-existence.

It is the artist in man who creates the mask. It has always been an essentially basic desire in man to recreate the image of himself so as to represent the various facets of his ego, to disguise or to hide them. The mask has been a most prominent feature in man's creative existence whenever he has reached for the two extremes: his return to primitive and basic levels, his escape into wanton ecstasy, or his sophisticated penetration of his self. In all the arts man's ingenuity has excelled through the millennia all over the globe in triumph over death and ephemera. His creative impulse has vied with the secret power of nature and the abundance of its imagination, with the wisdom of the unknown.

The mask is only one means and form of man's creative expression. In many obvious as well as hidden ways it has always been closest to him, physically, of course, but even more so spiritually. By virtue of being the mask of man, it cannot help being a part of him. Artists, in whatever medium they work, have always been aware of it. Many have made use of it some of the time. Some have used it as a salient feature of their work. Most artists have given *Gestalt* to masks in one way or another, using their symbol and simile as a creatively motivating force.

The world is full of masks. We have learned to live with them on our own faces and on those of our fellow men without being aware of it. What is more surprising is that we are inclined to take them for real faces. We are all mask-makers, who partly prefer and partly enjoy and mainly cannot help living with a masklike make-believe of reality, a reality we assure ourselves daily that we must learn to face while, fortunately for us, we can keep it masked.

In a remote and symbolic way many more things belong to the world of masks than we ordinarily realize or wish to accept. It is a truism that it is we who project our own vision of a person on to his face, and that a person's facial expression can change with his emotional or physical state. We know,

moreover, that we can study our face and, to some extent at least, give it the appearance which we would like to be seen. 'There is nothing true anywhere,' a manual of Zen Buddhism says, 'the true is nowhere to be seen; if you say you see the true, this seeing is not the true one.'

To make a complicated story more complex, we all have two different halves to our face. Experiments have proved that the left half is more readily recognized by others than ourselves. The left side carries the underlying wishes of our being, that is, our 'wish face', as the depth-psychologist Werner Wolff called it, the face of our unconscious, while the right side is our real face. From a psychological viewpoint, therefore, do we not all run around with a mask of two different meanings?

In his Socratic dialogue the *Symposium*, Plato lets Socrates say, 'To know what is serious, we must also know what is laughable.' The Greeks thought of the theatre in terms of masks and, in particular, of displaying one half of the face as laughing comedy, the other half in the serious mien of tragedy, the driving life force beside the tragic experience. Thousands of miles and close to a millennium away, the Zapotecs sculpted a head which was found in Oaxaca (dating back from AD 800 to 1200) and which shows the image of life on the right and that of death on the left side. Apparently our left side is not only our wish face, but carries all the reflections of our subconscious, including our death wish.

'Man is least himself when he talks in his own person,' Oscar Wilde wrote. 'Give him a mask, and he will tell the truth.' The reversed and far more simplistic variation on this theme is Jean-Jacques Rousseau's saying that when the mask falls, man becomes revealed. Wilde was quite aware of the complexities of human reactions. We feel safe behind a mask, and it is most often the mask which best reveals the reality of our self.

Jung called man's mask the *persona* – the name for the mask worn by the actor in the ancient Greek theatre – and visualized it as the manner or system which we have created for ourselves to help us adjust to the world. The danger to which Jung points lies in the total identification with one's *persona*, which may finally come to be what the actual person is not, but what he and other people believe him to be. Such total identification, of which we are told to be wary, was the very aim of early man.

The formation and wearing of our mask is a general experience and a seeming necessity for life in our society. The *persona* is the mask which protects us not only against the other people behind their masks, but also against our own real self. Our environmental experiences, beginning with our childhood years and an essential part of our education, work towards the formation of our invisible mask. If it were visible, it would probably not have the demonic character of the masks of primitive man, but be a colourful mosaic of all that not really *is* but *seems* to be; of all we have learned to accept

13

as the reality of truth and the truth of reality; of the things we say and do not mean, or mean and do not say; and of the things we see and know do not exist as well as those of whose existence we know, but which we refuse to see.

We consider those who do not recognize the image of the *persona* and each person's right to present himself to the world through it as iconoclasts and rebels who disturb the social order, the equilibrium of society. What these revolutionaries may expose and attack as immoral has become accepted and sanctioned as moral and the truth by such a multitude of *personae* that the deeper layers of man's unconscious seem inaccessible to it. The mask of morality can then crucify those who break the taboo with the best conscience and greatest ethical indignation of their *personae*. Whenever new situations are created through historical and socio-cultural pressures, a new mosaic immediately crystallizes protectively in the form of a changed *persona*. This process is possible only because the real ego identifies with the *persona*, as primitive man identified with the images of demons and spirits his masks represented.

The *persona* is the invisible bridge leading from man's hidden being to the daily aspects of his world. It is his protective mask which, from time to time, he tries to burn in an act of sophisticated exorcism, in an ecstatic dance of despair at finding himself walking and walking across that bridge without a feeling of fulfilment, of having left or arrived. But even a partial destruction of his mask is self-deception only. It immediately grows new parts to complete itself again, because man cannot live without it. Jean Cocteau sensed this inevitable process when he said that 'to be reborn one must burn oneself alive'.

In a symbolic and unconscious way this is what early man did with his masks. This is, moreover, what man has done with his *persona* ever since, while endeavouring to grow beyond himself in order to find out what he really is.

What is mask and what is face when a pilot returns from a bombing mission during which he has executed thousands of people and, taking off his mask, shows his smiling face with the gratified expression 'mission fulfilled'? Or, is not the astronaut divorced from reality when, in his space suit, he dances on the moon?

Primitive man put on a mask to pacify nature, the mysterious and frightening face of the unknown. His inner experience was a surrealistic nightmare, his subliminal experience belonged to his struggle with demons and evil spirits. Modern technological man puts on masks to challenge nature, to demystify the mysterious and to penetrate the frightening face of the unknown. His mask has demonic power of a different kind from that of early man, but he feels the same oneness with his mask which helps him dispel his fear and conquer spirits. The spirits of primitive man were imaginary creations and yet real to him, the spirits of modern man are creations of his imagination, tested in high-powered laboratories.

Mystery and magic are still with us, for all they have done is to change their connotations. We now put on the mask of the voyeur to look through the keyhole of creation. Mystery is bunkum, we claim, and clandestinely try to escape our technological traps by going back to the soil and everything that we can relate spiritually to primitivism.

Christianity turned against the pagan spirit in primitivism. The Church sensed that, in the final analysis, masks came about as the result of man's aspiration to a divine countenance, and it could not tolerate this. The Church Fathers recognized the danger of the demonic quality people projected into the mask. They did not realize that, through St Paul's clearly defined dichotomy in man of body and soul, a new type of invisible mask was created. In tearing the sin-crushed body from man's soul, the body was worn like a mask destined to be burned in purgatory, as some early tribes destroyed their masks by burning them as a climactic and final accomplishment of dance and exorcism. In this manner primitive man liberated himself from the demonic spirits. Medieval man was asked to drive the devil out of his body.

The Central European and Nordic people never gave up the use of the mask, not even in the face of the chastising and cursing clergy. Towards the end of the Middle Ages and the beginning of the Renaissance – when the Church became a patron of the artist celebrating the reawakened spirit of joyful living – the mask and, with it, many variations of disguise returned. But the development of the mask moved in the direction of a theatrical and playful manner.

The mysterious spirit of the mask can be suppressed and diverted but not silenced forever. Our century was destined to rediscover the inherently demonic quality of the mask. When Picasso turned to the Congo masks he felt the power in the darkness of an elemental world that did not mind defying the universe, and he then realized the instinctive force that went beyond all refined variations of realism into new forms of primitive, and yet sacred, simplicity.

After the First World War, when all the old values collapsed with the empires and traditional ideas, the search went on for the forgotten primitive forms and sources which were resurrected in basic modern dance, in the volcanic stammering cries of Expressionistic despair, in the Dadaistic fury of self-defiance, and in phantasmagoric Surrealism with its glazing of Freudian imagery. The mask returned, reflecting and revealing the savage instincts of man let loose again, the old demonic spirits in new clothing, the spirits man feared and tried to escape while falling prey to them. The mask triumphed in leading man back to its crude sources and projecting its influences with a sophisticated gesture, often hiding as a mask behind non-masklike masks.

Primitive man faced a chaotic order with which he tried to live and which he tried to master through incantations and exorcism. Modern man faces an

ordered chaos in which he tries to find himself and which he tries to master through the incantations of technology and the exorcism of formulae. Little has changed, except the level and its dimensions. Man remains alone with his fear, which his pseudo-scientific knowledge of its reasons and ramifications only serves to magnify. Through our growing awareness and our skill in playing little gods, the god-made chaos has changed into man-made chaos. The mystery of being may be duplicated by man tomorrow and seemingly demystified. In fact, he will then face another mystery. In order to live with it and master it, he will need another mask.

The mask is the beginning, trauma, and essence of all metamorphoses, it is the tragic bridge from life into death, it is the illusion of another reality, or the disguise with which man reaches reality on a higher plane, stronger in its awareness, clearer and more concrete in its expression than the elusive image of reality itself. The mask contains the magic of illusion without which man is unable to live.

CHAPTER II

Literature and the Theatre

No creative writer, in whatever age he may live, can bypass the challenging and tantalizing question of how man uses his being and appearance; how he interchanges the various faces created by his tortured mind; how fact and fiction – so often indistinguishable to the individual – become intermingled; how his subliminal existence tries to protect itself through a masklike image. This is what almost all writing seems to be about: to look beneath all appearances to the heart of the many truths, to confront fiction and facts, to unveil the subconscious perplexities of man, to unmask him or, if need be, to dramatize his mask.

A Sophocles or a Shakespeare, a Euripides or a Dostoevsky recreated the mysteries of man's existence like a learned psychologist. The poet knows about man through his intuitive gift – sometimes to the puzzlement of the psychologist, as Sigmund Freud's letter of 8 May 1906 to the Viennese dramatist, novelist and physician Arthur Schnitzler shows:

For many years I have been aware of the far-reaching agreement between your and my conceptions existing in many a psychological and erotic problem. . . . I have often wondered and asked myself from where you could have taken this or that insight which I have acquired through such laborious explorations of the subject, and I finally came to the point of envying the poet whom otherwise I admired. . . .

The very material of the writer is man and his relationship to his fellow men. Therefore the *persona*, the mask in many different forms of presentation, appears and reappears in literature, and only a small number of instances can be treated here. The many variations on this eternal theme are interesting in their treatment and in the depth to which the authors were able to penetrate the *persona* as much as the make-up of its wearer, what facets they brought to light in order to enlighten us.

Arthur Schnitzler was only one of the many early twentieth-century writers totally engrossed in this problem. He began to write at the time when Freud started to probe man's psyche (as a matter of fact, he lived round the corner from Freud although, strangely enough, the two never met). Schnitzler's major theme was love and death, dream and reality: he saw man in his unrealized fear of death throwing himself into love to prove and find himself; he realized long before Pirandello nailed it into our consciousness that,

as Schnitzler said in *Paracelsus*: 'Dream and waking flow into one another,/ truth and lie. Certainty is nowhere./We know nothing of the other, nothing of ourselves./We always play-act; he who knows it, is clever.'*

Schnitzler was aware that we are not only alone in the moment of death, but that lonesomeness often appears at the seams of our existence and is, in its symbolized feeling of abandonment, another form of death. 'No spectre', he wrote, 'attacks us in a more manifold disguise than aloneness, and one of its most impenetrable masks is called love.' There is probably no other author, except Pirandello and Genet, in world literature in whose work the mask is such a recurring phenomenon. Schnitzler is fascinated by the questionable truths beneath man's *persona*. All his works reflect the almost compulsive intention to unmask the truth and man's belief in it as man's greatest illusion, to which he must adhere for his sheer spiritual survival.

However, it would be a fallacy to assume that such realizations led Schnitzler to a nihilistic attitude. Unlike Pirandello and Genet, who succeeded him, he did not embrace scepticism to the point of believing in futility because there is no truth to be recognized. He believed that man must dare himself and explore life, or whatever life permits him to explore, even though he realized that the price man has to pay for this exploration is inescapable disillusionment. Such explorations were, in his eyes, an ever-changing mask, the seeking of pleasure a natural instinct with which we are born and in which we indulge from our infant years as a disguise of and protection against our solitude, as the mask covering a void.

Schnitzler's irony (always a perfect mask for the writer) was largely misunderstood. He tried to reveal that we cannot help going about with the *persona* which overpowers the person. He saw a profound force at work as *Ur*-source and ultimate goal of all life behind the emptiness of man's erotic games – 'the eternal principle that must appear in the mask of an individual', as he said. In Schnitzler's conception any empty emotional gesture may be a protective illusion, but must, of necessity, turn into disillusionment.

In his *Traumnovelle* (*Dream Novel*) the mask plays a major part. It is the catalyst for all the events and even appears physically during a masked ball. It is the propelling motif of the story and, what is more significant, hidden feelings are revealed through it, the mystery behind the driving forces of the leading characters. In their 'desire without courage' the vision of a dream can be dispelled as if man and woman had to do little more than take off their masks, or, as literally happens in the story, to drop them on the floor. Having dropped their masks they come closer to one another and yet discover that the innermost truth cannot be revealed in a night or a lifetime.

Schnitzler's dramatic masterpiece is *Reigen* (also known as *La Ronde*), a ritualistic play of love, the inescapable round of pseudo-ecstatic copulation

* 'Es fliessen ineinander Traum und Wachen,/Wahrheit und Lüge. Sicherheit ist nirgends./Wir wissen nichts von andern, nichts von uns./Wir spielen immer; wer es weiss, ist klug.'

and ennui. His characters are well-chosen types who, in the twilight of an emotional void, in the anxiety of an escape from nowhere into nowhere, or in the business-like manner of routine, meet, unite, and leave one another after a carnal act of despair. The monotonous identity and repetition of the sexual act seem like synchronized pulsebeats in the loneliness and lostness of life. The play's fascination emerges from the dialogue, revealing the skilful change of masks before and after the social string of copulation. Man and woman are hiding behind the futile exercise of love without any reality to it, and behind the disguise lurks the fear of lonesomeness and death, the desperate will and need to assert one's being in the face of an ultimate finale. As a moralist who was able to look behind man's mask, Schnitzler did not say 'Don't do it!', because he knew we cannot help doing it. In the sad and sentimental manner of a civilized man, this frustrated physician and visionary poet smiled understandingly and sighed.

We all live in a zone midway between things and ourselves, as Henri Bergson observed, and the poet is most sensitive to this mysterious interrelation. In trying to explore and explain their mutual effects, the poet creates a world of wonders which takes us away from ourselves in order to give us a better view of ourselves. Since most creative efforts are autobiographical he creates this world of wonders strongly in his own image.

In the attempt to record one's own experiences, the discrepancy between things and ourselves becomes the very personal problem that, by the nature of the genre, any autobiography is. Since autobiographies are usually written at an advanced age, from a remote point of observation, our emphases must differ from the realities as we may have experienced them. Goethe was proved wrong in many instances as to the date and event of experiences recalled in his *Poetry and Truth*. What he told was the truth, which need not necessarily be the reality of things. Living between them and himself he expressed the absolute poetry of the highest relative truth.

If masks had not existed before his time, Goethe would have invented them.∗ He took the mask as the metaphor it is to its stylistic climax. The mask he wore throughout his life was many-faceted and brilliantly coloured. His sight was all-embracing, his insight of great depth. He said everything that one man can say and, as is the habit of proverbial meaningfulness, his wisdom could express complementary opposites. He was more often than not divided within himself while appearing to be in full harmony. He was far more human than Olympian, but while recognizing the one and aiming for the other he patterned a life of unity out of variety and created continuity within constant change. He worked on his life with full awareness of what

∗ Goethe wrote a series of dramatized poems which he called *Maskenzüge* (*Mask Parades*). Some were devised for official festivities, others were allegorical, stylized fantasies. On his Italian journey he encountered the Roman carnival to which he devoted a long chapter. Within this chapter we find a section on masks and disguises which he described in detail and with great relish.

he wanted it to be, as if he could hide behind himself while sculpting the statue and stature of the image he had of himself. Casting himself in the role of a universal genius and giant – he was, no doubt, the last *uomo universale* of Western civilization – he often had to transcend all humanness.

On the occasion of the suicidal wave provoked by his novel *The Sorrows of Young Werther*, he maintained with an Olympian shrug: 'That does not concern me.' This was rightly so, from the viewpoint of the genius who visualized and captured the feeling of his time. When his son died, Goethe said: 'Über Gräber vorwärts!' ('Across the graves and forward!'). He wanted to overcome his pain in his own fashion: through work and activity. It is difficult to say how time should dry those tears which man cannot weep. But it sounds a bit too masklike, too self-controlled for such experience when he writes to his friend Karl Friedrich Zelter: 'The body must, the spirit wills, and he who sees prepared the necessary road for his will does not have to think twice.' Perhaps a super-consciously lived life is measured by loftier yardsticks than others and is weighed on the scale of symbolic meaningfulness.

Being his own private Faust with at least two souls, alas, warring in his breast, he had total faith in his intuitive and visionary faculties, while painstakingly penetrating and probing the mysteries of Nature and Life – including his own. His dualism reached the perfection of duality and, like a master juggler, he could hide behind and look through his masks in constant interchange. 'If I', he said to Eckermann on 26 February 1824, 'had not carried, through anticipation, the world within myself, I would have remained blind with my eyes wide open, and all search and experience would have been nothing but a dead and vain effort.' It was far from being dead or vain. He translated the whole range of human experience into the language of his own life. He saw himself as the highest accomplishment of an extraordinarily ordinary man, which explains Napoleon's exclamation at setting eyes on him: 'Voilà un homme!'

If one believes in a totality of existence, then the mask is one of its essential parts. As a counterpart to the reality of the face, or as a reality hiding the inconclusive and everchanging facial image, 'masks are arrested expressions and admirable echoes of feeling at once faithful, discreet, and superlative,' as George Santayana said. And he continued:

Living things in contact with the air must acquire a cuticle, and it is not urged against cuticles that they are not hearts. Yet some philosophers seem to be angry with images for not being things, and with words for not being feelings; words and images are like shells – not less integral parts of nature than the substances they cover, but better addressed to the eye and more open to observation. I would not say that substance exists for the sake of appearance or faces for the sake of masks, or the passions for the sake of poetry and virtue. Nothing arises in nature for the sake of anything else. All these phrases and products are equally involved in the round of existence.

In such total fusion one can go to extremes and imagine that, in the final process, all creative substance is absorbed by the mask, that the mask becomes man's symbol, his work, his ultimate achievement, leaving the body behind as the ephemeral thing it is. In this sense we can accept Rilke's concept when he speaks of the dying poet:

> His mask which now in anguish dies
> is tender and exposed as if it were the inside
> of a fruit, left rotting in the air.*

Among the great dreams of man since his mythological days have been his ability to fly, to make himself invisible at a whim's notice, and to change his personality in a variety of metamorphoses. The dream of Icarus and Leonardo da Vinci has been amply fulfilled. To charter our way through the air from continent to continent has turned into a pedestrian stroll through the skies, and to become a commuter between planetary orbits will be a part of tomorrow's scheduled programme. Plastic surgery and the feasibility of changing man's moods, motions, and emotions through chemical means are some of the accomplishments of the twentieth century. A practical application of the magic hood cannot be too far off.

What interests us here is the role which the mask plays in man's metamorphic games, and how far it has influenced the ingenuity and imagination of literary man. Contemporary science fiction has made rather little use of the mask, except perhaps as a part of technical implementations. Impressionists and symbolists have seen in the mask a magic means of literary expression. Some signal examples can be found in Oscar Wilde, Sir Max Beerbohm, and Guy de Maupassant.

In 1890 the only novel Oscar Wilde wrote, *The Picture of Dorian Gray*, appeared in *Lippincott's Magazine*. He had watched the growth of a painting in an artist's studio. It was the picture of a radiant youth. The thought that the beauty of such a glorious creature would have to fade and the idea that such beauty may not necessarily reflect the psyche of the man portrayed turned into the fictional concept of letting the portrait age and wither in the man's stead. In his preface to *The Picture of Dorian Gray* the author played at paradoxes, saying: 'All art is at once surface and symbol. Those who go beneath the surface do so at their peril. Those who read the symbol do so at their peril.'

Going beneath the surface Wilde discovered that 'each of us has Heaven and Hell in him' and that beauty is often the best and subtlest camouflage for an ugly and beastly character. It is this very appealing mask which may so easily awake the worst instincts in us, tempting temptation and succumbing to the victims in love with their own mask. Oscar Wilde played with the

* 'Und seine Maske, die nun bang verstirbt,/ist zart und offen wie die Innenseite/von einer Frucht, die an der Luft verdirbt.'

thought that the artist is endowed with a microcosmic spark of the Creator's power, and thus enabled the painter to breathe into Dorian Gray's painting the symbolic spirit of the portrayed man's corporeal existence. After all, it is only art that can transcend reality and reflect man's soul.

Oscar Wilde must have enjoyed his own paradox of using the real face of Dorian Gray as his rigid mask of radiant youth and making the portrait show the reflection of Dorian's shameful, cruel and corrupt actions. When, for instance, shaving in the morning and seeing our image in the mirror, do we never observe how our ugly thoughts and deeds, or our beautiful ones for that matter, look back at us? Was not Abe Lincoln right when he remarked that after forty everyone has the face he deserves?

When the hour of retribution should have come to Dorian Gray, 'the mask of youth saved him'. Oscar Wilde gloried in his ironic twists and added one more towards the end of his tale. Dorian, forcing himself to do what he considers a good deed, has to recognize that the painting registers no improvement of his soul: 'In hypocrisy he had worn the mask of goodness.' Dorian, who has murdered the painter of his soul, finally wants to do away with his creator's and his own image in order to begin life anew. He takes the knife with which he has killed the painter and stabs the picture with it. However, 'lying on the floor was a dead man . . . with a knife in his heart. He was withered, wrinkled, and loathsome of visage.' Oscar Wilde was chided for having written an immoral story. But all he did was to look beneath the surface at his peril and to make us read the symbol at our peril.

Oscar Wilde's contemporary, Sir Max Beerbohm, took up the same topic in a dissimilar story which he called *The Happy Hypocrite*. It is a fantasy based on an autobiographical experience. It is written in the artificially playful tone of the Regency period and yet, beneath its flippant, light-hearted appearance and despite its romantic sentiment, it contrasts a corrupt with a happy world. The story is a typically adult fairy-tale with a happy ending.

Beerbohm reversed Wilde's story. An ignoble nobleman by the name of Lord George falls in love with Jenny Mere, a young actress of great innocence and beauty. She rejects the man, whose well-earned reputation is as dreadful as his worn, corrupt countenance indicates. Lord George takes a second look at himself and goes to a famous mask-maker from whose hands he emerges with a perfectly fitting mask of youthful beauty and saintly gentleness. Unrecognized, he again proposes to Jenny Mere, who accepts him. He begins life anew with her somewhere in the country in pastoral bliss. When a former mistress discovers his identity he removes his mask, but by then his face has taken on the same beautiful and saintly expression.

In his book *Portrait of Max*, S. N. Behrman tells us about Max Beerbohm's sincere belief in the magic of the mask. Behrman quotes him: 'I have always been interested in masks. . . . So was Yeats. I once began to collaborate with Aubrey Beardsley on a book about masks. We never finished it.'

'It would be easy', Behrman reports having said, 'if just by buying a mask of goodness, a mask of beauty, you could achieve them both.'

'But, oh, you have to live *up* to the mask, you know,' said Max. 'Lord George lived up to the mask. His love for Jenny made it possible for him to do it.'

Some maintain that the 'irrepressible' Max always wore a mask himself. He needed to amuse himself. He also felt like amusing other people and thought that the wearing of masks helped to facilitate social intercourse.

In his long short story *The Mask* Guy de Maupassant was interested in the age-old problem of man's inability to age with dignity. The wife of an old man reveals that, in his young days, her husband was a dashing fellow, triumphant in his pursuit of women and sexual happiness. 'You wouldn't believe it,' she says to the physician who has brought him home in a desolate condition, 'this man outdid all roués, he outdid all tenors and generals.' He had been a well-known coiffeur at the Opéra, who would come home late and torture his wife by telling her in great detail about his successful adventures with women. There was no masked ball in the city he would have missed. When he grew old, he would put on the mask of a young man and try to outdo the youngest dancers until he collapsed.

The story is told from the wife's viewpoint. We are indirectly told about her minor frustrations and major torments, her fading hopes when her husband's first grey hairs do not bring him back to her but throw him into fits of despair and tricks of disguise, until finally he fools no one but himself behind his youthful mask. In the old man's life the mask becomes a means of playing a memory game with himself, a projection of the past into the present.

Thus the mask is often little less than a symbol of escape, a protection with whose help a direct confrontation with the contemporary world can be avoided. It seems that giving preference to the historical novel reveals the writer in a duality of vision. The past, always associated with the glorified gesture of greatness – Sir Walter Scott called it 'the crowded hour of glorious life' – becomes a substitute for a masked protection against real experience. In the historical novel the author's flight of fancy can break through historical barriers behind which identification is sanctioned by time past. The choice of this genre is indicative of the narrator's need for escape. It is mostly the result of unresolved conflicts between the writer's emotional and intellectual allegiance to another era and his difficulties in accepting his own time. Sir Walter Scott's delight in revelling in the past was a perfect *persona* in respect of his social ambitions and the inadequacies of his private life. As was often said, Scott invented the historical novel for his own glory and the glory of Scotland, but in trying to serve the needs of his own time he also invented the tourist's view of his country.

Scott's counterpart in Central Europe was the Swiss novelist Conrad Ferdinand Meyer. 'I did not live. I lay spellbound by a dream,' he wrote. From his twilight existence living a sheltered and uneventful life in a Swiss villa he conjured up the lives and deeds of people of the past whose flamboyant gestures, psychological entrapments, or simply radiant beauty captured his imagination. He visualized his heroes and heroines in poetic full-bloodedness, he recreated their daring and savage lives brilliantly. He felt most at home in a sumptuous Renaissance setting but loved to lose himself in the ascetic rigidity of Gothic motifs. Passions and tragedies fill his pages, written in an atmosphere of utter tranquillity. Conrad Ferdinand Meyer's neurotic withdrawnness was the reality of his life. With regard to his *persona* it is highly revealing that, in anger, he rejected being stamped as a historic novelist. In a letter written in 1888 to a periodical he tried to explain himself by saying that he only used this novelistic form to express in it his mental experiences and feelings. Moreover, he preferred it to any contemporary setting because it masked him better and kept him at a distance from his reader. His confession could not have been a more explicit explanation of his need for and use of his *persona*.

We must take a particular interest in Herman Melville's morbid, moody and mysterious Captain Ahab, that romantic hero in the Byronic vein of Melville's *Moby Dick*. Ahab's attitude towards the white whale reflects Melville's thoughts about the ambiguity of appearances, his belief that whiteness may be merely a disguise for blackness, that man's goodness may be a mask behind which he hides the world's evil in his own nature.

In the chapter entitled 'Moby Dick' the narrator analyses Ahab: 'Ahab had cherished a wild vindictiveness against the whale ... he at last came to identify with him, not only his bodily woes, but all his intellectual and spiritual exasperations. The white whale swam before him as the monomaniac incarnation of all those malicious agencies which some deep men feel eating in them.' The identification with the white whale becomes complete in Ahab's transference neurosis. In 'deliriously transferring' the idea of evil 'to the abhorred white whale, he pitted himself, all mutilated, against it.' The white whale becomes Ahab's *persona*, in which 'all evil' is 'visibly personified, and made practically assailable in Moby Dick'.

Thus, Ahab's *persona* is a complex mask, looking inside out and outside in, as much protective as serving as a tool for the Captain's frustrations and aggressiveness. At first, his is a Promethean quest. He feels charged to strike through the mask of sinister whiteness. The creative principle of light, however, and of turning all wrong into right is, in the course of his human struggle, changed into the principle of darkness serving little more than personal vengeance. In humanizing Ahab's drama, Melville conceived this ever-mystifying and, at the same time, self-explanatory mask which helped

his hero survive his agonies. In the chapter called 'The Quarter Deck' Melville makes an attempt to interpret Ahab's ambivalent feelings and attitude towards his *persona*:

'All visible objects, man, are but as pasteboard masks. But in each event – in the living act, the undoubted deed – there, some unknown but still reasoning thing puts forth the mouldings of its features from behind the unreasoning mask. If man will strike, strike through the mask! How can the prisoner reach outside except by thrusting through the wall? To me, the whale is that wall, shoved near to me. Sometimes I think there's naught beyond. But 'tis enough. He tasks me; he heaps me; I see in him outrageous strength, with inscrutable malice sinewing it. That inscrutable thing is chiefly what I hate; and be the white whale agent, or be the white whale principal, I will wreak that hate upon him.'

This, in essence, mirrors the struggle of man with himself, with the mask playing a major part in the challenges coming from without and within. Ahab's mask becomes a focal point of his fixation.

Melville began with a less dramatic and profound concept; he originally intended to write a romantic narrative of the whale fishery. While writing several versions of the story, however, he went through an important metamorphosis. Undoubtedly, he grew with his story and hero, with whom he felt an outcast and pitted against a universe which was the devil's. Melville-Ahab's indignation and defiance, the morbid suffering eating his heart, the trauma of mutilation and his final cry for vengeance, which meant inner liberation for him, hardened into and revolved around this fixed centre: his mask.

There is a curious similarity between Ahab and the hero of Carlyle's *Sartor Resartus* who also thinks that 'all visible things are emblems; what thou seest is not there on its own account; strictly taken is not there at all: Matter exists only spiritually, and to represent some Idea, and *body* it forth.' Carlyle's hero and Melville's Ahab are brothers under their masks.

Ahab's struggle with the white whale, epitomized as his *persona*, had a purifying effect on its author, as Melville admits in a letter addressed to Nathaniel Hawthorne: 'A sense of unspeakable security is in me at this moment, on account of your having understood the book. I have written a wicked book, and feel spotless as the lamb.'

Ahab is passing from depression to militant defiance which, of necessity, has to lead to the destruction of himself, his boat, and all its crew save one. The ending of *Moby Dick* has Shakespearean power and biblical simplicity. The gesture of heroic grandeur may be little more than 'a pasteboard mask', and man's psyche is shown engendering and magnifying its own evil, making man seek his own worst fate. From our vantage point we may see in it Ahab's death wish disguised as reckless defiance.

A similar problem was treated by Edgar Allan Poe in a totally different ambiance and with different connotations. The mysterious and the macabre were the playground for Poe's deeply disturbed mind, and in his story

The Masque of the Red Death he made use of one of the oldest mask images: death. In a Renaissance setting the plague strikes with merciless fury at the people of Prince Prospero's country. 'He summoned to his presence a thousand hale and light-hearted friends from among the knights and dames of his court' and withdrew with them to one of his castellated abbeys to escape the world and 'Red Death'.

Poe pictured one of those gay and magnificent Renaissance revelries and masquerades with music, dancing, and masks of 'delirious fancies'.

'Feverishly the heart of life' was still beating, while the night was waning away: Before the last echoes of the last chime had utterly sunk into silence, there were many individuals in the crowd who had found leisure to become aware of the presence of a masked figure which had arrested the attention of no single individual before. . . . The figure was tall and gaunt, and shrouded from head to foot in the habiliments of the grave. The mask which concealed the visage was made so nearly to resemble the countenance of a stiffened corpse that the closest scrutiny must have had difficulty in detecting the cheat.

Everyone in the crowd recognizes the 'scarlet horror' of the red death and is enraged about the daring of the masker. The Prince loses his gay mien and dancing gesture. Gripped by terror or distaste, 'his brow reddened with rage' at this insult and 'blasphemous mockery'. He demands that the stranger be seized and unmasked. When none of the gay courtiers dares to come near the masked figure of death, the prince, 'maddening with rage and the shame of his own momentary cowardice' rushes after the masker with drawn dagger. When the figure, which is later found wanting 'any tangible form', turns around, the dagger drops from the hand of the dying Prince who is followed into death by all the revellers.

Poe used the setting of a masquerade to introduce the figure of death masked in his proverbial attire. The simile Poe chose was death masked as death. The story is one of the many versions of man's rendezvous with death which cannot be evaded nor postponed. Antiquity was familiar with figures masked as death, but it was left to the Middle Ages to turn the image of death into a frightening symbol. The skeleton and the skull-like mask became death personified. The sin-crushed minds of medieval men could not free themselves from the imagined presence of death, with his shape of no 'tangible form' and his features of no features. The mask of death was often seen in medieval plays and gained catalytic power in such morality plays as *Everyman*. Disguised and symbolized, the figure of death has haunted most men of letters who, like Poe in *The Masque of the Red Death*, have used the image of this mask as the denouement in the drama of man.

'Everything that is profound, loves the mask,' said Friedrich Nietzsche, a most interesting example of a poet-philosopher who embraced the concept of the mask wholeheartedly and used it in an almost compulsive manner in many of his works. When speaking *On the Land of Enlightenment*, he shouts

at his contemporaries: 'Indeed, you could not wear a better mask, you who are of now, than your own face! Who would be able to recognize you?'

Nietzsche's mind and its creative output point time and again to his own personal ambivalent existence in which disguise and daring, mask and chastity play an existential role. Too often a tormented mind hid behind the voice of truth. In his *Will to Power* he recognized that 'truth, the will to truth is actually something else and only disguise. (The need for truth is the greatest handicap for veracity.)'

The mask of the Dionysian, music-inspired ecstasy of his youth was later changed into a mask of resigned wisdom and profound vision. As he extolled the light-footedness of the spiritual dancer, so he also saw in each artist an actor, the original image of the *persona*, ready at the script's notice to show another *persona* to his audience. There was never only one Nietzsche, not even one basic Nietzsche besides his many masks. He himself defined his own complexity and his compulsive need for his many beings when he wrote:

> Sharp and gentle, coarse and fine,
> Intimate, remote, dirty and pure,
> A meeting place for fools and sages:
> All this I am and want to be,
> Dove as much as snake and swine!*

He propounded many enigmatic, ambiguous and contradictory concepts. Basically, he was obsessed with the idea that man must overcome himself to transcend his own mediocrity and ordinariness. As God created man in His own image, Nietzsche created Zarathustra in his image. Zarathustra set out to teach liberation from the self and to preach faith in ecstatic terms of a higher type of being.

After having finished *Thus Spake Zarathustra*, Nietzsche wrote a self-revealing letter to his friend Johann Friedrich Overbeck:

My whole life has fallen apart in front of my eyes: This whole weird life I kept hidden and that moves one step within six years and does not desire anything more than this one step: while everything else, all my human relationships have to do with a mask of mine, and I constantly remain victimized by it to lead a totally hidden existence. I have always been exposed to the most cruel accidental events – or rather: It is I who has turned all incidents into cruelties. The book of which I wrote you, a matter of ten days, appears to me now like my testament. In the sharpest contours it retains a picture of my being as it is, as soon as I have thrown off my entire burden.

Nietzsche's ethical pathos claimed as the highest ideal the will to truth, which was only a mask for his concept of the will to power. Standing on a moral pedestal he proclaimed the great goal of evolution, the highest type of humanity which, however, could only be accomplished through the

* Scharf und milde, grob und fein,/ Vertraut und seltsam, schmutzig und rein,/Der Narren und Weisen Stelldichein:/ Dies Alles bin ich, will ich sein,/Taube zugleich, Schlange und Schwein!

inhuman. The duality in Nietzsche divined a morality emerging from amorality, while at the same time, as Karl Jaspers pointed out, his moral criticism sprang from the highest morality.

Jaspers saw in the indirect information which we receive from Nietzsche a way of telling the truth by letting the reader find it out 'by an ambiguous manner of calling attention to it'. In speaking of the necessity and truth of the mask, Jaspers recognized that the mask belongs to existence; 'not the mask which only wants to deceive, but also the protective mask enabling any genuine glance to penetrate the truth. The indirectness is no longer a technique of information but truth of the being in existence and of the information itself. The mean lie as much as the actual truth lies in the mask; a work as mask is the interchangeability through ambiguity and foreground manifestation.'

This is one way, the way of an existentialist philosopher, of explaining Nietzsche's many *personae* while delineating the incapacity of man to exist without a mask.

The inability of man to live without his mask and the significant role the mask plays in our lives must have been known to the earliest poet-philosophers, the anonymous writers of the most profound literary document of man, the Bible.

The God of the Old Testament is an invisible God who says 'thou shalt not make thee any graven image, or any likeness of any thing that is in heaven above, or that is in the earth beneath . . .' (Deuteronomy 5:8). A great deal is made of the 'face' of the earth. This may simply refer to the surface, but nothing in the Bible is simplistic, since its authors were the first literary symbolists. Cain, who complains of being driven 'out this day from the face of the earth; and from thy face shall I be hid . . .', talks to the Lord who talks to man whom he created in his own image.

Jacob's grand illusion makes him say that he has seen God 'face to face' when, in fact, it was an angel, an emissary of God (Genesis 32:30; 33:10). Speaking to Esau, Jacob comes closer to the illusionary reality when he feels that, having found grace in Esau's sight, 'I have seen thy face, as though I had seen the face of God.' The image of God's mask is seen on the face of man as it is seen on the face of the earth, the only tenuous link between ourselves and His likeness in heaven.

By implication the Bible says that no one can return from the dead to claim that he has seen the face of God since God has proclaimed that 'there shall no man see me, and live' (Exodus 33:20). Moses, however, could see his back parts when his glory passed by because 'my face shall not be seen' (Exodus 33:23). Only Lazarus could have told us whether he saw the glory of God, but St John does not tell us what Lazarus experienced.

An interesting exchange of *personae* occurs in Exodus 34:29–35. When

Moses comes down from Mount Sinai with the two tables of testimony in his hand, he is not aware that 'his face shone while he talked with him'. But Aaron and the children of Israel notice it. While giving them

all that the Lord had spoken with him in Mount Sinai . . . he put a veil on his face. But when Moses went in before the Lord to speak with him, he took the veil off, until he came out. And he came out, and spake unto the children of Israel that which he was commanded. And the children of Israel saw the face of Moses, that the skin of Moses' face shone: and Moses put the veil upon his face again, until he went in to speak with him.

At a most climactic point in the drama of biblical man, the messenger of God seemingly wears God's mask, that is the reflection of God, which he has to cover when facing his brethren. Moses is the only character in the Old Testament who measures the distance between his self and the glory that is in heaven above.

In this context I cannot help thinking of the Austrian poet Hugo von Hofmannsthal, who in his *Aufzeichnungen zu Reden in Skandinavien* (*Notes Towards Lectures in Scandinavia*) described the ambiguous role that the actor has played from *The Persians* of Aeschylus to our own day. By the nature of his role he stands apart from the multitude, sometimes as their antagonist, sometimes as the one marked for greatness or for exile. But basically the actor represents each individual; he is, as Hofmannsthal expressed it, the 'mask of the God, the character who suffers for the others'.

In *Purity of Heart* Sören Kierkegaard compared the theatre with the worship of God and came to the conclusion that we are too easily tempted to transpose the theatrical pattern into the one of the church. In the theatre the prompter is the one who remains hidden, whispering the words the actor speaks, and thus becomes the embodiment of the role; and the audience, observing the actor, assesses the wholeness of being he manifests and the singleness with which he embodies the role. It is wrong, Kierkegaard said, even though it is how we customarily distribute the *personae*, to see God as the prompter, the minister as the actor, and the congregation as the audience. It would be more correct to visualize the minister as the prompter, each member of the audience as an actor, and God in the role of the audience watching the way in which each one acts out his role in life, on the stage leading into eternity.

This would be the most ideal formula for the religious play. The writer should wear the mask of the prompter, the audience should be able to identify totally with the actor, and God should watch the actors act out their roles in his honour. T. S. Eliot – to mention the best-known representative of the religious playwrights – came closest to writing a fulfilled religious play in *Murder in the Cathedral*. It tells of the assassination of the Archbishop Thomas à Becket who dared to oppose King Henry II.

When at the end of this liturgic-poetic play the Fourth Knight apologetically explains why he killed the archbishop he tries to make it clear that Becket used every means of provocation: 'He had determined upon a death by martyrdom.' Becket is fully aware that under the cloak of the martyr hide many evils. Eliot chose three Tempters whom Becket could easily thrust aside, but it is the Fourth Tempter who interests us here. The Fourth is an unexpected visitor whom Becket has to ask: 'Who are you?' The answer:

> As you do not know me, I do not need a name.
> And, as you know me, that is why I come.
> You know me, but have never seen my face.
> To meet before was never time or place.

And when the Fourth Tempter in the course of their discussion says: 'I am only here, Thomas, to tell you what you know', then Eliot reveals this Tempter as Becket's *persona*. It is the mask with which Becket led his life and of the wearing of which his killer accuses him: the mask of the martyr who will 'rule from the tomb', the mask expressing the thought 'of glory after death'. The Tempter rightly says: 'I am only here, Thomas, to tell you what you know.' Thomas shouts at the Tempter: 'Who are you, tempting with my own desires?' and receives the reply: 'I offer you what you desire. I ask what you have to give' Becket expects and recognizes the other three Tempters easily, but he neither expects nor wishes to recognize his *persona*. Becket realizes that yielding to the *persona* means yielding to the last temptation, which, in his eyes, is the greatest treason: 'To do the right deed for the wrong reason.' In *Murder in the Cathedral* Eliot wears the mask of the prompter (appearing as Tempter on stage) and makes it possible for the audience to identify with Becket's greatness of vision and weakness of character.

Where Eliot failed – and certainly he failed in approximating the Kierkegaard formula – was in two of his more popular plays, *The Cocktail Party* and *The Confidential Clerk*. Here the playwright twisted the term *deus ex machina* into *deus ex Eliot*. In these plays we remain the audience, more alienated from than involved in the fate of the actors, and the playwright becomes the prompter and God. Eliot does not use actual *personae*, but his figures are life-size puppets. If a playwright creates masklike characters, he must endow them with the contours of a sharply profiled type turned loose in a world of wonderment, as Cervantes did with Don Quixote. With the exception of Becket, with his moral and intellectual urgency, and Harry, the knight errant in *The Family Reunion*, driven by the furies of his conscience and seeking peace with himself, Eliot's characters are either stand-ins for the dramatist or pale marionettes.

In *The Cocktail Party*, for example, Eliot is disguised as an unidentified guest who, later taking off his mask, turns into a psychiatrist, speaks with the

tongue of a priest, and acts with creative compulsion, rearranging the lives of the other characters. There is a great deal of symbolism in this vacuum. He sends one man to Hollywood to fulfil his purposeless life; he sends a woman with some religious leanings into martyrdom and death; and he forces an estranged couple to stay together. If there is meaning in all this – and, no doubt, Eliot wants to say that everyone must carry his cross to his destination in his own manner – the characters, with their invisible masks, are neither symbolized nor sufficiently typified. In Kierkegaardian terms, Eliot is too much God and too little prompter, and his characters are too schematically drawn to make us care to act out with them their lives' identities.

The French language uses the telling phrase '*jouer du masque*' – to play the mask. It best indicates man's playfulness in constantly presenting a face other than his real one to the world while we must doubt whether he knows his real face or is at all aware of the one in which he shows himself. La Rochefoucauld well recognized that 'our virtues are most frequently but vices in disguise'.

It would be simple if we could look through faces. At best, we can look through masks. We hardly ever get to the point where a person's dramatic desire to 'know thyself' is sufficiently revealed to make us see or even surmise the person's traumatic will to 'suppress thyself'. Kierkegaard pointed to the self that 'wills desperately to be itself – with the exception, however, of one particular, with respect to which it wills despairingly not to be itself'.

Language is one of the most helpful handmaidens of our self-deceptions. We feel secure behind clichés because they are immediately recognized and accepted. Like small change, they often come in handy. The threadbare and tired clichés are especially cheap but indispensable for small talk. When clichés are properly grown-up and placed in a very specific environment, they are often called slogans. The majority of people live and die for them. John Ruskin said in *Of Kings' Treasures*: 'There are masked words abroad, I say, which nobody understands, but which everybody uses, and most people will also fight for, live for, even die for, fancying they mean this, or that, or the other, of things dear to them.'

Well-phrased lies often enough repeated can become totalitarian masks, as Fascism proved. Such a wonderful writer as Knut Hamsun never liberated himself from the mannerism of repeating phrases and underlining certain descriptive statements about his characters.* Words and phrases habitually used

* Literature-sociologists thought to see in this methodical mannerism a logical precondition for Hamsun's fascistic leanings at the end of his life. The literary aspect of this mannerism is as impressive as it is deceptive, with its rhythmic simplicity reminiscent of the Bible. A passage from Hamsun's *Growth of Soil* (translated by W. W. Worster) may illustrate my point: 'She did not go away next morning; all that day she did not go, but helped about the place; milked the goats, and scoured pots and things with fine sand, and got them clean. She did not go away at all. Inger was her name. And Isak was his name.'

can be a part of our wish face (wish mask), or of our armour-plated defence.

Two of Eugene Ionesco's plays use the language beyond its communicative means and with the explicit purpose of unmasking it as the mask it is. Ionesco tells us that he was prompted to write his first play, *The Bald Soprano*, by the linguistic discovery of the total emptiness of our existence, the sham level on which we communicate, the mask behind which we disintegrate as characters whose 'words become meaningless absurdities'.

It represented, for me, a kind of collapse of reality. Words had become empty, noisy shells without meaning; the characters as well, of course, had become psychologically empty. Everything appeared to me in an unfamiliar light, people moving in a timeless time, in a spaceless space. . . . While writing the play (for it had become a kind of play or anti-play, that is, a parody of a play, a comedy of comedy), I felt sick, dizzy, nauseous. . . . All the same, once I had finished, I was very proud. I fancied myself having written something like *the tragedy of language*!

In essence, *The Bald Soprano* is a satirical replica of the mechanical aspects of our existence, the loss of our identity in a computerized world of human automata, a world drowning in its own clichés. In Ionesco's *The Lesson* the language is no longer a communicative problem, it is an instrument of power. The professor hides behind the linguistic mask, words are sharpened to the point of becoming a physical reality, scoring a symbolic victory over the mind before the person steps in front of his *persona* in order to kill. The repeated rhythmic enunciation of the final key word 'knife' goes beyond its obvious connotation of a sexually sick man. The mere sound of the word becomes more significant than its meaning and seems to symbolize authority in its sadistic nature.

A man may sometimes be afraid of losing face when, in reality, he is trying to protect the mask he wants to be seen and recognized as. Eugene Ionesco exposed it as the hollow mask covering our cliché existence, reflecting 'the absence of inner life' and a spurious social environment.

Although there are several theories about how the theatre developed in ancient Greece, everyone agrees that man's histrionic sensibilities are innate, basic, and rather specific virtues or curses. The combined forces of man's need for self-expression and his natural instinct for imitation are at the root of them, and these, of course, existed before the Greek experiment of forcing the initially uncontrolled and seemingly uncontrollable revelries in honour of Dionysus into more lawful channels.

Masks were employed by early man in a very loose histrionic manner. The first actor and mime was, undoubtedly, the man who killed an animal and wanted to show his fellows how he had accomplished this feat. With mimetic gestures and imitative sounds he probably played himself and the animal by putting on the slain animal's head, as Robert Edmond Jones outlined in *The Dramatic Imagination*. This early man was the first to recognize

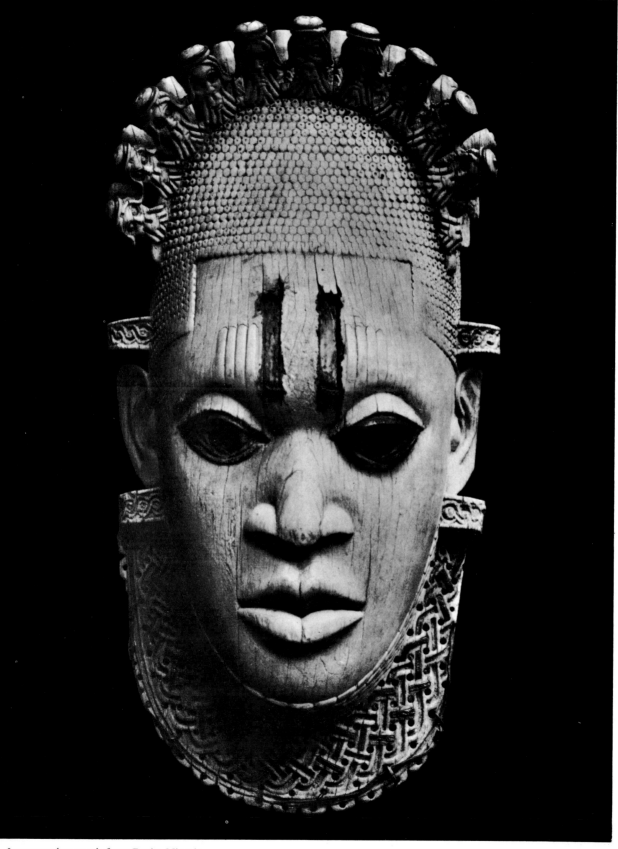

Ivory pendant mask from Benin, Nigeria

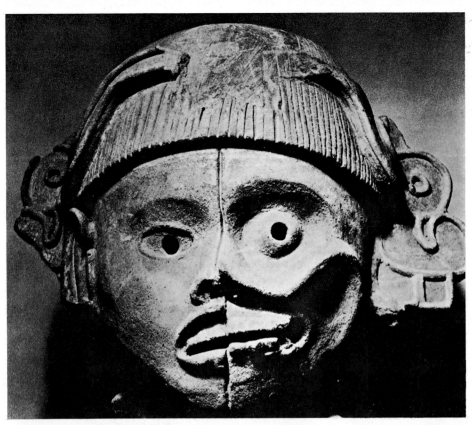

2 Zapotec mask representing life and death from Oaxaca, Mexico

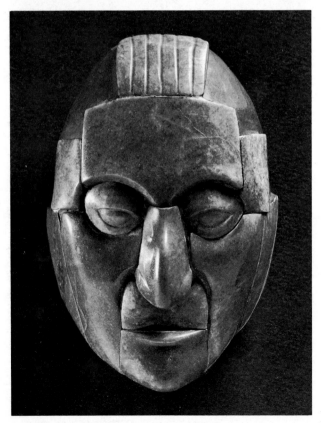

3 Jade mask from Palenque Chiapas, Mexico

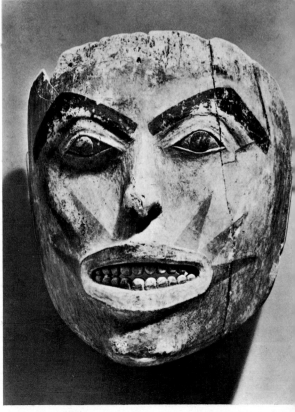

4 Indian mask of painted wood from the north-west coast of North America

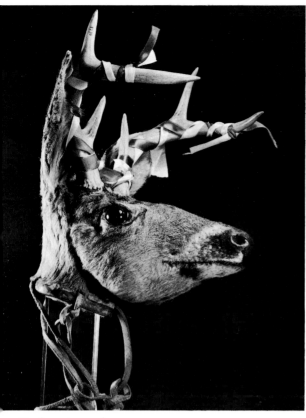

Mexican stag mask

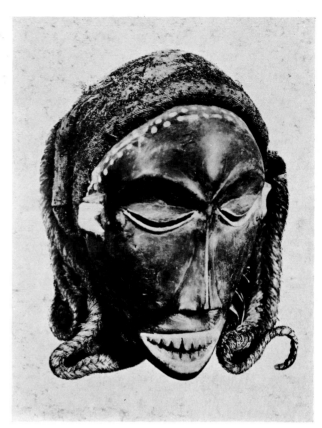

6 Congolese dance mask

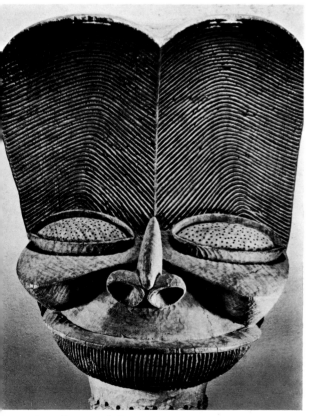

Bacham dance mask from Cameroun

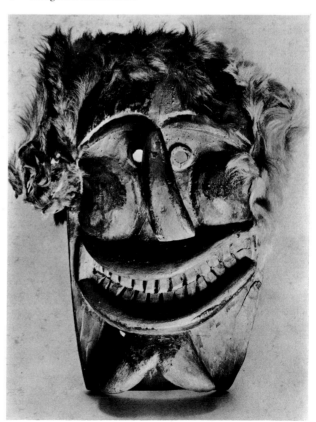

8 Painted wooden mask with sheepskin from Switzerland

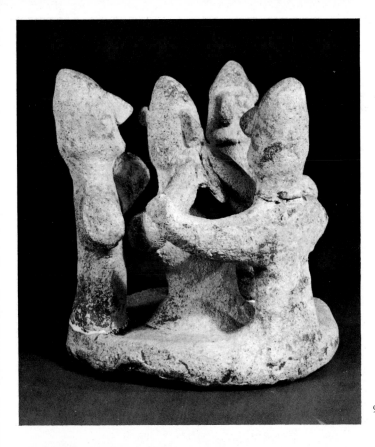

9 Cypriote terracotta group of a ring dance round a flute-player

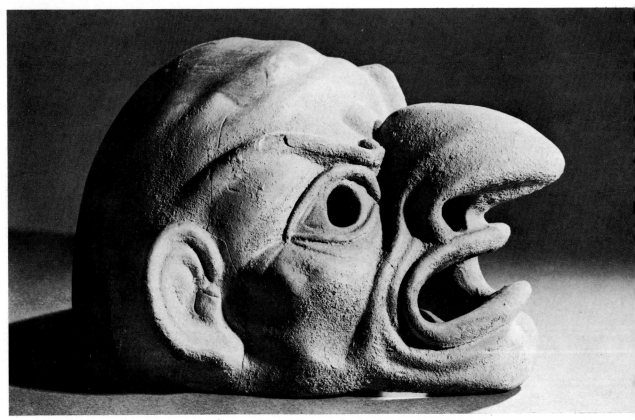

10 Third-century BC terracotta actor's mask from Taranto, Italy

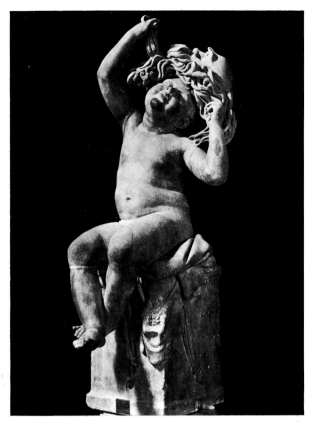

11 Putto playing with a mask, from Rome

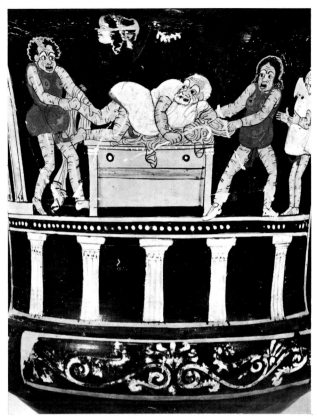

12 Fourth-century BC *phlyax* vase-painting

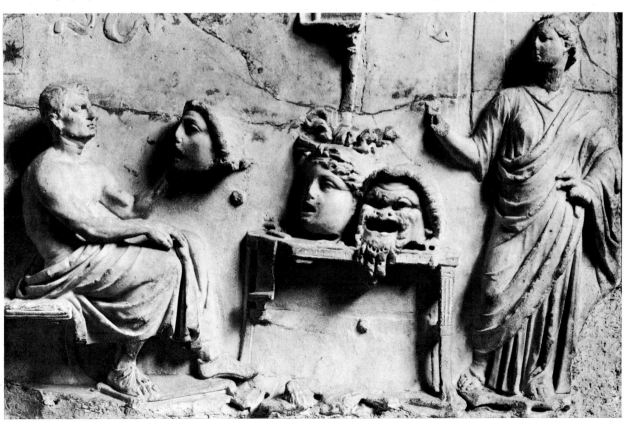

13 Hellenistic relief of an actor with theatrical masks

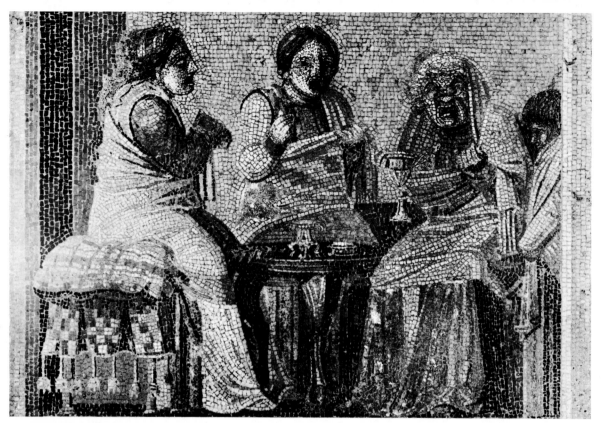

14 Pompeian mosaic of a sorceress with her clients

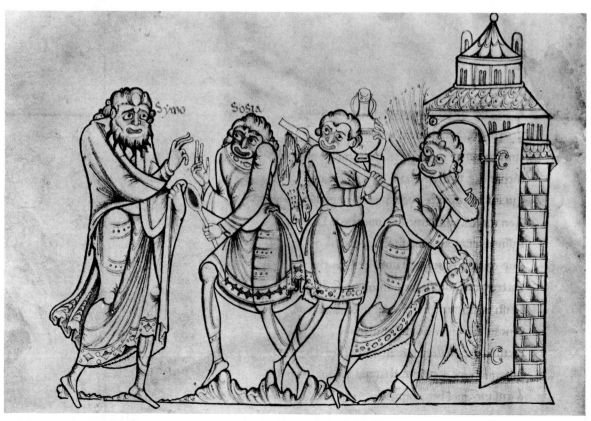

15 Manuscript page showing a scene from Terence's *Andria (The Woman of Andros)*

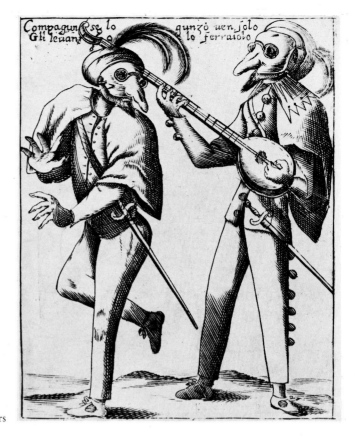

16 Seventeenth-century *commedia dell'arte* players

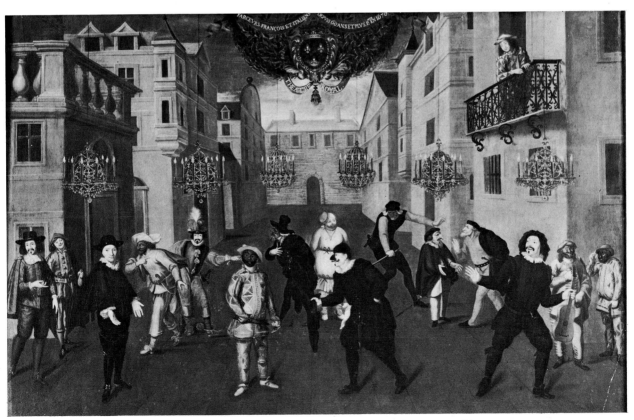

17 French comedians of the 1630s, some of them derived from *commedia dell'arte* characters, and later actors

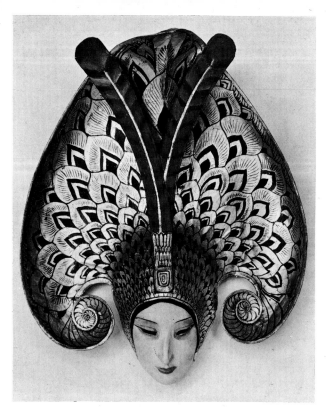

18 Mask by W. T. Benda worn in the Greenwich Village
Follies, 1919

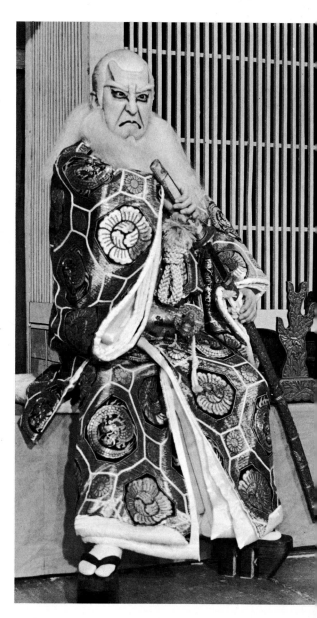

19 Scene from the popular *Kabuki* play *Sukeroku*

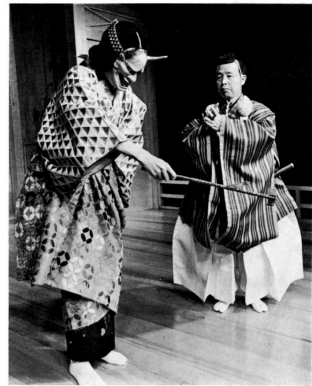

21 Scene from the Japanese *Noh* play *The Lady Aoi*

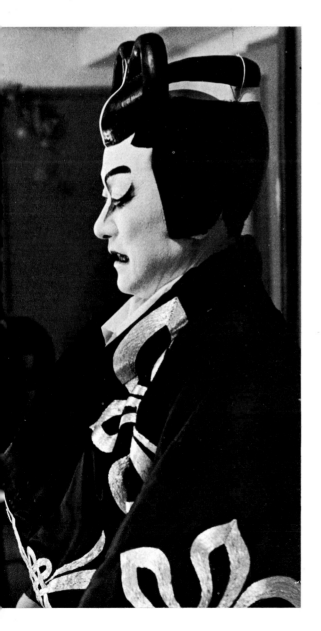

20 *Kabuki* actor

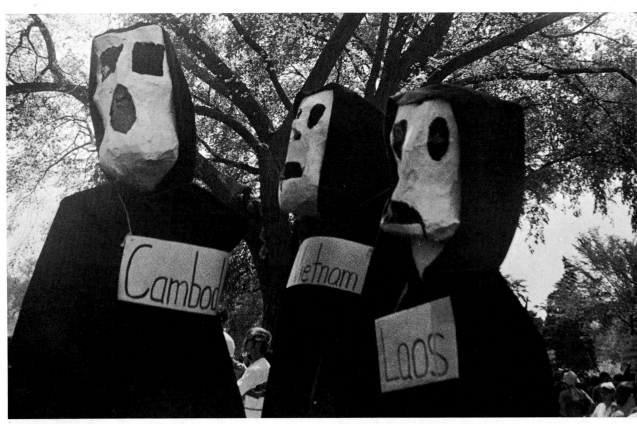

22 Giant puppets used in a demonstration against American policy in South-East Asia, Washington, D.C.

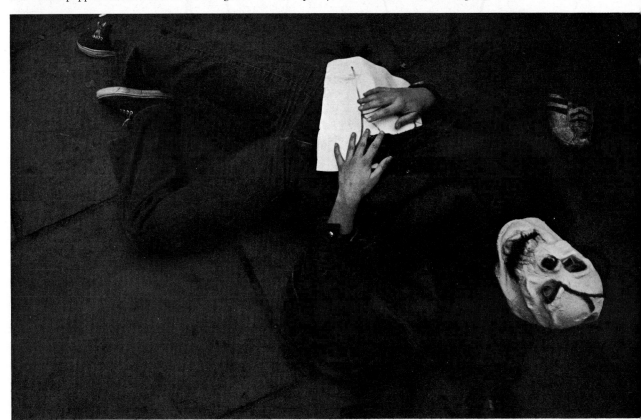

23 Street theatre in Manhattan

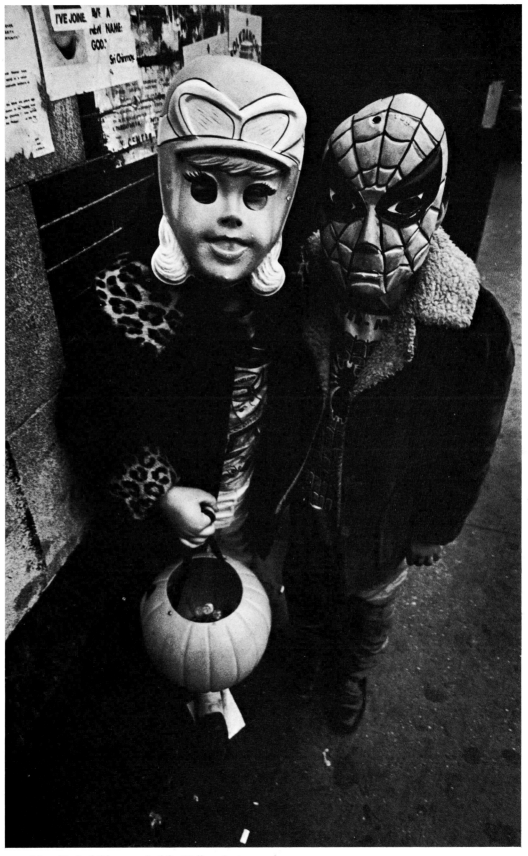

24 New York children masked for Hallowe'en

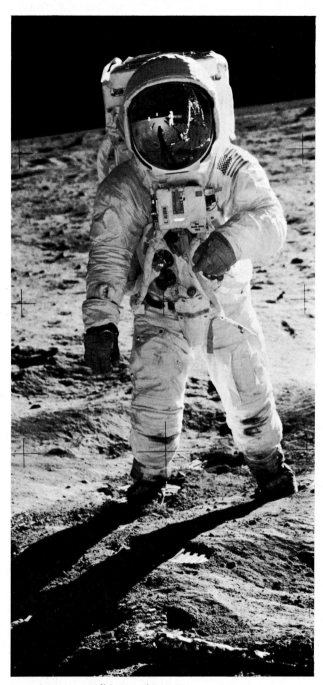

25 Astronaut walking on the moon

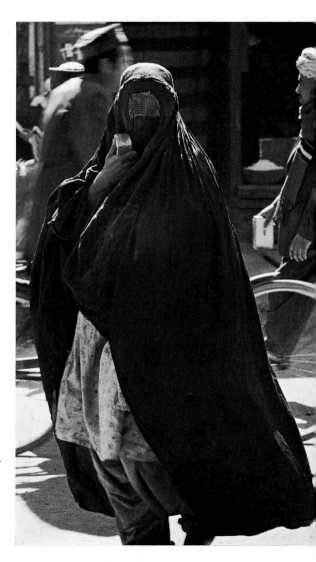

26 Moslem woman in Kabul, Afghanistan

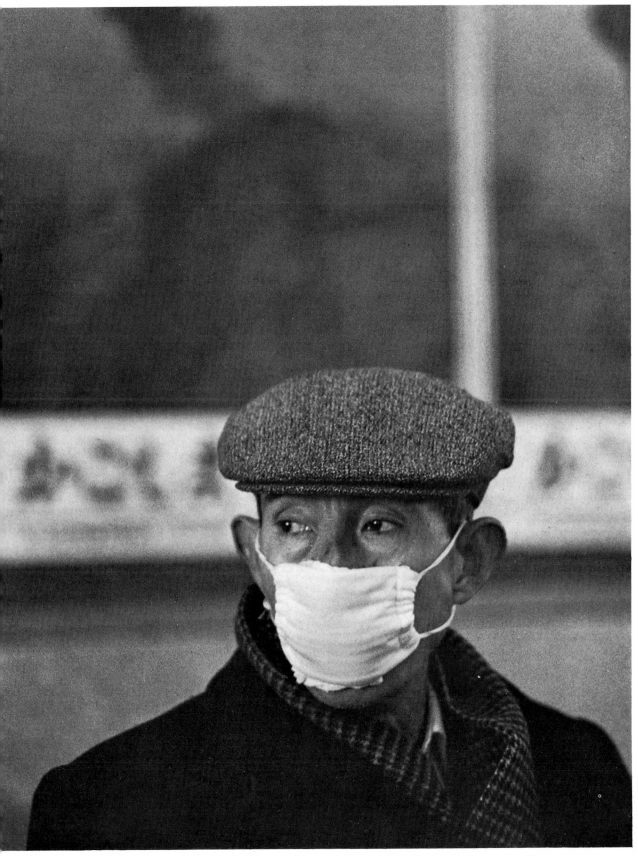

7 Hygienic mask worn in a Japanese railway station

28 Guests at a masked ball, Switzerland

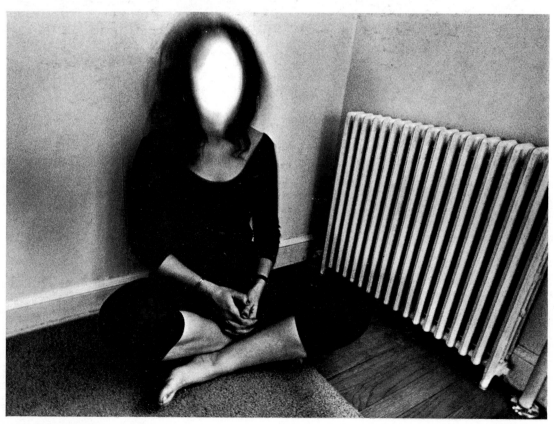

29 Girl meditating

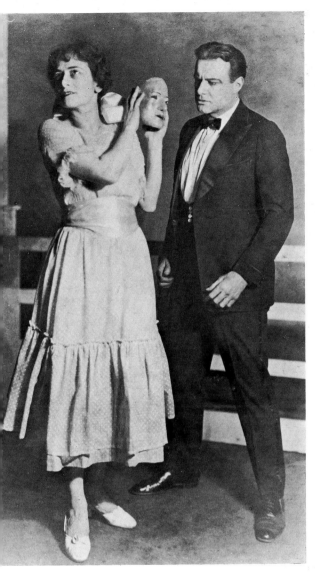

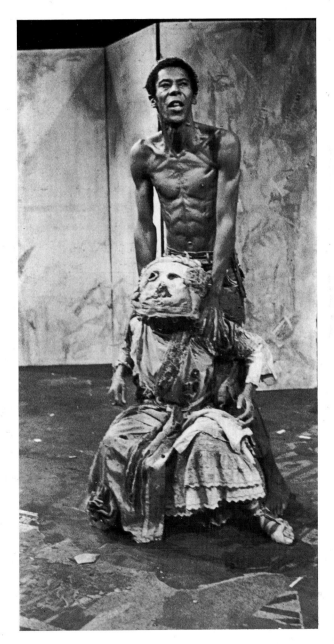

31 Scene from Jean Genet's *The Screens*

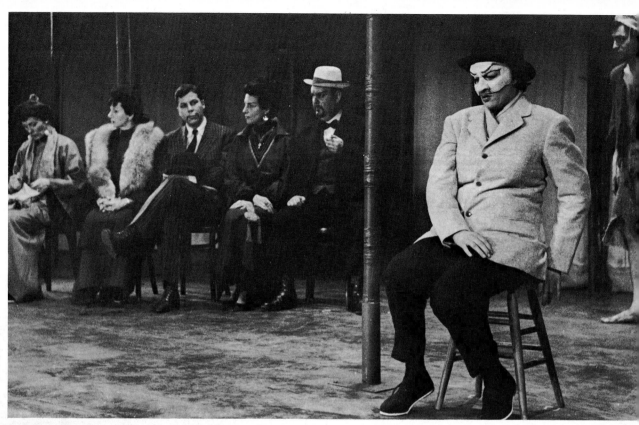

32 Scene from Bertolt Brecht's *The Good Woman of Setzuan*

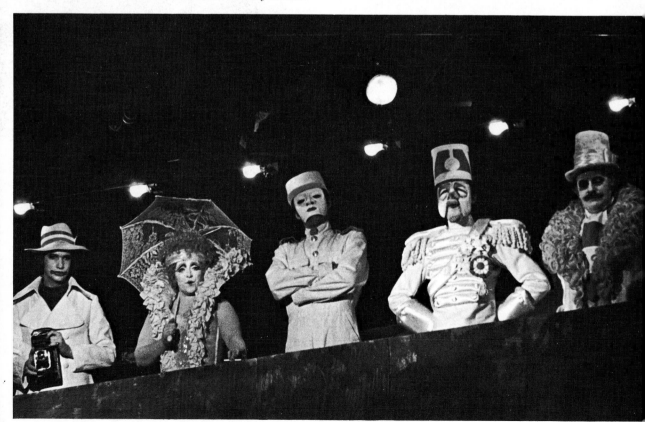

33 The Europeans in Genet's *The Screens*

the impact of a dramatic conflict and the effect of a dialogue, however silent it may have been, simply punctuated by some sounds, cries and grunts.

In his hour of triumph he may have dragged out this fight, exaggerated the animal's strength and his own cunning and skill. He may have done it unintentionally and unconsciously. But in doing so he added another dimension, the dramatist's imagination, to the actor's imitation of an action. He had no mimetic technique, but in recreating a true action as he imagined it took place, his histrionic sensibility made him use a mask. In wearing the animal's head as a mask, he felt its spirits helping him create and impersonate his adversary in a truly realistic manner. He could have been only vaguely aware of the mysterious power with which the mask made him react kinesthetically and imitate dramatically the movements of the fighting and dying animal.

Essentially, what early man thus portrayed was his continual fight against death. He saw the victory of the force of life over that of death symbolically repeated by the alternation of the seasons – the dying and resurrection principle – which, next to his fertility rites, became a major part of man's ritual celebrations. Beginning in primitive societies, vestiges of all this can still be recognized in the folklore of many peoples and their folk festivals, in the mummers' plays of England as much as in the *Fasnacht* (carnival) festivities in Switzerland. Moreover, death has always had its mysterious meaningfulness and still evokes ritualistic feelings in man. Many theoreticians see the origin of drama in tomb rituals which undoubtedly had dramatic implications in ancient Egypt.

It may be claimed that the first dramas were based on the so-called *Pyramid Texts*, whose hieroglyphs indicate stage directions and identifications of certain characters who usually introduced themselves, as is the case in most Japanese *Noh* plays. The story of the resurrection of the god Osiris was basic to all burial rituals. The dead king was identified with Osiris and played by a priest. Horus, the son of Osiris, may have been acted by the living king or a priest since all the actors were priests. Most of the deciphered text tells us that the mourners were reassured by the actor-priests that the king did not depart forever, that he was being resurrected. The priests would say 'Throw off thy wrappings!', and the actor playing the king would rid himself of the costume and mask, and enact a resurrection.

Man was frightened and awed – and probably both at the same time – by the mystery of being and dying, which he viewed as magical phenomena. The resurrection principle is not only a copy of nature's rhythmic, annual resurgence in beauty and bloom, it is also based on man's inability to accept that when he has died everything ends.

The *Pyramid Texts* and later ones indicate that animal masks were employed in most Egyptian ritual dramas, as they were in Egypt's most well-known ritual, the Abydos Passion Play. Some passages of the text have been

interpreted as indications that priests wore animal masks in their representation of deities. Early man's identification with the animal world was so strong that he would transfer a divine spirit to a single animal. It was worshipped, and therefore neither killed nor eaten. On the other hand, it might be worshipped for a short period of time and then killed. Man wanted to offer atonement to the animal's species for killing and using it for food. The ceremonial killing was a religious act, usually connected with masked dancing. The Bull Apis was associated with the god Osiris as the bringer of agricultural blessings. Feelings of guilt and a desire for protection were the propelling forces in man's worship of animals. On the one hand, it could lead to seeing in the animal a living image of the god, as in the identification of Apis and Osiris, or the goat and Dionysus. On the other hand, wearing the animal mask intensified man's identification with the divine spirit through the process of transference.

This also holds true for the very first step which, traditionally, is considered the beginning of the theatre as we know it. Arion was supposed to have written out the first lines. But when Thespis dared to leave the ritualistic chorus and assumed the stance of a single speaker, thus creating through questions and answers the dialogue between chorus and one actor, he also introduced the device of a white linen mask over his face. It could easily be that the idea of the mask was suggested by the fact that the impersonator of Demeter always wore a mask at her mysteries. This mask enabled Thespis to make the god manifest. Although the mask was only a symbol for the god Dionysus represented in the ritual, it gave Thespis and those who followed his daring the inspiration to articulate the dramatic conflicts locked in man's being and becoming. It was left to Euripides to return to these very beginnings of the drama in his last play, the *Bacchae*. In this play man's natural instincts, his blind beliefs, his ecstatic and orgiastic worship of Dionysus, clash with those denying nature and win recognition; for rationalism alone is never the last word about truth, which lies between all rational and irrational forces.

Thespis' megalomaniac act does not seem to have been an isolated case, but the one of which history took notice. Nor can the emergence of the drama from the ritual be limited to ancient Greece. It is the widespread use of the mask in ritualistic ceremonies everywhere – from Persia to China, from India to Japan – that created the concept of impersonation and with it the foundation for various characters in disguise and in conflict with one another.

It would be wrong to assume that the mask in the Greek theatre was an aesthetic or purely artistic device developed by the first dramatists. Nor was it psychologically conditioned, as in more recent history. The mask became a necessity. The single voice, the actor – or *hypocrites*, 'the answerer', as he was called – did not suffice after a short while. In order to change his character he

changed his mask. Aeschylus added a second actor and dared to diminish the role of the chorus. Sophocles, whose plays were complex in their dramaturgic structure, introduced a third actor. The *dramatis personae* grew and with them the number of masks. An actor could easily impersonate three characters by quickly changing his masks.

The actor's mask was identical with the character in the play, and both were referred to as *personae*, from *per sonare*, to sound through. (This is why Martin Heidegger rightly remarked that the ancient Greeks lacked a word with which to indicate a facial expression or concealment of a character's inner responses.) Each mask was fitted with a resonant mouthpiece of brass. It reinforced the voice of the actor, enabling it to carry to the audience from the orchestra, the circular centre from where he spoke and acted. The theatre was an arena, an open bowl with a capacity of 17,000 and often more spectators, at least half of them more than a hundred feet from the orchestra. The vocal delivery was most important, and the success of a play was often decided by the projection and beauty of the actor's voice. The acting was done with broad gestures and the delivery of lines was undoubtedly closer to an operatic recitative than mere declamation.

Therefore the mouthpiece within the mask was as essential as the mask itself, which was larger than the actor's face and, in an instant, helped all the spectators to recognize the character portrayed. When well-known contemporaries were represented on stage – mainly in comedies, such as Cleon in *The Knights*, Socrates in *The Clouds*, or Euripides in the *Ecclesiazusae* – the masks imitated their actual features, most often with a touch of caricature. When Aristophanes' *Clouds* was produced, Socrates, who was among the spectators, had to get up from his seat to let them see how true to life the mask was.

In the beginning the masks were crudely fashioned out of bark, but most of those worn for the dithyrambs were of leather lined with cloth. Later, for stage productions, each mask was made of cork, wood, or linen and was fashioned to fit the actor, with proportions suited to the size of the amphitheatre. The mouthpiece was as close as possible to the lips, which were kept open and exaggerated in order to function as a rudimentary megaphone.

Since the masks were mostly quite large, their realistic and rather concrete expressions clearly characterized a human type or the image of a god as he was generally conceived. The exaggerated features could easily be frightening, and even in comedies some of the masks were often terrifying in their crudely comic aspects. The Greek sophist and grammarian of the second century AD, Iulius Pollux, describes a series of masks as they were used in the earlier Greek theatre in his encyclopaedia *Onomastikon*.

We can visualize better what they looked like from frescoes, sculptures, and vase-paintings. Pollux lists about thirty masks for comedies, categorized according to age, class, birth, and facial expression. Eyebrows, lips, the colour

of hair and the complexion often indicated the mental condition and temperament of a character.

Among the masks for tragedies Pollux mentions nine types of old and eleven types of younger men as well as seven servants. There are seventeen types of women, ranging from old hags to young girls among whom Pollux distinguishes genuine and false virgins and prostitutes. There is also a female domestic servant characterized by a flat nose and two molars only in each jaw. A clear characterization, often going to extremes as to headdress or complexion, was intended. Wherever it seemed necessary, the masks of the chorus were clearly detailed in their characteristic expression. Thus, according to tradition, the masks of the Furies in Aeschylus' *Eumenides* showed bloody faces surrounded by snaky locks that were fearful to look at.

The detailed descriptions by Pollux correspond rather accurately with the listed types in the Aristophanic comedies. We often wonder about the stock characters of the *commedia dell'arte*, but we already find a set of stock figures in Greek comedy, old and new, as well as in the Sicilian *phlyakes*, where we always encounter an old man and old woman, a cook, a doctor, a baldheaded parasite and several comic slaves. The types in the Atellan farces resembled those of the *phlyakes*. In both, the leading comic characters wore masks, while some maskless actors appeared in those more or less improvised satires. The *phlyakes* were a comedy genre with scenes full of the most ordinary lusty life with a great deal of eating and drinking, of thieving and deceiving. They were burlesques with phallic overtones, and their animalistic eroticism gave the masks a demonic touch. But, in general, the mask in the Greek theatre no longer had the magic power it had for primitive people, or which the masks of the *Noh* plays retained. The action or activities to which early man tied the meaning of the mask functioned on a purely mimetic and strongly visual level with hypnotic suggestiveness. No longer so the mask on the Greek stage, where the spoken and sung word carried heavy and meaningful cargo which the mask elucidated in an interpretative or illustrative manner. The catharsis with its pity and fear replaced all demonic energy, the cerebral content arose as a new magic. Only the identification remained unchanged in its intrinsic purpose, even though it now worked on a different level and in a rather vicarious manner.

The Roman drama relied heavily on its Greek models, and so did its costumes and masks. In some of the Roman plays masks were only used by the comic actors, as a manuscript page, now in the Bodleian, of Terence's *Andria* shows, and these masks varied as to their natural lifelikeness or satiric exaggeration. The *mimus*, strongly leaning on the Greek *phlyakes*, developed a farcical entertainment with adultery and broad humour as its major attractions. Masks were not always used, but whenever they were the appearance of the masks was realistic or grotesque, and both most often grossly

exaggerated. Rome's original contribution was the *pantomimus* whose art was essentially terpsichorean.

The Greek playwrights were fully aware of the limitations dictated by the mask's rigidity. Only the gestural language could help to explain an emotional change in a character during a scene. When Orestes makes himself known to Electra in Sophocles' *Electra*, the joy by which Electra is suddenly overcome does not give her time to change her mournful mask. Sophocles is at pains to explain this to the spectator.

ORESTES: Take care, you, that our mother may not discover you
by your radiant face. . . .
ELECTRA: Do not be afraid that she will see
my face
radiant with smiles. Our hatred is too old.
I am too steeped in it. And since I have
seen you,
my tears of joy will still run readily.

There is no compelling reason for any modern stage director to use masks in a revival of the Greek plays, since the physical conditions of our theatres do not ask for them. Nevertheless, attempts in this direction have repeatedly been made in the erroneous belief that this will give the play a feeling of greater authenticity. Some directors think highly of the use of masks and will use them even in Elizabethan plays where the dramatist does not ask for them.

In our own time masks generally tend to look different from those rather crudely realistic masks of antiquity, and rightly so. For whatever reason they may be used nowadays, they are and should be strongly stylized, imaginatively symbolic, sculpturally surrealistic. Where they are still most appropriate is at productions in open-air theatres, and particularly in those still intact since the days of antiquity. There are some in the Mediterranean countries and in Switzerland. The Swiss have a special predilection for masks, since they are the European nation most steeped in folkloristic customs in which the mask has always been an impressive feature.

In 44 BC, the Romans founded a town they called Augusta Raurica, now the village of Augst near Basle. They built there an open-air theatre which has been kept substantially alive and is often used for theatrical productions. In revivals of the classical playwrights there the actors appear in artistically beautiful masks, be it in Euripides' *Iphigenia*, or Aristophanes' *Ploutos*, or in Menander's *Dyskolos*.

As in ancient days, the masks must be fashioned to fit the face of the individual actor, although it appears spatially over-dimensional. It also reaches beyond any facial expression into a sculptural form. The mask-maker must see to it that the mobility of the actor's second face allows for a variety of emotional expressions. The modern actor is charged with a most difficult task. He is not used to wearing a mask, relying greatly on vocal

modulation. He can no longer be himself, he must become one with the mask, master it by serving its peculiarities.

The mobility of the head must be used to express the emotion–ability of the mask. Lifting or lowering of the head must become articulate and meaningful, and each movement of the head must be relearned in terms of the mask. The nuances and variations are innumerable. The slightest movement of the head can shorten or enlarge the opening of the eyes or the mouth. The profile of the mask can be utilized to underline ideas. Or, if the masked chorus moves in unison, a heightened and exciting moment can be created visually. What the actor needs is a total metamorphosis in his inner experience as an individual and in his technique as an actor.

If an actor in an Eastern play wears no mask, then his make-up is so complex and expressive that it is little less than a mask, as the Chinese actors prove. Some of the head-dresses, too, are most intricate and are said to possess such powers as to transform the actors into the characters they portray, as in a Kathakali play.

Movement has always been an essential means with which to give more potency and meaningfulness to the mask. Probably the mask has continued to play such a dominant role in the Eastern theatre because the drama has never parted company with the dance, as happened in the West after the Middle Ages. In many cases theatre in the East is pure dance theatre.

The Greeks began our civilization with the idealization of man, whose body was full of energy, whose mind thirsted for action. Superficially, Eastern man has absorbed some influences from the West as Western man has flirted with certain concepts of the East. But our Western thinking moves in realistic channels, action-oriented; our theatre is based on conflict, suspense, and tension. The Oriental theatre sees meaning in symbolism. One man on the Chinese stage is accepted as the symbol of an entire regiment, as a Japanese brush can paint one branch of a tree and create with it the atmosphere of spring. Western man cannot easily accept such stylization. Eastern man can see stillness in movement and, in fact, demands peace in rhythm and does not mind duration filled with sameness. He thinks far more in terms of timelessness than we ever can. The notions of nirvana and reincarnation were born within such philosophies of life. The Oriental mind is tradition-bound; ours asks for change and newness.

This is where the mask comes in with its symbolic significance, its timeless rigid expression, its sameness and stillness. In contrast to it, the face is alive, it changes with the character's mood and reaction to outside impressions, it is fraught with fear and enlivened with joy, and briefly reflects the ever-changing moment. Therefore, we should only be surprised when the mask or a masklike make-up is missing from an actor's face in the Eastern theatre.

It does happen, as in the Indian court theatre, or in contemporary Westernized plays, or wherever religion has anathematized the image of the 'other' face; but these are the exceptions. India had its 'Golden Age' or the Gupta Renaissance under Rajah Chandragupta and his son between AD 320 and 460. Most of the dramatic material used in South East India is based on the two great epics *Ramayana* and *Mahabharata*. The most famous dramatist of this court theatre is Kalidasa and his best-known work *Shakuntala*, a delightfully romantic play about a lost ring and true love. It was preceded by another play, *The Little Clay Cart*, which also has to do with true love, carnal lust, and jewellery. But beyond its intricate love story it has humour and a touch of social idealism. It was based on a similar play by an earlier writer, Bhasa, who is considered the founder of India's dramatic school. He and Kalidasa wrote for court entertainment, for an intellectual élite, and small theatres. There was, of course, no compelling need for the actors to wear masks.

We find a quite different situation in the East and North of India. In these regions the theatre is very much a part of communal life, strongly ritualistic, with dance playing a major part. All over South East Asia the theatre is a social institution and, more often than not, the theatre consists of wandering troupes and comes to the people in the villages. It has very much in common with the *commedia dell'arte*. Here, too, the action is improvised and only its skeleton idea is known to the actors; this much is equally known to the public since the basic themes are taken from familiar Buddhist and mythical-historical stories. In Burma or Cambodia the mask is an accepted symbol in all these performances.

The Javanese have three different kinds of theatre. All over the Orient, including Turkey, the shadow and puppet plays are part of a region's folk-lore. They occupy an important position on Java where the shadow plays are called *wayang*. There are two other types of theatrical entertainment. The *wayang gedog*, a pantomime show in which living actors without masks dance and mime; and the *wayang topeng* or *wayang wong* which is played by costumed and masked actors. These masks are held tightly over the face by an inside strap around which the actors' teeth are clenched. As a matter of course, their lines must be recited by a narrator while they dance their parts.

The *wayang topeng* masks are often impressive in a frightening way, conveying their demonic quality. Despite being highly stylized, their impact is one of realism, portraying servants or merry fools behind whose second faces hide indigenous spirits and demons. There are certain types, such as the fool Pentul or Buto, who have always the same and easily recognizable masks. In their stylized realism these masks are very grotesque and their demonic expression may be linked to the symptoms of ugly diseases frequently recurring on these islands, that is tumorous swellings, open wounds with tissue debris, or any tropical skin diseases. These people try to overcome

the dull and gloomy feeling of unease and fear which these visible symptoms arouse by making them very concrete on the masks. In earlier days these people may have thought that the demonic spirit of the mask would help to free them from such illnesses.

It may be difficult to associate a Lamaist monk of Tibet with erotic poetry and religious plays mostly based on Hindu fables. But this is what we find in the works of the Sixth Tale-Lama, who lived in the seventh century AD and whose name is not only memorable because, among the many anonymous monk-playwrights, he is the one known to us, but also because his name can hardly be memorized: Tsongs-bdyangs-rgyam-thso. His and the other dramatists' plays were performed in or in front of monasteries by monks who were supported by lay professionals in the female roles. The style was very formal, the narrative part extensive. Similar to that used in Greek productions, the chorus provided the link between the various scenes and its movements were as stylized as the text. A variety of masks were employed which gave colour to the characters and were, in their suggestiveness, indicative of primitive totemism. John Gassner says in his *Masters of the Drama* that 'the very extravagance of Tibetan humanitarianism becomes a poetic virtue' in these plays. 'Here, in short, is the theatre of idealism in its most unalloyed form.'

There are distinct similarities between the Tibetan and Korean masks, not only in their folk simplicity, but also in their contrasting colourfulness and their exaggerated and often grotesquely distorted features. However, the content and the entire approach of the Korean masked plays, or dance plays, has nothing of the lyric beauty and refinement of the Tibetan plays. The Koreans underline the farcical aspects of human life, pleasing the taste of the common people. Their mask plays have a folk origin and developed during the late Yi dynasty (seventeenth–nineteenth centuries) in a rebellious spirit against the ruling class. The two most popular forms are the *yangju pyol sandae* mask play and the *pongsan* mask dance. The masks for the play are made of wood and gourd, those for the dancers of paper. The plays consist of many loosely knit scenes and feature twenty or more actors who are all differently masked according to their roles with slight nuances in shape and colour. The *pongsan* dance masks are less stylized and more realistic, with exaggerated and grotesque features.

Each of the various different scenes of these mask plays is a unity in itself, different in tone and style. Their plots have little to do with a general theme. But all the theatrical elements – masks, music, movement, songs and dialogue – contribute to a highly theatrical production which is close to a Greek satyr play or, in certain ways, to a modern burlesque variety show. The vulgar overtones of most of the fun are glossed over with a disarming innocence.

Few of the traditional Korean plays can still be seen today. Marxist and Western realism respectively have created marked changes in China and

Japan as much as in Korea. It seems, however, that neither China's nor Japan's traditional theatrical spirit has given way to the contemporary pressures of an alien world as much as has been the case in Korea.

It must suffice to say here that, like our own, the Chinese theatre originally emerged from danced rituals, but that theatre from the literary viewpoint has never achieved the same importance there as the theatrical brilliance of the performers. Over the centuries the Chinese experienced several invasions which were detrimental to a sequential development of the drama, but the thirteenth and fourteenth centuries brought forth a few notable dramatists despite, or because of, the Mongol invasion. It was said that at that time the learned Chinese found a means of self-expression in the rather despised form of the drama, and theatrical activity continued to flourish under the Ming Dynasty (1368–1644) after the Mongols were driven out.

The West has become acquainted with a few plays, such as the thirteenth-century *Romance of the Western Pavilion* and *Lady Precious Stream*, translated by S. I. Hsiung into English, and above all with another adventure story, *The Chinese Orphan*, which Voltaire turned into *L'Orphelin de la Chine*. *The Chalk Circle*, which was beautifully adapted by the German poet Klabund, is probably closest to the Western mind. It contains not only a great deal of humour and intrigue, but also one of the famous scenes in dramatic literature: in it a judge uses Solomon's tactics to discover the real mother of a child. He draws a magic circle of chalk around the child and charges both women to drag the child out of it, declaring, moreover, that the true mother only will be able to do so. The woman who, fearful of hurting the child, does not tear at him is pronounced the true mother. (In Bertolt Brecht's version, *The Caucasian Chalk Circle*, the real mother is the one who did not give birth but love to the child.)

Beyond a handful of dramas it is the theatrical aspect of the Chinese theatre that makes it unique. The Peking Opera (in its former set-up) exemplifies all that is very special about an art form approximating to what the Western world refers to as total theatre. In almost every respect it has remained faithful to its tradition and stage conventions. Thematically, it has been customary to think in terms of civil and military plays, the latter being mainly based on legendary and historical material, the former running the gamut from romance to crime.

The Chinese theatre demands that the actor be a singer and dancer as well. As a dancer he belongs to the world's best acrobatic virtuosi. A Chinese actor-dancer begins his training from the age of eight or ten, and from then on his tireless work never ceases. Assigning female roles to male actors was practised until quite recently, a throwback to the days of feudalism when women were forbidden to act in the theatre.

From its very beginning the Chinese theatre created types as the synthesis

of human characteristics. In this respect we find great similarities with the *commedia dell'arte*. The actor-dancer begins from his early youth to concentrate on roles of a certain type for which he seems best equipped, and then remains all his acting career a warlike hero, let us say, or a comic character. Everything depends on the skill with which he can make his part come alive through his very personal interpretation and spirit. Without being allowed to improvise, he must be able to achieve absolute harmony in miming, singing, dancing, and speaking. It is a highly suggestive theatre with a minimum of scenery and props; it frankly admits that all that is happening on stage is play-acting by employing dark-clad property men who assist the actors during the play with adjusting or changing their complex costuming and furnishing the few needed props. The stage convention forces the audience to accept the ultimate of pretence by ignoring these property men.

All this goes a long way to explain why in a theatre of the utmost suggestiveness and illusion the mask must play a significant role. During the early part of the third century masks were used, but later exchanged for a highly stylized and masklike make-up in harmony with, and expressive of, the whole character and type. The actors take great pains, and sometimes spend hours, over the painting of their faces, as is also the case in Japan. There are exactly prescribed rules as to how the facial make-up has to look, since the type and its character must be immediately recognized by the audience.

Since writing and painting are done by the same brush and are spiritual brothers under one stroke, we may visualize the whitening of the face as an act of neutralizing it and converting it into a sheet of white paper. The actor can write the legend of his own character on it. If he leaves the face white, it indicates evil, infamy or at least uncouth behaviour and unchecked passion. White on the nose alone is a sign of the comic character (there is a parallel here to the clown face, as we know it), displaying cunning but not necessarily bad traits. This is also the make-up that servants, tramps, and less important characters use.

Red is the colour of the loyal hero, the honorary military commander, and courageous persons in general; blue belongs to basically nice people who are well-meaning, even though they may be rough in their behaviour. The man behind a predominantly yellow mask is reserved, but also characterized by hidden strength and cleverness. Black denotes a vehement nature, a man whose actions are ruled by fierceness and self-control. Green is the colour of demons and devils, gold of supernatural creatures. A shattered or broken face is shown by curves, lines, and spirals of colour; this is the mask worn by evil men, bandits, and traitors. The opposite is the smooth face of the young heroes, scholars and reliable ministers.

Thus, the actor-dancer has an immediately identifiable face. The tradition of these complicated masks is about five hundred years old. Before this time

there were only black and white masks. Such simple masks, in which one colour predominates with only the eyebrows emphasized, still exist today. This mask is technically known as the simple face. The mask indicating a female also has a light make-up in order to bring out the natural beauty of the face.

Of all the Eastern plays, the Japanese *Noh* drama has had the strongest fascination for Western man, perhaps because it is technically, visually, and spiritually the most divorced from all we know as theatre. It reached us with the greatest impact shortly before, during, and particularly after the First World War, when our trust in our own spirituality was lowest. Its effect on some of the Western artists was only eclipsed in its impact by I Ching and Zen Buddhism at a time when, after the Second World War, we finally had to declare our spiritual bankruptcy. The flight from ourselves took us into the obscure world of the East where we felt more secure in our feeling of lostness.

The tea cult and its ceremonies are an essential part of Japanese culture. 'It inculcates purity and harmony, the mystery of mutual charity, the romanticism of the social order. It is essentially a worship of the Imperfect, as it is a tender attempt to accomplish something possible in this impossible thing we know as life,' explains Okakura Kakuza in his slender volume, *The Book of Tea*. At the time when this book reached the best-seller lists Ezra Pound embraced the esoteric world of the *Noh*. In China in the eighth century, tea entered the realm of poetry, Okakura tells us, and Pound assures us that about that time the Japanese aristocratic élite 'established the tea cult and the play of "listening to incense". In the fourteenth century the priests and the court and the players all together produced a drama scarcely less subtle.'

Pound calls the *Noh* play 'a drama of masks' and refers to the platform on which it takes place as 'a stage where every subsidiary art is bent precisely upon holding the faintest shade of a difference'. Again, one could describe *Noh*, which means 'accomplishment', as a total theatre concept, but in trying to capture it with words we defeat the purpose of what we want to achieve. As I see it, the essence of its being is total allusion, and all the theatrical arts are subsidiary to the total art of total allusion. If we are justified in saying that the eyes – in a broader sense the face – are the windows of our soul, then the mask is the essence of allusion. For *Noh* the actor-dancer 'must feel the thing as a whole, from the inside. . . . It is a *Noh* saying that "the heart is form".'

The old masks for the 250 extant *Noh* plays were gems of sculptural achievement. I read in Ezra Pound's and Ernest Fenollosa's *The Classic Noh Theatre of Japan*, published for the first time in 1917, that an ordinary mask may be worth 30 yen and a great one 200. The point is that one can hardly distinguish between them. 'But the longer you look at a good mask the more charged with life it becomes. A common actor cannot use a really good mask. He cannot make himself one with it. A great actor makes it live.'

We will find this true, of course, for all actors and dancers wearing masks. To make a mask come alive, the spirit of the mask must penetrate its wearer in order to enable him to give life to the mask, i.e. his character. Only when the actor is one with the mask will turning the head no longer be difficult. On the contrary, movement – as we must stress time and again – only helps to give the mask the illusion of features which its rigidity does not have. The *Noh* mask was carved of wood, and its greatness consisted in being of more than one expression, holding potentially different characteristics which the actor must realize through nuances of movement. In other words, the actor is aware and makes the audience aware of the mask's physiognomic features which are there only when they are made to be there.

The *Noh* and its humorous counterpart, the *Kyogen*, were always performed for an initiated and highly intellectualized élite. Such a special audience does not exist today, and this may be one of the main reasons why very few *Noh* companies still preserve the mysterious wonders locked behind a wooden mask and acting accomplishments polished to perfection.

There was hardly any entertainment for the Japanese masses before *Kabuki* filled this gap in the seventeenth century. *Kabuki* stands for song, dance, and technique; it is quite similar to the *Noh* play, and yet in vulgarizing or popularizing traditional themes, in exaggerating the highly stylized acting of *Noh*, in taking liberties wherever possible, *Kabuki* has served the populace and also proved a more saleable export article than *Noh*. The *Kabuki* groups discarded the wooden, for the masses incomprehensible, masks of the *Noh* and exchanged them for a bizarre make-up, closer to the facial painting of the Chinese than the *Noh* actors.

The *Kabuki* plays are far more flexible than the *Noh*, and some of the greatest writers have contributed new dramatic material for it. The greatest Japanese dramatist, Chikamatsu Monzaemon, who has often been called the Japanese Shakespeare, was born in 1653. He had the brush of a great poet and created some of the finest pieces for the *Kabuki* repertoire. But two facts made him turn to the puppet theatre: first of all, puppets became the great vogue in Japan in the eighteenth century and, secondly, he became disgusted with the liberties the actors took with his finely chiselled texts. One of his pronouncements best circumscribes the essence of the Eastern theatre: 'Art is something that lies in the slender margin between the real and the unreal.'

In spite of man's desire to maintain his individuality, he has a need to be a part of a group, to identify with others and to be easily identified and categorized. Our physical appearance, especially the form and expression of our heads, leads easily to a comparison with an animal, and there was a fad at the time of the Renaissance for identifying a man with a certain beast. We only have to think of Ben Jonson's *Volpone*, subtitled *The Fox*. Jonson was also strongly influenced by the then current concept that man's bodily secretions

determine his feelings and reactions, producing the choleric, melancholic, phlegmatic, or sanguine personality.

We ourselves are often induced to think in terms of types, which are the sum total of certain characteristics projected on to the personality. Types are in a broader sense nothing but easily recognizable, ready-made masks. Sometimes an individual can create the image of such a mask. Charlie Chaplin's mask created for us a memorable type of the tramp. Falstaff's physical misproportion has the instantaneous effect of a body mask. On the other hand, there are types, such as Don Juan or Tartuffe, that are marked by a certain spirituality. They are archetypal masks that reappear in slight variations again and again. At times, types are found in pairs. Don Quixote's gaunt shape evokes a clearly defined image, particularly in juxtaposition to Sancho Panza. Groucho Marx' cigar, moustache, flashing eyebrows, and leer are like Chaplin's outfit a substitute for a mask. These accoutrements, however, have meaning only because they are a part, although the most characteristic one, of the artist's total *persona*. They are the type's trade mark.

The people in the Middle Ages moved through and were moved by contrasts. They felt forced to see in the earthly church the divine spirit, in the joys of the flesh the tricks of the devil. They were torn between the fear of damnation and the hope of salvation. They lived under the terror of darkness and escaped into the joys of processions and the spectacles of burnings and executions. The real was only an excuse to profess the ideal, and all happenings became hallowed symbols in their eyes.

The most common symbols of medieval days were death, devil, and fool, and all three – wherever they appeared – were realistically masked to stimulate and to cater to certain images of the people's imagination. A unique ninth-century phenomenon was the nun Hrosvitha, who, in the abbey of Gandersheim in Germany, wrote comedies based on the all too secular works of Terence with Christian symbolism, glorifying martyrdom and chastity. In one of her six comedies three virgins are wooed by a seducer at night. The lustful pagan governor embraces three sooty pots disguised as the virgins and emerges from his adventure with a dirty face and soiled clothes. As punishment and repentance he is compelled to dance through the woods as the Bacchantes once did.

Death and the devil became important allegorical figures in the medieval morality plays. The devil especially was fantastically costumed and hardly ever failed to appear in a grotesque animal mask. According to Allardyce Nicoll, 'masks or "visors" seem to have been fairly common', an assumption based on some of the extant lists of properties from the plays in Yorkshire and Leicestershire during the late fourteenth century. Since a prompt book of the *Mystery of the Passion* at Mons in 1501 has recently been found, we know how the re-enactment of the Passion took place in this medieval

extravaganza with sixty-seven mansions, with Heaven and Hell at opposite ends. The costuming was lavish, and the devils were grotesquely masked as if they had jumped out of a Hieronymus Bosch.

Based on most of the extant pictures of the devil we may safely assume that medieval man visualized the figure of the devil as 'a wild man' who seemed to come straight from the fauns and satyrs of antiquity. Lucifer, clad in a bear skin with tail, was not an unusual sight. All devils without exception wore masks, as is stressed in many accounts, but these masks varied a great deal. The one thing they had in common was their frightening and ugly appearance. 'His head was mighty wondrous and hairy', one description says. 'His eyes were bloodshot, and a crown was on his head. His mouth was huge and his teeth very sharp. He had the head of a cat, and a hairy animal's body. So ugly a beast could not be found in our age. His head was hideous and his countenance dark.'

Some of the devils' masks are far more fearsome and repulsive than the verbal power of any contemporary description can make them appear. There is the picture of a scaly costume, a concept also borrowed from antiquity, with fins, a frighteningly horned mask and a gruesome-looking animal head with a huge tongue covering the devil's genitals. Most of these masks reiterate the ancient idea of the demonic power alive in masks. We also know of a goat-like devil with a distorted face showing a ferocious-looking mouth and an unusually twisted nose. All this only bares the incredibly warped fantasies with which medieval man lived, the Gothic cruelty which indulged in self-flagellation as much as in the burning of witches and heretics, and which made of executions a theatrical spectacle.

The medieval fools have an old tradition leading back to the classic stage fool. But it was in the Middle Ages that their *raison d'être* became weighty in meaning. Their very special costume and wit were their trade mark and mask. They were usually clad in red and yellow clothes, with a cap that fell over their shoulders in the form of asses' ears. The costume was often hung with bells, and there was an inflated bladder at the end of the fool's baton, or bauble, which he could use to underline his caustic remarks with light blows.

Fools formed important acting companies in France, and in their annual *fête des fous* they fooled and annoyed everyone. Neither the clergy nor the lords were safe from their ridicule on that day. When their merrymaking got out of hand, the Church had a hard time imposing a ban on what it was forced to sanction. Fools were also kept like symbolic pets in the households of the mighty and rich. They were tolerated, however painful their jokes and acid their wit may have been. Dwarfed or hunchbacked fools had the greatest freedom. The lords who kept them to be reminded of their follies and weaknesses pretended they believed their fools mad, and madness was holy to medieval man.

In his *Dance of Death* cycle, Hans Holbein made death sometimes appear

with a fool's cap. Did he wish to remind man how foolish it is not to think of death all the time? We must not forget that the 'Gothic imagination' was self-torturing. It also delighted in the creation of gargoyles, those grotesque animal images spouting water – or perhaps only fear.

Shakespeare used the fool as a clown as he used the clown in the fool, sporting the one as a mask for the other. Shakespeare knew that the fool was an intellectualized clown, the latter bitterly funny in his unconscious aggressiveness, the former funnily bitter in his conscious thrusts. This is how he used the clown Launce in *The Two Gentlemen of Verona* and the Grave-diggers in *Hamlet*. Both are philosophers in clown's clothes, while the Fool in *King Lear* is a clownish mask for the serious fool in Lear himself, as if wishing to say to the king from the beginning: 'Ay, every inch a fool!'

The humanists dominated the court theatre during the Renaissance. They were poets before they were dramatists, and humanists before they were either. In trying to revive antiquity they went back to the use of masks in their scholarly plays – scholarly in the sense of copying the Greek and Roman masters in free adaptations. These stilted imitations were mostly based on Roman versions of Greek originals, and thus watered down twice. That most of these productions used masks in a rather superficial imitation of what was done in antiquity goes without saying.

In the second half of the sixteenth century the Renaissance was in its decline. It is symptomatic that a third-rate painter and muralist, Giorgio Vasari, became the first modern art reviewer in writing his *Lives of the Painters*, giving artistic and aesthetic value-judgments in a rather journalistic manner. Benvenuto Cellini's life and work also symbolize this period with the utilitarian, playful touch that was added to the classic revival (we would now say he commercialized the great accomplishments of a Leonardo or a Michelangelo). The stuffy plays at the courts hardly pleased anyone but a handful of pedants holding on to the illusion of having correctly revived the plays of antiquity. The populace was starved of entertainment, and the actors were bored with reciting hollow-sounding verses. As a reaction to the declamation of these literary dramatic exercises came the improvised Italian comedy which first took to the streets, until the leisure class recognized its entertainment value and invited its masked actors to their castles and newly built theatres. The *commedia erudita* was dead. The *commedia dell'arte* lived from then on for more than two hundred years.

It makes little difference whether the *commedia dell'arte* descended from the Doric mimes of the ancient Greeks and therefore was an afterthought to the vogue for revivals of antiquity at that time; or whether, as the eighteenth-century historians thought, it was a continuation of the *fabula Atellana* of the Oscans and Romans; or whether the many wandering mimes and joculators of that period banded together to create a more substantial theatrical

entertainment. The fact is that after some groping beginnings to free the *commedia erudita* from its pseudo-classic and meretricious fetters, a new type of improvised comedy arose in the middle of the sixteenth century.

The name *commedia dell'arte all'improvviso* was not given to it until much later. For quite some time it existed under different names, such as *commedia improvvisa* (improvised comedy), *commedia non scritta* (unwritten comedy), or *commedia a maschera* (masked comedy). The importance of the mask went far beyond the mere masking of a face, for the mask implied the totality of a personality type, giving 'an illusion of permanency to a favourite character', as Pierre Louis Duchartre said.

The mask of the *commedia* clearly defined the personality of the character without expressing any emotion. The mask neither cried nor laughed as it did in antiquity or in the East. It typed a stock character like Harlequin, Brighella, or Pantalone. The audience recognized and accepted him for what he was. The players had to provide the emotional nuances. Since all of them were dancers, jugglers, fencers, and mimes, their gestures and coordinated body movements were essential for expressing their emotions and underlining the spoken words. In fact, the play of the body superseded any verbal message. (Cicero once said about a mime of his days that 'even his very body began to laugh'.)

Although the minutest gesture and motion of the body had to be very precise and articulate, the actor did not minimize the importance of the spoken word. To make sure that the word would reach his public, the actor never covered his whole face. His masks were made of thin leather lined with linen. Usually they were half-masks leaving the mouth free, or even smaller masks covering eyes, nose, and cheeks. The very variety of larger and smaller masks on the stage of the *commedia dell'arte* created, through such contrasts, a stronger dramatic impact.

The actor of the *commedia* is unthinkable without a mask because it gave him the strength of his own conviction, the power to believe in himself as Pantalone or Dottore beyond the immediate reality of being an actor who improvised. He needed the illusion of becoming in order to convey the illusion of being what he pretended to be. Briefly, the reality of a larger reality created for him the world in which he could do the most unrealistic things and make them believable.

Early this century, when interest in the mask was revived, Jacques Copeau spoke of the mysterious dialogue that takes place between the mask and the actor:

The actor who performs under a mask receives from this papier-mâché object the reality of his part. He is controlled by it and has to obey it unreservedly. Hardly has he put it on when he feels a new being flowing into himself, a being the existence of which he had before never even suspected. It is not only his face that has changed, it is all his personality, it is the very nature of his reactions, so that he experiences emotions he could neither have felt nor feigned

without its aid. If he is a dancer, the whole style of his dance, if he is an actor, the very tone of his voice, will be dictated by this mask . . . a being, without life till he adopts it, which comes from without to seize upon him and proceeds to substitute itself for him.*

An ensemble spirit that worked to perfection was very much alive among those Italian players who, after a glance at the scenario before the play began, improvised with great ingenuity and imagination. Each actor had a few 'stock lines' memorized which fitted his stock character, but beyond this he invented his words and actions and blended them with those of his colleagues on stage. He was able to do so because he never changed his role. His mask announced the character he was and determined his movement language as much as the lines that would fit his type. The cleverest actor, of course, depended on the wit of his partner in the dialogue. Whenever a scene began to drag or an actor's verbal wit failed him, he could resort to acrobatic tricks and horseplay, which the players called *lazzi*. But even the *lazzi* were in harmony with the stock character.

Harlequin's mask was black because his two ancestral lines reached back to the *lenones* of the ancient satiric plays, poverty-stricken servants and often thieves and panderers, and also to the *phallophores* who blackened their faces with soot and played the parts of foreign slaves. Pulcinella's grotesque mask was characterized by a huge hooked nose. The Dottore wore either a black or a flesh-coloured mask covering only his forehead and nose. Carlo Goldoni tells us that 'the singular mask which covers his forehead and nose took its form from a birthmark which disfigured the face of a jurisconsult of those days.' Red spots on his cheeks and a short, pointed beard completed the Dottore's mask, a character contrasting seriousness with foolish complacency. It must be said that the costuming as much as the actor's dialect helped the mask to identify the character instantaneously.

Columbine and Inamorata, the two important female characters, wore no masks. The main prerequisites for their roles were a winning personality and a beautiful face. Sometimes they wore a tiny black velvet mask, called a *loup*, but this can hardly be considered a stage mask. Such *loups* were then the fashion for ladies. Most women were seen on the streets in such masks, even at home, since it was a part of their dress or make-up; these masks enhanced, through the contrast with their skin, the ladies' complexion and added a touch of mystery to their coquetries.

The phenomenon of disguise played a great part in the social life of that era, and it is interesting from a psychological and socio-cultural viewpoint that it should have been of such importance in a period characterized by a reawakened and daring spirit of individuality. The masquerade mask covering the eyes only was initiated at this time and has been kept alive for playful purposes at carnivals and masked balls. However, in feudal Europe and

* Compare a similar description of the mask's effect upon man and the artist in particular by Hugo Ball (page 73).

especially during the Renaissance, mumming and masking had serious connotations. The mask was associated with excitement, danger, and escape. If you wanted to be incognito, you put on a mask. It was part of the social game and its convention that you were seen but not recognized when hiding behind a mask. Wearing it, your incognito had to be respected. Masked, Romeo could enter the house of the Capulets and dance with Juliet. Everyone, even the Nurse, knew it was Romeo, the son of the hated Montagues, but Tybalt could not challenge him as long as he remained masked.

Brief masques and masked dance scenes appear repeatedly in Shake-speare's plays, mirroring customs and interest in the mask, as in *Henry VIII* and *Timon of Athens*, and there are innumerable references to masked dancing in his plays. Shylock, for example, warns his daughter Jessica: 'What, are there masques?' He admonishes her to lock up his doors and warns her not to 'thrust your head into the public street/To gaze on Christian fools with varnish'd faces.' He is afraid she may be caught by the contagious spirit of carnival.

Here a short digression from the stage to the carnival celebrations as a free-for-all theatrical outlet of the people seems justified. We may see in it an improvised ritual with many histrionic sidelights. It has survived since the Middle Ages as the one annual opportunity to throw off the yoke of all inhibitions and to give laughter its innocent freedom of self-mockery. W. H. Auden once tried to define the meaning and magic of the carnival spirit:

Carnival celebrates the unity of our human race as mortal creatures, who come into this world and depart from it without our consent, who must eat, drink, defecate, belch, and break wind in order to live, and procreate if our species is to survive. Our feelings about this are ambiguous. To us as individuals, it is a cause for rejoicing to know that we are not alone, that all of us, irrespective of age or sex or rank or talent, are in the same boat. As unique persons, on the other hand, all of us are resentful that an exception cannot be made in our own case. We oscillate between wishing we were unreflective animals and wishing we were disembodied spirits, for in either case we should not be problematic to ourselves. The Carnival solution of this ambiguity is to laugh, for laughter is simultaneously a protest and an acceptance. During Carnival, all social distinctions are suspended, even that of sex. Young men dress up as girls, young girls as boys. The escape from social personality is symbolized by the wearing of masks. The oddity of the human animal expresses itself through the grotesque – false noses, huge bellies and buttocks, farcical imitations of childbirth and copulation. The protest element in laughter takes the form of mock aggression: people pelt each other with small, harmless objects, draw cardboard daggers, and abuse each other verbally. . . .

It is surprising how much theatrical ingenuity, how much visual imagination can be seen in the streets of most South American cities, in New Orleans or in Nice at carnival time, how the child in man still seeks to rejoice over its freedom. It is a fascinating thought that man must put on a mask to free himself of all his masks. The Swiss historian Jacob Burckhardt tells us of the fifteenth-century carnivals in Rome and Florence, of the stupendous games

and colourful parades that gave the streets and public squares a throbbing feeling of joy and wantonness. He stresses that 'the freedom in masking was then very great and was sometimes extended over several months'.

Another place where the *commedia dell'arte*, carnival festivities, and the mask as a social accoutrement played a great role was the Republic of Venice. In fact, the Venetian mask has become a trade mark in the world of fashion. The function of the mask was not only to preserve the lady's anonymity and protect her reputation – when she might have been seen at places where she had better not be seen – but also to shield her delicate complexion from sun and dust. The mask of earlier days gave way to the veil in the nineteenth century. The veil pretended to protect the lady's beauty only slightly, for it unashamedly admitted that its essential task was to excite curiosity by enhancing the mystery of the face behind its meshes.

The comedy writers Count Carlo Gozzi and Carlo Goldoni, both Venetians, hotly debated the use of the mask on stage. In Goldoni's day, particularly between 1732 and 1762, the *commedia dell'arte* was still going strong, as is proved by references to some of the players, critiques which praise their high abilities. There was, for instance, a certain Antonio Collalto who, as Pantalone, could make 'the expression of grief, anger, and joy pierce through his hideous mask'.

Goldoni felt that the theatre, which in his eyes was lost to the will and whims of the comedians, badly needed to be reformed. He was a counterpart to his contemporary, Christoph Willibald Gluck, who at about the same time declared war on an operatic style dominated by singers and pompous artificialities. While Gluck strove for truth, naturalism, and a grand simplicity in the opera, Goldoni's reform aimed to wipe out the clownish and farcical character of the Italian players and to create a comedy of character. What he learned from the theatre, as he wrote in his *Memoirs*, was 'to distinguish what is more apt to make an impression on the sentiments, to arouse wonder or laughter or some such pleasing delight in the human heart'. He wanted to see 'errors and follies naturalistically depicted and put elegantly before the audience'.

To achieve this aim he attacked the unrealistic, improvised dialogue and, above all, the use of the mask, symbol of the *commedia* players:

Comedies without masks are always more natural and pithy. The mask always interferes with the actor's performance whether he be interpeting joy or sorrow . . . he always has the 'leather' face. He may gesticulate and change his tone as often as he will, he can never communicate by the expression of his face the passions that rend his soul . . . nowadays the actor is required to have 'soul', and the soul beneath the mask is as fire beneath ashes. That is why I conceived the idea of reforming the masks of the Italian comedy and replacing farces by comedies.

Carlo Gozzi, who wanted to uphold the tradition of masks, fought Goldoni with all the satiric power and venom he could muster and finally drove him from Venice. Goldoni also encountered great difficulties with the actors, who were concerned about their freedom to improvise and cash in on the laughs provoked by their antics. Ultimately, however, the temper of the time was on Goldoni's side. The great artistic reformers of the age were Noverre, Gluck, and Goldoni, and all three were children of the Age of Reason, dominated by the encyclopaedists. The *commedia dell'arte*, triumphant over more than two hundred years and one of the most influential powers on the stages of Europe, had, by the end of the eighteenth century, run its course.

Goldoni's adversaries always claimed that the mask never proved a hindrance to any emotional expression if only the actor knew how to wear it. At this point historians usually tell the story of the great English actor, David Garrick, who viewed the *commedia* players with great enthusiasm. On seeing Carlino Bertinazzo – a famous Harlequin of the eighteenth century whose 'inimitable graces . . . and gestures' Goldoni, too, praised in his *Memoirs* – Garrick was particularly impressed. After a scene in which Carlino stood with his back to the public, rubbing his thigh and shaking his fist at someone who had struck him, Garrick supposedly said, as reported in Edward Gordon Craig's *The Mask*: '"Look," said Garrick, "look at the character and expression in Carlino's back!"'

It must be said that Garrick was an ardent student of pantomime and a strong believer in the body as a highly expressive instrument for the actor. It was also Garrick who supported the revolutionary ideas of the choreographer Jean-Georges Noverre, whom he called the 'Shakespeare of the Dance'.

After many detours into the past, West and East, we return to our own time, a time to which man has reacted with somersaulting sophistication and, as a natural antidote to this, with a feeling of desperate need to return to primitivism with all its mystic manifestations. The mask is one of them.

The interest in the mask at the beginning of this century and particularly in the 1920s was also noticeable in other art forms than the theatre, especially in the visual arts and the modern dance. The trend towards primitivism coincided with a reawakened interest in Eastern art. It is questionable whether a single person can create a trend if the time is not ripe for it. Ezra Pound said that culture is made by twelve people; if so, then a new revolutionary trend can certainly be set in motion by one artist, and this has often been the case, when all the artist's sensibilities have felt their way in the direction of the time's mood and needs.

The poetic power of William Butler Yeats may have been one of the reasons for Ezra Pound's decision to leave the United States for England, but

it was Pound who converted Yeats to the Japanese *Noh*, its subtle shades of symbolism, its esoteric spirit of intellectual élitism. Yeats was attracted by the love of allusion in art, and *Noh* became to him the perfection and summation of the art of allusion. It is fascinating to a twentieth-century Westerner to see how, with all its formalism, the *Noh* achieves a certain reality evoked by the symbolism of its unrealities. A poet like Yeats, who felt he had to express himself dramatically and who was utterly repelled by the pedestrian, grubby realities of a disillusioning and unenlightening theatre, could not help ecstatically embracing the illusive-elusive world of the *Noh*. He could summon, as he said,

rhythm, balance, pattern, images that haunt the edge of trance; and if we are painters, we shall express personal emotion through ideal form, a symbolism handled by the generations, a mask from whose eyes the disembodied looks, a style that remembers many masters, that it may escape contemporary suggestion.

In his *Four Plays for Dancers* Yeats wedded Celtic myth, Cuchulain's world, to the spiritual subtleties of the world of the *Noh*. He never quite succeeded in giving his plays the mysterious power and relevance of wonder that characterizes the *Noh* plays because his dramatic ability limped behind the poetic vision. His failure may have had deeper reasons. The *Noh* plays, however esoteric they may have been, emerged from the realities of a very specific ambiance fully understandable to an initiated group. Yeats admitted that his plays 'should be written for some country where all classes share in a half-mythological, half-philosophical folk-belief which the writer and his audience lift into a new subtlety'. He also conceded that such a country only existed in his fantasy.

At the Hawk's Well is the most characteristic of the four plays which demand dance movement to enliven the drama. Cuchulain tries to gain immortality by drinking from the Hawk's Well guarded by a 'bird, woman, or witch' whose hawk's cry indicates that the water is about to flow. But she bewitches the young man as she did the old man who came to the well long ago, and neither of them gets to the water while it flows. The two men wear masks, while the Guardian of the Well and the musicians wear make-up which resembles masks. The masks in this play are very likely to help the actor escape his self with the same intensity with which his spiritual trans-figuration into the portrayed character takes place: to reach the shores of the miraculous, to accept a world of otherness which we can only people with the imaginative beliefs of a child.

This play was first performed at Lady Islington's home in 1916. It was produced for the benefit of a war charity. Then it was seen in Dublin in 1924. The Japanese dancer Michio Ito played the guardian spirit of the well, and he took the play with its masks, costumes and Edmund Dulac's music to New York, where it was produced at the Greenwich Village Theatre. By then

New York was well acquainted with the sight of masks on the stage. The man who had popularized the mask in the Western hemisphere was an immigrant from Poland who called himself W. T. Benda and of whom more will be said in the chapter on sculpture. Benda was, no doubt, influenced by Yeats and Gordon Craig's notions, but he knew how to translate them into slick and fashionable terms. He started to work with masks for the Greenwich Village Follies as early as 1919, designing the popular kind of mask that became a famous feature of Sir Charles Blake Cochran's revue, *The League of Notions*, and other musical revues. Benda's success with his rather flamboyant masks for the Follies in the early 1920s established him as a wizard of the 'social' mask.

In spite of finding fertile ground, Yeats' plays were never really successful. He lost himself in his dreams of a theatre transcending its traditional dramatic form. Yeats failed in practical terms. And so did Gordon Craig despite, or rather because of, his visionary qualities, his pamphleteering and propheteering crusades for a new theatre as a mystically conceived reality. He clearly stated that he would bring life into the theatre, 'not by means of live things, but by means of things that do not possess life until the artist has touched them, and thereby brought them to life'. This led finally to the supermarionette which was to take the place of the actor. Craig parted company with the idea that the written play is of any deep value to the art of the theatre, and he would not even have minded a drama of silence. He saw the theatre mainly in visual, architectural terms and, at best, granted that 'the ideal theatre would focus all the arts in a magnificent overpowering unity of impression', a kind of *Gesamtkunstwerk*.

Craig, who was reproached by his adversaries for his artistic megalomania, could only visualize the theatre in terms of superlargeness: '. . . a great building to seat many thousands of people . . . a platform of heroic size on which figures of a heroic mould shall move. . . . The movements on these scenes shall be noble and great: all shall be illumined by a light such as the spheres give us, not such as the footlights give us, but such as we dream of. . . .'

His actual scenic designs, strongly influenced by Adolphe Appia, were of a grand simplicity but unpractical. Dreaming of a colossal stage, Craig produced designs which could not be fitted into any stage; dreaming of a supermarionette, he disregarded the needs of the actor who has to fill the space. He was so immersed in his role as the apostle of a new theatre that he never found time or courage to match his words with a practical body of work.

His enemies wronged him and his friends let him down, as he wrote in his diary, issued as *Index to the Story of My Days*, in 1957:

Not one of my friends would encourage or assist me to get or develop one small playhouse – which was what I had in mind as a beginning. As they were indifferent to this, so they become today delightfully responsible for the greater change which has taken place all round the

world. Indifferent to the mere thought of publishing *The Mask*, they obliged me to bring it out in spite of them, in 1908.

He published a great many essays and pronouncements in *The Mask* (1908–1929) which also contained forty original scenic designs with his notions *Towards A New Theatre*. He gave us a few drawings for a masque, called *Hunger*, for which he wrote a fragmentary synopsis opening with the lines: 'At the first note of music the curtain, which is a thing of shreds and patches, is rent in the middle, and a man with a hideous mask is seen standing on a little hillock of mud. . . .'

It is obvious that Edward Gordon Craig's overdimensional theatre could not exist without the use of masks.

The frightening aspect of masks has exerted its fascination in many parts of the world, on many occasions, and at all times, It was also referred to by two writers with quite different sensibilities: Charles-Ferdinand Ramuz and Bertolt Brecht. Ramuz wrote the text to Igor Stravinsky's *L'Histoire du Soldat* when both worked in Switzerland towards the end of the First World War. The Swiss painter, René Auberjonois, was responsible for the set, costumes, and masks, but Ramuz seems to have been very concerned about the masks:

The more abstract the mask, the stronger the impact. We rehearsed yesterday with a plain, unpainted mask – no details or features. I wonder whether this is not what we need. It looks like a void – truly satanic.

Bertolt Brecht kept on the wall over his bed a life-size image of Baal, 'that Semitic-Phoenician deity of insatiability which Christianity had declared the principle of evil', as reported by Max Högel, a writer from Augsburg, Brecht's home town. Baal's image meant to Brecht the primary, raw forces of life, vitality and fertility. Undoubtedly, this masklike image inspired him more often than not, since Brecht flirted with ruthless strength and even brutality manifested in life, which is also shown by his hero Baal in his first play of that title. It is an Expressionistic play (to lampoon all Expressionistic plays) in which Brecht deals symbolically with the battle between life and death, picturing Baal as 'an ambiguous, ambivalent figure', as Eric Bentley described him, 'part monster, but partly, too, the martyr of a poetic hedonism'. Undoubtedly, Brecht created with this hero a most genuine replica of his own *Ur*-instincts and latent desires.

His dualism becomes apparent when we think of the Japanese mask which hung on the same or another wall of his room and to which he referred in a poem, called *The Mask of Evil (Die Maske des Bösen)*:

On my wall hangs a Japanese woodwork,
The mask of an evil demon, painted with gold lacquer.
Compassionately I observe

71

The swollen veins of the forehead, suggesting
How strenuous it is to be evil.

The cynic in Brecht held the balance between the guilt-ridden hedonist and the realistic visionary. Brecht could fool anyone including himself, and how he fooled the Un-American Activities Committee in Washington in the early 1950s is history. He played several parts in life and could change his *personae* at will.

Brecht was mask-conscious to such an extent that his *Verfremdungs-Effekt* ('alienation effect') demanded the destruction of all illusion of reality. His epic theatre wanted the spectator to realize all the time that the stage is a stage is a stage and that it does not *pretend* to be reality. By tearing off the mask of illusion he only magnified the mask of what he called reality.

The actor speaks his 'sentences as if they were in the third person', Brecht explained. The actor does not represent, he presents. He refrains from pretending to wear the theatrical mask of a fictitious character; instead he wears the mask of a commentator commenting on the character whom he presents in the *persona* of what the dramatist imagines to be the character he wishes to comment upon. Brecht does not want us to identify with the problem and plight of the character, he asks us to view him in a detached manner, and instead of feeling pity and terror he expects us to come to an objective verdict, to see with the 'estranged' eyes of the discoverer, to realize coolly the situation in which the dramatist has placed the character. Thus he asks us to see, through the mask of the commentator, the *persona* of the character. We may be detached from the illusion of reality as we see it through our *persona*, but we are not detached from Brecht's illusion of how he sees reality through his mask.

At the time when Brecht played with the idea of the alienation effect, Dadaism had already reached its climactic point. Many years before Brecht's alienation theory, the Dadaists had adopted a stance of defiant detachment, or, more often than not, aimed at the total destruction of all established aesthetic principles. The entire movement was an artistic expression of artistic hostility. Briefly, it was the first reaction to, and reflection of, the twentieth century's trauma.

Obviously, in its playful fury, Dadaism made good use of the mask. Hugo Ball* recorded some of the events that took place at the Cabaret Voltaire in his diary, *Flight from Time* (*Die Flucht aus der Zeit*). The entry dated 24 May 1916 reads:

* Dadaism was founded by the poets Hugo Ball and Tristan Tzara, the poet-painter Hans Arp and the painter Marcel Janco in the Cabaret Voltaire in the Spiegelgasse, Zurich, in February 1916. Ball explained: 'The Dadaist fights against the agony and the death ecstasy of the time. . . . He knows that the old systems of the world broke down and that time urging man to pay cash opened a clearance sale of the philosophies of dethroned gods. Where fear and bad conscience begins for the shopkeepers, there starts loud laughter and mild appeasement for the Dadaist.'

Janco made for the new programme a number of masks which are more than gifted. They remind one of the Japanese and ancient Greek theatre and yet are fully modern. Aiming at an effect on a distant spectator, they had an unbelievable impact in the relatively small cabaret auditorium. We were all present when Janco arrived with his masks, and immediately everyone of us put one on. Something strange happened then. At once the mask cried out for a costume, it also forced upon us rather exalted gestures, almost brushing madness. Only five minutes previously none of us would have surmised that we would move in the strangest manner, draped and adorned with impossible things, each of us trying to top the other with ideas. The kinetic power of these masks hit us with surprising inevitability. Now we began to realize the importance of such a mask for mimesis, for the theatre. The masks simply demanded that those who wore them moved around in a tragic-absurd dance.

This seems to be one of the rare accounts of how a sophisticated mind can be gripped by the raw feeling and primitive instincts of the hidden self, how the artificial transformation through a mask can provoke a freedom from inhibitions and a need to express oneself in a manner forced upon us by the mask's image. 'What fascinated us about these masks', Hugo Ball concluded, 'was that they did not embody human, but larger-than-life characters and passions.'

Masks continued to dominate the Dadaistic scene for quite some time at the Cabaret Voltaire. The painter Oskar Kokoschka, less known as a dramatist, wrote a great deal in his early years and was the first to herald Expressionism and, even more so, Dadaism with surrealistic touches in his plays. One of them, *Sphinx and Straw Man* (later retitled *Job*) is a three-act playlet, full of ironic twists and heavy with symbolic meaning. Marcel Janco directed the play and designed the masks. Hugo Ball spoke of this production in his diary on 14 April 1917: 'The play was acted . . . in tragic body-masks; mine was so large that I could comfortably read my part inside it. The mask's head was lit up electrically, and it must have made a rather strange effect in the darkened auditorium, with light coming from the eyes. . . .' Tzara also thought highly of this play and its performance which, as he wrote in his diary, 'decided the role of our theatre'. However, despite Tzara's own attempt at writing a play – *Le Coeur à Gaz* (*The Gas Heart*), which he called 'the biggest swindle of the century in three acts' – the Dadaists produced little of value for the theatre, and the movement was soon overshadowed by the less radical, more poetic and aesthetically sounder movement of Surrealism.

Aesthetic elasticity and protean playfulness characterize Jean Cocteau, who participated in all the 'isms' of his time. He was a fascinating figure. But his character was too dazzling and too much caught up in its bravura pyro-technics for its genius fully to develop. Cocteau, however, is important for us here because, in the early 1920s, he echoed Gordon Craig in the Preface to his playlet, *Les Mariés de la Tour Eiffel* (*The Wedding on the Eiffel Tower*):

A theatrical piece ought to be written, presented, costumed, furnished with musical accompaniment, played, and danced, by a single individual. This universal athlete does not exist. It is therefore important to replace the individual by what resembles an individual most: a friendly group.

In the play two narrators masked as human phonographs describe the absurd action from the left and the right of the stage. The actors themselves dance and mime the events of the drama. Cocteau was attracted by a play of disguises, but often he used them more indirectly than openly. He most enjoyed the feeling that some regarded him as a magician. Wallace Fowlie, who has edited and translated Cocteau, says about him in one of his essays:

It has been difficult for Cocteau's public to realize that his agility and his brio are only masks, and that his works, rather than being feats or artifices, are serious projects related to the great problems of the poet and human destiny.

> *Les choses que je conte*
> *Sont des mensonges vrai.*
> (The matters I relate
> Are true lies.)

Luigi Pirandello may be said to have started the development which Jean Genet has since tried to bring to a nihilistic conclusion. To understand Pirandello's self-destructive fury and desperate compassion as the two compelling forces of his creative *daimon*, we only have to read two of his pronouncements. One is: 'I think that life is a very sad piece of buffoonery. ... My art is full of bitter compassion for all those who deceive themselves; but this compassion cannot fail to be followed by the ferocious derision of destiny which condemns man to deception.' His other pathetic statement played with his favourite game of topsy-turvying everything: 'Ask the poet what is the saddest sight and he will reply: "It is laughter on the face of man."'

In Pirandello's eyes, however, man's face is not what we think it is, and therefore laughter and sadness are interchangeable manifestations, the one putting up pretences for the other. In filling out his own emptiness, man feels compelled to build up a reality in which he deems himself secure, a mask with which he can face the world. But the mask man puts on is not necessarily the face seen by other people; Pirandello perfected the idea that we are what we are as much as what we are not, since the world can only see us the way it thinks it sees us.

Pirandello maintained that every person has at least two identities and, to complicate a complex situation, both seem to be blurred into a relative image only because of the constant interaction between man's pretences and a reality he takes for the real reality. Man is thus surrounded by an all-round uncertainty to which the world is reduced or blown up in a frightening game of futility. Pirandello's philosophy makes him appear as the rightful precursor of the Theatre of the Absurd.

Novel ideas are rarely isolated phenomena in history. Luigi Chiarelli and the so-called *Teatro del Grottesco* preceded Pirandello by a few years. Chiarelli's most Pirandellian play is his farce, *The Mask and the Face*, in which a man, to adhere to the customary code of honour, pretends to have killed his unfaithful wife, is acquitted by the court and celebrated as a hero. When her scarf is found by the lake, the town insists on the ritual of a burial, at which the dead wife arrives, veiled in black, determined to be at her own funeral. Afterwards the man runs away with the supposedly dead wife, realizing he cannot live without her. Despite the light weight of this farcical plot, it contains the nuclear concepts of pretence and truth, illusion and reality – Pirandello's major themes, on which he produced fifty variations.

One of the first plays, written in 1914, *Think of It, Giacomino*, is reminiscent of Chiarelli's charade with mask and face. But Pirandello goes far beyond making fun of accepted conventions and, in quixotic fashion, proves that the socially unaccepted view is not only the better but also the more human one. From then on Pirandello played at turning the world upside down. He brought the intermingling of reality and illusion to a somersaulting climax with his famous *Six Characters in Search of an Author*. Life, incomplete as yet, invades the stage of illusion that pretends to dramatize life. Where is the mask and where the face when the unreal characters appear more real than the real actors of the playing company? Pirandello is facetiously at pains to explain the inexplicable time and again: 'Life is full of infinite absurdities which, since they are true, do not need to seem plausible,' says one of his characters. 'To try and reverse the process, to aim at verisimilitude, to make these things appear true, is nothing but folly. . . .'

No creative person can ignore the influences and impulses of his own time, nor can he escape being shaped by his own experiences. It has often been said that both played a decisive part in helping create Pirandello's philosophy. Pirandello lived the life of one of his characters, for years being what he was not and not being what he was when he had to cope with his paranoid wife, who was consumed by jealousy. Only after he had made enough money from his plays about reality and illusion could he afford to send her to a sanatorium. In those years of domestic torture he could not have escaped the thought of how unreal reality was. In self-defence he had to live with a mask and build for himself a life of illusion.

Having lived with madness at the doorstep of his existence for so many years, it was obvious that one day he would fashion a character acting as if sanity were only the state of another illusion. He did so with *Henry IV*, one of his most mature works. Impersonating the German Emperor Henry IV during a masquerade, this character loses his mind after falling from his horse. The accident is caused by his rival in love. After having lived in the delusion of being Henry IV, surrounded by a grotesque retinue in a reconstructed medieval court, he recovers sanity and learns to despise the reality, full of deceit and

perfidy, and to love the security of his own illusion. Then he is visited by his former love and the rival who caused the accident. His visitors, unaware of his apparent recovery, prepare a shock therapy to cure him. His reactions then being those of a normal if highly strung person, he kills his rival and must go on pretending madness to escape the legal consequences of his vengeance. Pirandello and his hero consciously denounce the illusion of all reality.

It is doubtful whether Pirandello would have written the way he did and, as Martin Esslin has said, have 'transformed our whole concept of *reality* in human relations', had he not matured in an age characterized by Freudian and Jungian concepts. In probing our self, taking it apart and analysing it, we have discovered our complexities. This was also the age in which all the old values collapsed, and man set out to demystify all myths and – this is only a seeming contradiction – to unmask all masks. In the demystifying and un-masking process one cannot help stumbling over the mystifying fact of man's many masks and the baffling overlap of reality and illusion. Both have probably been the major topics of most creative writing in the broad sense in various forms and manners through the centuries, but our age was destined to give them the appearance of finality.

In his most important essay on his philosophy and art, entitled *On Humour* and based on a series of lectures delivered in Rome, Pirandello says:

Today we exist, tomorrow we will not. Which face have they given us to represent part of a living person? An ugly nose? How painful to walk around with an ugly nose for the rest of our life! It is good for us that after a while we don't pay any more attention to it. Then we don't know why other people laugh when they look at us. They are so silly! Let us console ourselves by looking at somebody else's lips, one who doesn't even realize it and doesn't have the courage to laugh at us. Masks, masks. They disappear in a breath, giving way to others. A poor lame man, who is he? Running toward death on crutches. Here life steps on somebody's foot, there it blinds somebody's eye – wooden leg, glass eye, and it goes on. Each one fixes his mask up as he can, the exterior mask.

Because inside there is another one, often contradicting the one outside. Nothing is true! True is: the sea, the mountain, a rock, a blade of grass. But man: always wearing a mask, unwillingly, without knowing it, without wanting it, always masked with that thing which he, in good faith, believes to be handsome, good, gracious, generous, unhappy, and so on.

Pirandello's attitude towards the mask was not only one of a cerebralization of such psychic phenomena as delusion and self-deceit in a seemingly unreal reality. In his original version of *Six Characters in Search of an Author* he wanted his six characters to appear in masks and explained his reasoning for their usage in his preface to the play (written in 1925):

Whoever wishes to attempt a production of this play must, above all else, achieve by every means possible a clear distinction between the Characters and the Actors of the Company. No doubt the positioning of the two groups indicated in the text at the moment that they enter the stage will help; as will the use of contrasting colours in the lighting. But the most suitable and effective means that I suggest will be the use of special masks for the six characters.

76

The stage direction describes the masks of each character in great detail and, even though the demand for the wearing of actual masks was later omitted in most editions, the descriptions of the characters' *personae* remain masklike. Also, Pirandello compares the tenuous light in which they first appear with 'the faint breath of their fantastic reality', and he indicates that 'they preserve something of the dream lightness in which they seem almost suspended'. In his attempt to blur illusion and reality, Pirandello stressed that such lighting 'does not detract from the essential reality of their forms and expressions'.

In this preface he claimed to be a philosophical writer going beyond narrating or dramatizing for the sheer pleasure of doing so; he tried to find 'a particular sense of life' in his creations from which one could acquire 'a universal value'. In presenting the six characters 'as rejected: in search of another author', and, for this purpose, having them invade 'the world of art', that is the stage, the world of illusion, he thought of giving them a larger than life-size dimension when he visualized them in masks. It is characteristic of the Pirandellian world that it is not the real actors but the characters appearing as refugees from real life which are masklike figures. Pirandello explained that 'the characters must not appear as phantoms but as created realities, immutable creations of the imagination, and thus more consistent and real than the ever-changing naturalness of the actors'.

For Pirandello the masks are not psychological or symbolic, but philosophical devices. Like the masks on the Greek stage of antiquity, they present a moment of an irreparable and continuous experience, as the tears on the mother's face express the epitome of grief. Pirandello's masks only suggest being masks. He specified that they be made of light material, easily worn by the actors and leaving eyes, nose and mouth free.

Pirandello's characters are personified masks who demonstrate their author's relativist philosophy. Their twilight existence between reality and illusion often makes them appear puppet-like despite their tortured and harrowing lives. Pirandello returned to the use of masks in some of his latest plays, in *The Fable of the Exchanged Son* (a whimsical comedy in which a prince lets an idiot, who was exchanged for him at birth, run the state) and *The Mountain Giants*, a play that remained unfinished.

The attempt to write philosophic dramas induced Eugene O'Neill to make use of masks in two of his plays. In contrast to Pirandello, however, O'Neill strongly believed in the mask as a symbolic device of striking possibilities. In 1932 he wrote the essay *Memoranda On Masks*, in which he confesses to a belief in the theatrical mask: 'The use of the mask will be discovered eventually to be the freest solution of the modern dramatic problem as to how – with the greatest possible dramatic clarity and economy of means – he can express the profound hidden conflicts of the human mind which the probings of psychology continue to disclose to us.'

O'Neill admits to seeing in the mask a helpmate in delineating the many facets of his characters' psyches. In *The Great God Brown* he employed Expressionistic symbolism with which he tried to transcend the visual stage image in its physical limitations. He created a composite type in his hero Dion Anthony, symbolizing partly 'the creative pagan acceptance of life' (Dionysus) and partly 'the masochistic, life-denying spirit of Christianity'. His counterpart Brown 'is the visionless demi-god of our new materialistic myth'. The play's heroine is a re-visualization of Goethe's Margarete in *Faust*, 'the eternal girl-woman with a virtuous simplicity of instinct'. O'Neill quite correctly sensed that the dramatic progression and changes in the characters' psyches can best be achieved with masks.

He invented three masks for Dion Anthony. Defying the stifling world of materialism his hero assumes the mask of the 'mocking, reckless, sensual young Pan' behind which hides Dion's real self, 'dark, spiritual, poetic, passionately supersensitive, helplessly unprotected in its childlike religious faith in life'. Later in the play the mask turns 'older, more defiant and mocking, its sneer more forced and bitter, its Pan quality becoming Mephistophelian'. The third mask plays its part shortly before Dion dies. Besides its terrifying intensity it shows signs of vicious cruelty, of a demonic quality, and a tortured expression while torturing others. When the spectator finally sees him unmasked, it is a martyr's face pleading for faith.

In putting on Dion's mask, Brown, the archetype of a successful but empty personality, hopes to become instilled with Dion's creative and sensual experiences. But while the mask remains unchanged, his face begins to show all the demonic qualities that were in Dion's mask which, at last, destroys him. With his ghastly sick and feverish face he dies in the arms of Cybele, who hides the mystery of Earth-Mother, the power of regeneration behind the rouged mask of the prostitute.

Margaret's mask preserves its innocent and hopeful expression. Only later do Dion's torturing mind and Brown's demanding life give her face a sad and, in its suffering, resigned appearance. When the characters remove their masks in each other's presence, they transcend their humanness and reach towards the mystery of their lives' fulfilment without being quite aware of what made them be the way they were. It is, above all, Margaret's strength that lies in her mask 'of the proud, indulgent Mother' and in the belief that love does not die.

O'Neill tried his luck again with masks and philosophic symbolism in *Lazarus Laughed*. Lazarus returned from death with the comforting message that no one has to fear death since there is only laughter in God's house. This theme, however, was treated in a repetitive manner, and *Lazarus* lacked the same dramatic impact that *The Great God Brown* had. The masks used were of little help in giving this play a bigger dimension.

O'Neill visualized masks of a mystical and abstract quality to convey the

symbolic meaning and the psychological complexities of his characters. Since his characters mask and unmask themselves in each other's presence, the dramatic transitions are demanding in their subtlety and spiritual implications. Despite O'Neill's great belief in the theatrical mask, he did not quite live up to his own promises. Not because he was not a skilled dramatist, but because he did not have the necessary touch of the poet.

Stark Young mentions in his book, *The Theatre*, that 'nothing is more obvious than symbolism when it is poor or perfunctory'. This is one of the pitfalls – if not the most dangerous – encountered in the use of masks. On stage the mask can only be a means of furthering the symbolic weightiness of the dramatic meaning of the character and the situation in which he finds himself. If the mask does not add another, supranatural dimension and a heightened poetic feeling to what the dramatist wants to convey, it only becomes cumbersome and meretricious. To make use of a mask only to underline the play's symbolism will not do. The mask, in its rigidity and elusive meaningfulness, puts great demands on the writer's poetic power and vision. In our day and age it works best where reality can no longer break its own barriers, or where a very specific atmosphere bordering on an esoteric and highly stylized world of form and content, feeling and fulfilment may be visually helped with an extraordinary touch of magic and mystery. Stark Young sees quite clearly the limitations of the mask when he says:

To have an actor use a mask to show us what he is in another man's eyes as contrasted with what he is to himself when shown without the mask, may be a visual device happily suited to the play in hand, it may be in complete unity with the quality of the idea and the writing and to that extent imaginative creation. But it gets no further except in so far as the artist, at every point where the mask is used, contrives to express through it what nothing else could express so wholly.

One could easily maintain that Harold Pinter and his 'Theatre of Menace' have little to do with masks. However, I can just as easily see a masklike attitude in the way he phrases his pauses. In fact, these pauses punctuate his enigmatic style. Pinter's characters, of course, can be seen as hiding behind their *personae*, uncertain of their own uncertainty, which creates a frightening or at least ambivalent feeling in the spectator.

More interesting than the audience's reaction is Pinter's own relationship to his characters. He, who claimed in an interview published in the *New York Times* that he does not believe in explaining himself, explained most vividly how he sees the characters he creates as his *personae*:

It may sound absurd, but I believe that I am speaking the truth when I say that I have suffered two kinds of pain through my characters. I have witnessed *their* pain when I am in the act of distorting them, of falsifying them, and I have witnessed their contempt. I have suffered pain when I have been unable to get to the quick of them, when they wilfully elude me, when they withdraw into the shadows. And there's a third and rarer pain. That is when the right word, or the right act jolts them or stills them into their proper life. When that

happens, the pain is worth having. When that happens, I am ready to take them into the nearest bar and buy drinks all around. And I hope they would forgive me my trespasses against them and do the same for me.

In his speech accepting the Shakespeare Prize in Hamburg in 1970, he went one step further in emphasizing the masklike role of his *dramatis personae*:

I have a particular relationship with the words I put down on paper and the characters which emerge from them which no one else can share with me. And perhaps that's why I remain bewildered by praise and really quite indifferent to insult. Praise and insult refer to someone called Pinter. I don't know the man they are talking about. I know the plays, but in a totally different way. I can sum up none of my plays. I can describe none of them, except to say: That is what happened. That is what they said. That is what they did.

In hiding he best reveals himself.

Antonin Artaud's theatrical hallucinations, perceived in the 1930s, became realized by Jerzy Grotowski in the 1960s. Artaud called for a return to the myth and magic of a ritualistic theatre, for laying bare the deepest conflicts of the human mind. Extreme action must be pushed beyond all limits, to where the impossible opens up new dimensions of theatrical intensity magically expressed in real terms. In such a theatrical performance, Artaud wrote, the gestural language must be evocative and symbolic and just as powerful as the 'enormous masks' which 'will appear with the same sanction as verbal images'. The actor is described as an athlete of the heart: 'To make use of his emotions as a wrestler makes use of his muscles, he has to see the human being as a Double, like the Ka of the Egyptian mummies, like a perpetual spectre from which the affective powers radiate.'

Artaud failed in realizing his dream of a new theatrical experience built upon ritualistic concepts. Grotowski gave Artaud's ideas their final stage realization. Grotowski's actors are impassioned athletes of the heart, totally surrendering soul and body, appearing as if beyond themselves, acting in a trancelike manner, creating a highly theatricalized ritual. His becomes a theatre of total involvement and can, at times, be an agonizing experience which leaves the spectator stunned and numbed, with his mind lacerated and his emotions in convulsions. Grotowski believes that artists like Artaud and Brecht adopted Eastern techniques to project the hidden sides of their own nature. In his opinion, the function of the theatre is to remove the masks we wear in everyday life. In fact, however, his very specific technique creates the aspect of the other self. Grotowski certainly tears off the mask from the face of our ordinary existence while translating our hidden nightmares into a weird – often fantastic and often unendurable – theatricalized form of sophisticated anti-sophistication. He makes his actors appear as a total or 'enormous mask', as Artaud visualized.

I African Dogon mask

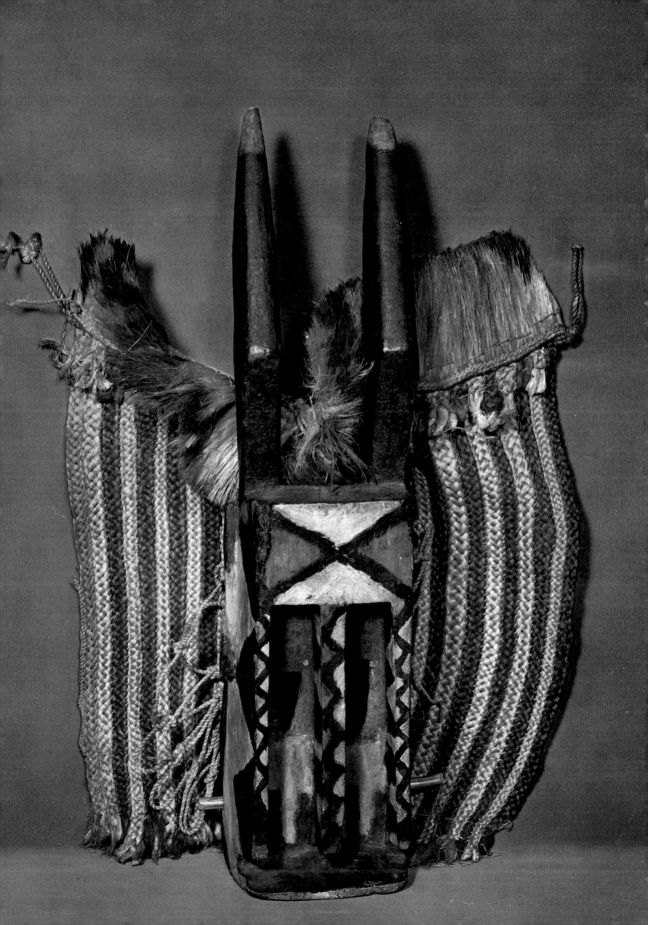

II

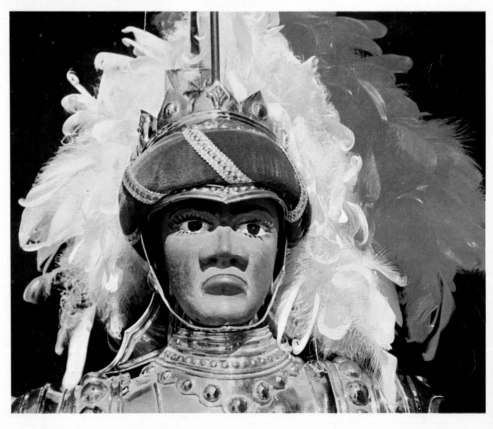

III

Jean Genet's world is full of masks and screens. His characters are only metaphors of what they are supposed to represent, he once said. An abandoned child, he has abandoned the world. He sees the original drama of the lost paradise enacted everywhere. He turned to writing for the stage not only because he is a poet with an unresolved drama within him, but because writing, and particularly writing for the stage, enables him to steal and murder vicariously.

He writes for the theatre despite his dislike for it. He feels it has 'an air of masquerade and not ceremony'. This is why he creates his own theatre as the ceremony of a masquerade or the masquerade of a ceremony. He goes beyond the theatre of illusion, of Brechtian truth, of Artaud's cruelty, or Pinter's menace. His is a theatre of an all-out confrontation, of an apotheosis of evil and nothingness. We are constantly mystified by being shown the naked reality of things. Theatricality, i.e. deliberate sham, is only the mask for the real which he shows in a poetically heightened artificiality. He is a poet with a vengeance.

After having enchanted us with stage effects, his intent is not only to disillusion us at the end of each scene, but to castigate us. In *The Blacks* the actor who mediates between the stage and the off-stage world says: 'Our aim is not to corrode and dissolve the idea they'd like us to have of them, we must also fight them in their actual persons, in their flesh and blood.' One of the Negroes discovers that the whites are not really white, 'but pink or yellowish', and black is not necessarily the colour of the Negroes. In this play Genet not only creates a confrontation between white and black on stage; he insists on creating a confrontation between the actors and the audience, which must be white. If he sets out to dramatize how the white mask must fall, then (at least in an imaginary way) he wants to see blood flow in the audience. Sham is always the mask for his reality in as much as he sees in the real reality nothing but sham. He de-realizes in order to give us the image of the super-realization of our sham existence.

When Claire says to Solange in *The Maids*, 'We shall be that eternal couple, Solange, the two of us, the eternal couple of the criminal and the saint . . .', we must understand that the one is unthinkable without the other for Jean Genet: they both function because one is using the other as a mask.

Genet stands outside society; therefore he feels like a saint. He has a murderous instinct against bourgeois society; therefore he feels like an assassin. Saint and assassin are identical to him, one being the mask of the other. In the same way he identifies death and pleasure as the metamorphosis of ecstatic experiences. The erotic and ultimate experiences transcend the ordinary, and the profanity of life is full of milestones of such transcendencies. These are the pivoting points of his continual metamorphoses, they are the sources of a ritual in which he burns his masks while re-emerging in a new metamorphosis and leaving the past experiences behind as another part

II Sicilian puppet theatre
III Traditional Belgian puppet used by the Toone Company

of life's myths. Genet visualizes life in the terms of primitive man, who senses existence as an eternal recurrence of violence and mystic enchantment, of vile profanity and sacred ecstasy.

His private reality turned him into an apostle of Evil. Like a child that acts knowing only too well it asks for punishment, his characters – symbols of himself – do the same. To face evil we must put on the mask of evil, to cope with corruption we must hide behind the mask of corruption, he seems to say. These are some of the many levels on which *The Screens* functions. This play apparently deals with the Algerian war. The white settlers are masked caricatures of white settlers in any colony, and the so-called hero, Sa'id, an anti-hero, becomes a traitor to his people, who could be colonial people anywhere. An older native woman is shot, but in good operatic style she goes on singing her aria, that is her harangue inciting her people to an orgy of cruelty against the oppressors. However, this is not a Brechtian call for liberation and the triumph of justice, it conjures up the evil spirits in man for the sake of evil. The uprising and war serve as rhetorical gestures, as a grotesque background painting.

Genet is not on the side of the rebels. He sees how they turn into oppressors, copying those who oppressed them. The hero is vaguely branded as a traitor to prove this point dramaturgically. He is exhorted by his ugly wife: 'I want you to choose evil and always evil, always to know hatred and never love.' His mother, maskless but evil incarnate in her make-up, seems to be the author's mouthpiece. In the final minutes when her son wavers between accepting the mask of so-called morality or the mask of an unheroically heroic death, she counsels him not to side with those who would love to pretend that the revolution was a moral act (man's acts can have no ethical motives). 'Don't let them make a cause of you', she advises him, since it is 'the abject and the vile who shall inherit the earth'. He escapes into the audience where the shots of the natives reach him. Is not Genet's intention to let the audience know that they too would be the targets of *his* bullets?

Sa'id is the poorest man in the land, travelling with an empty suitcase to be wed to the ugliest girl, whose mask is as grotesque as it is frightening. To console himself Sa'id visits a brothel (the whole civilized world is a brothel in Genet's bleeding eyes, as he demonstrated in *The Balcony*). Since he cannot earn enough money to escape his environment and situation he becomes a passionate thief, who not only must steal but also wants to be punished. The judge claims to speak with the authority of God and decides against sending Sa'id to jail, where he would feel safe as if regressing into the womb. The judge's final wisdom: 'If God makes a mistake, let Him punish Himself.'

Almost half *The Screens* is devoted to death, a theme with endless variations for Genet. He plays on death as if it were an instrument yielding a life full of nuances when treated with virtuoso hands. Genet's hands are just that. The huge cast is seen almost in its entirety as being composed of dead people

mocking at death as much as at life. Other playwrights create life, Genet creates death. These scenes in the afterworld are poetically and dramatically most exciting, they are weighty and most meaningful.

It is in these scenes that Genet's stage concepts and philosophy become clearly defined. It is not enough for his actor to identify himself with a character. Jean-Paul Sartre has pointed out that 'in Genet's plays every character must play the role of a character who plays a role'. Genet wants the actor 'to become a sign charged with signs'. It is not a visible world in which his notions take place. He calls for a formula which demands an 'entirely allusive' theatre. Appearance is masked as reality which, at the same time, is unmasked as myth and unreality.

In its tremendous range, length, and depth, his play *The Screens* is probably the quintessence of whatever Genet may have to say. The distortions of the real and unreal are so intense in their symbolism that they are hardly noticeable. As he sees it, the world is playing games, and he plays his game with the world. While his characters struggle behind their masks to be their true selves, we, the imaginary audience, feel more and more naked behind our masks.

CHAPTER III

Marionettes and Mimes

My very first theatrical experience was Richard Teschner's marionette theatre in Vienna. The make-believe world he conjured up on his little stage was of such magic that it became real to me. He was a great painter who never lost the imagination locked in a child's brain. His marionettes had the bizarre reality of a child's dream vision. Everything on his stage was alive with colours and movement. Richard Teschner's fingers, which set the marionettes in motion, performed a masterpiece of coordinated movement with graceful lightness.

The piece I saw was called *Der Drachentöter* (*The Dragon Slayer*). I still remember the beautiful princess, guarded by a monstrous dragon. No one was able to liberate her. A brave knight was sent to slay the dragon, but failed in the attempt. Then a godlike figure appeared and freed the princess after he had overcome the beast by his divine will. It was Buddha who did this deed, but I was much too small then to know who Buddha was. I still remember a gentle tinkle, as if the sound of a musical box accompanied the scenes. There was no narrator, no human voice for the actors, only the magic of movement and colour. The puppets moved with self-evident, beautiful precision, organically and as if animated by God. I saw trembling tongues of flames devouring space. It was frightening to sense how they tried to plunge the whole world into a sea of burning red. And the beautiful princess, in her delicate majesty, stood there surrounded by fear and flames and hope. But the world is good. The flames died with the dragon. I felt safe and happy to know that the princess could return to safety and happiness in her castle.

Ever since this experience I have been drawn to the theatre, to its mystery as much as its revelations. In discussing marionettes, Elisabeth Brock-Sulzer has said, 'a child exposed in early years to a working experience of marionettes will have a better eye for the theatre later on than a child deprived of such experience'.

The world of the child is naturally much closer to the puppets than is that of grown-ups in general, who have learned to accept reality as something irrevocably real. If for primitive man the demarcation between the concrete and symbolic is blurred, so it is for the child who has still the power to see the real in the imaginative and vice versa. Moreover, it can translate the one into

86

the other with joyful intensity as if they were not the two totally different idioms which they are. The child's imagination is quick, lively and colourful, as exciting as it is excited.

Elisabeth Vigée-Lebrun, who has become famous for her portrait of herself with her daughter, speaks in her memoirs of marionettes which 'were so well made and their movements so natural that they created a perfect illusion. My daughter – she was six years old at that time – did not doubt in the beginning that these figures were alive. I enlightened her and remember that, when we sat in the theatre a few days later, she asked me: "And those, madame, are they alive too?" Can one say anything more charming about the marionette theatre?'

There is something essentially fragmentary about the art of the marionette in its intrinsic suggestiveness. The margin of error and failure which always exists with any live performance by live actors is here replaced by a larger margin of the viewer's imagination. The puppeteer, of course, is also human, but neither does he face the audience – at least in the majority of cases – nor does the audience face him. The puppet theatre creates an increased aesthetic distance which invites the viewer to fill the space left open with his own fantasy. It invites him to go on dreaming the puppet's and the puppeteer's dream. This open space between the suggested reality and one's own potential imagination is not predetermined. Only a highly sophisticated mind will measure this distance with the same pleasure and stimulation as the mind of a child, as yet unburdened with experience and knowledge, even though both stimulations take place on different levels. 'The childlike and sophisticated forces meet', in Elisabeth Brock-Sulzer's words.

That puppets are mostly small, inanimate creatures which must come to life through the wonders of art and the miracle of man's imagination is part of their charm and the magic connected with it. We are fully aware of the puppet's diminutive existence. The adult accepts it as a world reminiscent of his own childhood. The child accepts it as something that is of his 'own' size, that is smaller than the grown-ups and even smaller than himself. He does not have to look up, he feels co-existent on one level with the puppets. The child's fantasy leans toward the strange, bizarre, grotesque, absurd. In many ways, this is how the child may see the world of grown-ups. To this intricate interrelation between the adult world and the world of the child and the puppet respectively, Stefan Brecht adds an intriguing thought:

Adults *are* puppets to the child. Our faces . . . stay the same; we exchange the masks of a few expressions, to be read as signs. Our movements are head-regulated: serialized by the tyranny of small pressing purposes, deadened by convention and routine, minimized by an economy of energy, they lack the life of running impulse. And our roles are established: the moving principles have been shaken down to a few simple reflexes. We are not older than they, we are old. We have lived. We are not real people, we are mechanical figures who to the child represent and obey two simple forces, the force of life – protection, warmth, sustenance,

admiration – and the force of death – suppression, interference, regulation. They read the work and relative strengths of these forces in our care-worn and inhibition-crushed physiognomies, classify us according to which force rules our movements relative to them. The unmasked operators of this theatre are the children, living the life of children to the extent that children are permitted, namely, play.

The marionette may rightly claim that it has a soul and is very much alive, but, at the same time, it does not deny its artificiality. Bertolt Brecht thought the actor should act as if he were commenting on the character he was playing, as if one could watch oneself acting. There is something of this in the manipulator's relationship with his marionettes. There is something remote and detached about the hands that move the strings that move the marionettes. It is different with the puppets and the hands that move them. With them the source of motion is immediate, direct. Marcel Marceau explained the difference by saying that 'the hand puppet is dramatic, the marionette lyrical'.

Marionettes and puppets are by the nature of their being far removed from reality without being unrealistic. They are surreal without being surrealistic. Through their heightened symbolism, combined with an almost naïve simplicity, puppets and marionettes reflect the essential features of the mask. It is as if life were to return to its roots and, in a most playful way, bring its unconscious secrets together with its consciousness of being. The puppet as a whole is a moving mask.

Technically, marionettes are puppets, the most sensitive of all puppets, manipulated by strings from above. Marionettes can also be rod-operated puppets, manipulated from below. A variant is the pedal-puppet which was used by the Hungarian Geza Blattner in his Paris Théâtre de l'Arc-en-Ciel for his unforgettable mask of Misery, designed by S. de Walles. This face is a masterly work of art, one that El Greco might have created had he ever been in a cubistic mood. It is a grief-stricken mask haunted by hopelessness, its sadness growing whenever it opens and closes its eyes, opens and shuts its mouth. This mask has broken the barrier of rigidity, and yet, on its hesitant way towards reality, made misery more obvious through eyes that speak and cannot cry, through a mouth that cannot voice its pain.

This is only one of many outstanding examples of masks which are impressive pieces of sculpture. The marionette lends itself more readily to artistic experiments than the real puppet, the hand or glove-puppet, usually seen without legs and mainly associated with the image of the English Punch, the Austrian Kasperl, the French Guignol. The Manhattan Standwells achieved a high artistic level less because of their well-typed puppet family than because of their sophisticated situations and texts.

All these are round puppets, a group that also includes the traditional Three-Man Puppet of the Bunraku Theatre at Osaka. This is a misnomer derived from the puppet manager Uemara Bunrakuken who opened a

theatre in 1871 and was so successful that this unique doll theatre, whose real designation would be *ningyo shibai*, has become known under his name. The use of dolls as theatrical performers is thousands of years old, but it became an established school in Japan in the seventeenth century and has reached a sophisticated level, second only to the *Noh* play itself.

Bunraku is unique in many ways. The half life-size doll is manipulated by the principal operator dressed in a ceremonial costume, and two assistant operators are clad in black with their faces masked. Each of them operates certain parts of the doll's body, from the eyebrows to the legs, aware of the minutest detail in their coordinated movements. A narrator, accompanied by a samisen player, tells the story. The stories are often identical with those of the *Kabuki* repertoire. Written in the seventeenth and eighteenth centuries, they are heroic or romantic plays based on Japanese legends, or domestic tragedies with a good deal of broad humour. As in *Kabuki* the plays are no longer presented in their entirety, so that programmes consist of a variety of dramatic episodes.

Chikamatsu is the name usually associated with Japan's doll theatre as its classic and most prolific playwright. He was a master at creating domestic tragedies, based on actual incidents, unhappy love stories ending in a double suicide, stories to which he gave the inimitable touch of poetic irreality. Many of his puppet plays were later adapted by *Kabuki* companies for their own purposes. But he was not alone. A host of other good writers were attracted by *Bunraku*, and they helped to create a very special art form. But, in the final analysis, the success of the performance has always depended on the skill of the operators.

The doll's heads look very much like *Noh* masks, with a porcelain appearance although they are made of wood. Carved like sculpture, they are used as any other mask is. The heads are often changed by the operator to show different moods or facial expressions as needed for the story's development, but the character is always recognizable. If a quick change of costume is necessary, the operator changes from one doll to another. The heads and the masklike expression remain the same. Many of the doll's movements are characteristic of the stylized *Kabuki* movements. The puppets try to create the impression of stage gestures appropriate to the action, from showing a subtle emotion to manipulating a fan, playing the samisen or *koto*, or reaching for a cup of *sake*.

When the doll 'acts' it must look lifelike in this puppet theatre. Although all faces are expected to show all kinds of emotions, some of them have no movable features and most of the women's masks have a sad expression. They are usually in sad situations, and it is said to be easier for the operator to make a sad face look happy than a happy face sad. These operators, of whom there are very few, are great artists. But their artistry depends on the special artistry needed to sculpt these dolls' heads.

There is hardly an Eastern country from India to China, from Persia to Turkey, that has not developed its own peculiarities in the creation of the shadow puppet. This type of puppet theatre has, however, reached its greatest peak of accomplishment on Java, where the Javanese cut the *wayang* figures out of buffalo hide with a fine feeling for line and colour.

The *wayang kulit* ('puppet leather'), the most important form of shadow play, is performed by a single *dalang* (puppeteer) who moves the richly costumed puppets with thin bamboo rods. He narrates the story, usually based on the *Mahabharata* or animistic legends, and is accompanied by a gamelan. He also operates flat leather puppets, casting shadows on a white screen. The spectators are seated on both sides, so that some see a shadow play, others a puppet drama. According to the legendary stories the puppet faces are fantastically designed, most often grotesquely imaginative and usually reminiscent of animal features. The *wayang kulit* has a long history from which other *wayang* plays are derived, such as the *wayang klitik* or the wooden marionettes of the *wayang golek*. The *wayang golek* is the only play that deals with Islamic stories, centring on the exploits of Amir Hamzah. This finally led to another form of *wayang* in which the actors were puppets, or humans with masks, a form more mysterious and profound.

The shadow puppet has remained popular. It was exported to Bali, where the figures were less refined in their carvings than on Java, more realistic in their crudeness. This either proves that the Balinese puppets go back to an older style of puppets used on Java, perhaps prior to Islamic contact, or it may simply reflect the more realistic, generally gayer and more carefree attitude of the Balinese people.

The Balinese *wayang wong* interests us here because most of its characters wear masks and most of the action is accompanied by the recitation of poetic passages. It may also be characteristic of the life style of the people that performances on Java last nine hours, those on Bali about five.

Karagöz is a form of shadow theatre that spread from the East to Turkey where it was first seen in the sixteenth century. The brilliantly coloured puppets used in it were made of thin leather or camel hide and placed between artificial light and a white screen on which their shadows appeared. The two main characters of this puppet theatre were the witty, sometimes vulgar, Karagöz ('black eye') and his equally popular companion Hadjivad. There was a dialogue section in which these two characters talked about topical events, lampooning dignitaries and members of the audience. After this teaser, the main plot followed, in which famous people appeared puppet-like on the screen. The story which accompanied this shadow play was, in its satiric wit, rather aggressive. The degree of freedom granted by the various pashas of course determined how much liberty these two comedians dared to take in their attacks on public figures. Besides the human figures, animals, mermaids, dragons, serpents, and inanimate objects also gave this funny

90

IV Javanese shadow puppet

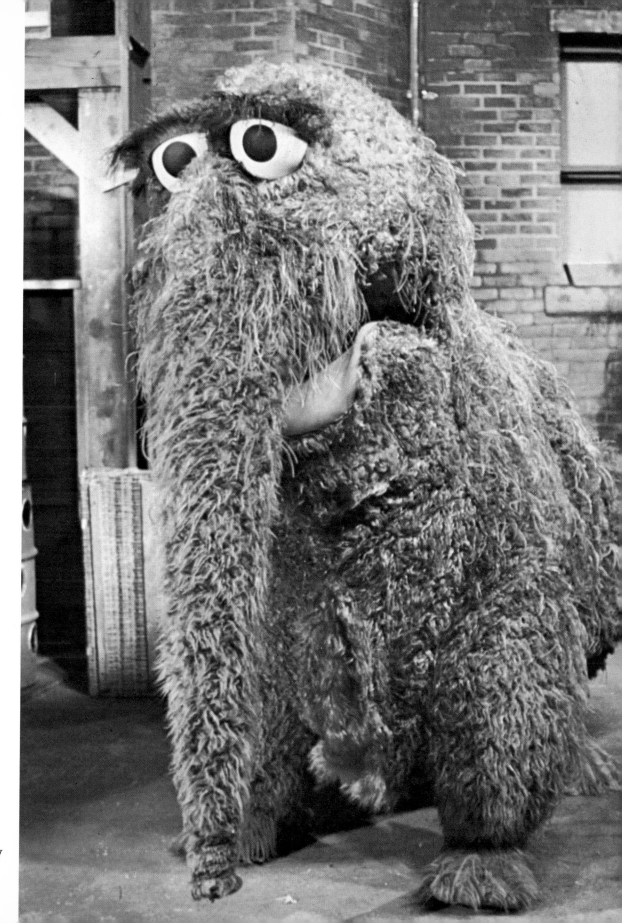

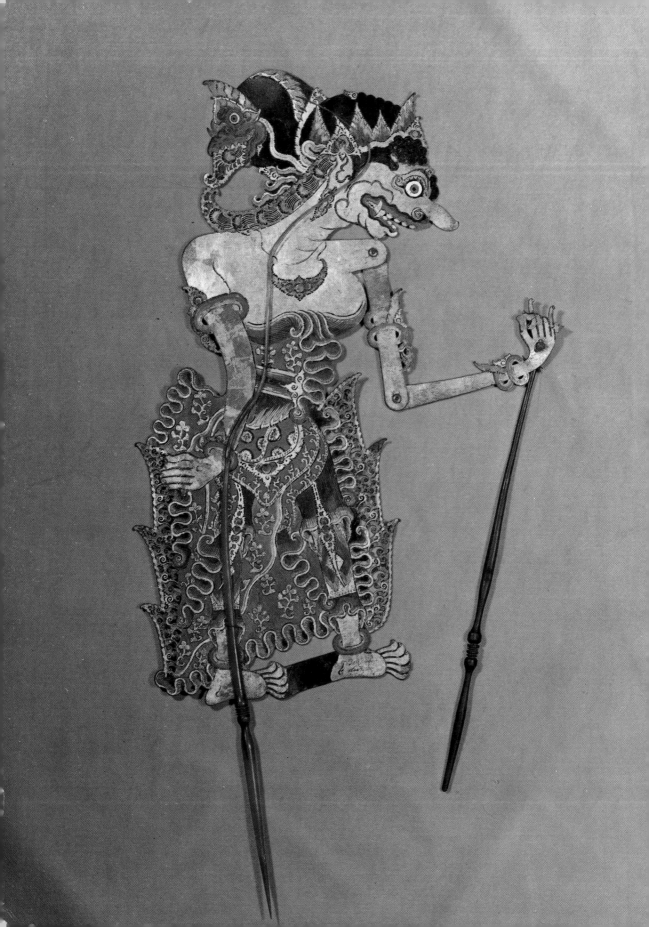

puppet show a realistic and, at the same time, poetically surrealistic feeling. Its unconnected episodes, the freedom in its use of language and visualization often had a touch of *non-sequitur* humour, of what we have come to know as the Theatre of the Absurd.

One other type of puppet must be mentioned, which is of rather recent vintage: the giant puppet. It rose to prominence in the United States in the late 1950s and 1960s with the twofold purpose of being playful and political, and political in the old sense of the word – of a citizen concerned with the affairs of the state as much as with the state of affairs. Oversized puppets have probably been used in different parts of the world occasionally. The Moppets, originating in Manhattan, have besides their enticing little puppet types a few giant ones, built with great ingenuity by Kermit Love. One of his giant puppets was the chimera which Don Quixote battles with in George Balanchine's ballet of that name. We also know of such puppets having once been employed in a folkloristic manner in Sicily; these were huge figures made of wood and metal, each weighing about eighty pounds, being at least five feet tall and moved by heavy iron rods. Their puppeteers emigrated to New York and, for a short time, performed on Mulberry Street in Manhattan's Little Italy, as Peter Schumann tells us in an interview in the *Drama Review*.

Schumann, a German-born puppeteer, created the Bread and Puppet Theatre in New York in the 1960s. His puppets, or at least the majority of them, were a response to the serious political questions which beset the United States in those days. He used to distribute bread after each performance, as a symbolic gesture intimating that theatre should be as basic as bread. He began to work with small puppets before he realized the artistic potentialities of the huge puppets, which, he maintains, he does not build as sculpture but in imitation of actors. For indoor performances Peter Schumann has used both hand puppets and larger-than-life figures. For the latter a single narrator is used, for Schumann senses a lack of credibility in making such giant puppets speak, while dialogue seems to him believable for the little puppets.

Experimenting with all kinds of puppets, Peter Schumann has come to the conclusion that very small puppets do wonders in comedy, while medium-sized ones can best be employed for drama. The effect of the really large ones – and he has some that stand eighteen feet high – is strongest when they are used to play buffoons. Schumann has proved with his shows in halls and on the streets that 'puppets have intrinsic power. They can be funny – or scary. They can say things that actors and dramatists can't say – just by their size.'

He adjusts his shows to the specific space or environment available to him, only rejecting anything resembling legitimate theatre. He feels strongest in the streets because he likes his puppets to take unsuspecting onlookers by

V The elephant 'Snuffle-upagus' from the American television series *Sesame Street*

surprise. They have not come to see something, the puppets have come to them to say in theatrical terms what concerns them. In these situations Peter Schumann mingles elements of the *commedia dell'arte* with those of carnival, with the one great difference that he is dead serious about what he does.

His characters are not persons but types, representative figures, or simply symbols, and the masks by which they are represented are a salient feature in his puppet theatre. Most of his masks have a sad countenance, even the grotesquely distorted ones, as if they could not deny nor help anticipating their future skull-like state. Sometimes he uses skull masks. At best there is a sad serenity in all these faces, a graceful touch of the primitive mask offsetting the images of the living dead, the monsters and those faces showing their scars of suffering.

Whatever this puppet theatre does – children's shows, political pageants, the story of the whole Bible in thirty-three scenes with a prologue in Greece executed by giant puppets, mime and mask or simply puppet plays – there is convincing simplicity, artful reality, a touch of pathos and satire in his ethos. There is poetry in his world of meanness and misery, in his hatred and belief. In the speech from the difficult life of Uncle Fatso, one of his frightening figures, there are a few thoughts worth remembering:

Go placidly amid the noise and haste and remember what peace there may be in silence. . . . If you compare yourself with others you may become vain and bitter; for always there will be greater and lesser persons than yourself. Enjoy your achievements as well as your plans. Keep interested in your own career, however humble; it is a real possession in the changing fortunes of time. . . . Take kindly the counsel of the years, gracefully surrendering the things of youth. Nurture strength of spirit to shield you in sudden misfortune. But do not distress yourself with imaginings. Many fears are born of fatigue and loneliness. Beyond a wholesome discipline be gentle with yourself. You are a child of the universe, no less than the trees and stars; you have a right to be here. And whether or not it is clear to you, no doubt the universe is unfolding as it should. Therefore be at peace with God, whatever you conceive him to be, and whatever your labors and aspirations in the noisy confusion of life keep peace with your soul. With all its sham, drudgery and broken dreams, it is still a beautiful world. Be careful. Strive to be happy.

This speech is from a text dated 1692, found in Old St Paul's Church, Baltimore. In its timelessness it could also have been written in 1962 in a moment of total poetic recall by someone anguished like Job and reconciled with God.

Like any other art form the puppet theatre has its own long history, and only a few moments of import and consequence will be mentioned here. Terracotta dolls with articulated limbs have been discovered in ancient Greek tombs, and references to figures pulled by strings are to be found in the writings of Plato, Aristotle, Xenophon, Apuleius and Horace. Interest in the puppet theatre never died out, but, like any other living idea, this form of drama has had its sociologically conditioned ups and downs. In a crude form it has existed everywhere all along the centuries. But in its artistic highlights

it has been, at certain crossroads in our civilization, the fascinating pheno-
menon it is today. At the beginning of our own century interest in the world
of the puppet was revived. This, however, was not an attempt to parallel the
progressing mechanization of our existence, but rather, on the contrary, to
counteract it, to create a higher allusion than any living actor can do for us,
and to erase the boundaries between mechanism and animated existence. We
are asked to see in the marionettes the 'collective soul' of those people whose
hands move the puppets, as Paul Claudel said.

This was the time when Gordon Craig wanted to regain 'the noble
artificiality' of the Greeks, who wore masks, he claimed, to veil emotions –
those human emotions which conspire against art. 'To me', he wrote in the
first volume of *The Mask*, 'there is ever something more seemly in man when
he invents an instrument which is outside his person, and through that instru-
ment translates his messages. . . . For a man through his person can conquer
but little, but through his mind he can conceive and invent that which shall
conquer all things. . . .'

What his mind conceived and invented was, as we know, the *über-
marionette*. Craig saw the super-puppet as the descendant of the stone idol of
primitive times (one of the many trends of modern man is that of escape
from the confinements of our super-mechanization by going back to
primitivism). As a mask is the symbol for a human face, so the marionette is
to be seen as the symbol for man. 'The *über-marionette* will not compete with
life,' Craig said, 'it will go beyond it. Its ideal will not be the flesh and blood
but rather the body in trance – it will aim to clothe itself with a death-like
beauty while exhaling a living spirit.'

First Craig experimented with the building of complicated models, then
he became disturbed by the complexity of wires, strings and pedals which he
found as limiting to a marionette as he had found emotion hindering to a
mere human actor. He finally designed small but very impressive dolls,
carved out of wood and painted in neutral colours like the scenes through
which they moved to allow for the fullest and most varied effects of lighting.
Each of his marionettes was allowed to make one or two gestures only, but
these gestures had to be exact. For this purpose he studied human gestures,
then extracted from his observations general and essential qualities of the
particular movement. Everything else that Craig ascribed to individual
peculiarities was left out as irrelevant for the stage. The gesture had to be in
harmony with the mask of the doll. Nothing was left to chance, for 'art . . .
can admit of no accident'.

While Gordon Craig theorized about the puppet having 'all those
elements necessary to interpretation' and about the puppet stage having
'every element necessary to a creation and fine art', Dr Vittorio Podrecca put
his dreams into reality. He founded the Teatro dei Piccoli at Milan in 1913
which successfully toured the world and reawakened interest in the marionette.

Some countries have more readily taken to the world of the puppet than others. This fact as much as the kind of puppet theatre that has developed locally is indicative of national characteristics. This holds true particularly for the mask or facial expression. One only has to study the faces of the Austrian and Czechoslovakian puppets. Hermann Aicher's Salzburg Marionette Theatre, specializing in the Mozartian atmosphere, features sweet baroque faces. Even the dream world which Richard Teschner presented in his little theatre in Vienna showed mainly lovely faces, somewhat influenced by Javanese or Indo-Chinese beauty. We find totally different masks in Prague, where puppetry has a tradition of more than three hundred years. Joseph Skupa became famous for his two characters, the slow-witted father Spejbl and his precocious son Hurvinek. They are figures as natural as the good soldier Schweik. Czech puppets have character in their masks and, like the plays in which they appear, they are full of fantasy without belying the crude realities of life.

Some of Albrecht Roser's figures from his Stuttgart theatre show similar trends of unbounded realism. His musical clown Gustaf has certain similarities with the Swiss clown Grock, particularly when Roser has Gustaf imitate Grock's famous numbers at the piano; close in concept is Roser's gossipy, shrewd Oma (Grannie) who knits away while commenting on the members of the audience. Among the many puppeteers in Germany Harro Siegel in Brunswick seems to have caught a very special poetic expression on his puppets' faces.

Two contrasting viewpoints in the artistic approach to puppetry in general and the puppet's countenance in particular can be seen in the work of Sergei Obraztsov of the Soviet Union and Fred Schneckenburger, who conducted his puppet cabaret in Zurich until his death in 1966. Both have created unique puppet shows and characters for adults rather than for children, with sophistication and a fine feeling for style. Obraztsov combines realism and fantasy in a masterly manner of characterization. Schneckenburger was more interested in sculpting the fantastic mask, and in making outspoken use of his biting, cabaret-like wit.

Some of the puppet theatres have reached international fame, others, fascinating in their way, have enjoyed their experimental way of being, never trying to be commercial. As an example I submit the Swiss-American Surrealist painter Kurt Seligmann. Being preoccupied with the occult and visualizing how in primitive magic the priests would cause the eyes and arms of effigies to move, he experimented with weird images and tried to create archetypes of his own imagination. Unlike Richard Teschner, who was also basically a painter but turned his hobby of playing with puppets into a life-long love affair, Seligmann flirted with the idea briefly and showed his fantastic ideas in a Manhattan studio to an intellectual élite who bravoed his inventive and astonishing efforts.

General acclaim has never been a criterion for quality, and to build a puppet theatre has been a great temptation for many artists. Many more creative people were influenced by puppetry. Of John Milton it is said that he received his inspiration for *Paradise Lost* while seeing a puppet show. Goethe, as he tells us in his autobiography, *Poetry and Truth*, was enchanted by the puppet theatre which his grandmother gave him at Christmas 1753 when he was four years old ('it made a very strong impression on me which had a great and long-lasting effect'). This puppet theatre remained a cherished possession throughout his childhood, and he played intensely with it while a French regiment occupied Frankfurt during the Seven Years' War. He then presented for his friends many plays that he had seen at fairs, among them *Doctor Faustus*, one of the most popular puppet shows at that time. 'This significant fable of the puppet theatre', he wrote about *Faust*, 'had taken roots in me and gradually wanted to take poetic shape. . . .' When Goethe was twenty-four he wrote *Das Jahrmarktfest zu Plundersweilen* (*Junkdump Fair*) which he introduced as 'a newly opened moral and political puppet play', a gentle satire on some contemporary writers and on the moral, or immoral, conditions of his time.

The Théâtre des Amis was born in 1847. George Sand's son, Maurice, and a friend, the painter Eugène Lambert (who later became famous for his paintings of cats), amused themselves with the improvisation of a puppet show for which they used an upturned chair and two roughly carved dolls. Their performance was such a success that mother, son, and friend collaborated on creating new material, new puppets, and a stage. The puppets' faces were painted by Lambert. The plots were more daring than the puppets' expressions. George Sand also translated one of her principle attitudes towards the arts into terms of puppetry when she said about the novel that it 'need not necessarily be the representative of reality' and about the representation of man that she was 'inclined to paint him as I wish he were, as I believe he ought to be'. The puppet theatre of the Sands first amused their wide circle of friends, then turned into a professional enterprise that produced about 120 plays in twenty-five years.

Particularly in the mid-eighteenth century, with Romanticism *en vogue*, the French expected their puppets to have a certain lifelikeness, and yet not lack charm. This can also be said about Lemercier de Neuville's puppet figures, one of which, his guitar-playing Pierrot with an exquisite facial expression, received great acclaim. Most of his characters were modelled after types of his own environment with a glaze of niceness.

It seems obvious that we should find in nineteenth-century France several attempts to give the puppets a literary and philosophical air, as was tried by Louis Emile Duranty at the Théâtre des Marionettes des Jardins des Tuileries and by Henri Signoret, a minor poet with a major dream. Signoret wanted to revive neglected, but highly literary, plays of various periods in his

97

Petit Théâtre in the Galerie Vivienne and succeeded in doing so for about six years. His figures were done in exquisite taste, mainly conceived by Edme Arnaud, and the heads were artistically modelled in plaster and tow. It was a puppet theatre for the intelligentsia and a few connoisseurs.

Signoret was the predecessor of a handful of contemporary puppeteers as poetic as Jacques Chesnais, or as daring in sophisticated simplicity as Maurice Claval, who, in many of his works (done for Les Marionettes des Champs-Élysées au Théâtre des Noctambules), created impressive faces out of unadorned but stylishly shaped masks; or André Tahon, who gives his puppets spherical heads, mostly without a nose and always without a mouth, these features being left to the viewer's imagination. Of course, the French have their Guignol- and *commedia dell'arte*-based puppets, but essentially they have always been literarily oriented in their choice of marionettes.

This explains the baffled reaction of the French when the English puppeteer, Thomas Holden, came to Paris in the latter half of the 1870s with marionettes of a puzzling lifelikeness. The French populace loved Holden's show with its all too real puppets. But the French intelligentsia and artists rejected the idea of marionettes whose faces and behaviour were so frighteningly human. Edmond de Goncourt wrote in his *Journal* in 1879: 'Holden's marionettes! These people of wood are a little alarming. There is a dancer turning on her toes in moonshine. An E. T. A. Hoffmann figure could have fallen in love with her. And then there is a clown who lies down and moves around in bed and falls asleep with gestures and poses as if he were a creature of flesh and blood.' Holden's French competitor, Lemercier de Neuville, said of his rival's marionettes: 'They addressed themselves to the eye, not to the spirit, their very perfection was a mistake. One admired them, but did not laugh about them, they evoked astonishment, but had no charm.'

Puppeteers in Great Britain have not, however, forfeited their artistic soul to mere realism. They have learnt a great deal from the masters of the popular puppet theatre, the Italians, and grew up with the image of Punch. Samuel Pepys records on 9 May 1662 that he went to Covent Garden 'to see an Italian puppet play . . . the best that ever I saw'. If nothing else, it informs us that Italian puppeteers had come to England even before Pepys made this note in his *Diary*. They were as popular in England during the Restoration period as their live compatriots of the *commedia dell'arte*.

Nowadays the variations and experimentations in the puppet world are as lively in England as in France. The realism in the face of Ophelia, one of Mary Saunders' figures for the Piccadilly Puppets, is counterbalanced by the stylizations of William Simmonds, a sculptor and one of the modern pioneers of refined puppetry; by the bizarre Hogarth Puppets (Jan Bussell and Ann Hogarth) and the Lanchester Marionettes (whose imaginative range is impressive, reaching from an *Underwater Ballet* to the taxing opera *L'Amfiparnaso* by Orazio Vecchio, with the 1597 madrigals as accompaniment).

Waldo Lanchester had the idea of sending Bernard Shaw figures of two puppets, representing the likenesses of Shaw and Shakespeare, with the request that Shaw should write a ten-minute play about himself and his 'rival' for the opening of the Malvern Marionette Theatre. Shaw responded with a delightful spoof, *Shakes versus Shav*. The year was 1949, shortly before Shaw's death. For the printed version of this playlet Shaw, who was famous for the prefatory essays to his plays, could not resist writing one on this occasion which began with the prophetic and ironic words: 'This in all actuarial probability is my last play and the climax of my eminence, such as it is.' It is comforting to think that the ninety-three-year-old playwright, in the face of death, delighted in a piece of self-irony.

Shakes introduces himself to the audience, seeking out the presumptuous upstart Shav:

SHAKES Who art thou?
 That rearst a forehead almost rivalling mine?
SHAV Nay, who art thou, that knowest not these features
 Pictured throughout the globe? Who should I be
 But G.B.S.?

'Punch'-drunk, Shav challenges Shakes to a knockabout duel. Shakes floors Shav for the count of nine and is then knocked out himself for ten. Then they spar as writers ought to do. In two inlet scenes Shav shows his rival that his Macbeth has been bettered by Walter Scott's Rob Roy and his Lear by his own Capt. Shotover of *Heartbreak House*. The playlet ends with Shav begging:

 Peace, jealous Bard:
 We both are mortal. For a moment suffer
 My glimmering light to shine.
 (*A light appears between them.*)
SHAKES Out, out, brief candle!
 (*He puffs it out.*)
 Darkness. The play ends.

G.B.S. once wrote:

The puppet is the actor in his primitive form. Its symbolic costume . . . its unchanging stare, petrified (or rather lignified) in a grimace expressive to the highest degree attainable by the carver's art, the mimicry by which it suggests human gesture in unearthly caricature – these give to its performance an intensity to which few actors can pretend. . . .

The most successfully experimenting group in England was under the guidance of Olive Blackham, who tested the possibilities of the marionette as an art form. Her Roel Puppets accomplished wonders in stylistic adaptability. Some of the faces were reminiscent of Picasso's blue period, as in Alfred Kreymborg's play, *People Who Die* (the carving was done by Gerald Shaw).

99

Then again, in *Lima Beans* by the same author, Miss Blackham used cubic and spherical masks as faces. She wrote a burlesque, *Dog into Sausage*, for which she asked Margaret Hoyland to create paper clowns. Their bodies and heads were shaped out of separate conic parts, with the faces sporting the biggest and finest of clown smiles.

I mention the Roel Puppets at greater length because of the American poet and dramatist, Alfred Kreymborg, who found in this group his best interpreters. He called his pieces *Plays For Poem-Mimes* and said:

The plays are intended for human as well as wooden actors; they have, in fact, been performed by both groups; but so far . . . the author of these experiments owes a deeper debt to the lifeless nonentities who have honoured him with their friendship and served him with their patience. . . . Burattini, marionettes, puppazzi – call them what you will – have invariably apprehended these demands [contrapuntal ritual, harmonious pantomime] with a fidelity the author has never quite seen or heard duplicated by a company of human actors. These suggestions are not ventured as a challenge to the latter, but rather as a request for them to consider . . . to do so with the art of the puppet theatre as a constant, though miniature, model.

In one of his plays, *Manikin and Minikin*, two dolls discuss the difference between humans and puppets. Manikin extols the inanimate being in wooing Minikin:

> I dislike, suspect, deplore –
> I had best say, feel compassion
> for what is called humanity –
> or the animate, as opposed to the inanimate. . . .

'Humans change with each going moment', he claims. 'That is a gray-haired platitude', while the inanimate beauty is eternal. Only as long, of course, as no human inadvertently knocks Minikin to the floor, where her eternally beautiful face would then lie broken into the little fragments of what was once her eternal beauty. Manikin realized that one can only speak of such things in relative terms.

Relative for Kreymborg was the fact that hardly any American puppet theatre availed itself of his poetic talent. Not that there has not been a great variety of such theatres! The Standwells and the Bread and Puppet Theatre have already been mentioned, and there is in all great cities a number of puppet shows on occasion, all with their peculiarities, but none with particularly memorable masklike faces. An outstanding experiment was made by the League of Composers and the Philadelphia Orchestra in 1931 when Igor Stravinsky's *Oedipus Rex* was performed. The singers were massed on stages, while the characters appeared as huge puppets ten feet high, controlled from above by strings, and from below by operators who, in the manner of the Orient, were clad in black. Robert Edmond Jones designed the giant figures for this experiment, Remo Bufano constructed the bodies

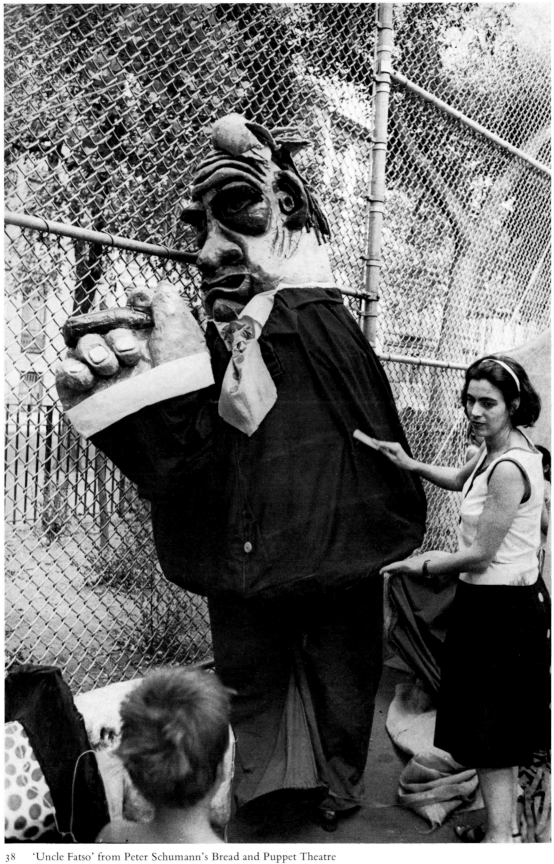

38 'Uncle Fatso' from Peter Schumann's Bread and Puppet Theatre

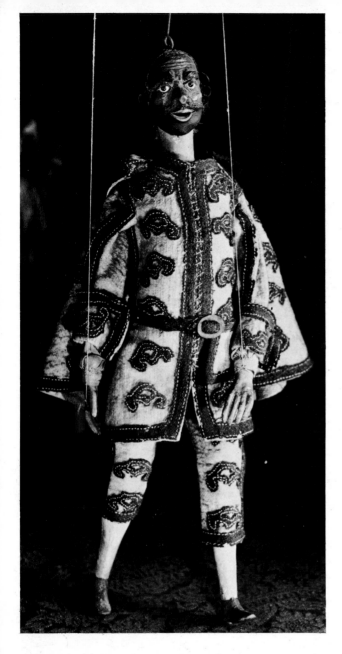

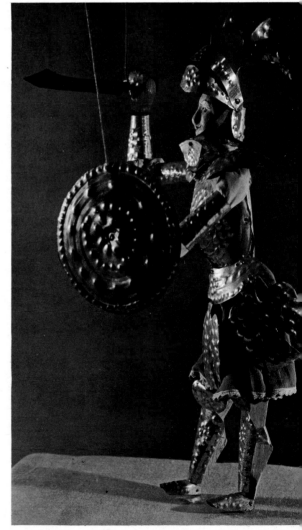

40 Traditional Sicilian puppet

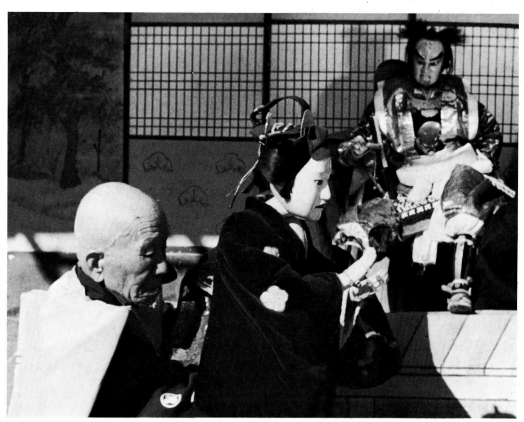

41 A *Bunraku* puppet show, Japan

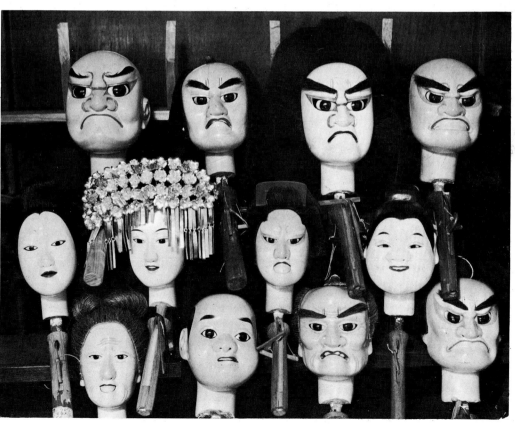

42 Puppets used in *Bunraku*

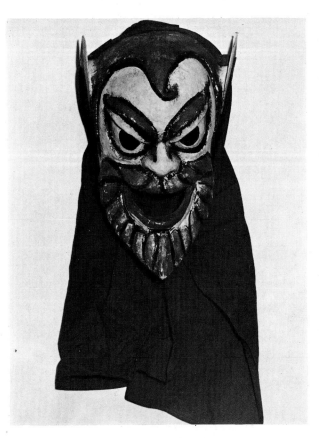
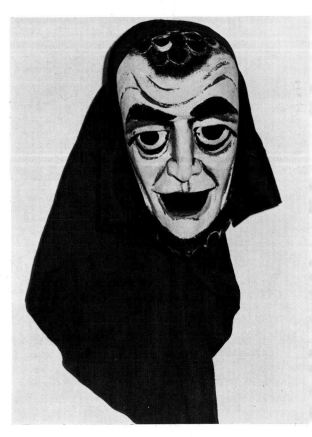
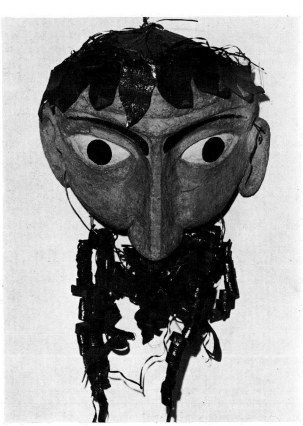

43–45 Masks used for modern productions in Switzerland: above, masks for a Satyr in Aristophanes' *Ploutos*, and for Prometheus in Aeschylus' *Prometheus Bound*; below, mask for Kallipides in Menander's *Dyskolos*

46 Puppets used in *Karagöz*, the Turkish puppet drama

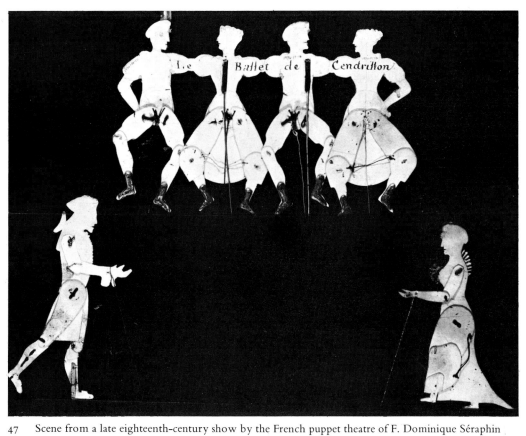

47 Scene from a late eighteenth-century show by the French puppet theatre of F. Dominique Séraphin

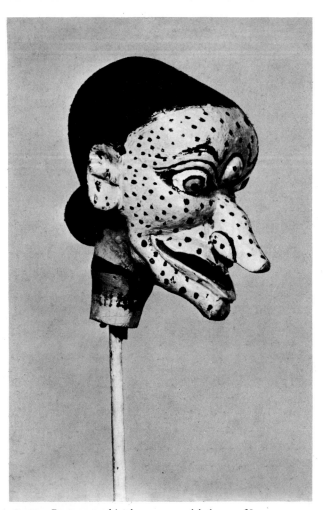

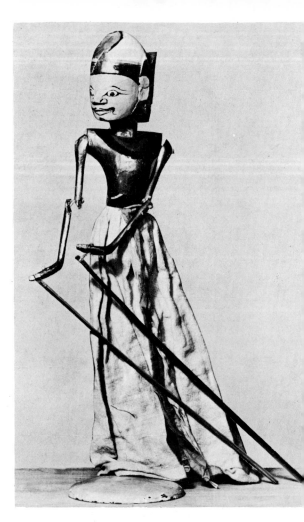

48, 49 Puppets used in the *wayang golek* shows of Java

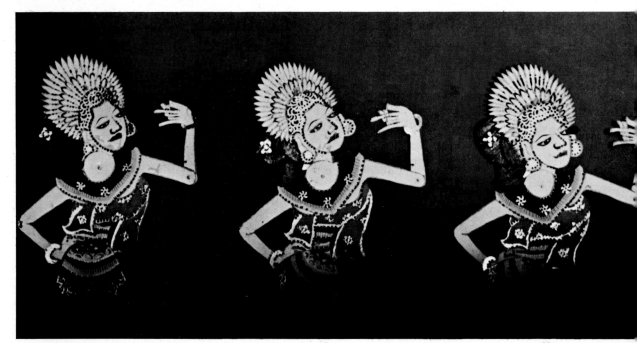

50 *Wayang kulit* puppets from Bali

out of paper, and the joints and hands were made of wood. The head masks simulated singers, with their mouths kept open.

Not puppets in the ordinary sense of the word are the animated cartoon creatures of Walt Disney. What else are Mickey Mouse and Donald Duck but masks that type a concept, masks seen in motion? The original still is the *persona* behind which the animator's idea hides. The movement of the cartoon character turns it into a cinematic puppet, and the sound helps the mimic and mimetic act to pretend that the inanimate is alive. This animated mask easily succeeds in presenting an imaginary character because its mask is close to something real with which we can quickly identify. The character may move through frightening horror or supernatural delight, and we are not only able but desire to believe in the unbelievable.

The improbability of the animated character's exploits and experiences symbolize what, in our waking dreams, we would like to be able to do ourselves. The more improbable and symbolic the animated mask is – while still being reminiscent of some real being – the more easily can we believe in it. Also, the mechanization of something basically inanimate and unreal has all the advantages of a fable.

Credibility and our imagination's willingness to translate the unreal into the reality of our being, to decipher the code of analogies and symbols, to embrace allusion and illusion with the heart of our mind and to see the poetry between the lines and gestures, are crucial for all performing arts, if not for all the arts. In recalling the origin of the word 'marionette', which was Marion or even Maria, we must go back to the movable figures of the Mother Virgin which in medieval France, as in all Romance countries, were nothing unusual. The Assumption of the Virgin Mary was annually celebrated at Dieppe by a company of clergy and laymen. They did not employ live actors to show the Assumption itself, but marionettes set in motion with strings and counterweights. Angels flew around and some blew trumpets before they lifted Maria to heaven.

This medieval custom and the representation of the Mysteries through marionettes spread to other cities, such as Lyons, Marseilles and Paris, where marionettes were busy demonstrating the creation of the world, the birth and Passion of Christ and other dramatic moments of the Old and New Testament. This custom was kept alive in Paris until 1647, when the mother of the nine-year-old Louis XIV decided that such representations were unbecoming in an Age of Reason in which new philosophical and scientific methods of inquiry were being devised. But this did not stop the presentation of sacred images and figures through marionettes.

In fact, a live actor in the shape of Jesus poses greater difficulties for the viewer in accepting the corporeality of the Christ figure than a puppet doing the same. I have always had qualms about seeing Jesus on stage. My

reservations do not arise from a feeling of sacrilege, but simply from a suspicion that this represents an error in aesthetic judgment. Great writers who have treated this figure have either totally humanized it, or, like Michel de Ghelderode in *Barabbas*, had Jesus appear but 'say nothing', or they have skilfully avoided bringing him on stage. Max Frisch, writing in his *Diary* about puppetry, said:

Christ as a puppet?

I recall as a student seeing a puppet-play in which the Last Supper was represented. It was deeply affecting. It was holy to such a degree that it would be thoroughly impossible for any human actor, trying to simulate a Christ for us, even to approach it. A Christ of linden-wood, such as Marion makes: if we consider a crucifix, then we will sense nothing blasphemous in the puppet: the puppet, in opposition to the human actor, meets us from the very first as form, as image, as a creation of spirit, which alone is able to represent that which is Holy. The human being, even when he plays as image, always remains a man of flesh and blood. The puppet is wood, an honourable and a fine piece of wood, which never lays claim to the deceitful pretension of presenting an actual Christ, nor should we take it to be such; it is merely a symbol, a formula, a text, which signifies, without wanting to be that which it signifies. It is play, not deception; it is spiritual in such a way as only play can be. ...

We could add to this that it is innocent. An earlier German writer than Frisch, Heinrich von Kleist, felt that only a puppet and a god are free from self-consciousness, one of the stigmas of man who dared to eat from the tree of knowledge. Of course, when he wrote the essay *On the Marionette Theatre*, Kleist was not interested in the question of whether a live actor, or a puppet, can more convincingly represent the man of God. He wanted to know about the god in man, about the final truth of 'the purest and most innate grace' in man, and, observing the lack of any affectation or self-consciousness in the puppet, Kleist concluded:

Grace becomes ever more resplendent and predominant with our dwindling and darkening awareness. It is like this: the way in which two parallel lines meeting at infinity reappear at the other end, or the way in which the reflection in a concave mirror, after receding into the infinite, suddenly emerges again close before us, – so must our consciousness journey into the infinite before grace reappears in its most exalted state. Thus we find the purest and most innate grace in those human bodies endowed with an all-encompassing awareness or with those having no awareness at all, that is in the godly being or in the marionette.

Kleist gives us the answer to the problem of why only the total innocence of the puppet – in contrast to a live actor – makes us view a wooden representation of Christ with a lack of self-consciousness and embarrassment. Kleist thought that to regain the state of innocence we would have to eat again from the tree of knowledge, and he added that 'this would be the last chapter of the story of the world'.

'I sincerely believed and still believe that the poetic dies when living beings are put into it', Maurice Maeterlinck wrote. He mistrusted words as he felt they could too easily obscure 'the communion of soul with soul'. In the theatre he sought symbolism and mystery, 'the expression of those profound

emotions that exist in solitude and silence'. Such great dramatic figures as Lear, Hamlet, or Othello lose too much majesty when presented on the stage. 'And for these reasons', he prefaced *Three Little Dramas for Marionettes*, 'I have destined my little dramas for those beings indulgent to the poetic, which for lack of a better name, I call Marionettes.'

In his youth he was probably greatly impressed by the many puppet theatres around Liège, even though no trace of their Brueghel-like peasant quality colours Maeterlinck's dreamy melancholy, delicate fantasy, or mysterious symbolism. No fewer than fifty-four puppet theatres were listed in the area at the turn of the century. These Belgian, or rather Flemish, puppet shows have preserved an old tradition. They use heavy wooden figures with crudely carved heads which are an immobile part of the trunk. The faces of these figures are very much like masks, cut like a planed surface with hardly any projecting details. Only the arms and legs are movable, and the whole body is moved by an iron rod. All this gives the acting figure an archaic feeling which, together with the dialogue spoken in a Flemish *patois*, is quite unique in the world of puppets.

Maeterlinck rightly said that, for lack of any better name, he called the poetic actors he visualized for his plays marionettes. But his puppet plays are stage plays for which the actors ('spiritualized by distance') who could do full justice to them have not yet been born. Maeterlinck, in other words, wrote poetic, 'static' plays of inner drama which, in many ways, ran counter to the dramaturgic principles by which the traditional theatre is ruled. He only knew the verbal nature of the dramatic image and did not realize that states of feeling are no substitutes for physical action, not even on a puppet stage.

In contrast to Maeterlinck, Federico Garcia Lorca knew how to give the drama of the inner world physical stage expression. I cannot help mentioning him here because his beginnings as a poetic dramatist were with the puppet theatre. Lorca was only seventeen when Manuel de Falla wrote a charming little opera for the puppet stage, *El Retablo de Maese Pedro* (*The Puppet Play of Master Peter*), and his friendship with the composer must have strengthened his belief that he could best experiment with these wooden actors.

As a child Lorca had played with a miniature theatre and had learnt to be a dramatist, actor, scene designer, and costumer at one and the same time. When he wrote his first play, *The Spell of the Butterfly*, which tells the story of a cockroach falling in love with a butterfly, he had all the dramatic ingredients for a puppet play. The play was a flop, not because real actors, masked as animals and bogged down by too many poetic images, were unacceptable, but because it was closer to a puppet than a stage show.

The young Lorca was surrounded by puppeteer friends and liked the rough-and-tumble Punch and Judy concept, replete with the flavour of Spanish passion. His years of infatuation with puppets were his apprentice years as a dramatist. The poet he basically was learned the mastery of the

mechanics of plot construction and the art of poetic and dramatic integration in which he was to excel later on. His brother tells us of Lorca's dedication 'to search in his own fashion for a *pure* theatre', and, in purging himself from an overflow of lyricism and poetic stage images which perfectly fit the puppet stage, Lorca finally reached the state of combining passion, poetry, and dramatic power into theatrically workable components.

Critics and literary historians pay little or no attention to his puppet plays, such as *Chimera*, *The Lass, the Sailor and the Student*, or *Buster Keaton's Constitutional*; and perhaps rightly so since they are stylistic exercises, however skilfully done. *The Puppet Farce of Don Cristóbal* and *The Love of Don Palimplin* are Lorca's giant steps towards maturity. They are, however, still based on farcical folk material, which has always been the essence of the Spanish puppet shows. Imbued with this source material, the traditional Spanish modes and moods of being remained the themes of all his works.

It is characteristic of Lorca's world of puppets and masks that when asked which part of his tragedy *Blood Wedding* he liked best he answered: 'When the moon and death appear as symbols of fate. The realism that has predominated up to then disappears and gives way to poetic imagination, and there I'm like a fish in water.' Or he said about *The Shoemaker's Prodigious Wife* that she is 'both a type and an archetype: she is a primary creature and a myth of our pure, unsatisfied illusion'.

How about the *personae* of Lorca's characters? They never deny their puppet origin. Their faces are masks for a reality that does not dare to be, or, on the contrary, spills all over the stage. His characters are stereotypes of Spanish folklore, and they are types rather than characters. They wear the masks of feminine martyrdom, emasculated Don Juanism, or the brutal rigour of matriarchal ideas. These masks hide passion, sex, and honour, the three propelling forces in Lorca's characters. They are predetermined traps, prisons, and straitjackets for his heroes and heroines. I have never seen a Lorca production in which his characters wore masks, but they could very well do so. On second thoughts, they do not have to. They all have the characteristics of a puppet that is a type.

Before closing this section on the puppet a letter comes to my mind which Heinrich von Kleist wrote to his half-sister Ulrike in May 1799. Beset with anxieties and the premonition of an early death in his student days, he spoke in this letter of his fear that, however strongly he might assert his independence, his future life would still be 'determined by chance', that he would remain a 'puppet on the wires of fate' – and that he thought such condition contemptible, 'even death was preferable to it'.

At that very early stage of the Industrial Revolution, the growing pressures of social conformity and the desperate will of the lone individual to be true to himself began to be felt. Kleist painted an image as if he had seen the handwriting on the wall: in our confusingly complex social structure we

experience exactly what he so much feared. We no longer live but are lived, puppets on the wires of circumstances in which we pull the strings by which we are pulled. Our interdependence has grown with the same frightening rapidity with which man's face has become more and more that of the faceless mass of man. Our individual tears run down our mask, whose rigidity is only slightly softened by our desperate smile.

Not all mimes work with a masklike face, but all of them 'put on a face' for each number in harmony with the theme. The 'deadpan' face is the one closest to the mask. Angna Enters has pointed out that deadpan is a misnomer which conventionally means 'a flat white or pale make-up which makes the face appear a mask'. The best-known and most ideal deadpan mask is that of Buster Keaton, who proves that it is not totally motionless. The actor's reactions and thoughts are an exaggeration of a conscious simplification. He is never smiling, his face is never saying more than the infinitesimal minimum that not even a wooden mask can help registering through the slightest movement of the head.

The choice of the mime's movements and his facial expression are the selected symbol of the essence of what he wants to convey, of what is most meaningful in its realistic existence. Time and space are at his command, he can order both as loosely or tightly as he pleases as long as he maintains truth and illusion well balanced, truth abstracted from reality, illusion created out of 'nothing there'.

There is often too little distinction made between mimes and pantomimes, and those who are vague about it can always claim that even Diomedes' important work on Latin grammar did not bother to discriminate between the two. When we take Marcel Marceau and Charlie Chaplin as two contemporary examples, then we realize that there is a difference between the two, not lying in their personalities so much as in their approach to and execution of their art. Taking Jean-Louis Barrault as a third example, we may face difficulties again, since with him the mime and pantomime easily overlap.

Glancing back at history, however, there seems to be no doubt that mime shows originated in ancient Doris, particularly in Megara, prior to any dramatic events in Athens. The name of Epicharmus, one of the first important writers in the genre of comedy-mime in the fifth century BC, must be mentioned. The themes of the Megarian mimes were taken from daily life intermingled with burlesque treatments of mythological topics. It was a low-comedy type, and probably one of the lowest, with everything being done for a laugh. This is borne out by the fact that Aristophanes and other later comedy writers refer with disdain to 'Megarian laughter'. Eupolis, a fine writer of whom we know too little, spoke of 'a dull and wanton Megarian jest' (which may, however, have been more wanton than dull for the audience).

113

The actors of the Megarian mimes wore masks, and there seems to have been a variety of masks for different types. Some of them made of stone, clay, or terracotta have survived. Most of these early masks had a terrifying appearance and, undoubtedly, demonic powers were attributed to them. Some of the extant masks reveal witch-like old women or hags, a favourite type in these mime shows. From there they made their way into the Athenian comedy.

Many such types were first established in the Megarian mimes, such as the gluttonous cook whose mask shows a good-natured, fat face with raised eyebrows, or the figure of the leading slave with a shrewd, ugly expression. The type of the old man with his peaked beard is another such early invention. The fool, the quack-doctor, and the schoolmaster pedant were figures with which Megarian audiences were familiar. The animal mask, too, was used in Doric comedy before it appeared in Attic. With most of these types established, and with the help of those Dorians who later settled in Sicily, the mimes were introduced into Italy.

Mimes were always presented during the annual *Floralia* festival in Sicily and on the Italian peninsula. They were lewd and crude performances, not shying away from total nudity or even acts of carnal gratification on stage. A favourite topic was adultery, a situation which has not changed very much to this very day. It goes without saying that the early Christians turned primarily against the mimes when condemning the Roman theatre. But we must not underestimate the historic role these mimes played. First of all, not all mimes lacked theatrical dignity, but all of them, with their stock characters and stock masks, established a tradition which, during their diaspora throughout the Middle Ages, they carried into the Renaissance, where we meet again the theatre mask and masks characterizing stock figures. Furthermore, a legitimate child of the Roman mime was the *pantomimus*, which outdistanced its parent in artistic achievement and popularity.

The pantomime was a great interpretative dancer who told his story, usually a mythological one, with the subtlest movements of his body and gestures. His was an artistic show with chorus singing offstage before and between the episodes, accompanied by diverse instruments. Sometimes a narrator, or herald, would tell the story to be enacted. If all mimes did not wear masks all the time, the pantomime did. The mouth of his mask was closed, to indicate that the performer could not speak. He would change the masks to clarify the various characters he impersonated. He wore long cloaks and richly embroidered costumes. He leaped and crouched, gestured, twisted and turned, executing dazzling feats of acrobatic or statuesque beauty. The pantomime had the body of a dancer and the mind of a poet. His 'most loquacious hands, the speaking fingers, the clamorous silence', were rightly praised by the writers of the period.

Pylades of Cicilia and Bathyllus of Alexandria supposedly introduced this

art in about 22 BC. Bathyllus favoured the *saltatio hilara*, the hilarious comedy. His style remained immaculate, although at times it had a touch of the burlesque. He was delicately built and liked to appear in female roles. One of his famous and most graceful impersonations was Leda in *Leda and the Swan*. Juvenal called him 'tender Bathyllus' and thought he was the only man who could teach anything to the fairly sophisticated mimic actress Thymele. Pylades was equally famous for his beauty and skill. He developed the grand gesture of the tragedian, and the style he is associated with is called *saltatio Italica*.

In contrast to the mimes, the pantomimes were closely associated with the emperors and politicians and frequently became involved in court intrigues. Banishments also often occurred, since the politicians resented the fact that the pantomimes stood high in popular esteem. Later their art deteriorated and they became corrupt, their performances growing lascivious and cheap. The populace still remained devoted to them, but the Christian Church waged relentless war against them, and finally they shared the fate of all mimes.

As joculators and *jongleurs* these medieval entertainers used masks on occasion only. But these minor artists, seen mainly at fairs, could not help being influenced by the Atellan comedians and the few pantomimes who sporadically made their appearance up to a late period of the Middle Ages. In such a way tradition and the memory of the Roman artists were kept alive. However strong the influence of the past may have been, the fact remains that in the twelfth century, when the first signs of man's rebirth were noticeable, we learn that masks were relatively common. They were worn not only by the layman or the lower clergy on such days as the Feast of the Fools and on other occasions of merrymaking, but by professional entertainers as well. In the thirteenth century we read that joculators sported 'painted faces'. Animal and devil masks were very much in use. At the beginning of the fifteenth century the Bishop of Nantes felt forced to prohibit mimes and *jongleurs* from using grotesque masks, and the fact that such a ban was thought desirable indicates how strong its frightening as well as satirical effects must have been on the public.

Miming continued to play a great role, and so did the mask, during the Renaissance and late into the eighteenth century. But the mime was absorbed by the *commedia dell'arte* players and the ballet, particularly by Jean-Georges Noverre's *ballet d'action*. (We will hear more of this in another chapter.) From the types of the *commedia* players came the figure of Pierrot, a French version of Pedrolino. Giuseppe Giaratone is usually credited with the creation of Pierrot. It was in 1685 that, after playing small roles, he appeared 'under the name and in the costume of Pierrot. The nature of the role is that of a Neapolitan Pulcinella a little altered', as a manuscript note in the Biancolelli scenarii says. 'In point of fact, the Neapolitan scenarii, in place of Arlecchino and Scapino, admit two Pulcinellas, the one an intriguing rogue and the other a stupid fool. The latter is Pierrot's role.'

This figure changed in the hands of Jean Gaspard Deburau, who early in the nineteenth century created in the Théâtre des Funambules the white-robed Pierrot whose characteristics were a white face and melancholy. The touch of sadness and pathos in the lovesick, pale fellow who goes from frustration to joy to frustration created his particular charm. In many ways Deburau and his Pierrot were the beginning of a great tradition of French mimes. Marcel Marceau is the greatest name among the French mimes today, Étienne Decroux is the outstanding theoretician. Jean-Louis Barrault, as actor-mime, probably most often crosses the line that separates the mime from the pantomime.

Charlie Chaplin, undoubtedly the most significant comedian of our century, is a pantomime. He is always involved in handling props which trick or overwhelm him, to which he becomes a slave. He was a product of the Keystone humour of the silent movie era. When Chaplin helplessly struggles with a machine feeding humans, then the innocence of fun gradually reveals itself as devilish malice. Chaplin's mask reflects the little man's struggle with obstinate objects in a tricky environment. If nothing else, his own hat, cane, or trousers turn into his antagonists.

There is quite a bit of the traditional clown in Chaplin, W. C. Fields, or Buster Keaton. They are clowns with a very personal, specific attitude towards the tragic in life that they try to overcome. They don't need the white, stereotype mask of the clown to be funny. They have their own *persona*. The clown fails in whatever he does and his action is laugh-provoking because he creates the difficulties over which he stumbles. The clown and mime need the reality to reduce it to a symbol. The mime creates his own reality and struggles with it symbolically. Through it, his realism seems to be more meaningful.

Marceau explains that 'the mime is man and object at the same time, wind and the man walking in the wind . . . child and balloon. . . .' If miming were little more than a means of expressing words through gestures, then the mime's face would be of no interest. But the mime expresses feelings by attitudes, and the attitude characterizes his mask. The mime may, of course, wear a non-committal, neutral mask, or one synthesizing the qualities of one particular expression.

The mime must often change his masks in quick succession. In Marcel Marceau's act, *The Maskmaker*, he creates a variety of masks through facial expression: gay, naïve, wicked, and melancholy masks. Then suddenly he displays one mask which he seems to be unable to take off or to change. He tries to move this last mask, he pulls on it – but in vain. His entire body expresses anxiety, despair and fury. Full of fear, he begins to tremble. He pounds the mask on his face with both hands. We see how his arms begin to weaken. His body loses its strength, its equilibrium. He staggers and finally collapses. The last mask his face created has turned into his death mask.

CHAPTER IV

The Dancing Mask

The artists of the twentieth century felt compelled to return to the use of the mask. The reason for this was the artist's wish and need to find a new way of expression. In the search for new values, or rather in doubt of those that articulated the immediate past, he groped for new roots and symbols which he thought to find in the oldest ones.

When John Cage claimed that the artist of our time must begin from scratch, he essentially meant that we must return to the primitive simplicity from which man once began. It is from there that we may gain a better perspective on ourselves and on a time which has the deceptive look of a non-time whence a totally new concept of existence must emerge. The dancer, living with and being the instrument with which he must express himself, discovered new ways of realizing himself artistically. At about the same time as Arnold Schoenberg broke with tonality and Picasso with conventional form, the Wright brothers took off from the ground to measure distances in flight, and Freud penetrated the many layers of man's self. There are no isolated phenomena in history.

Isadora Duncan is commonly identified as the dancer who successfully rebelled against the past. She did so because she rebelled against life as well and, consciously or unconsciously, recognized that man must find a grand simplicity – grander than the one that Gluck, Noverre, and the encyclopae-dists looked for at the end of the eighteenth century – in order to find *himself* again, to find his sanity in a world which, in its overcleverness, is destined to trap itself over and over again.

All that Isadora wanted was to give the 'soul' its ecstatic expression. When she went back to the Greeks, she only borrowed their freedom and ecstasy. Her great discovery was that one should not arrange designs, however visually pleasant, with human bodies, but that the entire body, including the face, should become an expressive instrument for the artist's feelings in a given dramatic or lyric situation. Isadora Duncan not only threw off the ballerina's paraphernalia, she also erased from her face the stereotype expression, the mask of the studied smile while turning a pirouette or ridiculing gravity with a self-reliant grin of grace before and after a *grand jété*.

Despite her innate relationship to the ancient Greeks she never used a mask. On the contrary, she insisted that the dancer's body and face must become an instrument of emotional expression, and that the dancer's 'other face' is the artistic externalization of an emotional state. Perhaps it is significant that at the same time Ivan Petrovich Pavlov was investigating the dualism of mind and body, experimenting with physical reactions to mental stimuli. This was also the time when Constantin Stanislavsky was trying to get his actors to evolve a character presentation from the process of 'inner feelings'. Stanislavsky was initially impressed by Isadora Duncan. Then, after having observed her 'improvisational' technique, he decided that she did not know how to make a logical explanation of her art.

If Isadora Duncan was all 'soul', dictated by her inmost mood of the moment, then Mary Wigman, as John Martin pointed out, gave body to her spirit. Wigman was a product of the postwar era after mankind's first cataclysmic exercise at the beginning of this century. 'Without ecstasy there is no dance' could have been said by Isadora, but the thought following it, 'Without form there is no dance', is already far removed from Isadora Duncan's concepts. Dance was no longer the emotional and lyric manifestation of an inimitable artist varying her *personae* according to the propelling impulses of the 'soul'. With Wigman dance turned out to be the result of a collision between outside forces and her emotional reactions to them. It was her awareness of man's relationship to his environment, in a wider sense to the universe, and their interactions which motivated her creative power.

Most of Mary Wigman's dances were concerned with the revelation of inner states of being. It was, therefore, a logical step for her to make use of masks in some of her dances. 'The dancer who does not love his mask cannot properly wear it', she told me. 'Moreover, he must know it even better than his own face, must know what it looks like en face, in profile, when he bends and turns.' In creating her *Ceremonial Figure* she imposed total restraint upon herself, restraint which her body obeyed. Yet, as she explained, there was the human face, which despite its disciplined immobility bore the features of Mary Wigman and did not want to subordinate itself to the natural rules of the *Ceremonial Figure*. The only way out was to banish this face with the help of a mask.

A mask-maker was called in and he observed the rehearsals of the dance as they progressed. He immersed himself in it. The result, however, was a mask which 'was an almost demonic translation of my face. I fell in love with it at first sight. But when I put it on my face, I had a very peculiar feeling. Instead of having a soothing effect, it was upsetting. It underscored the personal, where it should have depersonalized.' The second version of the mask was exactly what she had hoped for. 'The finely grained wood was carved down to a chinalike thinness, transfixed into an oblong shape, with a mere suggestion of human features. Mouth and eyebrows painted with

greyish blue brush strokes on the ivory-coloured wood. Two small slits for the eyes. Nothing else! But even in this abstraction was retained a trace of the personal dance face.' Mary Wigman felt that with the help of the mask the dance work was a triumph and had become 'more exalted, noble, unapproachably beckoning from afar . . .'.

What interests us most here is the personal relationship that evolved between the dancer and her mask. 'When I took it off after the dance, I could not help feeling that the mask had identified itself with me – or I with the mask – to such an extent that I was gripped by the fear that I would never be able to get rid of my mask-face.'

When about a year later Wigman worked on her *Witch Dance* she returned to the unused first version of the mask for *Ceremonial Figure*, the one which gave her features a demonic expression. Now, she felt, this mask might give the *Witch Dance* its very own stage realization. But it still seemed to have a powerful and personal life all its own:

Every movement of the body evoked a changed expression of the face; depending on the position of the head, the eyes seemed to close or to open. As a matter of fact, even around the mouth – intimated with a few strokes of the brush – there seemed to play a smile which, in its unfathomableness, was reminiscent of the Sphinx. . . . 'Keep the secret . . .'. What a discovery! By incorporating this element, which became clarified through the warning gesture covering the mouth, through the play of question and answer between a remote background plunged into twilight and the glaring foreground action, the character of the dance, tumultuous in itself, found its corresponding opposite pole, for which I had searched in vain for a long time. Only now was *Witch Dance* really accomplished.

When Mary Wigman began to work on a solo dance which was to express the thought that 'we weave at the fabric of time' she wanted to call it *Song of the Norns*. She intended to create three stages in the life of a woman, young, mature, and old, and was convinced that the dancer would have to wear masks, not only to depersonalize the dancing figures, but also to give the dance a timeless face. When the masks were ready she thought that the one belonging to the young woman was a perfect dance-face. She had qualms about the mature woman's features, but the mask of the old woman terrified her

because all that emerged from this face, I could not do – I could not yet do – and would probably never be able to do. The figure wearing this mask was no longer the symbol of an old woman. What looked back at me was the age-old, archaic face of a very old woman, so totally remote and removed from life that the language of this creature could only be motionless silence. This woman could no longer lift her foot, and her deadly tired hand could not even finish that last and gently symbolic action, the cutting off of the thread of life which was her destiny.

The mask was discarded and so was the dance. However, the residues of its concept recrystallized and became alive in another solo, *Song of Fate*. In her *Dance of Death*, a group work, and in the more monumental choral dance,

Totenmal, masks were employed again. Her account of how a superimposed concept of masked faces was made to work artistically seems significant:

... all the *Totenmal* dancers were supposed to wear masks. Confounded, I stood in front of the fifty faces carved of wood ... the male masks could be best adjusted to an almost ghost-like message. On the other hand, the torn-open faces of the women were brought into the focus of too much realism which – even though on a different level – also seemed to be forced into something phantomlike. And thus the first practical attempt failed by slipping somewhat into the grotesque. What was to be done? I knew no way out. And yet a way had to be found to come closer to these masks.

We tried it with 'meditation exercises'. The female dancers sat on the floor ... and stared at the masks lying in their laps: one minute – two minutes – five minutes. No word was spoken. Only a softly played gong melody filled the room. The same was done next evening. But this time the dancers had put the masks on their faces and observed them as reflections in mirrors which they had brought with them. This way we gradually adopted and became immersed in the style and character of the mask.

Then I began with the molding of each single figure. I had every dancer approach the larger mirror in my studio in order to show where the discrepancy could be found between mask and human shape. I particularly remember the dancer wearing the mask of an old woman. The dancer's body was in utter contrast to the tormented face of the mask, furrowed with wrinkles and with the expression of one about to die. Only with utter cautiousness did I then succeed in giving the young body the gait, posture, and gesture, the imprint of the decrepitude of old age. ... I was not only concerned with bringing mask and mask-wearer into harmony with each other, but also with determining their style and with turning them into types while preserving their individual character. Only in this way could the collaboration of all in the choric message be achieved. ...

I have dealt at length with Mary Wigman's experiences, since they have exemplified the modern artist's struggle with the mask. She thinks that make-up gives the dancer a second *skin* and can help interpret meaning and message in all their nuances. The rigidity of the mask gives the dancer a second *face*, it characterizes and typifies. She doubts that the mask can be exploited psychologically, even though her own work was in many instances proof to the contrary. She is certainly right in saying that 'it would be a masquerade to force the mask upon a dancing experience'.

'When should a dancer wear a mask?' she asked, and explained: 'Only when the mask is inherent in the dance theme, when something evolves out of the unfolding of movements and their meaning, something that effects the *Gestalt* and its metamorphosis of the dancer.'

A dancer whose talents were first recognized by Mary Wigman, but whose development showed a marked trend towards theatrical and even spectacular effects, was Harold Kreutzberg. When he said, 'I dance to express myself. I dance from my heart, blood, and imagination', he seemed to be closer to Isadora Duncan than to Wigman.

Kreutzberg mainly wanted to express his mood, poesy, and his inner feeling with movement, with his body. He reawakened the image of a Hellenistic-Roman solo pantomimist who created legends and symbols of

human existence. His characterizations proved the timelessness of human experience whether he conjured up a medieval miniature or Orpheus' lament for Eurydice. He did not intellectualize, he danced out of sheer inner compulsion. He was a Dionysian artist in the truest Nietzschean sense. Thus, the mask had to play a major part in his creations.

With the assistance of the mask-maker Peter Ludwig he proved the eternal power and demonic magic of the dancing mask in a great variety of masked images. As Emil Pirchan said: 'Now they are classic symbols, then again comic or ghostlike grinning visages, petrified human types behind which the dancer hides in order to reassert himself from behind the mask with a knowing, convincing smile on his face.'

Kreutzberg danced with the mask of Eurydice's face, with her classic beauty as a close relative to his own expression of dignified pain. With masks resembling Aristophanic comedies he created – in his legendary *Tanzspiel*, *Der Ewige Kreis* (*The Eternal Circle*) – such timeless types as The Criminal, behind a frightening mask with oversized, piercing eyes; The Vain One, with her overstressed beauty; The Invalid with his suffering expression; The Strumpet, with a devouring mouth capable of sucking several penises at once; or The Drunkard with the sad face of an almost clown-like mask. Kreutzberg was a product of the period following on the First World War; the spectre of death was always with him (as it was with Mary Wigman), and he often danced death behind the mask of a demon of destruction.

Death is the central figure of one of the greatest and most enduring ballets created in the early 1930s, Kurt Jooss' *The Green Table*. A savage anti-war satire, this *Lysistrata* of the ballet is a sequence of dramatic tableaux depicting the vanity and viciousness of the world's politicians and war profiteers, and the mass of men being slaughtered for no other reason than to satisfy the patriotic war cries of megalomaniac stupidity. For this allegory masks were needed in order to depersonalize the faces of evil and to create a dramatic impact of timeless validity. What enhances the power of the masks is the emphasis on a disarming simplicity in the dance's conception which makes this Dance of Death an inescapable experience.

Satire ridicules men to expose their weakness and wickedness, attacking in order to remedy evil conditions. We may see in satire a sophisticated dramatic extension of early man's attempts to exorcize evil and the demonic forces by which he felt beset in his body when sick and in his mind when troubled by visions of fear.

In the process of transferring evil from one person to another, masks were used. Among many primitive tribes it was customary to call on a devil-dancer to cure a sick person when the medicine man failed. The devil-dancer would conjure up the demons of disease by wearing their masks, would lure them out of the sick man's body and absorb them into his own.

Then, lying down on a bier and feigning death, he was carried outside the village; after being left to himself, he would soon come to and return to claim his reward. However primitive this procedure may seem to us today, it was man's first recognition that many of his maladies are purely or partly psychological and that the belief in the possibility of being cured through whatever play of masks may be applied was at least half the cure. Early man, of course, had no other medical recourse. Moreover, his notion of pain and sickness was one of evil demons taking possession of his being.

The expulsion of devils and demons with the help of dance and masks was nothing unusual. Primitive man felt troubled and tortured by all kinds of evil spirits which not only endangered the individual but often the entire tribe. James G. Frazer speaks of this in *The Golden Bough*, citing an example from Celebes of how the people reacted to a general disaster or an epidemic whose occurrence was blamed on sinister forces infesting the village. All the people, men, women, and children, would leave their homes early in the morning with all their belongings, to return only after a few days of offering sacrifices. The men would wear masks, or at least blacken their faces, and they would all enter the village as if on a war path and ready to kill the enemy. At a signal from the priest they then rushed through the village, howling and dancing and striking on walls, doors, and windows to drive the evil forces from their homes.

These people did not know of the institution of the confession, but they must have felt the need for it. Some Indian tribes, such as the Iroquois, celebrated the arrival of the new year with a 'festival of dreams', which, in essence, was another version of the Roman saturnalia. This was a time of general licence, when the Roman people were permitted to act without restraint, and they would not have been human had they not taken advantage of it. One day of this festival was set aside for the ceremony of driving out all evil spirits. Men hid in the skins of wild beasts and covered their faces with grotesque and hideous masks. They went from hut to hut and scattered embers and ashes about the floor with their tortoiseshell-covered hands. This act of expelling the evil was preceded by the general confession of sins. When the masked men took the fuel from the ceremonial fire this was seemingly a symbolic act of freeing the people from their inner burdens by collecting and casting them out. The masks were a device with which to recognize, face and overcome the demons' and devils' ruses.

These are only a few of the many times when the mask served a vital function in the life of those who accepted the fear and challenge of the un-known and counteracted it in the only way they knew.

Before the Dionysian festivals were channelled into theatrical productions they were loud, wanton, ecstatic revelries in which the mystery of disguise and the magic of the mask played a great role. The dithyramb which,

through the genius of the poet Arion, developed into a chorus of fifty had always been a communal, ritualistic celebration dominated by exciting words and movement. Masks were used in order to intensify the individual emotion into a collective feeling of ecstasy.

The Dionysian cult was characterized by the *oreibasia*, a frenzied dance of maenads and satyrs in a state known as *enthousiasmos* – 'the state of having the god within one'. As the stylized paintings of these scenes on Greek vases indicate, the men wore goat-skins and sometimes footgear resembling cloven hoofs. There was also some disguising of the women, who might wear fawn or panther skins. During the *oreibasia* the dancers would, in their frenzy, run over mountains and through woods. It stands to reason that masks were rarely used by the dancers on these occasions, since any kind of mask would have impeded rather than helped their frenetic pace and expressiveness.

The characteristic dance of the dithyramb was the *tyrbasia*, whose etymological origin points to tumult, disorder and revelry. This dance was, no doubt, improvised and, as most scholars assume, full of horseplay in which masking and disguising were of signal importance.

There were a great many orgiastic and mystery dances throughout Greece during the classical period. When we add to these the dancing at shrines, festivals, and symposia it becomes obvious that the ancient Greeks were a dance-conscious people. In most cases one can only speculate on the use of masks, particularly since the mysteries were kept secret. But it is more than likely that in orgiastic and initiation dances masks were employed – especially in the Eleusinian Mysteries, which reached back to Mycenaean times, and all those rituals connected with deities borrowed from the religious practices of earlier periods and far-off, mainly Eastern, peoples, such as the Syrians, Phrygians, Thracians, and the inhabitants of Asia Minor in general. They were mostly nocturnal, frenzied dances and, in their sensational character, it is unthinkable that masks, and above all animal masks, should not have played a part.

We know of several dances executed at festivals in which the dancers were disguised and masked. The Dance of the Maidens, or *partheneion*, was a spirited, graceful dance performed by beautiful girls in honour of a deity or a hero. They danced hand in hand. Either the dance was accompanied by music and words, or music and words were expressed through movement. Since one of these compositions is at least partially extant, a song written to accompany a chorus of Spartan girls at the festival of the *thosteria* which compares the girls to swans, doves and owls, it is safe to assume that certainly some of the girls must have been clad and masked accordingly. In contrast to this gentle dance we know of an obscene dance called *brydalicha*, which also took place in Sparta, and in which the men wore masks and were dressed as women.

Of the greatest importance were the animal dances of the Greeks and Romans. However much we may be impressed by the humanistic and cultural accomplishments of the Greeks, we must not overlook the fact that their Golden Age and the Hellenistic period lasted a relatively short span of time in comparison to the many centuries that had led up to this climactic moment in history. Among primitive and archaic peoples animal dances are an important part of ritualistic life. These dances were often connected with sacred rites, and since it was believed that animal masks or the skins of animals possessed strong magical properties, mask and disguise were essential for them.

Superstition never seems to die out. The Greeks of the Golden Age, who set themselves a still unmatched monument of greatness, remained superstitious and continued to cultivate rites as well as the dances indispensable for them, even though they reached back to the earliest days of civilization. The custom of using masks went with this. Probably because man felt closest to the animal world in his very beginning, animal dances are the most numerous among all ritual dances. Another reason why animal dances were kept alive is pointed out by Lillian B. Lawler in her study of *The Dance in Ancient Greece* when she refers to the mystic cults: 'if protected by the secrecy, mystic atmosphere, and rigorous prescription of detail to be found in a mystery ritual, the animal dance can survive unchanged for centuries.'

During the Middle Ages the Church tried to stamp out the dance, since everything bodily was decried as evil; but the clergy saw far greater danger in the pagan residue, particularly in the Nordic countries, of the people's belief in the magic power of the mask.

Fertility rites, always accompanied by vigorous, almost vehement, dancing, are unthinkable without some use of disguise. To become possessed, the dancer had to blot out the self, and the ancient Germans danced themselves into a state of ecstasy by putting on animal skins and masks. It was one way of admitting animal spirit and virility. On a higher plane, ecstatic dances in all forms of mummery conjured up the spirit of the gods, who were thought of as becoming flesh in the dancer. The importance of the mask rested in the fact that it was no rhythmic over-exertion that readied the dancing body for ecstasy, but that this was effected through the stimulation of the senses with the help of the mask.

Saint Augustine decried man's habit of disguising himself and of hiding behind animal masks, and more than two hundred years later, in 692, the Trullan Synod made it clear once more that any use of masks was anathema to the Church. This struggle, however, was in vain, for the Church never overcame the deep-rooted desire of the people for disguise and particularly for the mummeries of pagan origin with animal masks. The best proof of this is provided by the famous *Fêtes des Fous* which took place in Paris once a year.

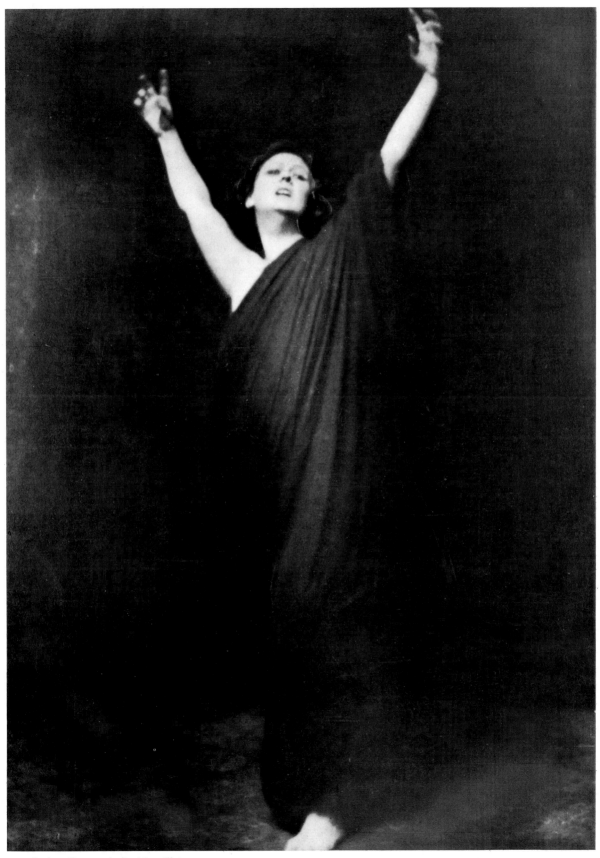

51 Isadora Duncan in *La Marseillaise*

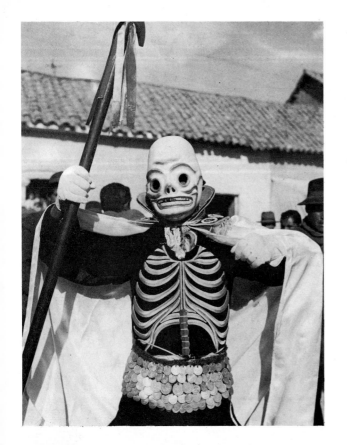

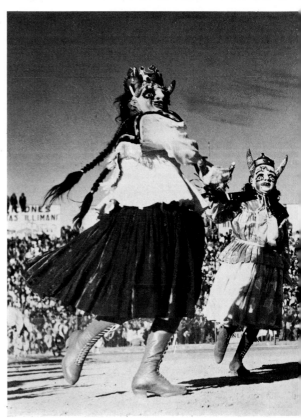

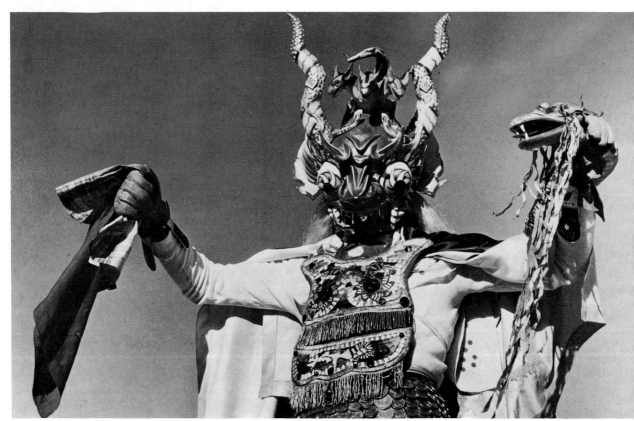

52–55 Masked dancers taking part in a carnival, Bolivia

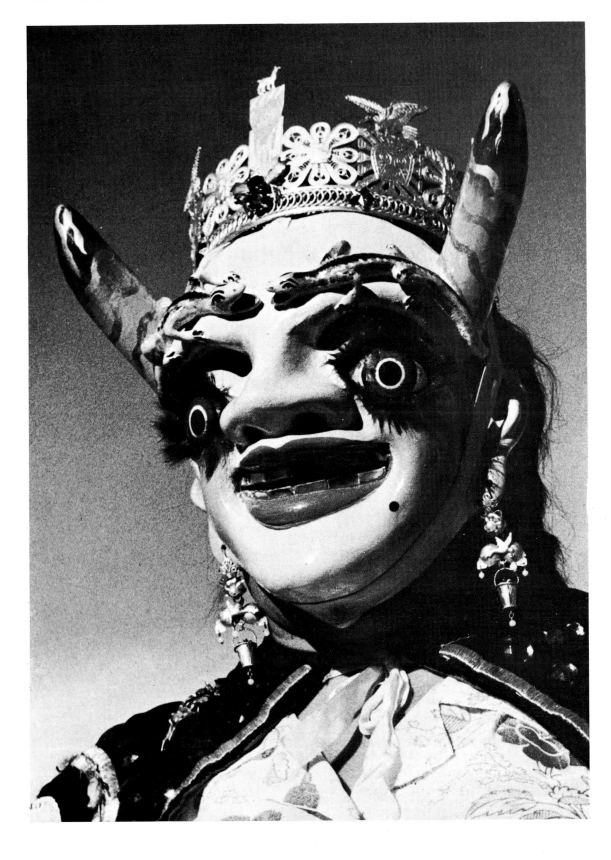

56, 57 Drawings by Inigo Jones: masks with head-dresses and a design for a masque, 'A Watery Spirit in the Temple of Love'

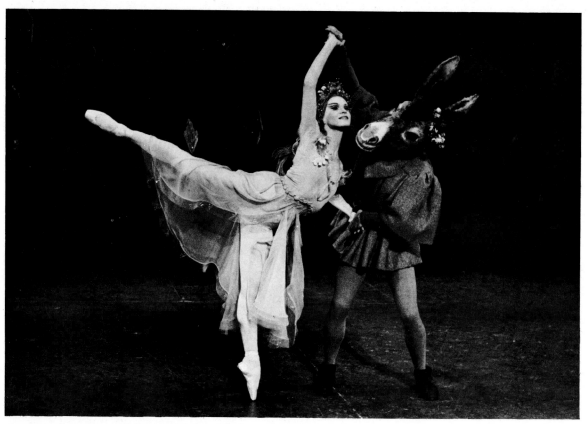

58 Scene from George Balanchine's ballet *A Midsummer Night's Dream*

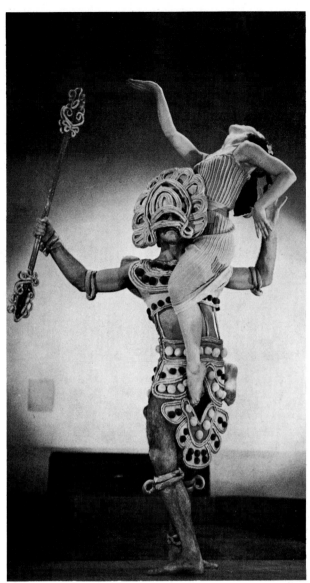

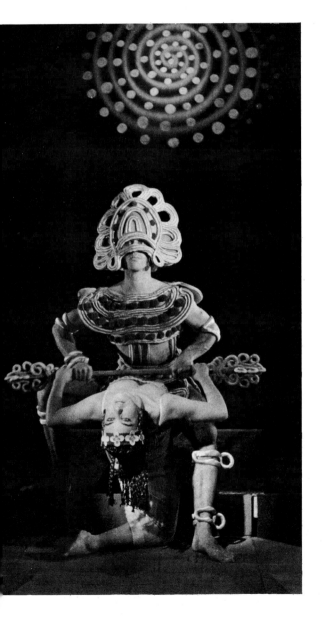

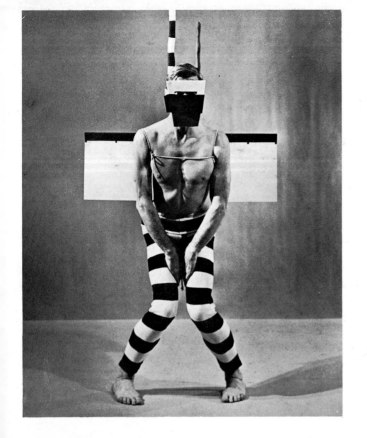

61–64 The art of Erick Hawkins: 'Inner Feet of the Summer Fly' and, below, 'Squash' from *8 Clear Places*; right, 'Cloud' (above) and 'Pine Tree' from *8 Clear Places*

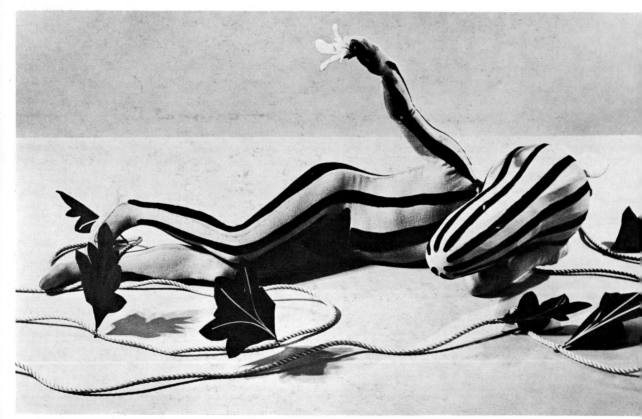

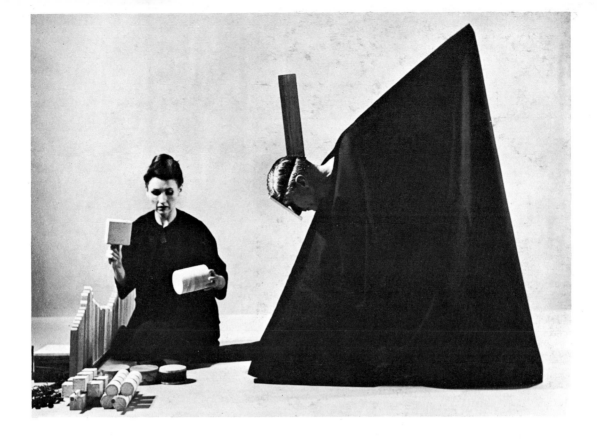

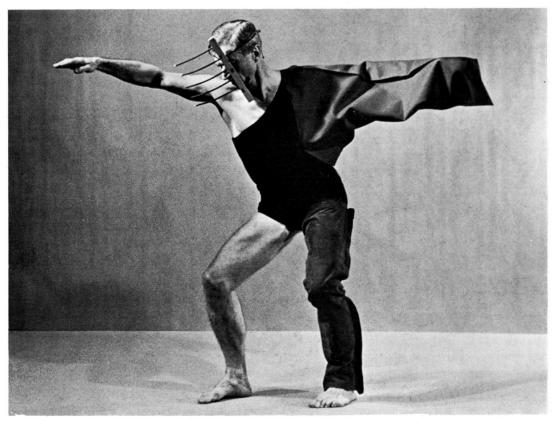

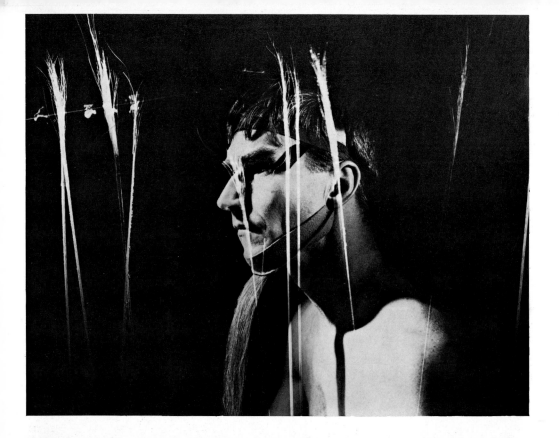

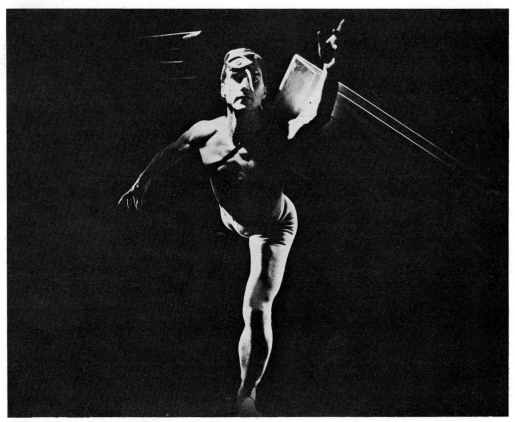

65–67 The art of Erick Hawkins: above, 'Goat of the God', below, 'Eros the First Born' and right
'Disconsolate Chimera', all from *Openings of the (eye)*

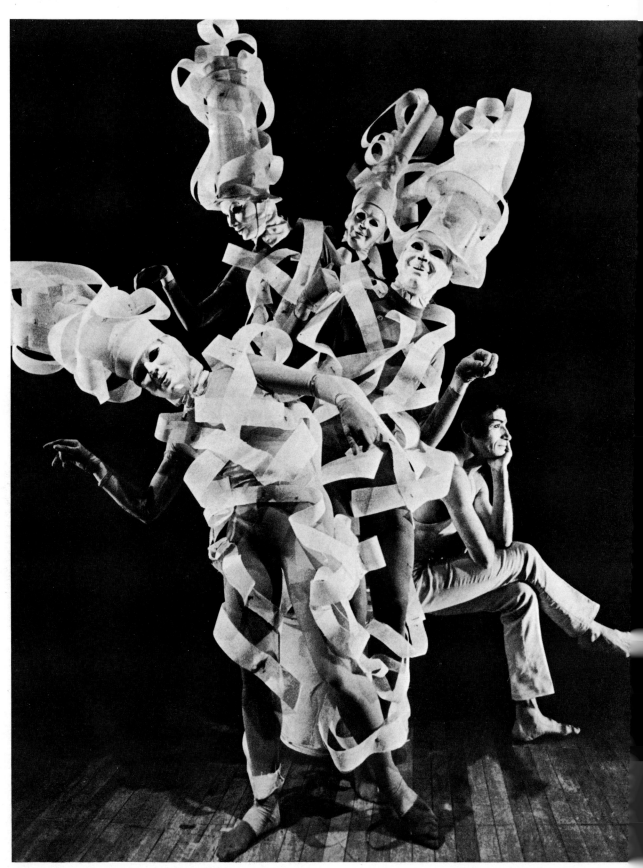

The Murray Louis Dance Company: *Intersection*

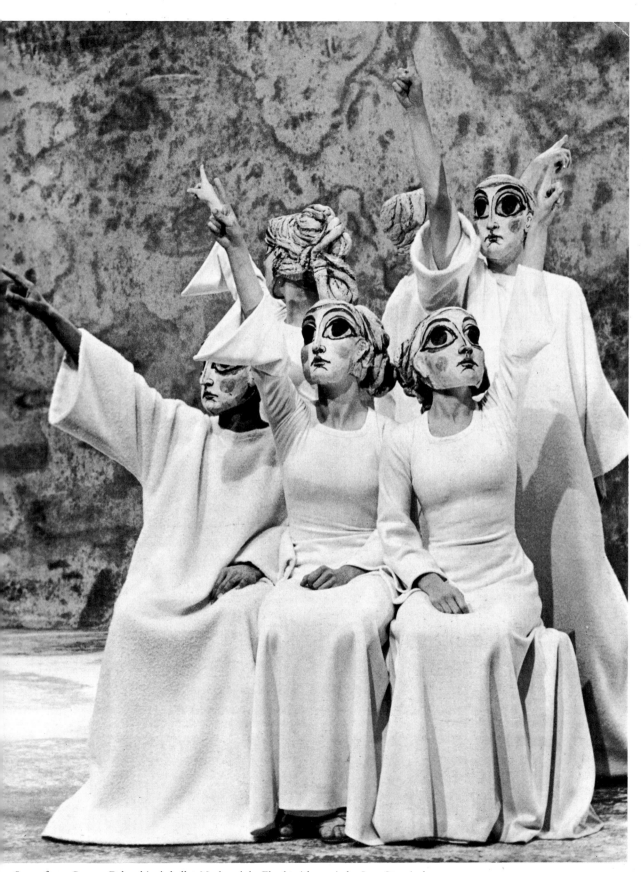

Scene from George Balanchine's ballet *Noah and the Flood*, with music by Igor Stravinsky

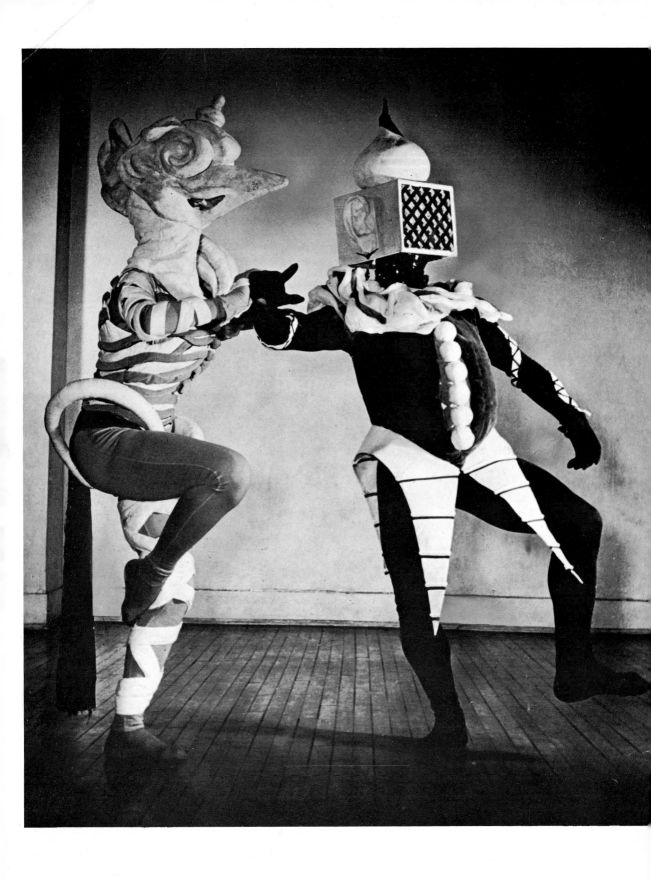

70 Scene from *The Golden Fleece*, designed by Kurt Seligmann and choreographed by Hanya Holm

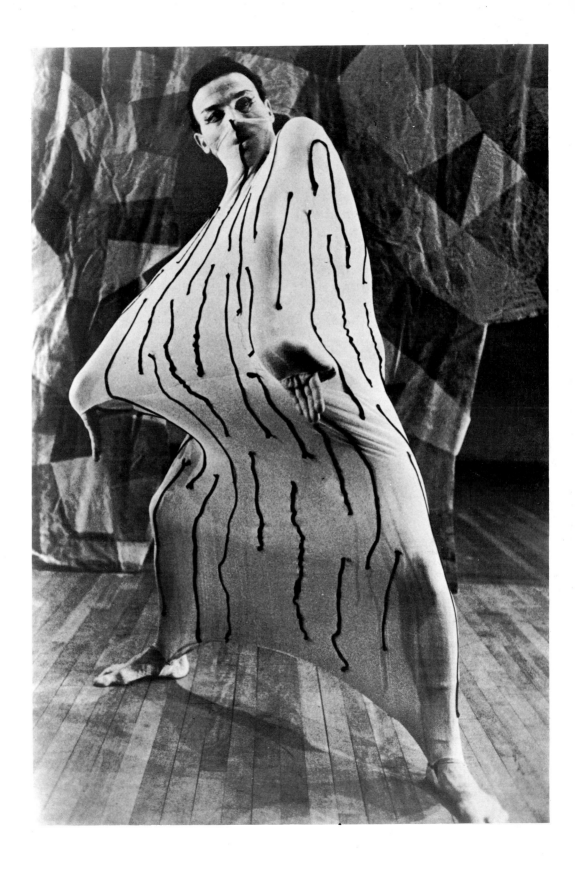

71 The Murray Louis Dance Company: *Chimera*

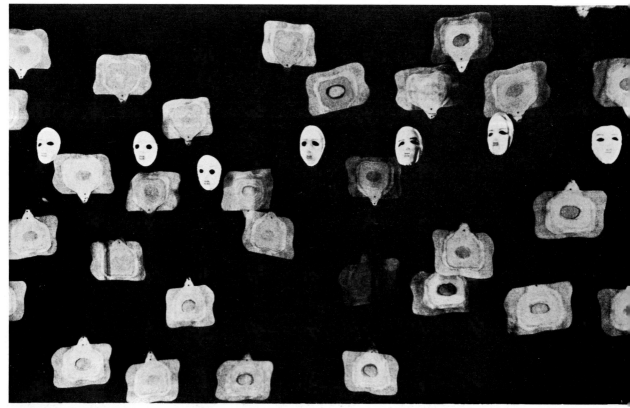

72, 73 The Nikolais Dance Theatre: scenes from *Galaxy* (above) and *Tent*

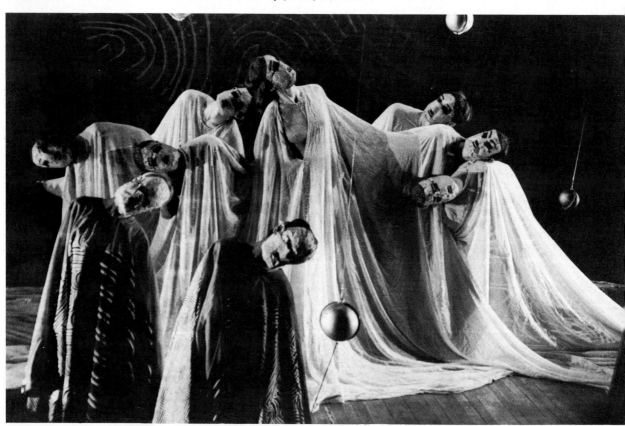

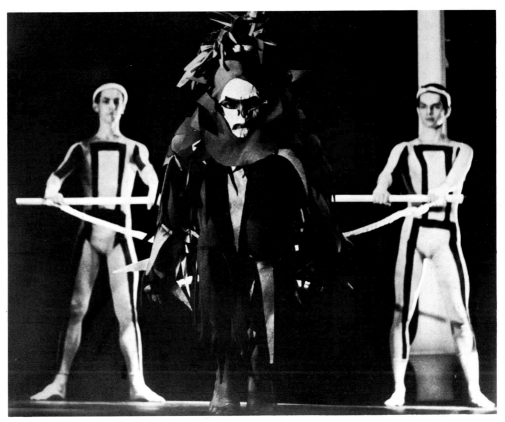

74 The Nikolais Dance Theatre: scene from *Totem*

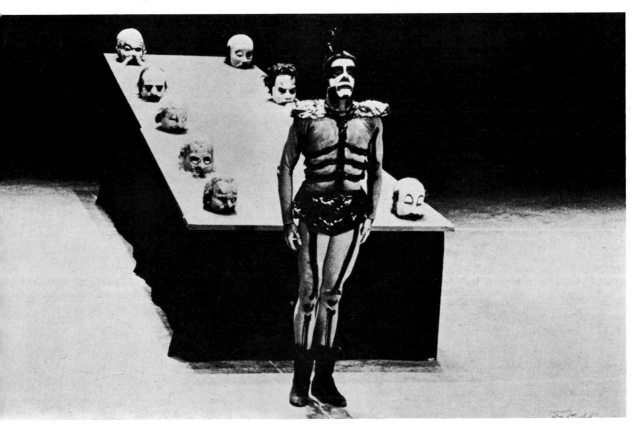

Scene from Kurt Jooss' ballet *The Green Table*

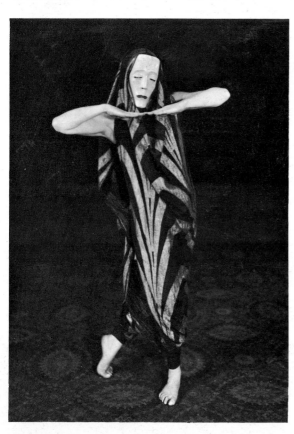

76, 77 Scenes from Mary Wigman's *Dance of Death*

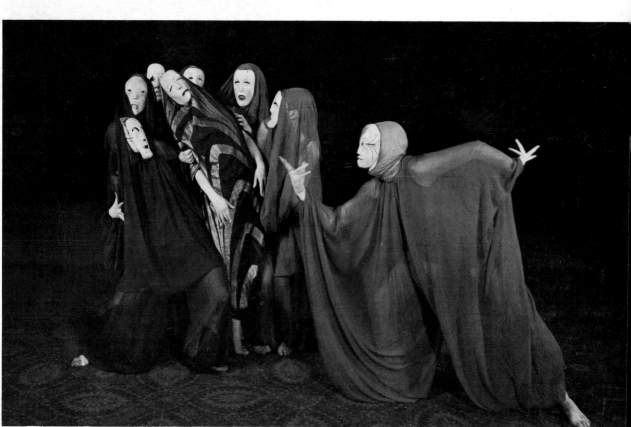

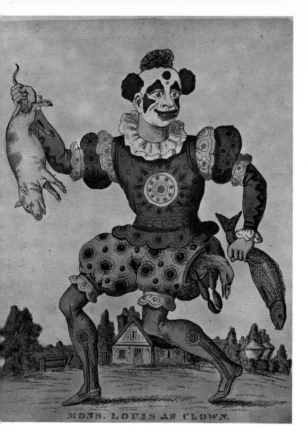

MONS. LOUIS AS CLOWN.

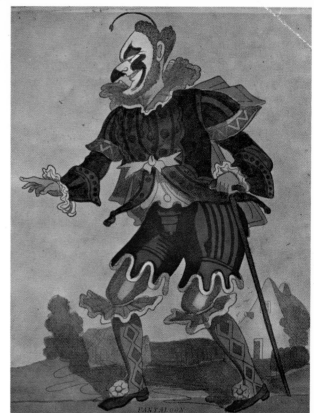

PANTALOON

VII

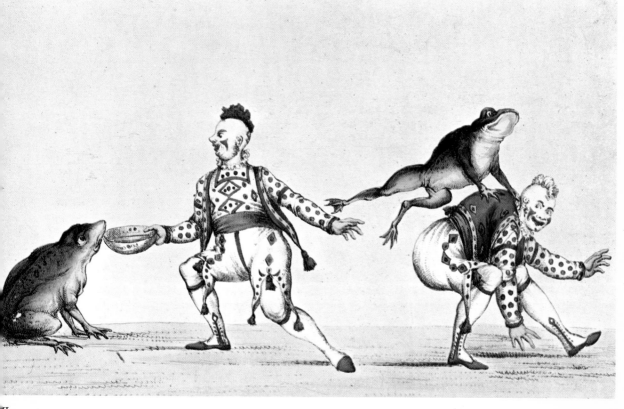

VIII

'Priests and clerks may be seen wearing masks and monstrous visages at the hours of office', complained Eustache de Menil, dean of the theological faculty at the University of Paris, when he spoke to the French bishops about the abuses of this festivity in 1445.

With the Christian way of life taking root on a socially accepted level, the Church and the people finally arrived at a compromise. The saints' days were superimposed upon the local gods and certain heathen qualities were lost, but among the vestiges of former days – the people retained what they liked from the old ways – were mask and disguise. Time has always changed some aspects of rudimentary customs. We only have to think of Hallowe'en, which reaches as far back as Celtic fire festivals and, in the course of centuries, has developed sinister significance as a late autumnal festival in which ghosts, witches, demons, and fairies are associated with the expiring year. The more popular customs of the eve of All Saints' Day have retained the mischief-making and the hollowed-out pumpkin with a lighted candle within and a demonic face carved on the outside. The children's 'trick or treat' game is accentuated by funny disguises and the sporting of grotesque masks.

The presence of Death as a daily guest, particularly while the bubonic plague raged in the late fourteenth century, left its imprint on the era in the concept of the Dance of Death. Its skeleton and skull-like mask was a time-honoured image. Reports speak of a figure of Death joining maskers who danced before the King and Queen of Scotland at a nuptial in 1285. The Scots poet, William Dunbar, wrote in 1507 a satirical description of the masked ball at the court in Edinburgh as a Dance of Death fused with a morality masque. Far more refined were the macabre masques in Italy, where a Dance of Death pageant was designed for the Duke of Florence by the painter Piero di Cosimo in that very same year of 1507. Giorgio Vasari said about it:

The triumphal car was covered with black cloth, and was of vast size; it had skeletons and white crosses painted upon its surface . . . within the car stood the colossal figure of Death . . . at a certain distance appeared figures bearing torches, and wearing masks presenting the face of a death's head both before and behind; these heads of death, as well as the skeleton necks beneath them, also exhibited to view, were not only painted with the utmost fidelity to nature, but had besides a frightful expression which was horrible to behold. . . .

Pageants, which were favourite events in the late Middle Ages and during the Renaissance, had seldom such a macabre touch. On the contrary, pageants at that time must be seen as providing one of the most important expressions of collective enjoyment in which the populace, however vicariously, could also participate. The most impressive pageants were those in Florence under Lorenzo de' Medici. The architectural brilliance of Filippo Brunelleschi contributed to the arrangement of their visual splendour. Since mythological scenes and allegorical figures were the main attraction on those beautifully

IX Mask of Penia (Poverty) used in a Swiss production of Aristophanes' *Ploutos*, 1965

decorated wagons, masks were obligatory, but many of the people following the vans in a carnival mood were also masked.

There have always been pageants of various kinds. The political parade started with the procession of naked youth in Athens which celebrated the victory at Salamis. Sophocles, blessed with genius as much as with beauty, led this parade in the nude (I am not quite sure whether nudity is not a mask in reverse, if the saying is true that *les extrêmes ses touchent*). There are ideological, but not basic, differences between the parades in the streets of Rome in honour of a Roman general's triumphant return, a New York ticker-tape parade for Charles Lindbergh, and even the goose-stepping demonstrations for a contemporary dictator.

Also, there is no difference in essence, despite the difference in visual splendour and intellectual depth, between a Renaissance pageant and the traditional Macy Parade on Thanksgiving Day in New York City – except that the Macy Parade is a commercial composite of the *trionfi* and *carri*, the former a triumphant display of the aristocratic élite, the latter a joyful and proud parade of the skilled tradesmen. I still remember a modern imitation of the original *carri* when, in the 1920s, Rudolf Laban staged a pageant of the guilds and artisans in Vienna and had them move on imaginatively decorated vans with live scenes along the Viennese Ringstrasse.

In spite of our technical know-how, nothing that may be done today can measure up to those Renaissance *trionfi*, the ideas and masques in which were staged and choreographed after classic models. The *carri*, symbols of crafts and trades, were not less impressive but, compared to the *trionfi*, an artistic expression of the leisure class, their visual splendour was toned down and given a touch of seriousness, as if to demonstrate a festive mood in working clothes.

It is an interesting phenomenon that, at a time when Renaissance existence was entirely keyed to individual accomplishment, disguise, mummery, and mask should have played such a major part in the people's social life. The mask was intricately tied to the dance which, in turn, was essential to all social gatherings. This was already noticeable during the Middle Ages, when tournaments and hunting parties customarily ended the day with a banquet whose finale was a dance, and most often a masked ball. There were many banquets and there were none that were not followed by dancing or entertainment between the courses in the form of the so-called *intermedii* (*entremets* or *intermezzi*, also known as interludes in theatrical performances), miniature spectacles consisting mainly of posing and dancing. These entertainments were reminiscent of the Greek symposia. With a great deal of poetic licence the *intermedii* borrowed from classical material, making mythological-allegorical notions easily digestible with the food. These scenes, short as they were, usually involved savages fighting for the possession of a beautiful woman when suddenly the goddess of Love would appear and set her free.

Or a girl riding in a chariot that was drawn by a unicorn would enter and unchain a few captives. The minimum of action was counteracted by a maximum of visual effects, costuming and, above all, masking, accompanied by a bit of dancing.

The favourite dance of these days was the *morisco*, or Morris Dance, which as a solo, but more so as a group dance, awoke romantic memories of the days when the Moors reigned in Spain. The dancers 'were very richly dressed as in the heathen or Turkish manner', as one contemporary description says, quoted by Curt Sachs. It was a lively, vigorous dance in which at least one dancer appeared with his face blackened to look like a Moor.

Most entertainments, as we can gather from Shakespearean and other plays, were of the order of masked balls or allegorical masques. After the most lavish production of the extravaganza *Ballet Comique de la Reine* in 1581 – a show that, for the first time, unified all the theatrical elements of the period, masquerade and pastoral, dancing and singing, music and the spoken word – an endless series of *ballet-mascerades* on a smaller scale followed. They mostly took place in the hall of a castle or in the house of a wealthy burgher with no stress on *décor* or action, but with all the participants masked. Pantomimes or acrobatic tricks were sometimes shown instead of dancing. These *ballet-mascerades*, or *ballet-comiques* as they were later called when they moved into theatre buildings, kept the basic idea of a lyric theatre alive, a blending of dance, music, and drama, with the performers mostly disguised and always masked. In the main, these performances were products of the original *ballet de cour*, consisting of numbers vaguely held together by a thin thread of plot.

For a short period, encompassing the first three decades of the seventeenth century, this development flowered in England, where it made history through the scenic mastery of Inigo Jones and the ingenuity of Ben Jonson. For some time the Tudors and Stuarts outdid all other European courts with their splendid productions of masques. Jones created scenic wonders of rare beauty and visual surprise. It must have been the dramatic genius of Ben Jonson which was responsible for the early realization that mere praise of beauty must finally lead to satiation and boredom. Thus the antimasque was added to the masque. What could more enhance beauty than the contrast of grotesqueness and ugliness presented in good humour?

These masques were performed by and for the aristocracy. Princesses and duchesses appeared as nymphs and goddesses, noblemen donned masks of Hercules, Mercury, Vulcan, and other mythological figures. There were professional actors in the theatre at that time, and they all had to be expert dancers. But the masque derived from the court ballet and, with the help of ballet-masters, the nobility performed its own dances. We know that Queen Elizabeth was fond of dancing (she did a few galliards as morning exercise). The French kings Louis XIII and XIV were passionate dancers and performers, and they could choose the nicest parts for themselves. The former

had a flair for dramatic, grotesque parts and liked to be seen in female roles; the latter derived his famous epithet of Sun King, *Le Roi Soleil*, from the *Ballet de la Nuit* in which he acted and danced the liberating sun. This illustrates the consuming interest of the nobility in dancing and performing. However, in the second half of the seventeenth century a marked shift took place in which the aristocratic performer turned into a patron of the arts.

The waning years of the Renaissance and the unfolding of the Baroque in the seventeenth century were characterized by many stage innovations, and as long as everything remained keyed to scenic splendour the amateur on stage was of little consequence. On the other hand, how much the unaccomplished performer created the need for the scene master and his dazzling feats must remain a matter of speculation. If the masques displayed both grandiosity and intimacy, the one was achieved by the masker, the other by the scenic designer. The aristocratic performers had rarely to speak or to sing. They were the beautifully and sometimes exotically costumed and masked dancers who had rehearsed their adagios and danced these stately measures in the Entry, the Main and the Going-Out. Only towards the end of the masque did the fast dances appear, the so-called Revels, in which the noble maskers chose partners from the audience for the ensuing galliards, courantos and lavoltas. The performers of the antimasque, the old hags, witches, beggars, and clowns, who had to be able actors, singers, and dancers, were most often professionals.

Inigo Jones had travelled and studied on the Continent; he had taken note of the technical marvels of the new theatres, was impressed by the engravings of Jacques Callot, and when he returned to London tried to translate the Italianate splendour and French *esprit* into the English idiom. He gave the proscenium stage its shape and designed a new frame of ornaments and symbolic figures for each masque. As a master of the stunning stage image and the magic of scenic changes, he took the spotlight away from Ben Jonson's efforts, which aimed at the creation of an integrated theatrical work of poetry, music, movement and colour. When, in anger, Ben Jonson ended his collaboration with Inigo Jones in 1631 he called him 'a maker of properties ... whirling his whimsies' and conceded that 'painting and carpentry are the soule of masque'. Johnson's words have a very familiar ring for us today when, bitter and frustrated, he complained that there was no hope for the pure and poetic in this 'money-got, mechanic age'.

In 1605, when their collaboration began with *The Twelfth Night Masque*, Jonson was not aware that a fantastic head-dress, make-up and masking could ever eclipse his words and ideas. But the masques with their visual surprises became the rage in England as much as on the Continent; dictionaries for masques were even issued, such as the famous *Iconologia* by Cesare Ripa. A wreath of flowers on the head was a common disguise to indicate sylvan

shapes; false hair and flowers often hung down to the character's neck, lending the entire head a rustic mood.

Head-dresses received great attention, for they caught the eye of the observer as the most immediate symbol of disguise. Animals were often indicated in the form of masks either covering the whole face (like the lion-faced man in Aurelian Townsend's *Temple Restored*, 1632), or enveloping the forehead alone. In the masque *Lords* by Thomas Campion (1613) the head-dresses were 'infinitely rich . . . on their heads they had Crownes, Flames made all of Gold-plate Enameled, and on the top a feather of Silke, representing a cloude of smoake'. One could often encounter types of 'wild men' in Italian masques, and these character masks were also found in England, as in Sir William d'Avenant's *The Triumph of the Prince d'Amour*, where they came on stage in 'Wastcoats of Flesh colour' which made them look naked, and with 'their heads cover'd with green leaves'.

In antimasques dancers appeared as Bottles, Tuns and Barrels in Ben Jonson's *Pleasure Reconciled to Virtue* (1618), and in one of his first masques he had such a sophisticated idea as to introduce a character called Nobody, 'attyred in a paire of breeches which were made to come up to his neck, with his armes out at his pockets and a cap drowning his face'. When the great pleasure derived from the grotesqueries of the antimasque characters demanded more and more fun, the familiar figures of the *commedia dell'arte* were introduced under different names. Ben Jonson used such figures in *The Vision of Delight* (1617) and in *Love's Triumph* (1631), and stock characters of the *commedia*, very similar in appearance to their Italian originals, play their comic parts in some masques by Sir William d'Avenant, such as *Britannia Triumphans* which was first performed in 1638.

In 1608 Jones and Jonson created *The Hue and Cry After Cupid*. A description of an antimasque scene in it reveals that the grotesque and fun-making shapes, in this case twelve boys 'most antickly attired' and representing 'the Sports, and pretty Lightness that accompany Love . . . fell into a subtle capricious dance, to as odd a music, each of them bearing two torches, and nodding with their antick faces, with other variety of ridiculous gesture, which gave much occasion of mirth and delight to the spectators'.

As long as they inspired one another, both Inigo Jones and Ben Jonson paraded their ideas with poetic wit and visual eloquence. The interest in the masque continued in England even during the Puritan reign of Oliver Cromwell, but France maintained her cultural dictatorship in the seventeenth and eighteenth centuries. Ideas and customs became codified while the French Academy, headed by Jean-Baptiste Lully, brought forth more and better-trained performers with each year. In spite of the fact that Lully aimed at coherent stage presentations and, toning down the dazzling effects of the Italian school, at a poetic stage atmosphere, he did not realize that the technical innovations in the ballet worked against the fulfilment of his dreams.

Nothing was done to liberate the dance from its artificialities – after all, this was the age of extravagance and artificialities in France – to achieve clarity or to express sentiments in a natural or naturalistic manner. The growing trend towards rigidity and virtuosity in the Academy and the outside pressures of affection combined to maintain a strongly developing tradition.

The mask was an integral part of this tradition. The first ballerina who dared to break with the past was Marie Sallé. As early as 1734 she threw off all the paraphernalia of the ballerina – as did Isadora Duncan at the turn of this century. Gone were the skirt, bodice and pannier. Sallé's hair fell loosely upon her shoulders, there was not a single ornament on her head. She wore a dress of muslin in the manner of a Greek statue. (This is how she was described when she appeared in her ballet-pantomime *Pygmalion*.) She presented herself in her natural grace at a time when wild, indiscriminate exoticism was juxtaposed to the artificial steps and bows of the minuet.

Sallé tried to articulate her emotions and give every feeling its expression. Jean-Georges Noverre, who danced in her company when a young man, wrote in 1756 after her death: 'Mademoiselle Sallé replaced tinsel glitter by simple and touching graces. Her physiognomy was noble, sensitive, and expressive. Her voluptuous dancing was written with as much finesse as lightness; it was not by leaps and frolics that she went to your heart.' Three years later Noverre's epoch-making book, *Lettres sur la Danse et sur les Ballets*, was published. In these fifteen letters he touched upon every aspect of his art. His penetrating analyses, enlightened criticisms and protests laid down guiding principles for his time which became the guiding principles for the ballet of all times.

Noverre was not alone in his fight for artistic freedom, purity, and integrity for the ballet as an independent art form, as I indicated in a previous chapter. About the same time Goldoni was attacking the *commedia dell'arte*, Gluck was striving for grand simplicity in opera and Gotthold Ephraim Lessing was deriding the French pseudo-classic school of writers and preparing the way for the romantic revolt. Noverre gave the ballet a new direction by setting down his fundamental beliefs:

Children of Terpsichore, renounce cabrioles, *entrechats*, and over-complicated steps; abandon grimaces to study sentiments, artless graces and expression; study how to make your gestures noble, never forget that is the lifeblood of dancing ... away with your lifeless masks; they hide your features, they stifle your emotions. ...

The mask had become as lifeless as the stereotyped virtuoso manner in dancing. Noverre made the self-indulgence of contemporary dancers clear when he remarked that one of the most brilliant of them, Maximilien Gardel, 'would rather have renounced kingdoms of the world than his *entrechats*'. Ballet history records that Noverre's thunderous *Letters* of 1760 were not immediately heeded. It was not to be expected that dancers would simply throw away

their masks after reading the book. It may be legend only, but it is said that it was in fact Gardel's vanity that brought the revolution about. One day in 1772, when his great competitor, Auguste Vestris, was indisposed and Gardel had to appear in Vestris' role, Gardel removed his heavy mask to let the audience see that the wonderful dancer on stage was not Vestris, as announced, but the great Maximilian Gardel. It is one of the many ironies of history – and also of Noverre's life – that from then on no dancer appeared in a mask any more.

A single consistent line of sentiment towards the principal ideas of what dance should be and how it be presented can be traced from Marie Sallé to Noverre and from him to Salvatore Viganó. That the same concepts had to be taken up again in defiance of established routine at the beginning of this century by Isadora Duncan and, to some extent, by Michel Fokine only proves that ideas in the history of art are born, grow and die in their natural process of being. It is wrong to blame man for not learning from history, or history for not being willing to profit from past mistakes. It seems that everything that is given life has to go through its three destined phases, its beginning, middle and end.

The fruit of Noverre's revolution passed him by. When he was finally offered the coveted position of a ballet-master of the Paris Opéra, his revolutionary concepts had been popularized by others, modified and thinned out. Perhaps Salvatore Viganó's work can be seen as the climax of Noverre's dream and, at the same time, its finale. Viganó's *choréodrame* stressed the very thing in which Sallé strongly believed. He erased the uniformity of facial and bodily expression, he gave each emotion a natural and individual feeling. Pantomine was for him 'the movement of the soul', and it was not enough for him 'to please the eye; I wish to engage the heart.' His method led to a silent declamation of the dancer's feelings, with dramatic statements written all over the face and pictorialized by the pantomimic gesture. Today we would certainly be perplexed by his pathos, but, having removed the mask, Viganó went to extremes to make the face reflect a character's emotional state. In its exaggeration his work resulted in another pose, another mask. It was, no doubt, romantic miming at its best.

Carlo Blasis, the great teacher and theoretician of the Romantic era, feared any expressional excess, and in his striving for purity in style he created a measured method, underlining the highly stylized and artificial gesture. Virtuoso technique took the place of self-expression and led to bravura dancing without a 'soul'. Artificiality was not only to be seen in the stylized gesture, it was everywhere, especially in the face of the dancer whose studied, stereotyped expression created the impression of a depersonalized *persona*. A reaction against it was unavoidable. It came with the many changes in the world and the world of the arts brought in by the dawn of the twentieth century.

Before discussing the contemporary dance scene, we may briefly turn to another art form, as stylized as the ballet and born about the same time, during the second half of the sixteenth century: the opera. By its very artistic nature, namely to serve music and, in particular, the vocal abilities of the acting characters, opera is basically inimical to the use of masks. Furthermore, singers have always objected in principle to wearing masks and tolerated half-masks only.

Opera came into its own at a time when dancers were still in the habit of wearing masks on stage. The predilection for disguise in the seventeenth and eighteenth centuries found in opera other means of self-gratification than the mask. For quite some time, when female actors, dancers, and singers were not yet granted the privilege of public appearance, young squeaking boys had to play the roles of women. Disguise became perverted in these centuries, when one could speak of a 'transvestitis'. The employment of pages, who were lovely females but had to pretend to be boys to facilitate the play's happy ending, had been a favourite baroque stage idea. (The feasibility of a successful seduction in disguise, however dark the woods or chamber may be, has always eluded me, but for titillation's sake audiences everywhere and at any time have accepted this implausibility.) The naïve theatrical trick of feigned transformation between the sexes was common currency in opera. As late as 1911, when Richard Strauss' *Rosenkavalier*, with Hugo von Hofmannsthal's libretto, was first performed, Octavian, a young nobleman, appeared disguised as a maid.

In a broader sense these disguises are masks. But there have been only a few operas in which the mask as such has played a part, mostly as an accoutrement for a specific occasion. Most suitable opportunities for the use of masks are the feast in Mozart's *Don Giovanni*, the masked ball in Tchaikovsky's *Pique Dame*, or the masked Rosalinde in Johann Strauss' *Die Fledermaus*. Of greater significance is the use of the mask in Verdi's *Un Ballo in Maschera*, the libretto of which deals with the assassination of King Gustavus III at a court ball in Sweden in 1792. The same subject under the title of *Gustave III* had been set to music some years before Verdi's version by Daniel François Auber. No one can stage *Romeo and Juliet*, in whatever form, without a first-act ballroom scene in Capulet's house. Nor did Gounod miss this opportunity when he wrote his opera about the star-cross'd lovers.

Music can easily evoke images that can be associated with masks and masked faces if we see them on stage. It is more difficult to create sound-colours which our senses can quickly translate into visual idioms representing *commedia dell'arte* characters, for instance, a Harlequin, Pantalone, or Colombine. Robert Schumann – who knew how to wear masks, hiding, as he did, behind the imaginary pen names of 'Florestan' and 'Eusebius' – gave us with his *Carnival* piano pieces (Op. 9) a most perfect example of how music can paint pictures which convey the romantic joy of masking. Hector Berlioz

based his famous *Roman Carnival* overture – vibrant with the melodic mood of Carnival – on material from his neglected opera *Benvenuto Cellini*.

In the early years of the minuet François Couperin composed a variation of twelve couplets under the title of *Les Folies françoises ou les Dominos* in which human characteristics are explored and created through tone colours as if those human qualities were hiding behind a masquerade costume and a half-mask. There is virginity depicted as invisible, modesty as pink, hope green, ambition dark red, and finally frenetic despair with the colour black. Couperin, foreshadowing the age of Watteau and Boucher, used the mask as a means to symbolize man, his follies and foibles, his dreams and daring, with frolicking wantonness and fine musical wit. Almost two hundred years later – after the *fin de siècle* mood had passed and man stood on the threshold of a new age – Claude Debussy gave masterly expression to the sensibilities of man between two ages. His music can evoke symbolic images of dream-like sensations and hidden memories, and his *Masques*, which he wrote in 1904, sound like a sophisticated improvisation of a remembered *commedia dell'arte* performance with its stock characters hiding behind the mock melody of tarantella rhythms and their masks.

If I desire to touch upon one or another ballet which we may see on stage nowadays with dancers in masked disguise, I do not think of the obvious, the many carnival, clown, and harlequin scenes with which the ballet world is richly blessed. We could cite the ballets concerned with inanimate objects like *Coppélia*, *Petrouchka*, *La Boutique Fantasque*, and certainly *The Nutcracker*, in which there are so many disguises and changes of masks that all that looks like child's play hides behind deadly serious images of the Freudian netherworld. Also, the psychologically fascinating change from white into black swan in *Swan Lake* is one of the many metamorphoses that bear a deeper truth than meets the eye: the split personality, the eternal betrayal of ourselves, not knowing what we want and so often not knowing who we are. Is not this story of the two swans a telling tale of a pirouetting *persona*?

Very few lovers of the dance are likely still to remember Charles Weidman miming Max Beerbohm's *The Happy Hypocrite*, which was turned into an inspiring dance work. Many more will recall various animal masks that have made their appearance in ballets, such as the ass's head in George Balanchine's *A Midsummer Night's Dream*. But of greater interest in this context seems to me Roland Petit's *Le Loup*, based on an idea provided by Jean Anouilh and Georges Neveux. This cruel fairy-tale tells of a young man who elopes with a gypsy girl. With the help of an animal tamer he pretends to have been transformed into a wolf. Gradually the girl becomes aware that her husband *is* a wolf. Instead of being horrified, she feels herself drawn towards this creature, for it turns out to be much kinder and braver than all the men she has known. However, when the villagers discover that a wolf lives

among them, they set out to kill the animal. Perhaps it is little more than the sad story of the animal in man and the human in the animal.

Orpheus is one of the many masterpieces George Balanchine created, and he found in Isamu Noguchi a designer of rare gifts who was able to visualize a mask for Orpheus reduced to a poetic abstraction, as if being of one piece with his lyre. Noguchi is a remarkable sculptor, and his stage designs and costumes have a sculptural, but very dramatic flavour.

To be a great sculptor or painter does not necessarily mean that genius can be easily and successfully transplanted from one medium to another. On the contrary, great painters are not always the happiest stage designers, and the mask can become a trap for the dancer as an overpowering and unwieldy accoutrement. The best example may be the Surrealist painter Kurt Seligmann and his design for Hanya Holm's choreography of *The Golden Fleece*. It was Seligmann's idea to create a ballet about 'An Alchemistic Fantasy' with strong surrealistic overtones. The dancers represented allegorical figures and appeared masked in the most fantastic and elaborate way. The masks and costumes were stunning at first sight and never tired the eye. But the masks were so overpowering – not only visually but also in their sheer weight – that they inhibited the dancer and kept the form and flow of the choreography from unfolding. Hanya Holm said:

If we had had the costumes and masks from the very beginning, it would have been a different matter. But the costumes were the last thing to be ready. We rehearsed to the very end without them. Much of the movement was born out of the spirit of alchemy and of the various elements we dealt with. Dynamically, it came close to what we had visualized. For instance, Louise Kloepper, who danced the bird Phoenix, had those characteristic pecking movements, but the moment she put on her mask she fell flat on her nose. The big hat had too much weight. The mask also limited the dancer's vision. These things had to be taken into account at the last minute with the result that only half the choreography got on stage.

Another magnificent failure was the television spectacular done in 1962 by George Balanchine and Igor Stravinsky, who had been working successfully together since 1928. Their *Noah and the Flood* was planned as a scenic oratorio. Stravinsky's score was a brilliant musical montage, reaching from the creation of the world through the exodus from Paradise to the Ark with a final *Sanctus*. Balanchine's choreography was as compressed as the music which it punctuated. He saw in this ballet 'a miracle play more than a masque' and tried to underline the theme of Stravinsky, who felt that the threat of the flood paralleled that of atomic annihilation oday.

The costumes and the slightly Byzantine masks, designed by Reuben Ter-Arutunian, were the most fascinating contribution to this musical composite. The designer explained: 'This work is a positive statement of spirituality. Stylistically the only period that comes to my mind is one that expressed devotion, dignity, humanity and emotion.' Masks that overpower the dancing can be disastrous for the ballet, as the example of *The Golden*

Fleece proves. On the other hand, the most impressive masks may be lost when the work as a whole does not match up to the masks' impact and misses the mystery of theatrical excitement. As a work of art the masks triumphed in both cases. Their super-reality has the power to reveal the secret without showing it.

It is odd that Bertolt Brecht should ever have wanted to write a scenario for a ballet. But this was what he did after he had fled from Nazi Germany. During his first stop in Denmark he wrote *The Seven Deadly Sins*, for which Kurt Weill composed the music and Caspar Neher, Brecht's best friend and great inspiration, designed the sets and masks; Lotte Lenya was to star. George Balanchine, then a quasi-refugee from the defunct Ballets Russes, started his experimental company Les Ballets 1933 and produced *Anna Anna*, as the ballet was also called. Its original title was *Die Sieben Todsünden der Kleinbürger*, but the reference to the Kleinbürger, the Petty Bourgeois, was dropped – probably out of convenience – even though it was Brecht's only justification for writing this light ballet cantata.

Brecht was concerned to reveal the irony and hypocrisy of a little bourgeois family that built a house – symbolic of fortune – with the money Anna had to make. We see and hear the family admonishing Anna to work harder and harder so that the house may rise. Anna, a dancer, is represented as two Annas, the rational and emotional self in her. In order to make the money for her family, her rational self prevents her from committing the seven deadly sins for which her instincts crave: she is not allowed to eat too much (greed) in order not to gain weight; she cannot afford to sleep with the man she loves (lust), since she has to do that with someone who will pay; she has to overcome pride and exhibit herself in strip-tease shows. Briefly, Brecht seems to say that what is normal and instinctively correct becomes perverted in the life of the petty bourgeois who is blind to the circumstances by which his money is accumulated.

It is a daring and fascinating idea to have a dual projection of a single figure onstage. Anna I is the personified mask of Anna II, the dreamer remaining challenged and driven by the realist in Anna throughout the ballet. George Balanchine's concept was to generalize and depersonalize in order to widen the scope of the Brechtian story. To bring this notion to a climax he had asked his designer, Reuben Ter-Arutunian, to have the *corps de ballet* appear in the scene from 'San Francisco' in high black boots, black belts and masks. The masked faces had the impersonal gigolo grin of a world in decay. Balanchine must have thought in terms of 'a face is a mask is a face', a notion that found its heartbreaking fulfilment in the final walk of Anna I and Anna II across the stage, both wrapped in a black cape with only their two mask-like faces showing.

When Jean Cocteau described to Roland Petit the scenario, dances, sets, and costumes for the ballet *Le Jeune Homme et la Mort* in 1946, it was no longer

the revolutionary Cocteau who surprised Diaghilev and the world of the arts with his *Parade* in 1917. *Parade* ushered in the new, the modern ballet. Its subject was as simple as one of the street parades in which performers of a travelling circus do one of their numbers to attract an audience. But far more unnerving than the *non sequitur* production numbers were the two rival managers in their cubistic disguise, two live masks about nine feet tall, virtually mobile props.

In comparison to this ballet, a turning point in balletic history, *Le Jeune Homme et la Mort* has a very common theme which, owing to its fantastic blend of the frighteningly realistic and the profoundly poetic, achieves a striking image in its resolution. A young artist, seemingly as neurotic as he is gifted, shows signs of great anxiety while waiting. Is he waiting for *her*, who-ever she may be, a doll, a female chimera? She enters and an exciting drama of pursuit ensues. He adores and desires her. She makes fun of him. Finally she leaves, and the young man hangs himself. The attic walls disappear, the roofs of Paris under a night sky are revealed. Death enters and, putting her mask over the young man's face, is revealed as the girl who has just left him. He escapes with her across the rooftops of Paris. So she was Death to begin with. So our passion or love is death. So, it is death we are waiting for with great anxiety.

Jean Cocteau expressed something that Lester Horton, the Californian choreographer, also felt when he used masks for some of his ballets: the mask, or the masklike use of a face, should convey the presence rather than the per-sonality of an emotion. If we extend the thought of removing the personality as an emotional experience we come close to the concept of a dancing figure as a total mask – which is, of course, the marionette or marionette-like dancer.

Only a mind fully immersed in the problems of man in space and in the beauty of form *per se*, a mind that believed in the anonymous passion for colour, could have thought of trying to build a spiritual and factual bridge from the naked man to the abstract figure. Oskar Schlemmer, painter and sculptor, stage designer, dancer and choreographer, possessed such a mind, or rather was possessed by it. Schlemmer intended to oppose this materialistic and practical age of ours with a genuine feeling for play and the miraculous, as he said (and that is exactly what Alwin Nikolais had in mind three decades later).

Schlemmer was an ideal representative of the Bauhaus in Dessau, which in the mid-1920s – to use Walter Gropius' words – 'sought a new synthesis of art and modern technology'. Schlemmer was convinced that the new poten-tial of technology would permit and serve the 'boldest fantasies' of the artist. If the process of mechanization cannot be stopped, man can escape its con-sequences by using the advantages of the machine for his own flight of fantasy. In Gropius' preface to *The Theatre of the Bauhaus* we find a perfect definition of Schlemmer's concept:

He transformed into abstract terms of geometry or mechanics his observation of the human figure moving in space. His figures and forms are pure creations of imagination, symbolizing eternal types of human character and their different moods, serene or tragic, funny or serious.

Most of Schlemmer's *Dances for the Experimental Stage* were executed by dancers wearing metallic masks and costumed in padded sculptural suits. Movement in space was for him as crucial as it was for Rudolf Laban and Mary Wigman. There are as many similarities as there are differences between Mary Wigman's and Oskar Schlemmer's approach to space, movement and mask. Ernst Scheyer's summation makes them clear:

Schlemmer was concerned with eternal types; man of the past, present and future, combined in one image. Because of this, he used masks for some of the dancers in the *Triadic Ballet*. The merely individual and temporary is transformed through the mask into the universal and timeless. Here the art of Schlemmer and the art of Mary Wigman meet. Both used the mask for purposes of transformation, which dehumanizes the dancer by wiping out the radiation of the 'soul' through the 'windows of the eyes', yet at the same time elevates him to the realm of the superhuman and demonic. While Wigman stressed the primitive, Oriental and tragic side of the mask, Schlemmer revealed the character of its grotesque side, that or the Greek comedy of Aristophanes, of circus clowns, of the technological age of space.

Alwin Nikolais has been concerned with the same problems: with man in space and the heightened meaning of the mask which, at times, he has extended to the entire body as a human prop. Like Schlemmer, Nikolais is basically a painter, but he is also a frustrated composer. His mind dances and choreographs. 'I am a compulsive creator', he said, seeking 'to explore motion in different aspects of light and sound. So actually the examples of "pure dance" in my chronology of creations are rare.'

He has fulfilled artistically what Schlemmer dreamt about. Schlemmer was fascinated by the architectural possibilities in moving apparently living shapes in space; he was prompted by the geometric logic of Cubism and the Dadaists' denial of all traditional aesthetic laws; he was caught up in the artist's enthusiasm for functionalism in the mid-1920s. His dance theatre was the result of a non-dancer's fantastic dreams.

The environment and past to which Nikolais reacted were different. His inspiration in the dance came from Mary Wigman, his dance training mainly from Hanya Holm, Wigman's right arm and leg in the New World. But when he became aware of the psycho-traumatic and super-narcissistic trend which modern dance was taking in America he parted company with it and went his own ways which, at first, led him back to naked simplicity of movement, to improvisation, to mere exploration of space. Simultaneously, he liberated the dancer from his personal idiosyncrasies, denuded him of his libidinal dictates, but sensitized him kinesthetically to function as a body, as a live instrument in harmony with colour and sound. After having denuded him, he clothed the dancer in prop-like fashion in order 'to extend his physical size in space'.

In this sense Nikolais has also used masks and often body masks. Pursuing intentions similar to Schlemmer's but translated into the most perfect artistic transformation, he has made the mask function as body, prop, light, and sound. The mask is used 'to have the dancer become something else'. Seemingly technical tricks gain visual power of exalting beauty in his hands and their surprises create evocative feelings, are compelling as much as they are illuminating.

Of all the modern dancers who have been influenced by Eastern philosophy, Erick Hawkins has most fully embraced it. This is why his use of the mask closes most sensitively the circle from East to West which, in many ways, are made to meet in his work.

Hawkins' work lies outside all confines of theatricality and beyond all traditional concepts of pacing and phrasing. Based on the philosophy of the *Tao-Te-Ching* which says 'by non-action everything can be done', Hawkins and his company move with utter tranquillity, seeking an expression of purity, the feeling of movement rather than the movement itself.

For many seasons, the sculptor Ralph Dorazio has designed the masks for the Erick Hawkins company. 'In working with Erick Hawkins', he told me,

> I encountered the possibility of sculpture invoking theatrical space, and of sculpture moving, not mechanically, not electronically, but with all the grace and fallibility of animal and human movement.
>
> Designing and making the face and body masks for Erick Hawkins presented a challenge. The materials to be used had to be light so that the dancers would neither be impeded nor weighted down. I discovered that although there are physical limitations as to what one can do with a piece of balsa wood, there are no limitations as to what one can do aesthetically if one enters into the true spirit of such a theatre of music-dance-sculpture.
>
> In doing the masks and then experiencing them from the audience, I think of them as sculpture ceremonies – epiphanies of rain, epiphanies of clouds, suspending all memories of unfelt rain, unseen clouds, so that the dance may take place.

Hawkins thinks that the dance and theatre tradition of Western man, particularly since the Renaissance, has preferred a mistaken notion of the mask which has deteriorated to become merely the actor-dancer's stage presence. 'This Western tradition in art has chosen to use a "false" mask, human "personality", instead of the true "*persona*", the mask of art.' The mask of a mere pleasure-giving and pleasure-seeking ambiance in the theatre without transcending humanistic consequences, and without expressing a sacred feeling, is the 'false' mask. 'Through using masks on the dancers, I have wished to reveal to the audience the deepest essence of the theatrical art, which is to highlight, in sensuous form, metaphysical notions which alone determine how the human being lives his life and how a society lives its collective life.'

Erick Hawkins claims that much 'dullness, vulgarity, sensationalism and negativity' exist in our Western theatre and that it may be traced back to our

'naïve realism' which has eschewed the use of masks. 'The mask more nearly makes every dance "sacred", that is, revealing essences, that is, revealing the big Self instead of the little self, that is, the nature of human existence.' The mask has helped him to avoid 'the paltriness of journalism', as he expresses it, 'the reporting of external life as it is lived in the seesaws of hopes and fears'.

The mask has the inherent quality of a ritual, the constant restatement and re-enactment of man's highest wisdom. 'Quite apart from the spiritual use of masks', Hawkins contends, 'I have always loved the possibility of a further addition to the aesthetic dimension, the aesthetic delight, of the dance art through the use of masks and the marvellous design they can achieve.'

How very different are the approach and the artistic results of Alwin Nikolais' and Erick Hawkins' works! And yet they would both subscribe to Hawkins' final statement to me: 'The mask permits the performer to transcend his own narcissism and exhibitionism and become an artist.'

CHAPTER V

Painting and Sculpture

The mask as a social institution was already known in the early days of the Renaissance. Its fascination has lasted into our own time, even though for us the meaningfulness of the mask is relegated to carnivals and masked balls, to the entertainment of children and to the infatuation of some artists. It is obvious that not only personal predilections but also certain socio-cultural conditions in history favour the artist's inclination to make use of the mask as a helpful means of expression or to see the human face in terms of the mask.

As long as the wearing of masks was a social custom and the fashion of the day, it found its natural reflection on painters' canvases. Thus we find the mask playing a salient part in Watteau's and Lancret's world, which pretended that life is a series of playful festivities with man's ego freed as long as his face was protected by a half-mask. In these *fêtes galantes* reality became a staged pastoral.

The Venetian painters of the eighteenth century, in particular, faithfully reproduced what they saw around them in gay, titillating faces covered by masks, and made the small scenes of everyday existence come to life. The Venetian mask occupies the spotlight on many canvases of Venice's great baroque genre painters, Pietro Longhi, Francesco Guardi, and Giovanni Battista Tiepolo. For them the mask was the legacy of a social custom, sometimes with a touch of coquetry, but little more.

Also responding to the social background and cultural atmosphere of their time were the fifteenth- and sixteenth-century painters Hieronymus Bosch and Pieter Brueghel. To understand Bosch, one must understand that in his time humanism was being created by an élite while the majority of the populace was still living in a slowly waning medieval world. Some of the clergy protested at the power of the papacy and demanded a reform of the Church. Social unrest played its part in these religious tensions. It must have looked like a confusing world to confused man, pitted against God and himself.

Bosch's paintings reflected this period of upheaval. He must have been understood by those who believed in the old order as well as by those who were about to change the *status quo*. He drew strength and ideas from local folklore, the mystery and puppet plays, from the colourful pageants and,

X James Ensor, *Self-Portrait with Masks*

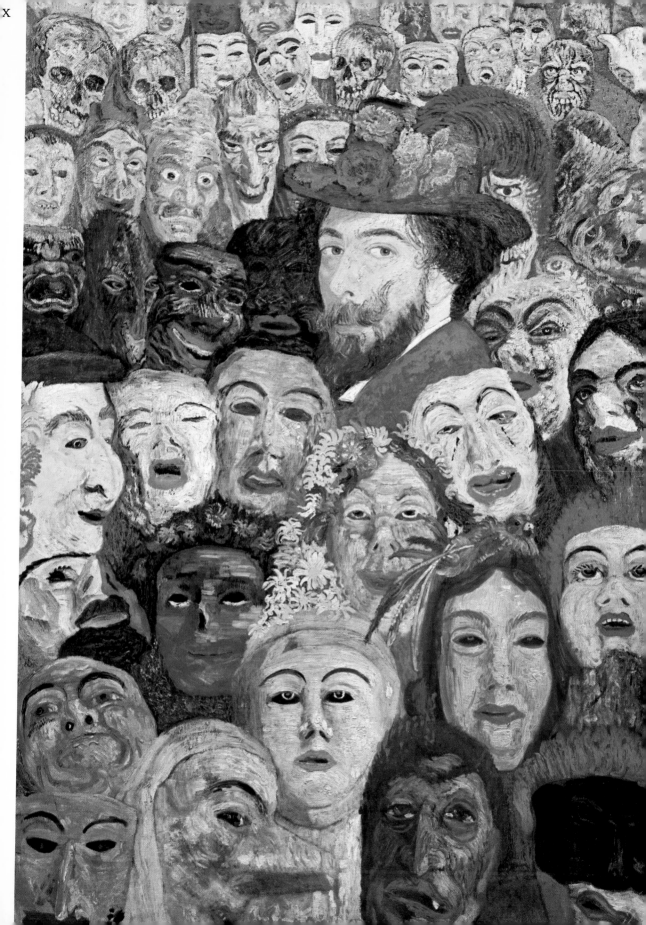

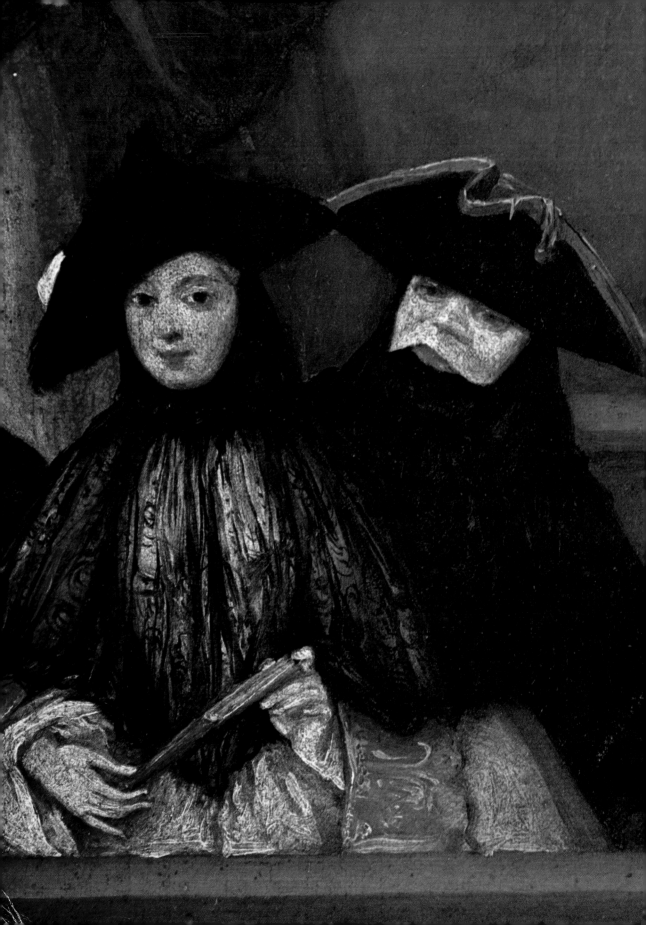

above all, from the favourite pastime of the Flemish people, their famous carnivals. With a Dante-esque fantasy and surrealistic visionary power Bosch fused the puzzling simultaneity of the divine and devilish into the same pictorial entity they were to most people in life. When he castigated man with his weird images – figures partly human, partly animal and vegetable, monstrous forms and malevolent objects – he did it with the scorn and vehemence of a Savonarola, like a medieval preacher conjuring up hell and damnation. But his bizarre allegories, often expressed as grotesque caricatures, had in their pitilessness the glaze of vibrant beauty and subtle, even though frightening, humour.

Bosch lived at a time when the first morality plays were being performed, epitomized by *Everyman*. The basic theme of his paintings was good pitted against the forces of evil, the hope of eternal life and the fear of damnation. Death, of course, was a predominant figure in many disguises, and wherever the wanton joys of carnival and the spectre of death dominate a canvas the mask is inescapable. One has to look a long time at Bosch's over-rich canvases, full of beautiful and eccentric shapes, in order to see how every little section is a perfectly self-contained entity, to marvel at the many disguises and to penetrate the reality of the world behind the mask of monsters and grotesque make-believe.

He was often imitated, but none of those who immediately followed him fitted into his footsteps. More than half a century later came Pieter Brueghel, another Flemish painter, who although very different from Bosch, had that artist's greatness as satirist, moralist, and painter. Too many wanted to be a second Bosch. Brueghel was so great because he only wanted to be Brueghel.

Bosch had been dead for forty years when Philip II of Spain, a religious zealot, tried to crush the Flemish Protestant movement in order to prevent the Netherlands from breaking away from Spanish rule. He did it with utter cruelty; thousands of people were massacred, racked and broken on the wheel, and hung on gallows on hilltops all over the country. In spite of the fact that the Spanish crown belonged to his patrons, Brueghel documented this earthly scene of hell with almost Bosch-like fury on huge canvases in *The Massacre of the Innocents* and in his medieval treatment of death among the people, which he called *Triumph of Death*. It is a frightening picture of man-made madness and misery, most horrifying and realistically correct in its detailed depiction. The overpowering landscape in the background shows gallows, and in surrealistic fashion, skeletons of death slaying and hanging the people. Death figures are everywhere on the painting, as if they were appointed messengers of Philip II or God.

At the beginning of his career Brueghel recaptured some of Bosch's spirit of a weird fantasy world inhabited by monstrous shapes. But more and more the 'Peasant Brueghel', as he was often called, began to depict scenes of the common man. For a townsman he showed great affinity to the mentality

XI Pietro Longhi, *The Rhinoceros* (detail)

of the Flemish peasants, to their gay simplicity and crude humanness. In Boschian manner he criticized the people for their superstitions and callousness. He celebrated the earthiness of these peasants without losing sight of social injustices. We only have to think of *The Parable of the Blind*, or *The Lean Ones* and *The Fat Ones*. His social conscience did not forsake him even on festive occassions. As he shows in his *Peasant Wedding*, he never forgot the outsiders of life. Besides the gay, gluttonous participants of the feast, there are people in the background trying to get in, and there is the hungry, forlorn look of the musician who sees the full trays passing him by. And, to stress class differences, the friar and the magistrates are kept separated from the crowd.

In his peasant paintings Brueghel created types. In his satiric and Bosch-like pictures the typified expression of the face becomes more and more faceless, exaggerated and distorted, coming close to the rigidity of a mask. But essentially the masklike feeling often results from the totality of the image, from his stark vision of man's stupidity, cruelty, and insignificance against the serene background of nature, seemingly caring naught for those creatures who want to master it and whom it is ready to receive.

Closer to our own time the Flemish nation brought forth a painter whose work is intrinsically tied to the mask: James Sidney Ensor. Like his predecessors he was a Surrealist, or rather an irrealist, without ever denying realism. He was a virtuoso of the *non sequitur*, pushing his imagination to the very edge of the absurd. Ensor was a painting poet who loved to play the clown. But his laughter was never vulgar, it was a laughter of despair and frustration, provoked by impotent rage as much as ironic resignation. His laughter had the bitter aftertaste of a man only too conscious of death all his life. This was why he loved to paint skulls wherever he could and where the face of death would be least expected. He was once asked what death he would prefer. 'That of a flea crushed on a virgin's white breast,' was his answer.

In 1879 he painted many self-portraits. The penetrating critical look he had to take at himself must have made him wonder about the many mysterious layers and expressions of the hidden man in him. It was long before Freud began his hazardous journey into the self that Ensor painted his first picture in which the *persona* played a major role. As a painting it was a minor design, called *Mask Gazing at a Negro Mountebank*, but it marked the beginning of his compulsive preoccupation with the mask.

Four more years passed before Ensor made his first artistically valid statement on canvas by means of the mask. In the painting *Scandalized Masks* a long-nosed, stupefied-looking man sitting alone in front of a bottle stares at a blue-spectacled shrew, who enters clutching a musical horn and waving it menacingly at him. The painting has a mysterious quality of squalor and evil. By this time Ensor had discovered for himself the stupendous power

inherent in the mask, especially if one could give the mask the unmistakable reality of a human expression. What he aimed at and finally accomplished was the painting of faces which were masks which were faces.

Ensor found that man's *Angst*, the poetic image of his anguish, can best be expressed through the mask or masklike expression. There was no beauty in man for him, he saw beauty only in nature, in his beloved sea ('all my paintings have come I don't know where from, mostly from the sea'). He would cry out against the ravaging and befouling architects, 'clumsy fools, preposterous and indulgent bunglers, wreckers of scenery', when he saw civilization encroaching on nature, on 'the virginity of the dunes' at Ostend. His pen described what he so often painted with the same diabolic and venomous power.* Here are some of his words about his painting *Beach at Ostend*: 'a strangely mottled world. . . . Bathers carrying their pachydermic shapes on broad flat feet. Grotesque gambollings. A rapacious tribe that sickens all sensitive souls and litters the lovely, delicately toned beach.'

Ensor was never quite happy with women and especially not with Augusta Boogaerts, his lifelong friend, whom he never married and called La Sirène. In 1925, when he was sixty-five, he wrote a prose poem on women, 'deceiving sex, respecter neither of law nor of religion, heartless and devoid of honour. . . . Constant mask and endless smile.' In 1889 he was commissioned to paint a portrait of an elderly woman. As has happened only too often, the portrayed person did not seem to recognize herself or was not at all pleased with the way Ensor saw her. The painting was rejected. Ensor repainted it, slightly exaggerating just those features which were most disliked. The face, surrounded by many laughing, frightening, pretty, and ugly masks, became the *persona* of the portrayed person.

This is how Ensor saw the mask: as the live realization of the real man in man, as the face with which to unmask the hidden hypocrisy, all camouflaged meanness. The mask became to him an intensified image of ugliness, evil, and vice, a personified menace, an expression of the horrors wrought by human naïvety, stupidity, and arrogance. His philosophy anticipated by sixty years the nuclear feeling of the existentialists. The grotesque tragicomedy on his canvases foreshadowed the Theatre of the Absurd. Ensor's paintings made light of the absurdities of man's fate and recorded life as a droll adventure. When he painted down-trodden man, his many beggars, tramps, and drunkards, his poor women, peasants and workers, he sympathized with them but did not ask them to rebel. He often protested against

* 'I love to draw beautiful words, like trumpets of light. . . . I adore you, words who are sensitive to our sufferings, words in red and lemon yellow, words in the steel-blue colour of certain insects . . . subtle words of fragrant roses and seaweed, prickly words of sky-blue wasps . . . words spat out by the sands of the sea . . . discreet words whispered by fishes in the pink ears of shells, bitter words, words of fleurs-de-lis and Flemish cornflowers, sweet words with a pictorial ring, plaintive words of horses being beaten, evil words, festive words, tornado and storm-tossed words, windy words, reedy words, the wise words of children, rainy, tearful words, words without rhyme or reason, I love you! I love you!'

oppression in all its forms, but saw the fate of the little man as the fate of Sisyphus tied to the futile struggle of mankind for no visible purpose but the final one of yielding to death. He recreated the incomprehensibilities in life in the mask.

Ensor once wrote in a letter: 'to see is to paint and to paint is to love – nature and women and children and the solid earth.' However positive this statement may sound, it is lightweight when measured against the far more often stated belief in man as a creature constantly in a state of decay, a quixotic figure rising against an eternally calm sky. Only a man of sincere and profound beliefs could be so negative. Ensor escaped into desperate laughter in order to preserve his sanity in an insane world. This strong man also admitted that he was tormented by demons when in 1899 he painted his *Self-Portrait with Masks*. Mocking at himself in a Rubens-like mask he filled the canvas around him with a variety of grinning, sad, gay, and ferocious-looking masks.

His two most popular creations epitomize his philosophy. In his etching *The Cathedral* he set a monument to man's ingenuity in the beauty of a towering church. On the square surrounding it we find a mob of people with the faceless face of the masses – Ensor was a master in the shading of nuances of non-expression – with their backs turned to the cathedral which is protected by a phalanx of military power. Ensor strongly believed in allegories, and this one tells its story with unmistakable painfulness.

Ensor's other key work is more often reproduced: *The Entry of Christ into Brussels*, a grotesque phantasmagoric image of reality. Christ appears as a tiny figure lost in the crowd. On the other hand, the faces of the nameless are visualized with great daring. The canvas is a huge panorama of vulgarity and buffoonery. They are all people we meet daily. They are most ordinary in their ordinariness and just a bit too human in their humanness. The painting is a fascinating and fearsome tapestry of our existence. 'Witness *The Entry of Christ into Brussels*,' Ensor explained, 'which teems with all the hard and soft creatures spewed out by the sea. Won over by irony, touched by splendours, my vision becomes more refined, I purify my colours, they are whole and personal.'

When Ensor was young he was surrounded by masks, which were sold in the family souvenir shop. The Flemish were fond of the masked carnival mood. Ensor's feelings about them were ambivalent, though he left no doubt about the carnival's importance to his work. He recorded them when he said on the occasion of an Ensor Exhibition at the Salon Jeu du Paume: 'O the animal masks of the Ostend Carnival: bloated vicuna faces, misshapen birds with the tails of birds of paradise, cranes with sky-blue bills gabbling nonsense, clay-footed architects, obtuse sciolists with mouldy skulls, heartless vivisectionists, odd insects, hard shells giving shelter to soft beasts.'

Hieronymus Bosch's world is recalled in this description of Ensor's carnival experiences. In the same speech he also referred to his masks:

And my suffering, scandalized, insolent, cruel, malicious masks, and a long time ago I could say and write, 'trailed by followers I have joyfully shut myself in the solitary milieu ruled by the mask with a face of violence and brilliance.' And the mask cried to me: Freshness of tone, sharp expression, sumptuous *décor*, great unexpected gestures, unplanned movements, exquisite turbulence.

About 1910 Ensor painted *The Vengeance of Hop Frog*, based on the tale of Edgar Allan Poe. This painting was done after an earlier etching dating from 1898. Poe, who said that he was tormented by the Angel of the Bizarre, was Ensor's spiritual brother. Owing to Baudelaire's translation of his work into French, Poe was greatly admired in France and Belgium; he was praised by Mallarmé, who endorsed Poe's symbolistic tendency, and by Valéry, who esteemed his critical faculties and flawless style. When Poe defined art (in *Marginalia*, June 1849) as 'the reproduction of what the senses perceive through the veil of the soul', he came rather close to the conception and genius of the Flemish painters. And when T. S. Eliot called Poe 'a gifted adolescent', he touched upon one facet (and one facet only) which we can also find in Ensor's artistic attitude.

Poe undoubtedly influenced Ensor and, in turn, Ensor and Poe greatly impressed Michel de Ghelderode, a Flemish contemporary playwright of distinction, who said about Poe in his 'Entretiens d'Ostende' ('Ostend Interviews'): 'We are relatives. We make up a huge family. It isn't possible not to be the friend of Edgar Allan Poe. . . . He was the very first to be able to put down the inexpressible, the unutterable.' Ghelderode also explained Ensor's relationship to Poe when he declared that 'a being endowed with any poetic sense is sensitive to the supernatural'.

I am speaking here of Ghelderode (and not in the chapter on 'Literature and the Theatre') because his spirit belongs intimately with that of the Flemish painters, who were pre-eminent in their special flair for and understanding of the mask. For Ghelderode a play is not dialogue only; 'For me', he said, 'a theatrical work does not exist without the sensuousness proper to the plastic arts.' Among his more than thirty plays is a pantomime called *Masques Ostendais*, a fantastic burlesque suggested by some of Ensor's canvases. Odd shapes and apparitions appear in this pantomimic play, curious '*masques: Figurants varié, de style ensorien*'.

In his 'Ostend Interviews' Ghelderode was very explicit about the Ensorian influence on this play. 'Ensor painted low women, down-and-outs, the fishermen of the port, all the maritime common people who work hard and who allow themselves no less rough compensations. It is in one of the old interiors of the houses of these fine folk that I set the frenzied carnival of *Masques Ostendais*. . . . I have only transposed the vision of a painter.'

Having grown up in Ostend, Ensor's native town, Ghelderode took very similar childhood impressions with him into his mature years: 'When I was quite a child, I was sensitive to public demonstrations – processions, parades, fairs, strikes, popular disturbances – to all open-air entertainments, funerals as well, triumphal entries, liturgical pomps, carnivals, masked balls.' All that was colour and movement fascinated him. He was drawn to the world of popular marionettes, which had meant a great deal to him as a child, and continued to do so to the mature man. All his life he collected dolls and puppets, these 'little rag creatures' and 'image-beings as treasures'. He was attracted to their magical nature, their natural reserve and silence, and he regarded these 'smaller-than-I dolls' as his friends, as little familiar spirits.

However strong these first impressions may have been, 'I insist', he said, 'that it was painting, giving colours to form, that led me towards the art of the theatre.' It was mainly Bosch and Brueghel who played Muse to some of his works. Brueghel's canvas *The Parable of the Blind* was transposed for the theatre as the touching pictorial anecdote it was to him, and the inspiration he received from the Flemish painters, their direct and indirect influence, kept pace with his writings.

There is a mysterious rhythm in Ghelderode's plays as there is in these Flemish painters. He wrote morality plays, and the conflict between good and evil is in them as much as it is everywhere in Ensor's paintings. They are tumultuous pictures that both writer and painter unfold, both believing that there is a little of God in everybody, but also quite a bit of the devil. Both loved mystery and drama, the drama that is in mystery, the mystery in the drama of life. And they love even their own fear, as Ghelderode confessed, and their own despair, as Ensor could have added. Both were preoccupied with death (Ghelderode: 'my fascination and even my love of it was nurtured by my mother, an intelligent and sensitive woman who was in tune with natural mysteries'). Both tried to reconcile the realities of our existence with their dream of life. Ghelderode said:

Am I lovely? And you? Men are not lovely, not often, and it's very well that they are not even more ugly: but I believe in *Man*, and I think that this can be felt in my work. I don't despair of him, and I find him very interesting, capable of everything – and of its opposite.

Ensor: 'Even when I had the blues, I saw everything through rose-coloured glasses.' And he also said: 'Our bodies begin to fail from our twentieth year . . . we are fated to descend and not to rise – but genius will save us.'

What souvenirs mankind can take home with it from that little town of Ostend and the Flemish people!

In its broader sense (as applied in this book) the mask is the simplest and most salient expression of symbolism and illusionism, a means of getting the better

166

of nature – however beautiful the Greeks, for instance, may have thought it – and of reality – however true it may *seem*. Most art in India is intimately tied to the realization of symbolism ('The chords of the lute are entranced/ With the weight of the wonder of things!'), and in China the meaning of a face lies in what it signifies and not what it looks like.

We have learned to discriminate between the need for likeness in all its deceptiveness and the desire to hold on to an image lying beyond and beneath all surface manifestations. 'Gothic painters did not treat the Virgin in quite the same way as they depicted donors,' André Malraux said. They applied the same talent to both, no doubt, but in one case they served to please, while in the other they pleased to serve and sought to see beyond the conventional likeness the Virgin's image of their own imagination.

Matthias Neithart Grünewald, the master of the Isenheim altar, is often likened to Bosch mainly because in the altar's panel, showing *The Temptation of Saint Anthony*, Grünewald used masks of monsters and a Bosch-like surrealistic atmosphere for his painted sermon. This visionary interpreter of religious ecstasy denied himself the opportunity of creating a pleasing kind of beauty, since the spiritual message was all he cared for. By the same token, the early Christians – in contrast to the later Byzantine artists – only thought in terms of symbolism. Sometimes their symbolism went to extremes of tradition, as, for instance, in the mosaic in the apse of S. Apollinare in Classe where the Transfiguration is shown with Christ symbolized by a great cross and the three apostles who accompanied Jesus by sheep. But in most paintings in the catacombs the artist's hands were conversing with God, and the faces these hands drew were, in spite of their primitive realism, not portraits but signs and symbols.

Overwhelmed by the photography of life and appalled by life's reality, the twentieth-century artist rediscovered the primitive mask as a point of departure on his explorations for a new reality. There is no artist of any period who has not received inspiration and sustenance from the work of other artists, and there is no time in history which, in artistic and aesthetic terms, has not felt very much akin to earlier experiences of the creative mind of man.

However much accident may rule our personal fate, significant artistic phenomena which have started trends and changed man's responses to new sense experiences have always had roots in the past, and the mask of early societies has played a major part in our time. Pablo Picasso is of course the most often cited example.∗ His ability to perceive the power of the Congo

∗ In *Life with Picasso* Françoise Gilot and Carlton Lake quote Picasso as saying: 'When I became interested in Negro art and I made what they refer to as the Negro Period in my painting, it was because at that time I was against what was called beauty in the museums. At that time, for most people a Negro mask was an ethnographic object. . . . Men had made those masks and other objects for a sacred purpose, as a kind of mediation between themselves and the unknown hostile forces that surrounded them, in order to overcome their fear and horror by giving it a form and an image. At that moment I realized that this was what painting was all about. . . . When I came to that realization, I knew I had found my way.'

mask, to recognize its magical connection of the *persona* with the inner person and the outer world, reoriented his and finally our sense perceptions.

I believe, however, that there is more to it. Unconscious impulses make man seek and find what he thinks comes to him by chance. The mentality of the man caught in the snares of his own imagination and superstitions is uncomfortably close to our own, even though devils and demons people our fantasy under different names and different masks. The unspoken, but fully realized, terror let loose by the magic realization and potentialities of the nuclear age have an effect on our psyches similar to that which the natural and mysteriously hidden phenomena had on the soul of primitive man. The causes as they can be spelled out exist on other levels, the anxieties do not.

Are we not afraid of our twentieth-century demons? But can we help existing with them as living realities any more than primitive man could? Does not our advanced knowledge of ourselves and of the things around us create an additional hazard because we recognize the devil for what he is but cannot free ourselves from him? Is computerized cruelty superior to the mysterious spirits that made primitive man act the way he did? Puzzled by the mystery of death, early man saw the ultimate danger to his life in the hands of supernatural and mystic forces. In reverse, are we not just as puzzled and afraid of finding ourselves on more and more intimate terms with death, ordering him around, fooling him with his appointments at Samara by transplanting vital organs and making men live with electronic hearts? Is not the human robot a devilish demon with which man will have to wrestle in his very near future?

The mask was the great invention of primitive man, of man's growing awareness of his being as related to a world of other beings and animals, to torrents and lightning, to the long silence at night and the sudden cry in the dark, simply to the mystery of it all. The mask was his protector and spokesman, it helped him to exist. Moreover, it was art that was still a necessity of life.

In our time, when art no longer seems to be a necessity of life, the artist has returned to the mask in order to find and reorient himself, to seek the simplest, most primordial means of giving the mystery of life an artistic expression and of giving his art a new life of mystery. Not all artists have gone that way, not all artists have had to, and, as is unavoidable when one is caught in the strong currents of the main stream, some have taken the turning without having noticed it.

The Dadaists certainly did not. From 1916, while the first horsemen of the apocalypse raged on the Western and Eastern fronts, the hobbyhorse riders of Dada capered and caprioled in the Spiegelgasse, in Zurich's Altstadt. 'Dada aimed to destroy the reasonable deceptions of man and recover the natural and unreasonable order. . . . Dada is senseless like nature', Jean Arp

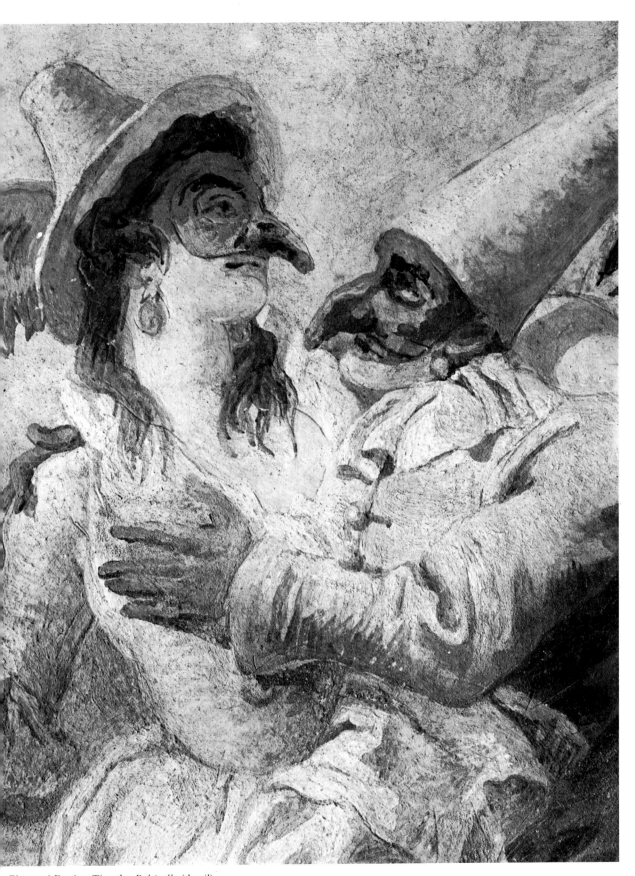

Giovanni Battista Tiepolo, *Pulcinella* (detail)

79 Pieter Brueghel, *The Massacre of the Innocents*

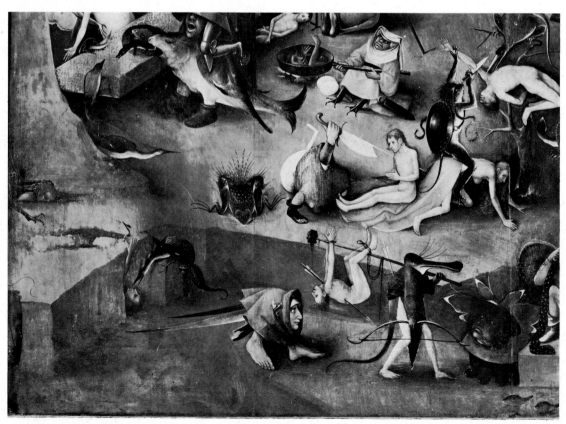

80 Hieronymus Bosch, *Last Judgment* triptych (detail)

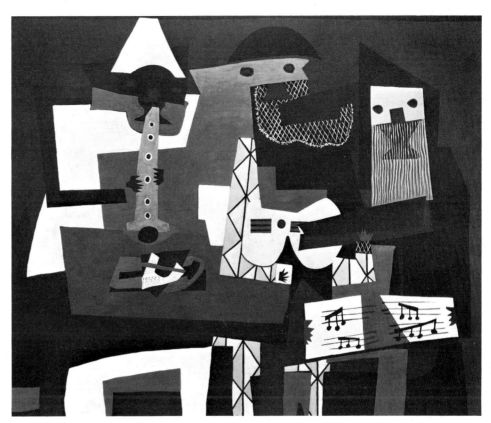

81 Pablo Picasso, *Three Musicians*

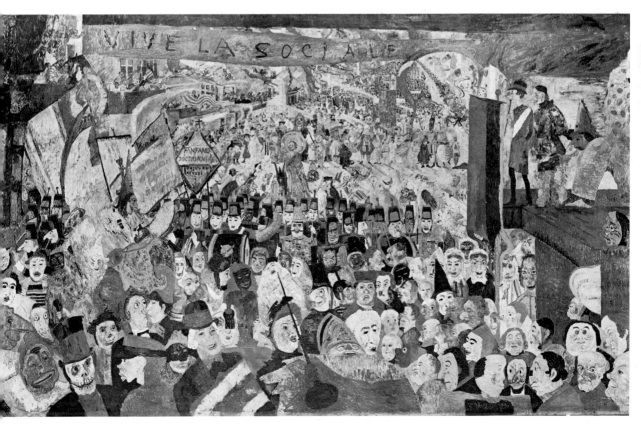

James Ensor, *The Entry of Christ into Brussels*

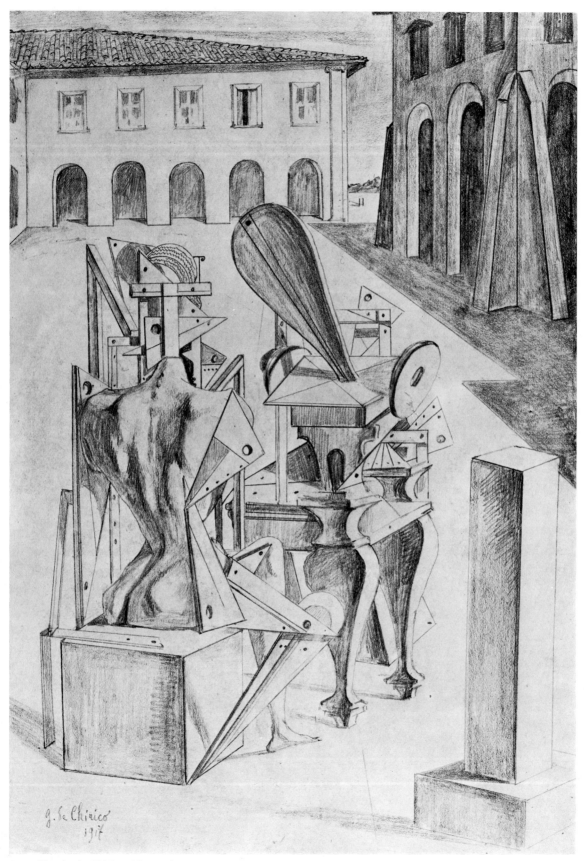

g. de Chirico
1917

83 Giorgio de Chirico, *The Mathematicians*

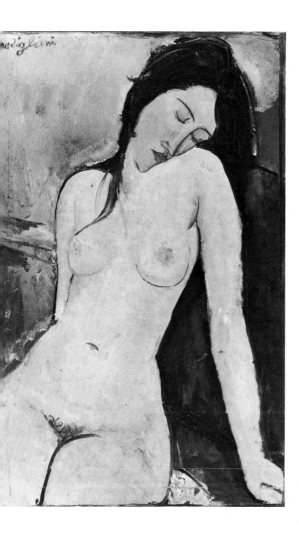

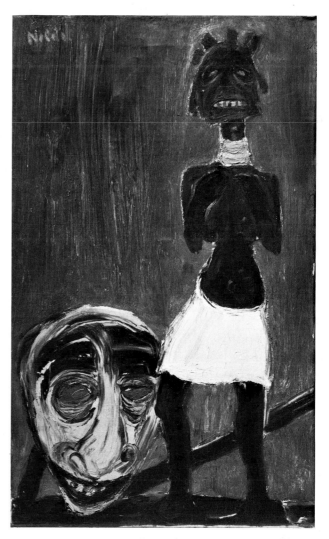

84 Amedeo Modigliani, *Seated Girl*

85 Emil Nolde, *Wooden Figure and Mask*

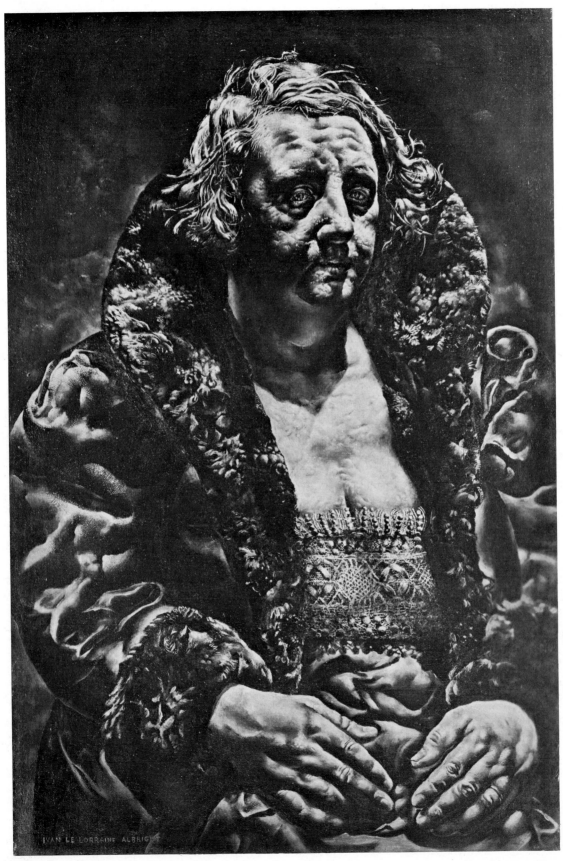

86 Ivan la Lorraine Albright, *Woman*

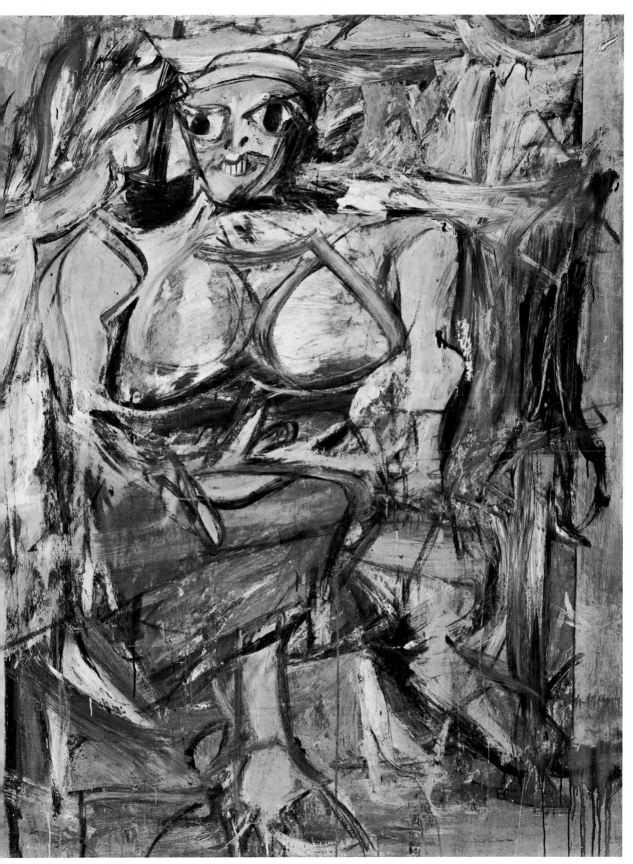

Willem de Kooning, *Woman I*

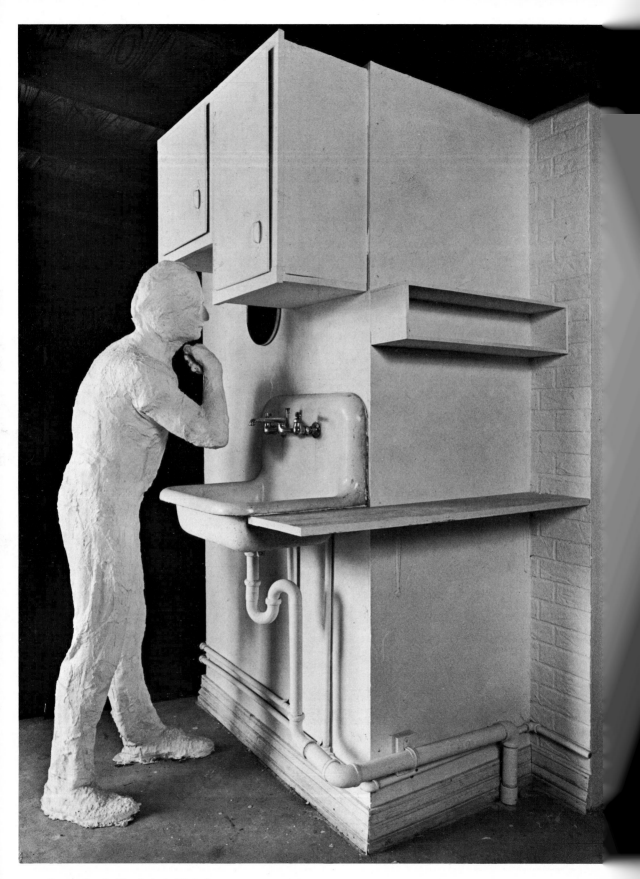

George Segal, *The Artist in His Loft*

said, but he should have said like man. That was what he meant, for Tristan Tzara, another founding member of the Dadaists, made it quite clear that 'the beginnings of Dada were not the beginnings of art, but of disgust'. Long before the fronts, East and West, collapsed, the Dadaists stood on the barricades 'to replace the logical nonsense of the men of today by the illogically senseless'. They were out to destroy the rationalist swindle, the hoaxes of reason, or whatever the slogans were. They pooh-poohed all aesthetic laws, laughed at any concept of beauty, humiliated art. Tzara proclaimed that each Dada creation was 'a cerebral revolver shot'.

In spite of the vociferous war cries for non-art, only those creations which were able to make a work of art out of the anti-art trend have proved Dadaism right and wrong at the same time. George Grosz was fully aware of the excesses to which this art revolution led (as any other revolution has done before) when he wrote: 'We simply mocked everything. . . . Nothing was holy to us. . . . We spat upon everything, including ourselves. Our symbol was nothingness, a vacuum, a void. . . .' Grosz belonged to the politically oriented wing of Dada and his scathing analysis of a time ruled by a sick *bourgeois* clique became manifest in all his drawings before he fled Germany and Europe in 1933. The stamp of a mask is all over his creatures' faces. I do not think of the most obvious example, the human image of his crucified *God with Gasmask*. His *bourgeois* men and women wear a stereotype mask which characterizes the German *petit bourgeois* in his most stupid meanness, or the ruling caste of officers, financiers, and 'bosses' of all kinds in their most cruel crudeness.

George Grosz' savage work had a purpose: to help rebuild, remake a materialistic, war-mad, senseless world. These political Dadaists were fighters for a better future, for a world that made sense. They did not believe what Jean Arp and the founding fathers of Dadaism believed: 'Dada wanted to change the perceptible world of man today into a pious, senseless world without reason.' For the bleeding, defeated Germans after the First World War, who physically experienced the bankruptcy of all old values, this was escapism into another illusionistic world. They believed in *Nie Wieder Krieg* (No War Again) and *Der Mensch ist gut* (Man is Good), even though they were exposing the brutish and sick aspects of society. In showing these aspects, in recreating the real inner man as an inescapable mask, they may have mocked everything, spat upon everything, but they wanted to bring sense into the senselessness of existence.

In the early 1920s the concept of the mask played a tremendous part in the artistic and daily life of men like George Grosz and John Heartfield, who had anglicized his name from Herzfelde in protest at German militarism. Grosz and Heartfield, who had both survived the horrors of the front, were disgusted by militarism and uniforms, and by the stupidity of those Germans who craved for new glories on the battlefield. Grosz would wear a skull mask,

emblem of death, over his head when walking in the streets of Berlin with a poster saying, *Dada über alles*, satirizing the famous slogan *Deutschland über alles*. Heartfield, though demobilized, continued to wear a tattered and torn uniform. As the central piece and main attraction at the International Dada Fair of 1920 the effigy of a German officer hung from the ceiling, his head masked as a pig.

Perhaps a remark made by Emmy Ball-Hennings, Hugo Ball's wife and one of the co-founders of Dadaism in the Cabaret Voltaire, may shed some light on the fascination exerted by the mask on the Dadaists at that time. In a brief essay, *Zur Erinnerung an Sophie Taeuber-Arp* (*In Memory of Sophie Taeuber-Arp*), she referred to the agony and death ecstasy of the time against which the Dadaists had tried to fight. 'Any kind of mask was welcome to him. It must be questioned whether everyone chose the mask fitting him best. The mask, however, served as needed subterfuge to hide the true, deeply moved face.' It seemed to her that the Dadaist despaired of man in his time, but never lost a youthful power which often disguised itself as wantonness and mockery.

Otto Dix, a German Expressionist and part-time Dadaist, helped Grosz to draw *Das Gesicht der herrschenden Klasse* (*The Face of the Ruling Class*). He was most concerned with the lot and with the face of the poor, beaten man, as his pictures of war cripples, matchbox vendors and prostitutes display. During the 1920s he showed the after-effects of the war in his tryptich *Grosstadt* (*Metropolis*), portraying life in the coffee-houses and on the streets. Sometimes he returned to the Renaissance concept of showing man as the animal he is; for example, in his *Fleischerladen* (*At the Butcher*) the three humans appear in pig heads.

In many of his portraits Otto Dix was able to reveal the image of salient characteristics with caricature-like sharpness, the avariciousness or the naïvety of a man who tried to hide behind his *persona*. It is worth recording what Dix said about the process and art of portraying a person: 'If one does someone's portrait, one should if possible not know him. . . . I only want to see what can be seen, the exterior. The inner man reveals all of himself by being himself. He is mirrored in what is visible.'

How very different were the Dadaists who first mounted the hobbyhorse to escape the reality of the world *and* art, who called for a *tabula rasa*, who wanted to humiliate art because they had seen 'through its fraud as a moral safety valve', as Richard Huelsenbeck claimed. They followed the logic of illogic and, in the process of dissociation or displacement, haloed any 'ready-made' by removing the object from its familiar context and presenting it as devoid of any aesthetic interest.

All this led to new forms of pretension and the celebration of the replacement of one thing by another. What interests most here is the Dadaist's predilection for the fabrication even of personalities, giving eccentric *Gestalt*

to Rimbaud's concept of 'I is another'. Marcel Duchamp went all the way, in an episode immortalized by Man Ray's photographs, by masking himself as his female *alter ego* whom he baptized Rrose Sélavy (compressed from *a . . . rrose, c'est la vie*). It was Duchamp who apparently thought of demystifying the mystifying smile of Mona Lisa by letting her grow a moustache and beard. I do not think that this was one of his primary motives, nor was the adolescent act of defiling a hallowed image through graffiti. The clue lies in the enigmatic title he gave his bearded Mona Lisa: *L. H. O. O. Q.* Pronounced quickly this reads in French *Elle a chaud au cul* – whose meaning is that Mona Lisa has hot pants. Did not Rrose Sélavy want to get even with Leonardo's homosexual leanings by taking revenge on the mysterious smile of his most celebrated female figure? What an interesting game the masked played here with masking!

Collage was the most natural way for the Dadaists to cover one image with another, creating with an innumerable number of images from diverse sources the disturbing entity of one idea. The idea was to attack man's complacent acceptance of his way of living as god-given normalcy by telescoping its insanity, by distorting size and sequence of events, and by establishing man's real mentality behind a cluster of images. Raoul Hausmann introduced the photo-collage, while, at the same time, Max Ernst found another technique, called *frottage*. With Max Ernst we have turned another page, entitled Surrealism.

When Surrealists begin to paint or sculpt they take off their figurative fig leaf and put it on as a mask. Thus, with their eyes covered, their poetic minds unravel their dreams as if lying on an analyst's couch. The faucet of their psychic automatism is opened. They spew their thoughts spontaneously, building dream-like realities, floating images loosely tied together, with Eros watching over their aesthetics, unprincipled but full of an undefinable fragrance. Passing between his erotic Scylla and the Charybdis of his mind, the Surrealist may have created a legible, realistically valid picture of an abstract dream. His realism must be taken for the mask of his dream, both being reversible.

'Rather than setting out to paint something, I begin painting and as I paint the picture begins to assert itself, or suggest itself under my brush,' Joan Miró said. 'The form becomes a sign for a woman or a bird as I work. . . . The first stage is free, unconscious.' This, of course, would mark Miró as the 'most surrealist' of them all, as André Breton maintained. Miró became a master of the incomplete fulfilment of wedding the trivial with the transcendental, filling space with colourful atmosphere, clowning the commonplace while giving it eloquent and meaningful charm. His work may seem to be nothing but psychic automatism, but Miró was too serious an artist not to know that 'the second stage' must be 'carefully calculated'. In some of his

drawings, and more so in his creations in space on the rare occasions when he came close to creating human likeness, it was the child's concept of the mask which he created in lieu of a face.

Distantly related to him – as distantly related as only two strongly pro-filed artistic individualities can be to one another – was Paul Klee, who noted in his *Diary*: 'I want to penetrate into the inmost meaning of the model. I want to reach the heart. I write words on the forehead and round the lips. But my faces are truer than life.' Klee visualized a face like a face as little as he accepted the world on its terms of reality. He was one of those artists, as Bonnard said, whom one imagines 'spending a great deal of time doing nothing but looking around and looking within'.

Klee felt that the art of contemplation, the art of revealing only non-optical impressions and images can lead to the penetration of within-ness. In trying to eschew the photographic image he permitted 'the "I" to deduce the interior of the object from its exterior; this it does intuitively in so far as the "I" is encouraged by optico-physical means to draw from the exterior con-clusions of an affective nature which can intensify the impression of the phenomenon to the point of functional interiorization.'

Sometimes the pure and linear element of his drawings may be bewilder-ing in its simplicity, but Klee's strength was in discovering the poetic magic of simplicity. By removing the mask of all outer appearance and trying to reduce man to the nature of his existence, Klee actually magnified man's image. This image was not man as he is, but as he might be. In adding a touch of almost sad humour, Klee created faces unique in their disarming enchantment.

Not all of those painters who escaped reality in order to find refuge in a world of lost wonders and secret dreams are of interest to us here. Some may concern us peripherally. From painters of Giorgio de Chirico's stature we could have expected a wider interpretation of reality through the mask. He strongly believed in the sensation of ominous shadows cast by the unseen and unknown. He recognized that what we believe to be real is a world adjusted to the phenomena of our own deceptions. Sometimes he had recourse to the concept of the mask, particularly in his scenic designs, or in such a drawing as *The Mathematicians*, in which two manikins have geometric-scientific shapes in lieu of head and face. Salvador Dali also created dream objects of such concreteness and persuasive beauty that the entire concept, including the facial expression, conveyed a feeling of imagined materiality. The face is then of no human consequence. Dali's clinical eccentricities are brilliant conversa-tion pieces, but they are cold, unemotional, even though they excite and stimulate our visual sense.

It is different with Marc Chagall. He cannot help being Chagall, while Dali, the magician and showman, can conjure up any other novel form

whenever prompted by the audience. Both use symbols in a rather literary manner. Dali's limp and shape-lost watches hang helplessly down from the edges of eternity. Time and form are erased. Chagall's time-ticking clocks, however, fly in the air. Everything soars upside down on his canvases, challenging the laws of gravity and credulity. But Chagall's dream visualizations are convincing, perhaps because they convey a genuine feeling in their bewitching naïvety. He makes us believe that a human figure can have a bird's face as much as a human face can have the face of a clock. Ultimately, the secret lies in its poetry. We do not mind seeing a woman wear the face of her *alter ego* as a part of her hairdo and veil, or seeing a severed head enjoy its separate existence in a world peopled with severed heads. We believe in Chagall's Surrealist poetry because we feel the love that made it what it is: eccentric, but also blissfully ecstatic; mad, but caught up in divine madness.

The works of a series of contemporary artists could be cited to prove that among the experimental painters many have tried to reconcile the trend towards abstraction or distortion with the dramatic power and traumatic drama of man's face. Woodcuts of the German Expressionists especially, of Ernst Ludwig Kirchner or Karl Schmidt-Rottluff, show us the eloquence of the stylized face that turns into a quasi-mask, a feeling also evoked by the strong contours in the faces of Georges Rouault.

It is through the ruthless passion of Rouault's brush that we receive, as Jacques Maritain said, 'an immortal wound'. When we face Rouault's work, is it not as if the ferocity of his accusing images is tearing off our own masks? The trauma of human suffering has never found a more devastating expression than through Rouault's lines, drawn with a heavy hand and brush to create a minimum of individuality and a maximum of meaning. His faces are an amalgam of modern sophistication, the spirit of late medieval iconography and stained glass windows, and the fervour of the primitive maskmaker who tried to enliven his masks with demonic power and whose simple and often brutal planes were full of evil and the menace from outside.

Early in his life Emil Nolde lived in Switzerland, a country which has one of the richest folkloric mask cultures in the world. Using the faces of the people of Appenzell as 'raw material', he experimented in a series of drawings with the expression of some primordial human passions and conditions. He created some stunning and fearsome masks of dynamic power, such as *The Mask of Energy* or *The Mask of Indolence*. From then on he was drawn to archaic-looking images and the demonic forces in man which, at moments, found their way into the consciousness of the face.

He was first influenced by Arnold Böcklin, who tried to build a world of new myths and also sculpted six inspired sandstone masks at the Kunsthalle in Basle. Nolde, was, however, far more strongly influenced by Ensor's work when he came to Flanders in 1911. The immediate results were four still-lifes

enhanced by exotic masks. This was also the time when many European artists came under the spell of primitive art, and Nolde was no exception. His experience of it was similar to that of Picasso. Nolde felt reassured that he had been on the right track, and he found certain of his beliefs and goals confirmed. These were to him 'absolute spontaneity, the intense, often grotesque, expression of energy and life in the simplest possible form'.

A stark simplicity marked most of his works. The situation in which he placed man determined his attitude towards the *persona*. In his painting *The Golden Calf*, for example, he obliterated any recognizable expression; only the demonic forces were retained on the faces in an archaic imprint. The movements of the wildly dancing creatures instil an intensity of non-being into the faces, an expression we find on masks of the very first and still primitive mask-makers. In contrast to this, Nolde could be very explicit in letting the face give away its story, as in *A Glass of Wine* in which the face tells of a life lost and mirrors a mask of moral weakness.

Nolde never lost interest in the mask *per se*, and many of his canvases show, behind the grotesque, man's clownish despair and fear of death. He always tried to touch the raw nerve of his subject matter and to reveal features of the collective unconscious. This is probably why Klee called him 'Nolde, the primeval soul, Nolde is more than a mere creature of earth; he is a daimon of the earthly region. . . . '

Most of the Surrealists were painters, draughtsmen and sculptors. Above all, they were poets, writing incandescent verse lines and phrases in prose which matched their painting and sculpting in imaginative and often somersaulting ecstasies. They are only one extreme example of how photography has taught the visual artist to relearn how to see and, in seeing, to have a new creative experience. Klee expressed it best when he said that 'the artist has gone beyond the visible, has processed it within himself, buried it in him. The visible world is not exhausted for him in its mere visibility. He must move forward to the image. He transcends reality, he dissolves it, in order to raise the inner reality to the visible.'

Some artists went rather far in dissolving reality. The abstract Expressionist Willem de Kooning abstracted from reality to the point of unrecognizability, and yet his forms are strong and obtrusive. As de Kooning once said, 'art never seems to make me peaceful or pure. I always seem to be wrapped in the drama of vulgarity.' This is exactly what his paintings convey. He had a long love affair with the image of a seated woman, of which he painted a dozen canvases. In the most merciless way he tore one mask after the other from her face; the woman's figure is an insinuation of a figure only and the face barely admits to having once been a face, creating rather the impression of the woman's final face, a skull-like death mask.

Ivan Albright can create another devastating image of human degradation, death, and decay with his portrait of a woman, 'whose torrid flesh folds resembled corrugated mush', as he himself described it. Albright's faces are aberrations of faces, expressing the fury of nature in her most vicious mood. His paintings are sub-realistic rather than surrealistic. Even though he has once mentioned that he amuses himself seeing what he paints as if he were looking through 'ill-ground bifocal glasses' at his objects, it seems that he exorcizes a clinical disgust of the human body and face with his paintings. This becomes clear when we read the small print of his confessions:

We live in a land of shadow and sorrow and blinding light. . . . If a room were lighted with a light as bright as the sun, you would see no more than if it were in total darkness. We are workers, see-ers in a twilight world of shadow. . . .
The body is our tomb . . . without eyes the light would not hurt, without flesh the pain would not hurt . . . without a body we might be men. . . .

Most of these painters, and Albright is no exception, are wonderful material for psychoanalytic interpretation. In his abreaction and his destructive *furor* Albright saved his sanity or, at least, triumphed over his death wish and frustrations. Sigmund Freud said about the process of sublimation in the artist: 'He moulds his fantasies into new kinds of realities, which are accepted by people as valuable likeness of reality.' De Kooning, Albright, and Francis Bacon, however, are going far beyond the acceptability of any valuable likeness of reality. Their new kinds of realities are an aggressive act and, to some extent, an act of self-flagellation.

Francis Bacon's paintings are a frontal attack on the spectator's senses. His is a paranoic, Grand Guignol approach, tracing the violence that bears the imprint of our century. The faces of his figures are brilliantly painted hallucinations, nightmarish masks of *homo ridens* after his collision with the gods or the machine. Human suffering is grotesquely presented as Bacon's last will of destruction. In comparison, even Bosch's pandemoniums suggest that the Creator might be willing to give man one more chance. This is no longer the case in Francis Bacon.

He started as an untrained painter, which may account for his escape into the scurrilous world of mordant fury. It may be easy for the untutored to distort, to show disintegration. He once admitted that 'real painting is a mysterious and continuous struggle with chance'. But there is nothing left to chance in his dramatic spatial sense or in the distribution and shading of colour. Even the delusiveness of his themes, his undefinable faces and vaporizing heads, seem to fulfil his intentions of surprise and shock. One cannot help feeling that, like a Charles Addams character, he must enjoy wallowing in the most gruesome aspects of life. If a painter could create a wave of suicides with his macabre work – as Goethe once did with his *The Sorrows of Young Werther* – then Francis Bacon would be the one to do it.

Earlier in the century and with different artistic accents, Alfred Kubin developed a predilection for the morbid and sick in the world. Even as a boy he compulsively drew cows with four horns, magicians, 'landscapes consisting entirely of fire'. In his childhood he also developed a burning curiosity about corpses, and he watched gravediggers drag decomposed bodies out of the lake in the Austrian mountains where he lived. 'This was the origin of my admitted interest in grisly scenes', he claimed.

Kubin was a man possessed, but also one who possessed the great gift of transmuting his visions and hallucinations into an embodiment of art which, in contrast to Bacon and Albright, remained within a reasonable scope of imaginative inventiveness. His weird imagery emerged from a twilight world of his own discovery, but most of his faces clearly delineate the essential features of the inner person. Kubin may be violent, but he is never destructive. He constructed the window for Franz Kafka, who pushed it wide open for those who could not help seeing reality, in its inexplicable absurdity and frightening cruelty, betray and deny itself.

Considering the consolidated as well as divergent efforts of so many artists of this century, T. S. Eliot was undoubtedly right in saying that 'humankind cannot bear very much reality'. Jean Arp, who conceived life as an irrational quantity of memories and dreams and whose sculptural forms held nature up to its mirror reflection, elaborated on Eliot's allusion: 'Man has lost his sense of reality, the mystical, the determinate indeterminable, the greatest determinate of all.'

In his essay *Beyond Painting* Max Ernst maintained that Surrealist painting opened up a tremendous range of vision, setting the mind's eye free to travel far into the most secret recesses of our being, 'limited only by the irritability capacity of the mind's powers'. In penetrating the deeper layers of man's psyche, the Surrealist painter can more readily remove the masks of pretension and come close to real revelations. 'We do not doubt', Max Ernst said, 'that in yielding quite naturally to the vocation of pushing back appearances and upsetting the relations of "realities", it [Surrealism] is helping, with a smile on its lips, to hasten the general crisis of consciousness in our time.'

Artists like Max Ernst and Jean Arp threw overboard the concept of absolute time and space. As André Breton speculated, the artist was preparing his future escape from the principle of identity. Max Ernst was very much concerned with the thought of breaking loose from this law of identity. 'I accustomed myself', he said, 'to simple hallucination: I saw quite deliberately a mosque in place of a factory, a drummer's school conducted by angels, carriages on the highways of the sky, a salon at the bottom of a lake; monsters, mysteries, a vaudeville poster raising horrors before my eyes.'

Max Ernst believed in the Daliesque 'multiple' or 'paranoic' image in which the representation of one object is also, without the slightest physical or anatomical change, the representation of another object. Dali used as an

example 'the image of a horse which is at the same time the image of a woman'. This would lead to a crazed and maniacal game of interchangeable masks, but Ernst subscribed to a limitless range of reversible images. To him, everything was transmutable into something else. Paul Éluard wrote *Eight Visible Poems* as a verbal illustration to Ernst's collages of the same title. In paraphrasing Éluard, let us try to see that it is not far from the clouds through the bird to the man and from him through the nature of the imagined to his visions and the visions of himself.

Max Ernst, who also had a wonderful way with words, wrote about *Instantaneous Identity* in gentle self-mockery. He describes how different his *persona* is from his real self, how hard it is for people 'to reconcile the gentleness and moderation of his expressions with the calm violence' which was the essence of his thought. He found that he was often compared 'to a very light earthquake which gently displaces the furniture, yet is in no hurry to change the position of things'. It seemed to please him and correspond with his work that it was not easy to discover 'his identity in the flagrant contradictions (apparent) which exist between his spontaneous comportment and the dictates of his conscious thought'.

One of the giants of this century, Pablo Picasso, has gone through many metamorphoses, and whenever he has varied his mode of expression he has only changed his way of thinking, as he says. 'I paint objects as I think them, not as I see them.' Whatever Picasso has done and in whatever form and manner, his point of departure has always been reality, although he may afterwards have wished to remove all traces of reality. In many cases in which the perplexing device of simultaneity, the transparency of overlapping planes and the stratagem of the double-faced portrait are used Picasso's intentions have been to recreate a new reality. When he places two eyes in a face seen in profile, it is not emotionally motivated. It seems to him at that time the most natural and dramatic way of visualizing that which is hidden but is known to exist.

The very first time when the mask as such appeared in his work was probably in 1904, when he created a bronze called *Man's Mask*, now in the Baltimore Museum of Art. It was still a very conventional mask, but it heralded his great interest in masks which, at a later date, were to be prominent fixtures in his studio. In 1904 he may not yet have encountered the African mask; but he certainly felt its influence two years later when, at the end of his rose period, he made a self-portrait and his impressive portrait of Gertrude Stein. The faces are no longer conventional, they have a masklike form of sculptural intensity.

These were only preludes to his complete reorientation, which occurred as a direct result of the influence of the Congo mask when, in 1907, he drafted many studies for a painting that, much later, was called *Les Demoiselles d'Avignon*. Originally, these five ladies were not alone. A male figure was surrounded

by women in apparent anticipation of carnal pleasure, while at the left another male figure appeared bearing a skull – either as a warning against the wages of sin or else to stress the shortness of life. But the idea of such a painted morality play was discarded in favour of a plotless presentation of five women.

Their facial expressions are daring. None of their features have any sign of regularity; they are reminiscent of archaic sculpture. The two faces on the right have the intense, vehement expression of masks. With this painting Cubism was born, provoked and inspired by the West African Negro mask. In none of the metamorphoses through which Picasso went, with the exception of the classic period, did he indulge in conventional legibility. All his life he has been obsessed with dislocated and distorted features and, in an almost whimsical way, with enlarged extremities of the body.

Picasso has ridiculed the idea that a painting should be understood when its purpose is to please, to stimulate, to attack our senses. It is therefore doubtful whether any psychological meaning can be attached to his masks. When he reached the climax of synthetic Cubism with his painting of the *Three Musicians*, he created a truly magnificent image of cubistic masks. The *Three Musicians* hark back to *commedia dell'arte* characters: the mask of Pierrot playing the recorder, Harlequin's image in the centre with a guitar, and a strange figure in a monk's garb, apparently singing behind his veiled mask, holding his music sheet on his lap.

In describing this painting Alfred H. Barr, Jr, referred to the subject as being 'traditionally gay; but by means of the monumental size of the picture, its sombre background and mysterious masks Picasso transforms the three music-making comedians into a solemn and majestic triumvirate.' Then he warned his readers that such interpretation can be very treacherous and tried to substantiate his warning by citing Picasso himself, who told one of his friends: 'People who try to explain pictures are usually barking up the wrong tree. Gertrude Stein joyfully announced to me the other day that she had at last understood what my picture of the three musicians was meant to be. It was a still-life!' Why not see in it a musical still-life of masks?

Perhaps the key to Picasso's credo can be found in his statement that 'we all know that art is not truth. Art is a lie that makes us realize truth, at least the truth that is given us to understand. The artist must know the manner whereby to convince others of the truthfulness of his lies.' The idea that it is possible to think of man's creative imagination as a lie goes back as far as Solon who, puzzled by Thespis' daring to challenge and answer the chorus, asked that pioneer of theatrical make-believe why he lied. As Picasso rightly said, each artist has to find the truthfulness of his lies in order to make them believable and to add another and larger dimension to our existence.

Alberto Giacometti did just that. He began as a Neo-Impressionist, but by the late 1920s he had joined the Surrealists and discovered a space sculpture which was very much his own and, at the same time, indicative of our era.

He had ceased to work from models and moved from working from memory to working from imagination. He reduced reduction to a reduced image of objects and men, a miniature illusion of reality. Everything became transparent, space as much as figures, since he felt that 'to render what the eye really sees is impossible'.

It was no longer a question of reproducing a lifelike figure, Giacometti felt, but of creating the essence of living, removed from descriptive reality. His figures evoke a feeling of mystery, but also of a frightening anonymity. The illusive beauty of a silhouette walking into endless space is matched by its alienation and aloneness. The longer a person was sitting for Giacometti, the less recognizable did he become. Giacometti tried to capture man surrounded by his void and to establish the relation of being to nothingness in the fashion of a Samuel Beckett.

Giacometti created a most fascinating mask. He deprived each face of its individuality. But in erasing the likeness of the individual he revealed man, *the* man with his tortured feelings walking through his void. The closer we look, the clearer it becomes that this lost figure is full of vitality showing the tremors of violent outbursts, the pressures of dynamic powers, a tenuous strength of endurance. *Ecce homo* of the twentieth century!

Giacometti is probably less known as a draughtsman and painter, but his spatial and expressive principles are applied to his non-sculptural work as well. By the same token, we can see in Amedeo Modigliani's canvases figures which, essentially, have a sculptural character.

Some artists have found a very personal idiom for their way of expressing themselves, unmistakably characteristic of all their works. They can thus easily remain limited, however fascinating they may be in their limitation. This can certainly not be said of Picasso, who has varied approach and style all his life, if only to prove true his dictum that an artist may plagiarize anyone else rather than himself. It is different with Modigliani, whose creations stay unvaried within a certain stylistic concept. Influenced by the African mask, Picasso used it as a point of departure. Influenced by the African mask, Modigliani made it his own in a Modiglianian fashion.

One may easily claim, as Dr Alfred Werner did in his essay on Modigliani, that 'anyone believes he can spot a Modigliani from a distance: the flat, mask-like face; the almond-shaped eyes; . . . the neck either overlong or virtually nonexistent. . . .' But Werner then claims that 'the frequent complaint that all Modiglianis look alike fades as one begins to study his work with some of the earnestness with which it was composed. The men and women whose countenances appear in his work . . . are characterized in the most subtle ways: by a stronger tilting of the head; a variation of the angle of the nose; an ironic, surly, or deeply sensitive mouth. . . .' Contrary to what Dr Werner wants to prove, however, there are no 'striking physiognomic differences'. Modigliani's stylization is a very individual visualization of a

'masklike' face. His work is not so much an instance of the modern trend of depersonalization as it is a return to the facial expression reduced to a very definite, but simple, shape with a few rudimentary lines in lieu of features: the beginning of the mask. The nuances in expression, such as 'a stronger tilting of the head' or 'a variation of the angle of the nose' should be expected as the characterization of man's *persona*. It is true that Modigliani's masks differ in the most subtle nuances. Therein lies his fascination as an artist.

Modigliani's affinity to the mask is especially proved by his sculptures showing faces that look superimposed on the head like masks. Such a face is an exaggerated oval with an overlong, straight, flat nose connecting, as it were, the narrow, tiny mouth put close under the nose with the oval eyes. In their variations, these face-masks are very much alive in a characteristically Modiglianian fashion. They display an aristocratic, elegant grace and a serenity which, however, is not the detached serenity of the death mask.

The masklikeness of his heads can best be realized when, first of all, we observe the unmistakable similarity between his drawings and sculptures – are all people's lips so close to their noses, or is this the mask-maker's intention? – and, secondly, when we compare Modigliani's work with that of Constantin Brancusi, by which he was inspired. Brancusi, the master of elimination, has gone the way of total simplicity and abstraction in which the surface appearance is negligible, and the form and beauty of the material essentially projects a textural and sensuous sensation. But even where Brancusi comes closest to the creation of a face – as in his famous sculpture, *Mlle Pogany* – it is distinct as an abstract portrait. Modigliani's reductions to the simple form and line are sophisticated, Brancusi's are playful and child-like ('when we are no longer like children', he said, 'we are already dead'). Brancusi once explained that 'we arrive at simplicity in spite of ourselves, as we approach the true sense of things.' Modigliani arrives at simplicity because he deliberately set out to seek it and forced it to submit to his beautiful, capricious will.

The twentieth-century sculptor who returned to the mask of primitive societies as a means of expression has, strangely enough, limited himself in scope and variation. The stress on the theatrical effects of the mask to give *Gestalt* to the mysterious and demonic forces in which early man believed compelled the mask-makers to find new, fantastically imaginative ideas time and again. When Picasso says that he does not seek, he finds, he is also describing the way in which the early mask-maker proceeded to find ever new forms and facial expressions. Among primitive sculptures the mask was the least tradition-bound of artistic realizations. Moreover, for a long time masks remained *the* medium of sculptural expression, and therefore artistic inventiveness was a necessity.

The idiosyncratic individuality of the modern artist defines and delineates the concept and scope of his work. A Modigliani is very much a Modigliani

whatever he presents, and so, in its way, is a Henry Moore; Moore, generally considered one of the great sculptors of the twentieth century, has explained the kind of archaic, masklike face his figures have:

You don't need to represent the features of a face to suggest the human qualities that are special to a human person. . . . If you see a friend in the distance you don't recognize him by the colour of his eyes (these you are unable to see) but by the total effect made by his figure. . . .

This is also why Moore's faces are of so little importance. The idea of representation is for him the whole man, alone or in a group, the organic feeling of natural forms, the way in which primitive man would gaze with wonder at rocks and give bones and roots a sculptural look. Moore puts primitive magic into a stone. He does not chisel the figure out of stone, but makes the stone suggest a woman, a man, a family. The thought of the plastic entity of a human being has occupied some sculptors of our day, such as George Segal about whom a few words will be said at the end of this chapter.

The death mask has played a major role in the history of man, from its magic implications to the realistic desire to preserve the facial expression of man's final moment; the life mask's purpose, however, bypassed all magic and mainly served to create the likeness of a man in pre-photographic days. It was mostly minor sculptors who made life masks professionally, portraits in wax and later from plaster of Paris; this reaches back to Roman days. Often, however, a very reputable sculptor would try to use the mask in order to help his memory while sculpting a bust, particularly if the person to be portrayed was not available for more than one sitting.

In the section on the theatre I mentioned Wladyslaw Benda, a Polish painter and illustrator who came to the United States in 1899. He first busied himself with illustrations for books and magazines, but later discovered his love for the mask and made his fortune with it. Benda's 'social' masks had a stunningly lifelike semblance and his New York studio was frequented by well-known personalities. For some time, especially in the 1920s, it was fashionable for people whose names were in the social register to have a mask made by Benda. Even though his work was impressive and, in many ways, artistic, his masks could never attain a sculptor's personal touch and imaginative dimension. But besides profiting from a fad, Benda's likenesses could still compete with photography which, at that time, was only beginning to develop into an artistic medium.

Wladyslaw Benda's work and name represent a climactic but final stage of the life mask, which had been popular during the eighteenth and nineteenth centuries. There was hardly a great personality who would not sit for a painted portrait or sculpture, and just as many had life masks made, from Bonaparte to Lincoln, from Beethoven to Keats.

The process of having plaster of Paris applied to one's face was usually anything but enjoyable, and in many cases it was rather painful and complicated. Either from sheer vanity or in deference to the pressures accompanying a public office, however, many luminaries subjected themselves to the discomfort of having a life mask made. Each of them could probably have told of their personal experiences, but the story involving Thomas Jefferson and a then famous New York sculptor by the name of John H. Browere is most illuminating, if for no other reason than the interest the newspapers took in this case and the storm in a tea cup which it created.

Browere, a minor sculptor, was fascinated by the idea of creating a gallery of nationally important personalities in Washington. He tried to improve on the method commonly employed by sculptors and experimented with a new mixture of thin grout which he put on face and body in successive phases, layer after layer. James Madison recommended Browere and his work to Thomas Jefferson shortly before his death. Madison thought highly of Browere's busts and felt that 'from his mode of taking it', a bust of Jefferson 'will probably show a perfect likeness'. On 15 October 1825 Browere visited the elderly statesman and remarked that, through the intervention of his friend James Madison, Jefferson consented 'to submit to the ordeal of my new and perfect mode of taking the human features and form'.

According to the artist's version, Jefferson stripped to the waist. Browere applied his layers of grout for ninety minutes on face and chest, but with intervals of ten to fifteen minutes during which time Jefferson got up and walked around. The procedure for obtaining the face mask took eighteen minutes and it was removed within three minutes. But Browere's work on Jefferson may not have gone quite as smoothly as the artist had hoped for. Jefferson was then eighty-two years old and suffering from several ailments. His family must have become greatly concerned, and their anxieties may have led to the gossip that the artist had suddenly to shatter his cast and pick up its fragments.

Newspapers exaggerated the incident, and reports circulated for some time that, within a year of his death, Jefferson had nearly been suffocated by Browere. Of course, there may be some truth to it, for one source is Jefferson's own complaint that Browere's mixture became so hard on his face and chest that the artist had to use a chisel to get it off his body. Browere was maligned and his new method rejected and ridiculed. He possessed a letter from Jefferson, written on the day when the mask was made, but it was at best a formal letter stating that

At the request of the Hon. James Madison and Mr Browere of the city of New York, I hereby certify that Mr Browere has this day made a mould in plaster composition from my person for the purpose of making a portrait bust and statue for his contemplated National Gallery. Given under my hand at Monticello, in Virginia, this 15th day of October 1825.

JEFFERSON

The rumour about Jefferson having narrowly escaped death in the process of having the imprint of his facial expression and bodily contours taken was still making the rounds more than half a year later. Browere wrote to Jefferson, complaining about the unfortunate consequences of the incident, and received the following reply:

Sir: The subject of your letter of May 20 has attracted more notice certainly than it merited. That the operé to which it refers was painful to a certain degree I admit. But it was short lived. . . . My age and the state of my health at that time gave an alarm to my family which I neither felt nor expressed. What may have been said in newspapers I know not. . . .

One hundred and forty-five years later, I take from a short interview in the *Neue Zürcher Zeitung* (5 September 1971) the following, which appeared under the heading of 'Segal's Live Mummies':

I can only say that during the making of my plaster figures something mysterious takes place which I would never have expected. Each time it is different. The simple procedure of having someone assume a pose, having him then wrapped in plaster-soaked bandages and making him keep the pose until the plaster hardens, creates surprising side-results. The persons involved are in such an uncomfortable position and condition that they cannot pretend or disguise anything. They must keep still and behave exactly the way they really are, stoic and brave, or wild and hysterical.

It needed our time of minimal and pop art, of the presentation of non-art as art, to perfect the total live mask and, placed into a social environment or dramatic scene, to create a semblance of sculpture. The master of the mask from head to toe is George Segal, who in pop-artistic fashion recreates the vulgarities of Times Square and bed, the morbid moments of life, the trash-uncanniest side of contemporary existence. Segal creates figurative sculpture, actually cast with and from living models, as the interview cited above explains.

If it is art, then it is a kind of authentic, three-dimensional, photographic sculpture which catches life, so to speak, in the act. There is a plaster man sitting on a bar stool watching a real television set; a niche with a bath tub and a woman shaving her leg; a man on a bicycle; two lovers in bed and post-coital sleep with their genitals still fully revealed. These petrified moments, these frozen shadows of life – are they presented to demystify reality, to prove to us how emotionally remote such closeness to a masked and yet maskless reality can be? Segal seems to be interested in the confrontation of an idea or situation with life itself. These total masks at best create a feeling of being in between the real and the frightening symbol of reality. George Segal may top Madame Tussaud, but more important are the questions he brings about: is his work reality or the mask of reality? Are his life-size masks the demonic harbingers of tomorrow? If so, it would be the end of all *personae* and of tomorrow as well.

CHAPTER VI

Mask and Man in Caricature

By now it has been sufficiently established that we all project an image into our daily mask which we desire to present to the world we live in. The caricature is this very mask in reverse, it tries to reveal the true man behind the mask of pretence, to expose his littleness, ugliness, and meanness through exaggeration and distortion and, with it, to expose the evils of society. Caricature is a visual epigram, sharply pointed at a certain target.

Caricature is largely underestimated, as is the satirical farce in dramatic literature, although from the satyr plays to the Theatre of the Absurd the element of the grotesque is essential for the dramatist who wants to speak with striking immediacy in topical terms to his contemporaries. But caricature in its satirically grotesque variations reaches far beyond its topicality, and Apollinaire rightly remarked that 'the spirit of caricature has played an important part in the development of modern art'.

Caricature at its best presents man with the mask with which he least likes to be seen and associated. Molière once remarked that men do not mind appearing wicked but cannot stand being made ridiculous. 'The perfect caricature must be an exaggeration from top to toe,' Sir Max Beerbohm said. 'The whole man must be melted down, as in a crucible, and then, as from the solution, be fashioned anew. He must emerge with not one particle of himself lost, yet with not a particle of himself as it was before.' What is so very masklike about the process is the fact that through oversimplification the caricature concentrates on the essential.

When Sir William Schwenck Gilbert of Gilbert and Sullivan referred to one of their minor heroines as having 'a caricature of a face', he realized that the face is the focal point of all caricatures. This is why we are interested in it here. Caricatures may, of course, include the entire body, and they often do, or they may aim at showing the caricatured person caught in movement and action, but even then the face (or faces) will determine the effectiveness of the caricature.

There are subtle and sometimes coarse disharmonies in all our features with which the caricaturist can create his devastating mask. But only those features which, at the same time, characterize the essence of the personality, or which can be made to illustrate what a man stands for and what makes

192

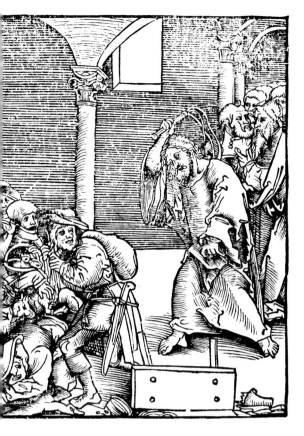
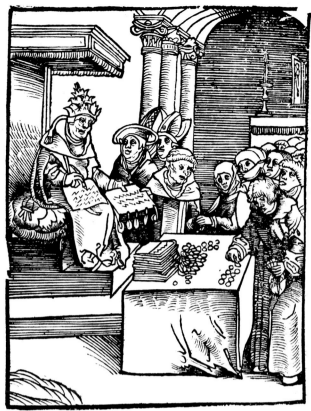
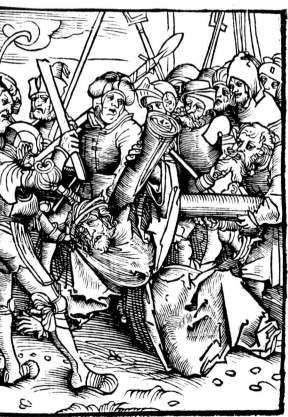
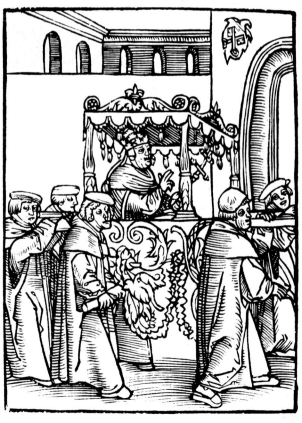

Lucas Cranach, illustrations to Philip Melanchthon's *Passional Christi und Antichristi*

93 Jacques Callot, *Pantaloon*

94 Jacques Callot, 'Two actors of the *commedia dell'arte*'

95 Cornelis Dusart, *Les héros . . . des Protestants*, a caricature of Louis XIV

Mon soleil par sa force eclaira l'heretique.
Il chassa tout d'un coup les brouillards de Calvin:
Non pas par un Zele divin,
Mais a fin de cacher ma fine Politique.

96 William Hogarth, *Morning* (Portico of St Paul's, Covent Garden)

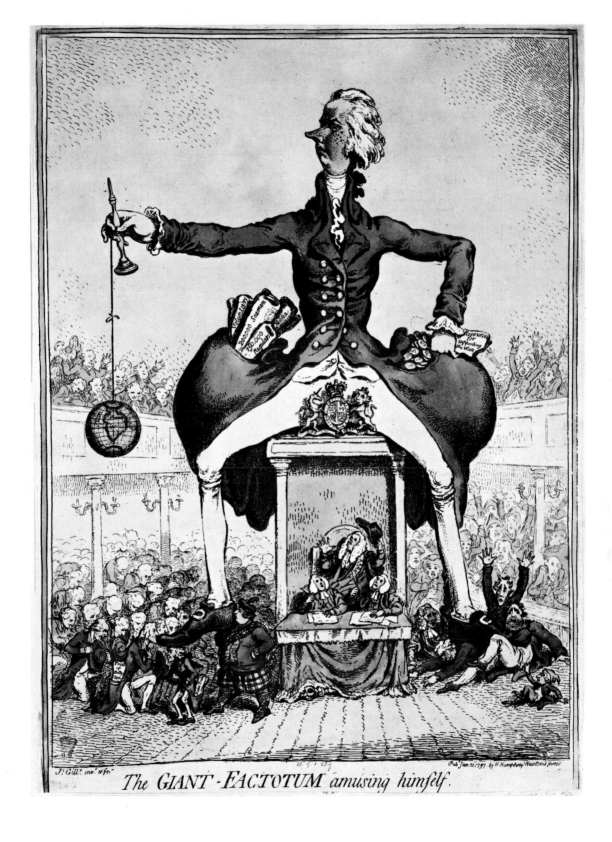

The GIANT-FACTOTUM amusing himself.

97 James Gillray, *The Giant-Factotum amusing himself*, caricaturing William Pitt the Younger

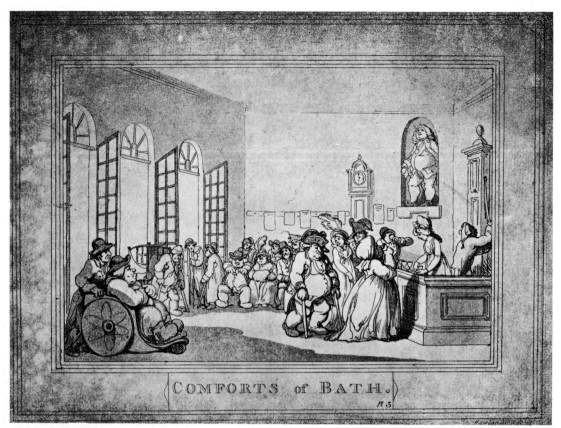

98 Thomas Rowlandson, *Comforts of Bath*

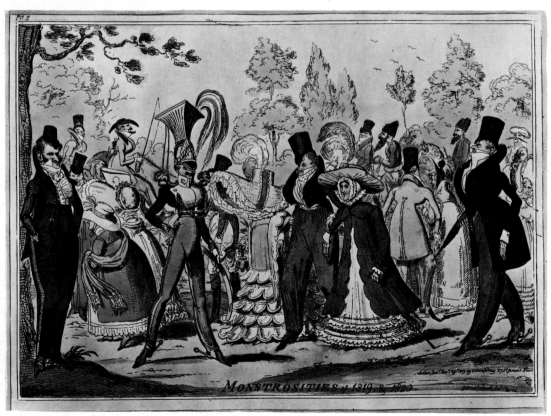

99 George Cruikshank, *Monstrosities of 1819 and 1820*

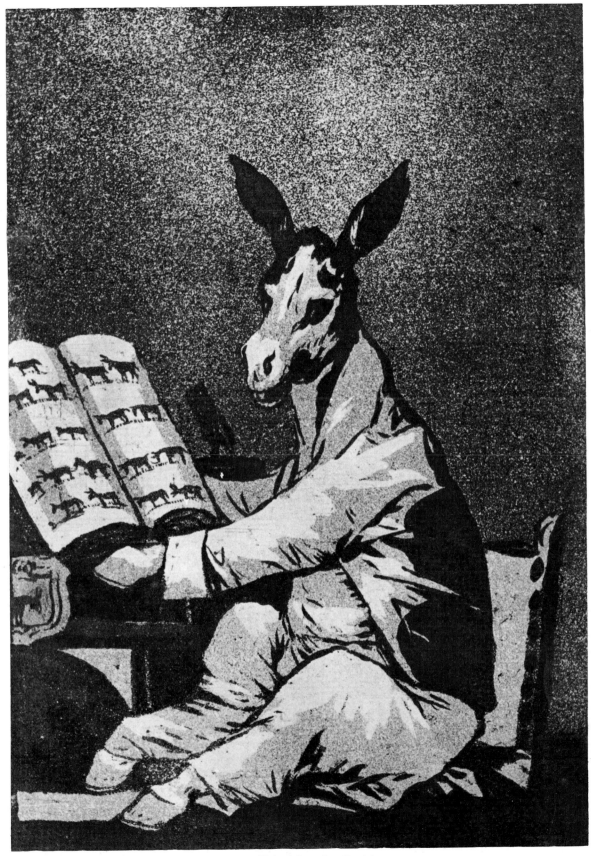

100 Francisco José Goya y Lucientes, 'To his grandfather' from *Los Caprichos*

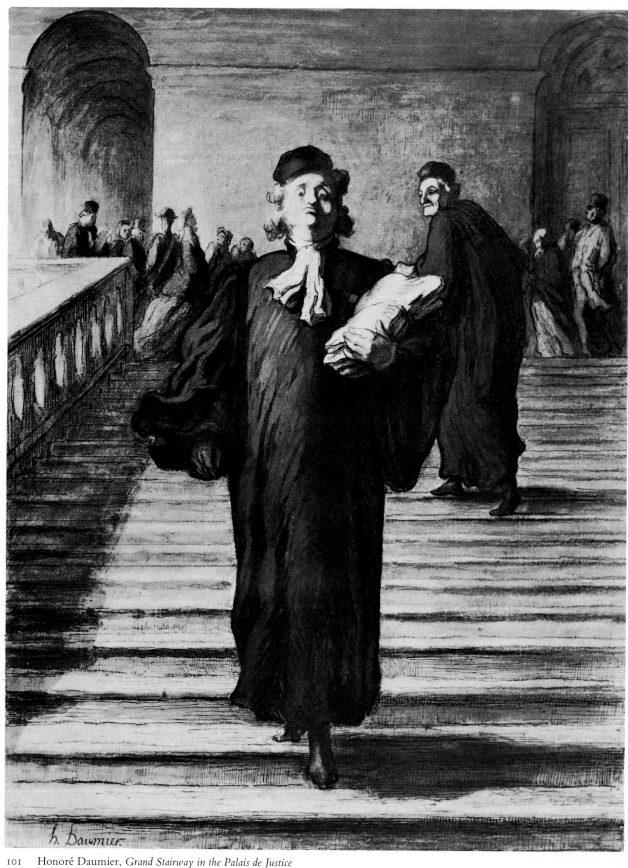

101 Honoré Daumier, *Grand Stairway in the Palais de Justice*

him a worthwhile target, are of significance. In other words, the highest form of caricature is the presentation of man's mask, lucidly defining his life's philosophy illumined by his psyche; it may be blown up or reduced to excess, but the excess must be within the bounds of recognizability. Henri Bergson dealt with the subtleties of face and its caricature in his essay, *Le Rire:*

However regular we may imagine a face to be, however harmonious its lines and supple its movements, their adjustment is never altogether perfect: there will always be discoverable the sign of some impending bias, the vague suggestion of a possible grimace, in short some favourite distortion towards which Nature seems to be particularly inclined. The art of the caricaturist consists in detecting this, at times, imperceptible tendency, and in rendering it visible to all eyes by magnifying it. He makes his models grimace, as they would do themselves if they went to the end of their tether. Beneath the skin-deep harmony of form, he divines the deep-seated recalcitrance of matter. He realizes disproportions and deformations which must have existed in Nature as mere inclinations, but which have not succeeded in coming to a head, being held in check by a higher force. This art, which has a touch of the diabolical, raises up the demon who has been overthrown by the angel. Certainly, it is an art that exaggerates, and yet the definition would be very far from complete were exaggeration alone alleged to be its aim and object, for there exist caricatures that are more lifelike than portraits, caricatures in which the exaggeration is scarcely noticeable, whilst, conversely, it is quite possible to exaggerate to excess without obtaining a real caricature.

The purpose of caricature varies a great deal, as does the environment from which it comes. We may think that caricature found no fertile ground in antiquity or the Renaissance, in an age that believed in beauty and the ideal images of nature. But caricatures were frequent components in comedies and satyr plays which, in turn, found their stylized reflections on vases and in figurines. Also, the *cinquecento* is usually referred to as the beginning of caricature as an independent art form. An important factor for the development of caricature in general was the fact that Renaissance man revived the old idea of comparing man's physiognomy with animal features. (Sir Thomas Browne mentions in his *Christian Morals*, published in 1690: 'When man's faces are drawn with resemblance to some other animals the Italians call it, to be drawn *in caricatura*'.) It was a widespread belief, codified in a text attributed to Aristotle, that to recognize the character of a man one had only to trace in his face the features of the animal he resembled most.

A book by Giovanni Battista Porta, published in 1601, illustrated with woodcuts the similarity between human types and animals. This has been a favourite game of the caricaturist ever since. To distort for the sake of a deeper truth and to make this image stick in our memory, the caricaturist finds great help in comparisons with animals or familiar images. As a means of characterization a man is likened to an ass, a wolf, a dog, a lobster even or a peacock. After Daumier had drawn Louis Philippe as a pear, as suggested by his editor, Charles Philipon, the French monarch could never hope to be thought of as anything else.

When Titian wanted to ridicule a school of art, he hit hard at its spokesman, the sculptor Bartolomeo Bandinelli, who thought to excel in the academic correctness of form as laid down by antiquity. In fact, he felt he had surpassed his paragons, including Michelangelo whom he emulated. When Bandinelli put up a copy of the *Laocoön* group in the dome of Florence, Titian reacted with his famous travesty in which he turned Laocoön and his two sons into monkeys.

Whether the Minos figure as Infernal Judge in Michelangelo's *Last Judgment* is the caricature of Biagio de Cesena, Pope Paul III's master of ceremony, is debatable, although the similarity between the likeness of both has never been doubted. The legend has it that Biagio censured Michelangelo for his many naked figures in the Sistine Chapel in front of the Pope. Michelangelo retaliated by turning him into a devil with much longer ears than he ascribed to any other devil. Moreover, he supplied Minos with a long tail (as referred to by Dante: 'with his tail makes as many circles round himself as the degrees he will have it to descend'). To turn this tail into a snake which bites at Minos' genitals would be satiric caricature.

Leonardo did not caricature any personalities. Interested in all the phenomena of nature, including ugliness, and ready to investigate the grotesque forms of nature, caricatures drawn by life fascinated him from time to time. In studying distorted features he drew some of the most frightening caricatures of man. The great number of these drawings indicates that Leonardo was systematically occupied with deformities and distortions of the human features, that very likely he invented them or drew them from memory rather than from real types. Caricature – although his heads are considered classic examples of the genre – seems not to have been an artistically interesting enough art form. What undoubtedly interested him were the physio-psychological aspects of deformed features and grotesque ugliness. Leonardo hardly ever occupied himself with the image of the mask. In one of his sketchy drawings we see in an oval and in a circle how the mask of Falsehood melts away in the rays of the sun of Truth and how the mask is held up in front of naked Truth by a winged figure. On another drawing, *Two Allegories of Envy*, we are told that 'this Envy is represented making a contemptuous motion towards heaven, because if she could she would use her strength against God. She is made with a mask upon her face of fair appearance.' In his *Notebooks*, in which Leonardo spoke of so many phenomena, he left the mask unmentioned.

Great caricature must be as hard-hitting as satire. It may be created with malice aforethought, if motivated by a moral cause. This was the case in the Reformation during the struggle between Luther and the Pope. This is why I would think that caricature – as seen within the development of modern art – started with Lucas Cranach, who fought on Luther's side and became the foremost visual propagandist of Protestantism. He illustrated Philip

Melanchthon's text with woodcuts arranged in pairs, in which the Passion of Christ and portrayals of the Pope in the role of the anti-Christ were juxtaposed. One woodcut in particular, in which Cranach retaliated with venom to the accusation that Luther was the child of one of the Furies, displays the artist at his most satirical. Cranach's anti-papal pamphlet showed a black demon giving birth to the Pope, already wearing his triple crown at birth; the Pope cradled by his nurse Alecto, with serpents in her hair; being suckled by Megaera; and being led by the hand of Tisiphone, the third of those avenging spirits of nature charged with the pursuit of the offender and the infliction of madness on him.

Cranach's was also the time of François Rabelais, who tried to liberate man from all sham and the fetters of medievalism as Cervantes did shortly after him. The mordant humour of Rabelais' pen in *Songes Drolatiques de Pantagruel* was also illustrated by the author. His caricature of Pope Julius II, done in 1565, is a minor masterpiece, even if Rabelais did not do the drawing, as some maintain. However that may be, it has the spirit of Rabelaisian fun.

This also was the time of Hieronymus Bosch and Pieter Brueghel, of whom I spoke in another chapter, as well as of Jacques Callot. The latter was one of the first great engravers with a genius for the grotesque and the caricature. Thanks to his work we have a vivid perception of the *commedia dell'arte* players, with their sharply profiled faces in telling masks. His ability to penetrate a face made it possible for him to abstract from it the essential lines and shape of its character. With the fewest possible strokes he could give his figures the excitement of movement that went with their facial expression. He could group a large number of people in a small space. His *Misères de la Guerre*, documenting the atrocities of the Thirty Years' War, was a prelude to the more powerful, anguished cries of Goya and Daumier.

A superb caricaturist, Cornelis Dusart, emerged from the Netherlands in the seventeenth century. He turned his ire mainly against Louis XIV and the dignitaries of the Catholic Church. Honest fury characterizes Dusart's designs, in which he leaned heavily on the concept of masks. In his caricature of the Sun King he surrounded an insignificant little face with sun rays and had both framed by a huge monk's hood. The notorious Madame de Maintenon was given a sexless face of utter meanness. Her crookedly set eyes look in both directions, her gaping mouth and prominently upturned nose in a huge round face, again bedded in a monkish cowl, appear like the mask of a Tartuffe whose only signs of femininity are two tiny ear-rings. When Dusart characterized the face of an unknown nun, it was as if he had designed the face of a nun for all times.

William Hogarth was a social moralist with a comic bent. 'My picture was my stage', he wrote, 'and men and women my actors who were by means of certain Actions and Expression to Exhibit a dumb shew.' In order to amuse his spectators he exaggerated and slightly distorted the faces of his

actors. A great many of them were seen as types, and as such they had a very specific make-up and expression. With few exceptions, such as *Scholars at a Lecture*, *A Consultation of Physicians*, or *The Bench*, his pictures show actors who seem to have been anxious to be recognized and identified with. Hogarth was intent on conveying his sermon and used gesture and dramatic situation to underline the facial expression of his characters. His *dramatis personae* consisted of a full cast, but in spite of the often grotesque types in his profligate happenings he never lost his eye for beauty. Perhaps to strengthen his point that beauty must not be surrendered to expressiveness, he once made a plate, *Characters and Caricatures*, on which he showed the difference between his visualization of characters and his concept of caricatures.

His compatriot James Gillray, who was born when Hogarth was already an old man, was most interested in the political cartoon. None of the great ones of his time escaped being reduced by him to their true absurd littleness. His work had something spontaneous in its direct aggression against its targets. Gillray's design of *A Parisian Beauty*, with her coarse face full of contemptible fury and bloodthirsty desires, exemplifies the vulgar concomitants of any revolution, being not just *one* face but *the* face of a revolution gone mad.

While Hogarth made his ethical pathos laugh and Gillray poured sardonic irony on his victims, Thomas Rowlandson loved to tell a funny anecdote involving many people, and George Cruikshank politely illustrated events and people. True, Rowlandson on occasion caught with a few bitter and embittered strokes the lies and inanities of life, and Cruikshank enjoyed moments of happy satire from time to time. But the reflection that they were contemporaries of Goya and Daumier, those master annotators of their time, makes their work seem pale in comparison.

It took Francisco José Goya a long time to find his own greatness. Not that he would otherwise be a forgotten painter today, for with 'his portraits of royal imbeciles, grandees, enchanting duchesses, *majas*, clothed and unclothed', as Aldous Huxley ennumerated, Goya secured for their empty, greedy, and vain looks the immortality they share with other royalties to be framed and hung in the musty climate of museums. Goya was a court painter during the early phase of his life, a time when he was seemingly on friendly terms with existence.

When, after a severe sickness, he lost his hearing and became deaf to the sounds that once enchanted him, he began to see with prophetic vision, and he learned to look into the darkness whose depth he penetrated. With the years he became a lonelier and unhappier man, desperate about the ways of the world. To avoid being crushed by despair, man can escape into humour. Goya's humour has all the connotations of that Spanish humour, known for its bitterness and violence, which is presented with the grand gesture of the

tragi-grotesque. Jusepe de Ribera prior to him and Pablo Picasso after him had something of this grotesque, cruel, self-tormenting violence in some of their works. It was Goya's artistic credo in his mature years.

In the prospectus for eighty prints which he collected under the title of *Caprichos*, violence and aggressiveness born of a nihilistic despair were toned down. Goya was presented as an artist criticizing vices current in society but making light of them. In spite of this attempt to pacify the Inquisitor, the etchings had to be withdrawn from sale.

It has often been suggested that Goya showed a predilection for wilfully distorting the human countenance. As supporting evidence it has been said that he belonged to a burlesque society of *acalofilos*, lovers of ugliness. But in recording the cruelties and crimes committed in the name of Napoleon or the Inquisition, the vicious stupidities and stupendous superstitions of the average man and woman, he created masks of bestiality that reflected their being.

Le monstrueux vraisemblable, 'the monstrous that looks true', was Goya's revelation according to Baudelaire. Even when Goya was in a mellower mood, using animals as substitutes for humans or visualizing fascinating women (often masked) whose love was a *Dream of Lies and Inconstancy*, to mention one of his plates, his laughter at the follies of man never had the lightness of a Rowlandson. Even for such a topic of tempting frivolity he would etch lies and inconstancy with a furious hand, showing Janus-faced creatures and the masklike face of an old woman. One cannot escape the observation that he must have been overwhelmed by a feeling of sadness about so much waste and wantonness in life.

In his series on *Bullfights* he clearly sided with the bull in the same way as he would challenge those higher forces brutalizing man. Or, in his escape into a world of dreams, in his *Proverbs*, he gave his figures a manikin-like, masked appearance and the scenes a farcical, guignolesque character. In his most famous etchings, *The Disasters of War*, he caught the image of man's diabolic bestiality. Based on actual events, the work transcends its documentary value into symbolic meaningfulness. Are the faces of his characters wilfully distorted and uglified? Goya made it clear that people do not know what they look like. He held up the mask to their real nature.

Goya was never imprisoned for any of his monumental condemnations of society's ruling cliques. Honoré Daumier, however, who in contrast to Goya bore no rancour, no hatred in his heart, was persecuted and sentenced to six months' imprisonment with an additional fine of 500 francs for having satirized King Louis-Philippe as Gargantua surrounded by the masks of well-known politicians pouring all the money they could squeeze out of the poor into the king's gorge.

Daumier was the son of a poetizing glazier and married to a seamstress. All his life his feelings were those of a middle-class man who loved liberty

and democracy. He was not a revolutionary, although he lived through the two great revolutions of 1830 and 1848 in France, the revolutions which established and fortified the reign of the *bourgeois*. The little world of the *bourgeois* was Daumier's big world. 'Il faut être de son temps' was his motto, and there was no one more of his time than he was.

When Balzac saw Daumier's first caricatures in *La Caricature* he spoke the legendary words: 'Ce gaillard-là a du Michel-Ange sous la peau!' And truly there was something of Michelangelo in this man. He could create a dramatically powerful, almost monumental image with a rare sureness of touch and stroke. A self-taught artist, he could draw as the great Renaissance artists drew and could make his design appear a 'sustained improvisation', as Baudelaire said.

Baudelaire thought highly of him as of 'one of the most important men, I will not say only in caricature, but in the whole of modern art'. Daumier was the only *bourgeois* who could satirize the *bourgeois* because he loved and pitied him. He did not want to wound the feelings of his fellow man, but to make him laugh about his own inanities and weaknesses, about the absurd situations in which he was caught. He had political passion, but tried to avoid the sharp satirical attack. Even in the choice of his allegories he was gentle and considerate. As Molière used little of the aggressive power of a Ben Jonson or Aristophanes, so Daumier did not display Goya's fire or fury. Daumier was the Molière of the nineteenth century, who was sincere about his moral indignation, but whose satire did not seek to overstep the limits of the comic.

In hundreds of lithographs he recreated the human comedy as he saw it. He could not draw from life, only from memory. This may account for his hasty, sketchy faces, which had to represent an idea, not a particular person. In a certain way Daumier can be likened to Edgar Degas who never tired of painting little ballerinas, whose movements alone interested him, not their human expression, their dreams and hopes. Movement *per se* fascinated Degas; he was obsessed with it, for he saw in it the manifestation of life. Like Daumier he created a certain mystery out of vagueness. We never see the dancer's individuality. They have no faces, they have only *one* face, the face Degas could have called 'the mask of the dancing girls'.

The same might be said about Daumier's series of laundresses – for example, the toiling woman in her twilight existence, already tired when she begins her day, walking with a bundle of dirty or washed linen under her arm. She is only a figure in the dark against a bright background, her face has the facelessness of non-existence, at best of resignation and acceptance of being the non-being she is. The technique may be similar in both artists, but motivation and purpose are diametrically opposed. For Degas the dancers, as he said, were a pretext for light, colour and space, for painting pretty materials and delineating movements. Daumier, however, was always guided by his compassion for the little man. When his laundresses, butchers,

beggars, people at the market or people returning from it are featureless, they lack a personal expression because they speak to us in the name of all laundresses, butchers, and so on who silently suffer the indignity of being forced into the half-light or darkness. Daumier's heart cries out for all the people who can only ride the second-class coaches of life (one of his favourite themes).

It is somewhat different with Daumier's actors, the professionals who play the more vociferous parts: the lawyers, generals, artists and their dealers, the acrobats, clowns, and comedians on and off stage, the Don Quixotes and Sancho Panzas in the streets and bistros of Paris. They were removed from the shadow and became typed and over-theatricalized. Their trade made Daumier search for a trademark of expression, their activities or their general behaviour pattern stamped them in Daumier's vision with a certain inescapable countenance. It was out of pity for the nonentities of life that he left out their faces, that he kept shut the windows of their souls. It was out of pitilessness for those who entered the arena of life with their big gestures, pretensions and lies.

The scene Daumier graphically and colourfully pictured was as varied as life. Baudelaire characterized the scope of Daumier's themes within the limited area of *bourgeois* existence:

Look through his works, and you will see parading before your eyes all that a great city contains of living monstrosities, in all their fantastic and thrilling reality. There can be no item of the fearful, the grotesque, the sinister or the farcical in its treasury, but Daumier knows it. The live and starving corpse, the plump and well-filled corpse, the ridiculous troubles of the home, every little stupidity, every little pride, every enthusiasm, every despair of the *bourgeois* – it is all there. By no one as by Daumier has the *bourgeois* been known and loved. . . . Daumier has lived in intimacy with him, he has spied on him day and night, he has penetrated the mysteries of his bedroom, he has consorted with his wife and his children, he comprehends the form of his nose and the construction of his head, he knows the spirit that animates his house from top to bottom.

Daumier was not alone in contributing to the panorama of nineteenth-century life, particularly in France and Central Europe, but he was one of the rare giants who could make man's mask in all its variations memorable. Nor were *La Caricature* or *Le Charivari*, satirical magazines for which he worked, the only periodicals trying to lift the mask from man's face or to show him in the mask that best characterized his real face. Thomas T. Heine's *Simplicissimus* in Germany, the British *Punch* and the *New Yorker* have continued to make light of the seriousness of man's doings and undoings, to ridicule the absurdities of our existence in the minor and the major key.

There is hardly a country nowadays that has not its own cartoonists, displaying some national characteristics, but far more a very personal image of how the artist visualizes man reduced to his eternal insignificance or blown up to his dreams of greatness. Most often the image is indicative of the face of

man caught in his own intricacies or those of a mechanized world. If I single out Saul Steinberg, it is mainly because he has been preoccupied with masks all his life and has typified the mask-face of the cartoon.

In a playful and pop-art gesture he once hid his own face behind a paper mask which he varied in nineteen ways; he then surrounded himself with them as if they were scurrilous reflections of his changing moods, parodies of his own pretensions, dreams and self-deceptions. In the drawings for his mostly captionless cartoons his characters have features of diabolic simplicity, frightening in their fantastic sarcasm, but fitting the commercialized madness of our time, telescoping the stupidities in which we indulge. Essentially, it is always the same Saul Steinbergian face. It has no features, but is full of expression, comic in its grotesque revelations.

We may be horrified by or feel morally indignant about the physical and mental cruelties which man has afflicted on man over the centuries, or rather millennia. Yet a person may enjoy looking at a caricature without realizing the pain it must cause the caricatured man, knowing of his exposure to ridicule. But tearing off the mask of pretence with which man lies about himself to the world and probably to himself, however consciously or un-awares, and forcibly substituting for it another public image which, however cruel, may be truer to the man has been part of the game of life for some time now.

The caricature is an act of mental flagellation, even though the carica-turist may be convinced of his high moral motivations. Like the satirist which he basically is, he may be prompted by his conscience, by an inner urgency – call it the pathos of ethos – to attack someone in order to bare the evil of an adversary in the name of a good cause, to remedy a bad condition.

Just as often caricaturists are not professional muck-rakers, but compul-sive punsters and jolly jokers. These are easily recognizable by the gentleness of the fun they are having with their victims, often not public figures, but symbols of fads or mad mores, fashions and other stupid indulgences. The need to inflict pain and punishment, and the degree of viciousness in one's attack on one's contemporaries, on one's time and environment in general, very much depend on the relationship between the caricaturist himself and his *persona*. The French mystic, Simone Weil, said that 'a hurtful act is the transference to others of the degradation which we bear in ourselves'.

Of course, some of the greatest artists have felt the need to use caricature as a means of permitting their own *persona* to triumph over the mask of their fellowmen by holding 'as 'twere, the mirror up to' their 'nature' at such an angle that the reflection shows the magnified lie of the truth of man.

CHAPTER VII

The Death Mask

Art reduces and, at the same time, heightens reality by giving it another dimension. Death, in its absolute conclusion, crowns life arrested with its final meaning. Perhaps we ought to visualize death as a postscript to something completed, an afterthought of which the death mask is the lasting expression.

If there is nothing more final than death, there is also nothing more puzzling and mysterious. Ever since man has tried to express himself artistically, the real motive behind his desire to give *Gestalt* to his thoughts and feelings has been his unconscious need to triumph over death and to perpetuate the concept of his hidden self. The creative act – whatever it may be, and in whatever medium – imitates the Creator in the minutest manner.

The death mask is not necessarily a work of art. Essentially, it is a copy of nature and, as its true replica, proof of nature's creative power which gives a very distinct facial expression to the 'soul' of man. The death mask seems to preserve the spirituality, the deep within-ness of the body. This shell may have carried through its life the power of genius or the genius of power, poet or prince. There is, undoubtedly, a spark of godly existence in all creatures, but naturally only those death masks have come to have meaning for us which have somehow kept alive the image of a man of meaningful stature.

There are exceptions to this rule, and the mysterious awe we feel when looking at an 'unknown' face that once lived – and was less important in life than it is now in death – is very special. The best example is the death mask of the so-called *Inconnue de la Seine*, that unknown girl, one of millions, who may have lived quite an ordinary life, and who was one of many who drowned herself for unknown reasons. Her bloated body, showing all the signs of having been submerged in water for an unduly long time, was found in the river Seine.

Mysteriously and inexplicably her face as it rose to the surface showed a sweet, enigmatic smile. Her identity was never established, nor the motive for her suicide. But the uniqueness of her facial expression astounded and perplexed the employees at the Paris morgue and provided sufficient justification for having its likeness perpetuated in a death mask. Its replica, in thousands of copies fashioned out of plaster of Paris, can be seen on the shelves

and in the windows of shops selling artist's materials as a tempting invitation to draw or sculpt a version of this strange, angelic-looking face.

All my life I have been attracted by the *Inconnue de la Seine*, by her dream-like, elusive expression. Looking at her, I have often imagined a gentle human being shattered by the realities of life. For years I had the mask hanging on the wall above my desk. I must have gained some comfort in gazing at it, some reassurance of a less frightening aspect of death.

(After the mask had become irreparably dirty, so that the dust of many years showed the age of the material and the mask begged to be replaced by a new one, my wife decided that it was time to rid myself of the *Kitsch* of my past. The mask came down from the wall and went with the rest of the garbage to the basement. To our surprise we found it next day hanging on the basement wall above the garbage cans. The superintendent of our apartment building, an Irishman, had put it on the wall. The Irish are known for their poetic vein. Unfortunately, they are also known for their predilection for alcohol, which lost our superintendent his job. With him the death mask of the *Inconnue de la Seine* disappeared from the basement wall, from where she had for many months looked down with her smile of sorrowful sophistication at the everchanging garbage.)

This mask is the subtlest homage to the ironic twist in man's fate, in his living and dying. Oddly enough, the face of the *Inconnue de la Seine* glorifies death by condemning life through the story attached to it. Even if the story is a hoax, as some maintain, and it could easily be so, it is still fascinating as a masochistic and, at the same time, liberating feature of the genius of man, who, of necessity, has always sought a comforting idea behind the cruel finality of existence.

If the saying is true that man's eyes are the windows of his soul, then his face reflects the lifelong journey of this soul. To recreate and preserve the face is a logical act in man's endeavour to build a bridge between now and then, the here and there. Early man could not reconcile himself to the finality of death and believed in a concept of the after-life which was always very real.

For the ancient Egyptians, with whom the story of the death mask begins, the end of man's physical existence was a reality and so overpowering an idea during their lifetimes that their entire artistic expression was linked with the idea of death and eternity. Their art was funerary in most of its aspects, but in no way sad, nor full of corpses and skeletons. Burials were such a reality to them that they became commercialized, with professional mourners and embalmers. Embalming developed into a flourishing nationwide industry. All this, however, did not diminish the sacred seriousness with which the road to an eternal life was opened for the dead man. The mystery of the hereafter was demystified by the strong belief of the people that the dead

man needed everything with him on his eternal journey to sustain him and to continue, in some form, the ambiance of his earthly existence.

What we call the soul, the ancient Egyptians called *ka*, the spirit of the departed. The hieroglyph for *ka* showed two human arms bent at the elbow, to which was often added a bearded human figure wearing this image as a crown. But besides the incorporeal energetic principle, the *ka*, man had also a corporeal soul, the *ba*. Egypt's mortuary cult was based on the idea that man could be 'made everlasting', as Oswald Spengler expressed it, if by some kind of magic the *ka* which escapes with death could be reunited with the *ba*. To make it possible for the *ka* to survive, to find a resting place in the after-life, or rather find its way back to the body, the entire body was mummified and the mask was supposed to help the wandering *ka* to return to its earthly shell, the *ba*. (Our verbal image of 'soul-searching' has its roots in this concept despite its connotational metamorphosis.) The mummifying always included a mask which essentially suggested the features of the deceased person, a mask often made of a thin gold plate, or of wood or stone. Before embalming was perfected in Egypt, the earliest mummies were enclosed in plaster envelopes, which are now rare.

The sepulchral masks of the Egyptians did not stress any similarity to the real features of the dead. Early man always thought in terms of symbolic imagery. He believed in the demonic power of the mask and its magic, and cared little for naturalistic identification. The Egyptians were rather inclined to idealize the features of the death mask in order to create a symbolic identification with their god Osiris, who had risen from the dead and with whose resurrection and everlasting existence every Egyptian wanted to identify himself. Those who could afford it tried to be buried in Abydos, Osiris' place of burial. The symbolic suggestiveness of the mask did not, however, altogether prevent the embalmers from perfecting their art of preserving the entire body in a true likeness. The influence of the ancient Greeks, with their realistic tendencies, turned the trend towards a stronger likeness, and later masks gained in portrait-like similarity. Finally, the craving for likeness became one of the characteristics of modern man, with the growing interest in scientific truth and knowledge that started to change the image of the world during the Renaissance and the seventeenth century.

We must recognize the universal practice and ritualistic validity of the death mask. There is no essential difference between the sepulchral masks from the gold treasures of Mycenae and the gold and silver masks from Peru or between those in Mexico and Melanesia. The Toltecs and Aztecs believed that the human spirit had its seat in the skull. This is why they took great care in the preparation of skull masks, particularly those belonging to great or important personages. Their skull masks were inlaid with bands of turquoise mosaic or of lignite, and the eye sockets were often filled with pyrites. These

masks were used with devotional intent, but since they were often of striking ornamental beauty, they must also have pleased the eyes of the observers. To hang up a skull mask as an idol was nothing unusual among the Aztecs, and in Melanesia as well as in Mexico ornamented skull masks were frequently hung in front of a dead man's statues or in front of an idol in order to give it the appearance of animated likeness.

A very strange clay mask, found in Oaxaca, Mexico, belongs to the Zapotec culture. It consists of two different face-halves symbolizing life and death in perfect harmony as if the transition from one state into the other were little more than a playful metamorphosis. A golden mask of the god Xipe has been excavated from a royal tomb on Monte Albán. The British Museum possesses an impressive example of a stone mask representing the flayed god Xipe Totec whose priests adorned themselves with the skins of sacrificial victims, an act of symbolized regeneration.

Wooden masks encrusted with turquoise were also often used by the Aztecs. The unfortunate Moctezuma, who believed Hernando Cortés to be the reincarnation of the white god Quetzalcoatl, gave Cortés one of these rare and precious wooden masks in 1519; it also is now preserved in the British Museum. Two intertwined serpents encircle the eyes and mouth with their coils, and the teeth are made of shell. This mask impresses with its morbid intensity and unreal realism. The same artistic skill was applied to the human skull mask which played an important role in the ritualistic ceremonies of the Aztecs. One of the finest examples is a Mixtec skull dating back to the fourteenth century A D. The top of the skull, a horizontal band across the nose, and the lowest part of chin and jaw are encrusted with pieces of obsidian. The rest of the face consists of an impressive turquoise mosaic. Shell and haematite were used to give the eyes a glaring, eerie quality. It is very likely that this skull belonged to a man who was sacrificed to the god Tezcatlipoca. Every year a physically perfect young man was selected as a sacrificial symbol representing the god. Such a man was seen as the god incarnate for a whole year before being sacrificed. The man's skull was then decorated and preserved as a relic for veneration.

The human skull, symbol of the death god Mictlautecuhtli and also worn as a face mask by Xolotl and the mother goddesses, was used as a prominent sign for one of the twenty thirteen-day sections of the divinatory calendar of the Aztecs. At various periods this macabre ornament was given different forms and prepared with different materials. Most often rock crystal, one of the hardest of natural materials, was used by the Aztec craftsmen for their engravings. These artisans had to employ great technical ingenuity in order to achieve realism combined with symbolic power and sinister beauty when working on skulls made of this material.

No doubt the Aztecs developed great skill in creating visual effects in their crafts, and their lapidaries and goldsmiths were so highly appreciated

that they formed a privileged social group. When Dürer saw some of the treasures sent by Cortés to Europe, he wrote in his journal that his heart was gladdened: 'These are wonderful works of art, and I was completely astounded by the subtle genius of the men of these strange lands.' Dürer was seconded by Benvenuto Cellini, one of the great Renaissance figures and the most accomplished goldsmith of his time, who also registered his surprise at the perfection of these artists.

The creation of carved stone masks was revived by and became quite common among the Aztecs. It reached an artistic level of great accomplishment in the classic period at Taotihuacán. The usage of these masks probably varied greatly. Some of them covered the faces of funerary mummies before the departed – if they were men of rank and distinction – were cremated with great ceremonial.

One of the finest examples among the death masks of older days is the one known as the gold mask of Agamemnon. It is by no means certain that it is Agamemnon's mask, but Heinrich Schliemann, the great excavator of Troy, called it so in the almost puerile enthusiasm with which he related his findings to his intimate knowledge of Homer. Whoever this mask may have belonged to, it is one of the great sepulchral sculptures, accomplished in its symbolic subtlety and realistic expression. One can imagine that this face once commanded trust, love and obedience. Homer referred in the *Iliad* to Agamemnon as 'the king of men', and we can understand Schliemann's rapturous joy at finding this mask and naming it after the great leader.

We know of a curious use of the mask in association with the funeral customs of the Etruscans, who arranged battles between gladiators to honour the deaths of famous persons. These bloody games were executed in the belief that the spilled blood of the fighters would help invigorate the souls of the dead. Such gladiatorial contests, as depicted on the walls of tombs, were among the most cruel games man has ever invented. It has always been characteristic of man that his naïvety and cruelty are interrelated and that both can claim superstition as their closest relative. Superstition also led to the custom of having the gladiators who had been killed during the combat dragged from the arena by men wearing the mask of Etruscan demons of the underworld.

The belief in an after-life was widespread in many parts of the world among ancient peoples which knew nothing of one another. This belief was based on fear and anxiety in the face of death and, in consequence, on the compulsion to provide for everything that would erase any doubt in man's after-life and help ease his soul's travels and possible travails. In the pretence that man's needs in his after-life would remain very much the same as in his terrestrial existence, he was buried with food and drink, with tools, weapons and clothing. The death mask had to fulfil a major task; to preserve the personality in one way or another by facilitating the return of the spirit to

the body, or to keep the spirit from escaping and having to wander aimlessly in the cosmos in search of its abode. Moreover, the death mask had to keep away demons.

Among various tribes in Africa and on many islands in the South Pacific the belief persists that the spirits of the tribe's dead ancestors live among them. These spirits take the place of God and are placated during the funeral ceremonies as well as by incantations and exorcizing movements. The Papuans of the southern coastlands, for instance, have developed a decorative flair for human motifs resolved into swirling ornaments. The natives on the small islands of the Torres Straits are known for their tortoiseshell masks, which they beautify with asymmetrical engravings. These masks were often used to represent an ancestor, who plays a magic role at burial ceremonials. Such masks were also worn with the purpose of calling up the spirits of ancestors long dead for whatever magic purposes they might be needed by the tribe. The most common use of masks is in rituals conducted by a few selected men of a tribe, who seek to banish the spirits of the dead.

Some people maintain that the death mask as we accept it now, that is, as the likeness of a man's features, came into its own with the early Renaissance. It was only then that the aesthetic trend in the realm of artistic creativity turned to the perception and recreation of reality, a change in direction that was greatly helped by a breakthrough in the understanding of anatomy and perspective, and also perhaps by the sharpening of the visual sense in general.

The wooden likeness of Edward III is considered the earliest surviving example of a death mask from a European country after antiquity. Edward III was crowned king at Westminster Abbey on 29 January 1327 and died fifty years later. A certain Stephen Hadley is recorded as having been paid for making 'one image in the likeness of a king'. The king's mouth droops to the left, and the left cheek is flattened. This seems to indicate the facial paralysis caused by the stroke which rendered the king speechless shortly before his death. The funeral effigy is of wood, roughly carved and thinly coated with plaster or gesso. When the effigy was carried at the funeral there was a beard and wig of real hair on the head, with eyebrows made from the hair of a small dog.

In those days a king's effigy was made as quickly as possible for the official funeral ceremonies. But in all cases the question remains unanswered as to whether the death mask was used as a model for the effigy or vice versa. In comparison to the expressive features of later death masks the impression given by Hadley's mask is of a stylized attempt, on to which certain details of the real image were superimposed. But no authentic proof can be given for this.

Effigies of crowned personages were known in England before this. A wax *imago*, as it was called, was made of Henry III (who died in 1272) and

also of Edward II (1327). It may be said that with the death mask of Edward III we are stepping over the threshold from Gothic formalism into an era in which meaning and value of the death mask were marked by progressive naturalism.

The practice of taking death masks became more frequent during the fifteenth century. While on the Continent death masks were fashioned with the help of wax, we have no documentary evidence that this was done in England before the middle of the seventeenth century with Oliver Cromwell.

The use of wax death masks seemed to have been quite common in Continental cloisters, as is indicated by the case of the famous Franciscan monk, Bernardino da Siena, who died in 1444, or the Holy Antonius, a Dominican priest, whose death mask has been in the cloister of San Marco in Florence since 1459. The dead Lorenzo de' Medici was brought to San Marco from his Villa Careggi, near Florence, to find his final abode in the vestry of San Lorenzo. But it is uncertain where his death mask, which is now in the possession of the Società Colombario in Florence, was taken.

At least three known death masks exist of Oliver Cromwell. There is a wax one in the British Museum. One made of plaster of Paris, not quite identical with the wax one, is in the possession of the National Portrait Gallery in London, and another is in the Library of Princeton University. Cromwell's remains had a very dramatic fate. Under Charles II the House of Commons decided, on 30 January 1661, that Cromwell's corpse should be disinterred. It was taken on a sledge to Tyburn, the former place of execution (close to where the Marble Arch stands today). Wrapped in a shroud, his corpse was then hung there on a noose. After a day it was taken down, the head was severed from the torso, and the body was buried under the gallows; if our records are reliable, however, the head still hung visibly from West-minster Hall for another thirty years.

A similar instance of historic perversion and senseless political revenge is reported to have been supplied by the corpse of Jean Marat a hundred years or so later, during an even more fateful writhing of history. Marat, the saviour of the French Republic against the monarchic reaction, did not survive the bath he took on 13 July 1793. It must be assumed that, after Marat's murder by Charlotte Corday, the famous painter Jacques-Louis David must have taken the death mask which has been exhibited in the Chamber of Horrors at Madame Tussaud's in London for many years. A copy of it is also in the Library of Princeton University. In 1793 the National Convention in Paris decreed that Marat's remains deserved to rest in the Parthenon. However, after the Revolution – true to the historio-political circus – all that was left of him was burnt to ashes which were then carried triumphantly through the streets of Paris in a *pot de chambre* and finally thrown into the sewer in the rue Montmartre.

The old and somewhat pompous custom of presenting effigies of crowned and other important personalities to the populace lost its appeal in the course of the seventeenth century. At that time death masks were often made for the sole purpose of facilitating a sculptor's work. To have such a documentary image of a man for future artistic designs was an idea that had come into being during the Italian Renaissance.

Probably one of the most outstanding examples was the pioneering architect of the early Renaissance, Filippo Brunelleschi. Since he was born in Florence, the Florentines buried him, as Giorgio Vasari tells us in his *Lives of the Painters*, 'with great honour and dignity in Santa Maria del Fiore . . . under the pulpit opposite the door. . . . Il Buggiano . . . one of his pupils . . . also did from life a marble head of his master which was placed after Filippo's death in Santa Maria del Fiore, to the right of the door at the church entrance.'

Vasari's description is inexact. Filippo's disciple and heir, Andres di Lazaro Cavalcanti, known as Il Buggiano, was, in comparison to the Renaissance giants, at best a second-rate sculptor. Not being quite sure of himself, he needed an image of Filippo's likeness in order to sculpt his marble head. When Vasari mentions that he did it 'from life' he means from a replica of what was once Filippo's lifelike expression. Buggiano himself took the death mask, whose original can be seen in the Museo di Santa Maria del Fiore.

From then on the death mask played the role of a handmaiden for sculptors and painters. In 1727 Sir Isaac Newton's death mask was taken by the French sculptor Louis François Roubillac, who then lived in London, to facilitate his work on a terra cotta bust of the great scientist. The bust is now in the British Museum, while the death mask has been kept on display by the Royal Society in London.

Not until the end of the eighteenth century did the death mask come into its own and become an accomplished artistic expression of nature with the skilful help of artists. The death mask, in its verisimilitude to the final moments of man before irrevocable decay sets in, has often been a most truthful image of the personality of the deceased, miming what has once been life. In some cases we have come to accept such a final picture of man as his eternal face. A good example is the likeness of Dante Alighieri, even though it is uncertain whether his characteristic features have come down to us through the Venetian sculptor Pietro Lombardi, who executed the tomb and bas relief of Dante for Ravenna in 1842, or from his death mask of which Lombardi may have known (or he may have used an old bust that was lost and refound). The first mention of a death mask of Dante is in the art historiographer Giovanni Cinelli's *Toscana letteraria*, where he refers to 'al sepolcro di Dante in Ravenna vi era una testa assai ben modellata'. This 'testa' was supposedly taken from Dante's tomb by the Archbishop of

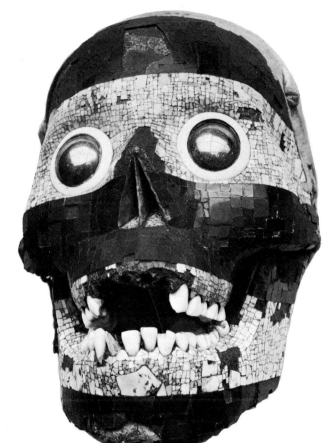

102 Turquoise death mask from Mexico

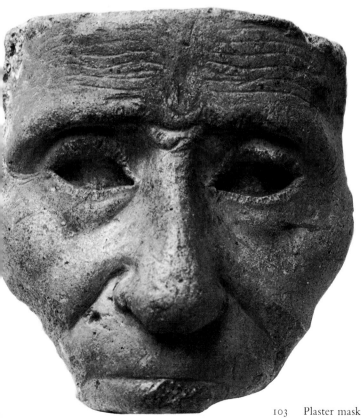

103 Plaster mask from Egypt

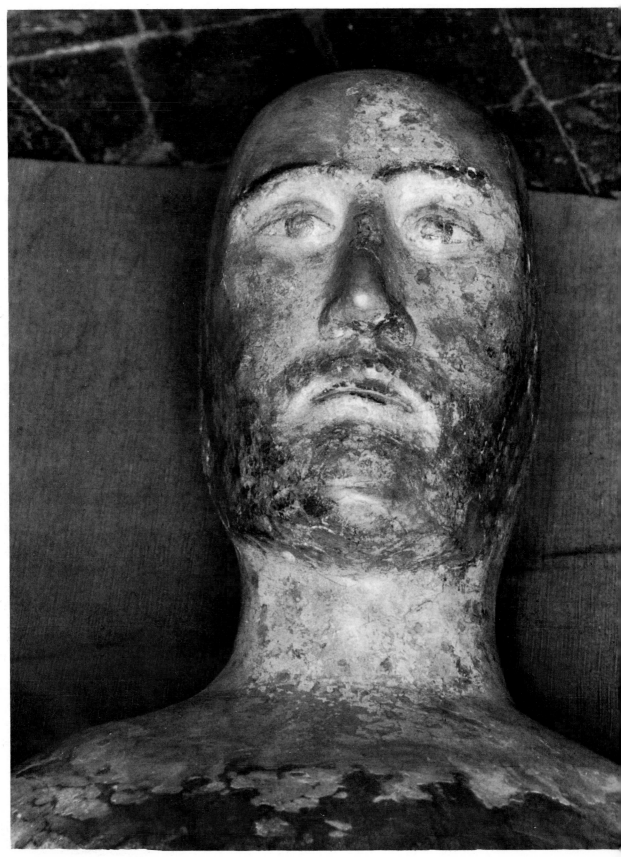

104 Death mask of King Edward III

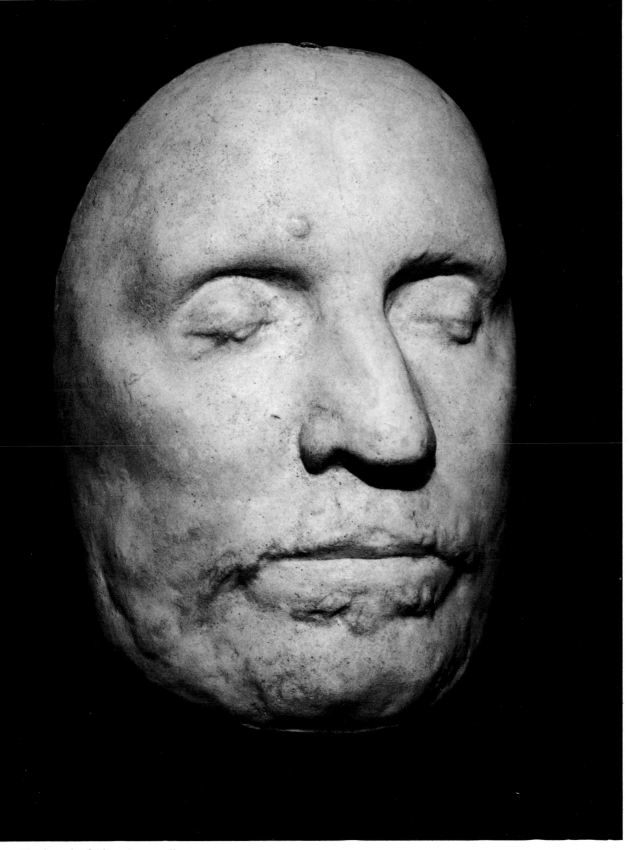

5 Death mask of Oliver Cromwell

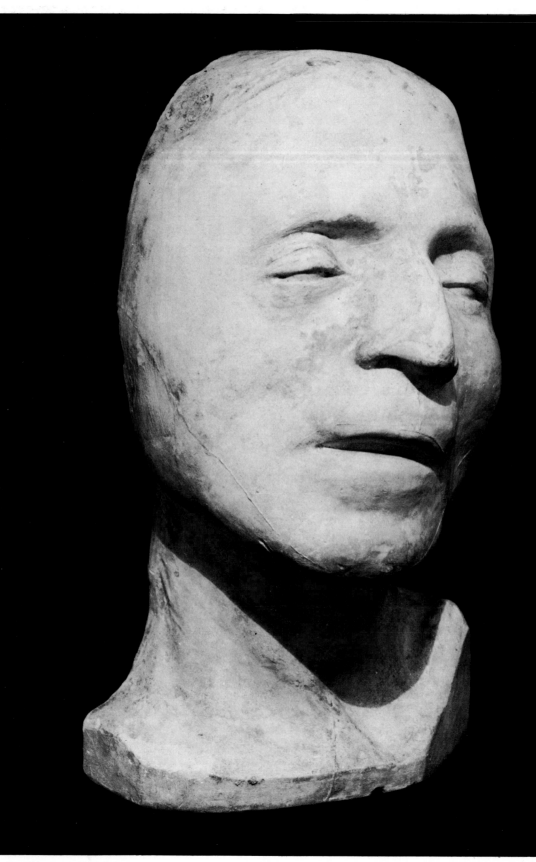

106 Death mask of Jean Marat

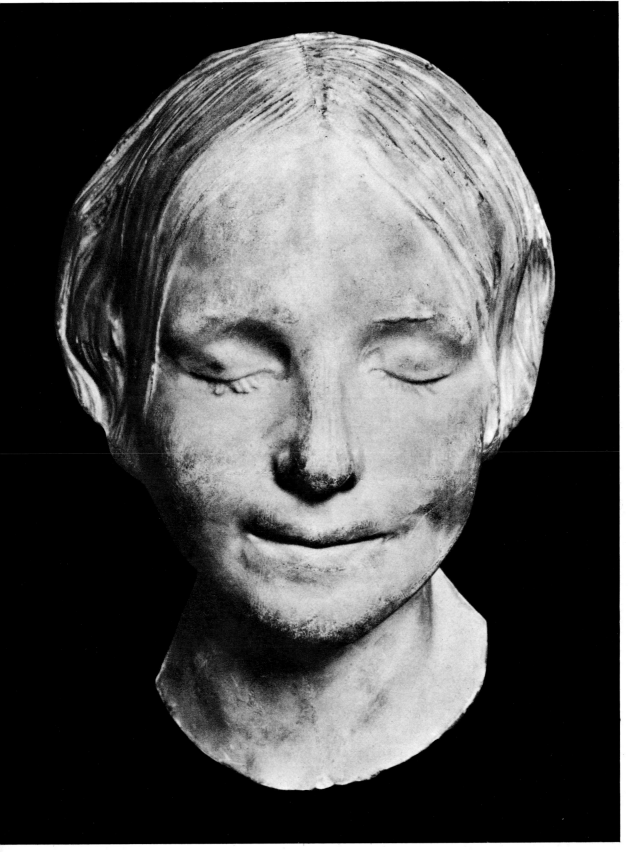

7 *L'Inconnue de la Seine*

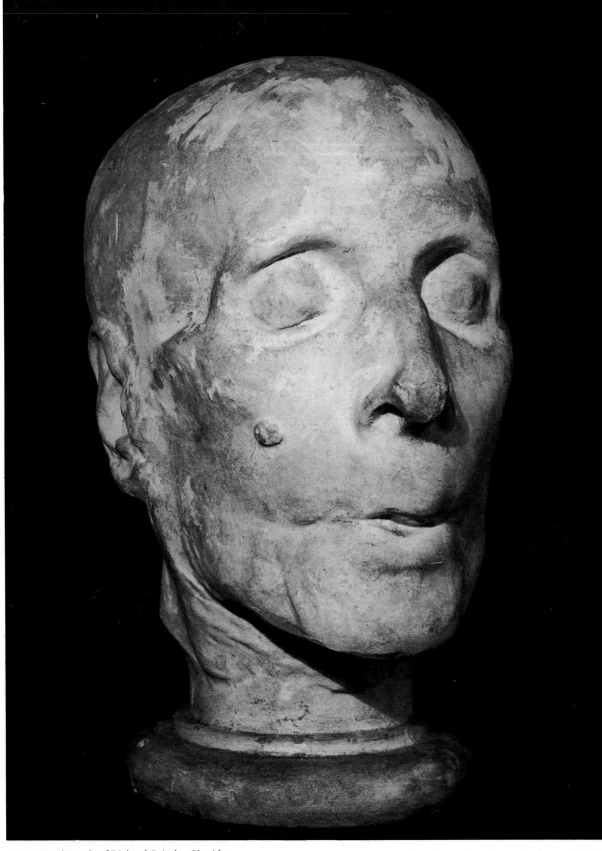

108 Death mask of Richard Brinsley Sheridan

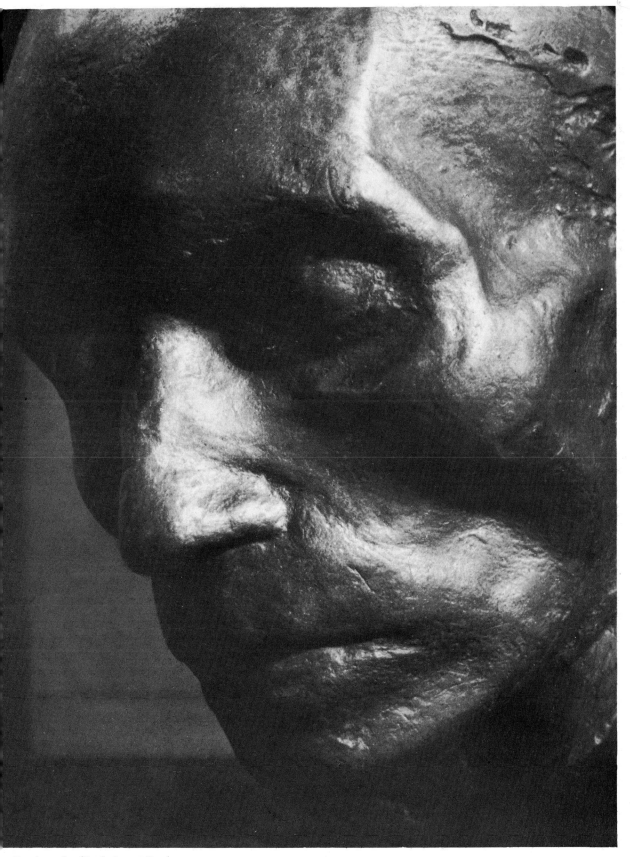

Death mask of Ludwig van Beethoven

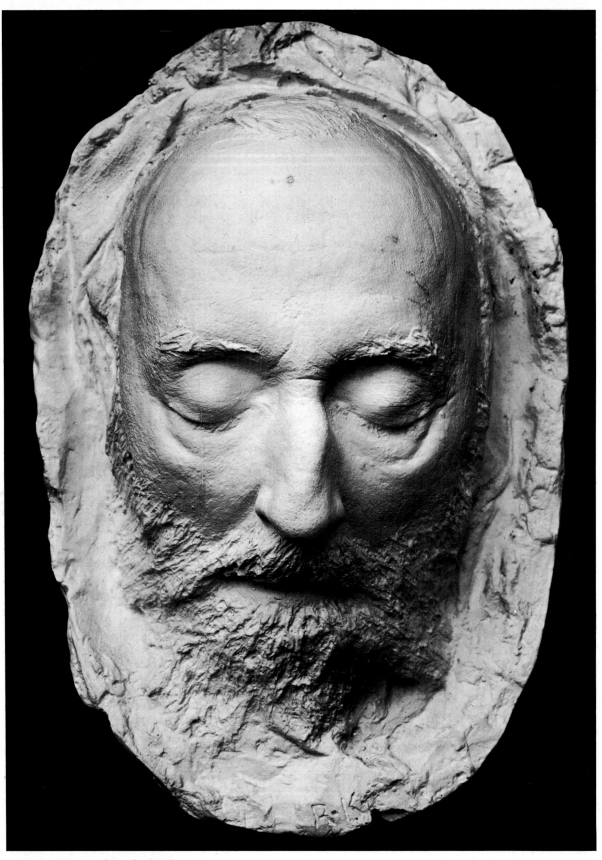

110 Death mask of Gottfried Keller

Ravenna (probably Pier Donato Cesi), who gave the mask to the famous sculptor Giovanni da Bologna for the creation of a bust.

We face a totally different problem with Ludwig van Beethoven's mask. His widely known image is that of a mask taken in Teplitz in 1812, fifteen years before his death, by a minor sculptor named Franz Klein. Since Beethoven was not prepared to sit for hours, Klein needed the mask as inspiration for a bust of the composer. The death mask was taken two days after his death and the day after an autopsy: the Viennese anatomists, under the leadership of Dr Johann Wagner, were interested in the composer's auditory passage. The expression of the jaws suffered from this post-mortem examination.

With physiognomic hindsight we can see how Beethoven's architectonic use of tonality and the forceful intensity of feeling found their reflection in his life mask, which became a symbol of the powerful genius in his magnificent isolation from his fellow men. Whatever Beethoven's disease and autopsy may have done to his facial expression, I find his death mask, taken by the Viennese painter Josef Danhauser, divested of certain external manifestations of the inner dramatic power of his genius. It shows the human aspects of the lonesome fighter in the struggle with himself and the world, however, all the more. The slight distortion in the death mask's features seems to dramatize his tortured life, full of sound which, to his deaf ear, must have been merely an imagined abstraction. His life mask looks to me like a demonstrative gesture towards the world. His death mask shows the tormented silence of one who can see what the world can only hear.

For the purposes of contrast there are no better examples than the death masks of Gottfried Keller and Richard Brinsley Sheridan. Keller was the most representative author of the Swiss. His novels and stories have epic breadth with didactic overtones. He was an official scribe in the service of the canton of Zurich and, unofficially, the Swiss ambiance is reflected in his writings. His death mask displays all the civility and self-satisfaction of a life fulfilled.

It is quite different with Sheridan. He is known to us as a comedy writer who, after more than a century, added a brilliant postscript to the Restoration spirit. He was a genius in the writing of clever dialogue, and his humorous criticism of society was to the point. His persuasive sallies against man's follies and his polished wit (in *The Critic*, *The School for Scandal*, and *The Rivals*) have led many writers on dramatic literature to place him as a natural link between Congreve and Wilde. For some time Sheridan was also manager of the Drury Lane Theatre and a Member of Parliament whose speeches and attitudes were indicative of the individual stand he liked to take.

His death mask does not make us think of his verbal bravura, his flair for the big gesture or his extravagance. We may discover some self-sarcasm around his mouth, the kind of sarcasm which leaves one with a bitter after-

taste; perhaps the mask's features indicate a predilection for repartee and sharp attack. But it is the mask of a sad and haunted face, even though it is not without strength. In his declining years Sheridan was still able to make a deep impression on Lord Byron. The fact is, however, that by then he had more creditors than admirers, and to the very last day of his life he was pestered by bailiffs. This mask covered a face that had lost its fight and seems to have wavered between disgust and despair in its hour of death.

Effigies as they were commonly used through several centuries were a part of the medieval heritage which received its final death blow during the Enlightenment. The effigies still carried with them connotations of superstition and magic. The Age of Reason taught men to view death in a more realistic manner. Although Romanticism injected a sickly-sentimental feeling for death, its acceptance became more and more real the closer man came to fighting death with modern medical means towards the end of the last century. Its enigma may still be as frightening as ever, but we have learnt to face and surround man's finality with less ritualistic superstition and more cool logic. Without being really aware of it we have been progressively brainwashed by our scientifically oriented age. Moreover, psychological indoctrination has likewise encouraged detachment.

This does not, however, minimize our interest in the death mask as the imprint of man's soul caught on its flight into eternity and as the artistic sketch of man's last expression, with nature playing a major part. Thus, the death mask remains alive as a memento reminding us that we are, as Boris Pasternak said, only guests of existence.

Johann Kaspar Lavater, the father of physiognomy, wrote:

The dead and the impression of the dead taken in plaster are not less worthy of observation than living faces. The settled features are much more prominent than in the living and in the sleeping. What life makes fugitive, death arrests. What was indefinable is defined. All is reduced to its proper level, each trait is in its exact proportion, unless excruciating disease or accident have preceded death.

It would be wrong to associate only the sober and morbid concepts of finality with the death mask. Too many of us have never come to grips with the idea of having to leave the world. Death masks can convey a feeling of accomplishment and peace with oneself if one has learned to look at them with the eyes of a tired wanderer – a sensation which we all may have from time to time – and with wonder at the expressive power that life projects into death.

All masks in their total rigidity are shaped and worn to create a definite relationship between the mask's image and the man whose face it covers. The living can afford to pretend, to play-act, and to transcend being through a mask. The dead have no such choice. The face becomes identical with the last mask. Then the mask and the masked are irrevocably one. In the face of death all masks of life finally make peace with themselves to reveal man's real mask.

Bibliography and Sources

ALIGHIERI, DANTE, *The Divine Comedy*. Edited by H. Oelsner and translated by J. A. Carlyle, T. Okey and P. H. Wicksteed. London: J. M. Dent, 1946–52. New York: E. P. Dutton 1932, 1950.

ARP, JEAN (HANS), *On My Way. Poetry and Essays 1912 . . . 1947*. New York: Wittenborn, Schultz, 1948.

ARTAUD, ANTONIN, *The Theatre and Its Double*. Translated by Mary Caroline Richards. New York: Grove Press, 1958.

— ARTAUD, ANTONIN, 'States of Mind: 1921–1945'. Translated by Ruby Cohn, in *Tulane Drama Review*, vol. 8, no. 2, winter 1963.

— AUDEN, W. H., 'Concerning the Unpredictable'. An Essay-Review in the *New Yorker*, 21 February 1970.

BALL, HUGO, *Die Flucht aus der Zeit*. Munich and Leipzig: Duncker & Humblot, 1927.

BALLOU, ROBERT O., ed., *The Bible of the World*. New York: Viking Press, 1939; London: Kegan Paul, 1940.

BARR, ALFRED H., Jr., ed., *Masters of Modern Art*. New York: Museum of Modern Art, 1954.

— BAUDELAIRE, CHARLES, *The Mirror of Art*. Translated by Jonathan Mayne. New York and London: Phaidon, 1955.

BEAUMONT, CYRIL, *Puppets and Puppetry*. London and New York: Studio Publications, 1958.

BEHRMAN, S. N., *Portrait of Max: An Intimate Memoir*. New York and London: Random House and Hamish Hamilton, 1960.

— BENDA, WLADYSLAW THEODORE, *Masks*. Illustrated by the author. Introduction by Frank Crowninshield. New York: Watson-Guptill Publications, 1944.

BENKARD, ERNST, *Das ewige Antlitz. Eine Sammlung von Totenmasken*. Foreword by Georg Kolbe. Berlin: Frankfurter Verlagsanstalt, 1926.

BOEHN, MAX, *Dolls and Puppets*. London: Harrap, 1932.

BORGESE, LEONARDO, *Daumier*. Translated by Cesare Foligno. Novara: Uffici Press, 1954.

BRECHT, BERTOLT, *Brecht on Theatre. The Development of an Aesthetic*. Edited and translated by John Willett. London and New York: Methuen and Hill and Wang, 1964.

BRECHT, STEFAN, 'Peter Schumann's Bread and Puppet Theatre', in *Drama Review*, vol. 14, no. 3.

BROCK-SULZER, ELIZABETH, *Wann ist eine Stadt eine Theaterstadt?*, in the programme bill of the Loosli Marionetten. Ottikon: Peter W. Loosli.

BURCKHARDT, JACOB, *Die Kultur der Renaissance in Italien. Ein Versuch.* Stuttgart: Alfred Kröner Verlag, 1952.

CECIL, DAVID, *Max. A Biography.* London: Constable, 1964; Boston: Houghton Mifflin, 1965.

CELLINI, BENVENUTO, *Memoirs of Benvenuto Cellini.* Translated by Anne Macdonell. London and New York: E. P. Dutton and J. M. Dent, 1903, 1960.

CHAGALL, MARC, *My Life.* New York: Orion Press, 1960; London: Peter Owen, 1965.

— CLARK, KENNETH, *Civilisation. A Personal View.* London and New York: BBC/John Murray and Harper & Row, 1969.

CRAIG, EDWARD GORDON, *The Art of the Theatre.* Introduction by Edward Gordon Craig and Preface by R. Graham Robertson. Edinburgh and London: T. N. Foulis, 1905.

COCTEAU, JEAN, *The Journals of Jean Cocteau.* Edited and translated by Wallace Fowlie. New York: Criterion Books, 1957.

COCTEAU, JEAN, *Das Leben und Werk des Jean Cocteau.* Selected and edited by Friedrich Hagen. Munich: Verlag Kurt Desch, 1961.

COVARRUBIAS, MIGUEL, *Indian Art of Mexico and Central America.* New York: Knopf, 1957.

DORST, TANKRED, *Geheimnis der Marionette.* Foreword by Marcel Marceau. Munich: Hermann Rinn, 1957.

DUCHARTRE, PIERRE LOUIS, *The Italian Comedy.* Authorized translation by Randolph T. Weaver. London: Harrap, 1929.

DURANT, WILL, *The Life of Greece.* New York: Simon and Schuster, 1939.

DÜRER, ALBRECHT, *Dürer: Schriftlicher Nachlass.* Edited by Hans Rupprich. Berlin: Deutscher Verein für Kunstwissenschaft, 1956.

EBERLE, OSKAR, *Wege zum schweizer Theater, XIII. Jahrbuch der Gesellschaft für schweizerische Theater Kultur.* Volksverlag Elgg: no date.

ELIOT, T. S., *The Complete Poems and Plays.* New York: Harcourt, Brace, 1952; London: Faber & Faber, 1969.

EMMERICH, ANDRÉ, *Art Before Columbus.* New York: Simon and Schuster, 1963.

ERBEN, WALTER, *Marc Chagall.* Translated by Michael Bullock. London and New York: Thames and Hudson and Praeger, 1957.

— ERNST, MAX, *Beyond Painting.* Translated by Dorothy Tanning and Ralph Manheim and edited by R. Motherwell. New York: Wittenborn, Schultz, 1948.

ESSLIN, MARTIN, *Brecht. The Man and His Work.* New York: Anchor Books, Doubleday, 1961.

ESSLIN, MARTIN, *The Theatre of The Absurd.* New York: Anchor Books, Doubleday, 1961; London, Eyre and Spottiswoode, 1962.

FRAZER, SIR JAMES GEORGE, *The Golden Bough. A Study in Magic and Religion.* Abridged edition. London: Macmillan, 1922; New York: Macmillan Co., 1951.

FRIEDELL, EGON, *Kulturgeschichte der Neuzeit* (3 vols). Munich: C. H. Beck'sche Verlagsbuchhandlung, 1930.

FRISCH, MAX, *Tagebuch 1946-1949.* Frankfurt-am-Main: Suhrkamp Verlag, 1960.

FUCHS, EDUARD, *Die Karikatur der Europäischen Völker*. Berlin: A. Hoffmann, 1901.

FÜRSTENTHAL, ACHIM, *Maske und Scham bei Nietzsche. Ein Beitrag zur Psychologie seines Schaffens*. Basle: Basler Druck- und Verlagsanstalt, 1940.

GASSNER, JOHN, *Masters of the Drama*. New York: Random House, 1940.

GENET, JEAN, 'L'Atelier d'Alberto Giacometti', in *Derrière le miroir*, no. 89, June 1957.

GENET, JEAN, *The Blacks: a clown show*. Translated by Bernard Frechtman. New York and London: Grove Press and Faber & Faber, 1960.

GENET, JEAN, *The Screens*. Translated by Bernard Frechtman. New York: Grove Press, 1962; London: Faber & Faber, 1963.

GENET, JEAN, 'A Note on Theatre'. Translated by Bernard Frechtman in *Tulane Drama Review*, vol. 7, no. 3, spring 1963.

GHELDERODE, MICHEL DE, 'The Ostend Interviews'. Translated by George Hauger and Gerard Hopkins in *Seven Plays*. New York: Hill and Wang, 1960; London: MacGibbon & Kee, 1961.

GHELDERODE, MICHEL DE, *Théâtre IV: Masques Ostendais*. Paris: Gallimard, 1955.

GILOT, FRANÇOISE, and LAKE, CARLTON, *Life With Picasso*. New York: McGraw-Hill, 1964; London: Nelson, 1965.

GOETHE, JOHANN WOLFGANG VON, *Gesammelte Werke*. Berlin: Verlag Ullstein, no date.

GOETHE, JOHANN WOLFGANG VON, *Die Werke Goethes*. Zurich und Stuttgart: Artemis Verlag, 1962.

GOLDONI, CARLO, *Memoirs of Carlo Goldoni: Written By Himself*. Translated by John Black. Edited with an introduction by William A. Drake. New York and London: Knopf, 1926.

GREGOR, JOSEF, *Die Masken der Erde*. Munich: R. Piper Verlag, 1936.

GROPIUS, WALTER, ed., *The Theatre of the Bauhaus*. Introduction by the editor. Translated by Arthur S. Wensinger. Middletown, Conn.: Wesleyan University Press, 1961.

GROSZ, GEORGE, *A Little Yes and A Big No*. Translated by Lola Sachs Dorin. New York: Dial Press, 1946.

HAESAERTS, PAUL, *James Ensor*. Preface by Jean Cassou. Translated by Norbert Guterman. London and New York: Thames and Hudson and Abrams, 1959.

HAFTMANN, WERNER, *Emil Nolde*. Translated by Norbert Guterman. London: Thames and Hudson, 1959.

HAUSER, ARNOLD, *The Social History of Art* (2 vols). Translated by Stanley Godman. London and New York: Routledge & Kegan Paul and Knopf, 1951.

HELLER, ERICH, *The Disinherited Mind. Essays in Modern German Literature and Thought*. Cambridge: Bowes & Bowes, 1952; New York: Farrar, Strauss & Cudahy, 1957.

HIRONAGA, SHAZABURO, *Bunraku. Japan's Unique Puppet Theatre*. Revised by D. Warren-Knott. Tokyo: Tokyo News Service, 1946.

HOFMANNSTHAL, HUGO VON, *Die prosaischen Schriften*. Berlin: S. Fischer Verlag, 1920.

HONIG, EDWIN, 'Lorca To Date', in *Drama Review*, vol. 7, no. 2, winter 1962.

HUIZINGA, JOHAN, *The Waning of the Middle Ages*. London: Edward Arnold, 1924; New York: Anchor Books, Doubleday, 1956.

— HUXLEY, ALDOUS, *Themes and Variations*. London: Chatto & Windus, 1950.

IONESCO, EUGENE, *Four Plays*. Translated by Donald M. Allen. New York: Grove Press, 1960.

IONESCO, EUGENE, *The Killer and Other Plays*. Translated by John Calder. New York. Grove Press, 1960.

— IONESCO, EUGENE, 'The Tragedy of Language'. Translated by Jack Undank, in the *Tulane Drama Review*, vol. 4, no. 3, spring 1960.

JONES, ROBERT EDMOND, *The Dramatic Imagination*. New York: Theatre Arts Books, 1967.

KACHLER, KARL GOTTHILF, 'Modernes Maskenspiel aus antiker Tradition', in *Sonderdruck aus Sandoz-Bulletin*, Switzerland, no. 12, no date.

KALVODOVÁ, D., SÍS, V., and VANIŠ, J., *Chinese Theatre*. Translated by Iris Urwin. London: Spring Books, 1959.

KENNARD, JOSEPH SPENCER, *Masks and Marionettes*. Edinburgh and London: T. N. Foulis, 1919; New York: Macmillan Co., 1935.

KERÉNYI, KARL, 'Mensch und Maske', in *Eranos Jahrbuch*, Ascona, vol. XVI, 1948.

KIRSTEIN, LINCOLN, *The Book of the Dance*. New York: Garden City Publishing, 1942.

KLEIST, HEINRICH VON, *Sämtliche Werke*. Stuttgart: Phaidon Verlag, no date.

LAFUENTE FERRARI, ENRIQUE, *Goya. Complete Etchings, Aquatints and Lithographs*. Translated by Raymond Rudorff. London and New York: Thames and Hudson and Abrams, 1962.

LAWLER, LILLIAN B., *The Dance in Ancient Greece*. London: A. & C. Black, 1964; Middletown, Conn.: Wesleyan University Press, 1965.

LEONARDO DA VINCI, *The Literary Works of Leonardo da Vinci*. New York and London: Oxford University Press, 1939.

LEWES, G. H., *Goethes Leben und Werke*. Authorized translation by Dr Julius Frese. Stuttgart: Verlag von Carl Krabbe, 1892.

LOCICERO, VINCENT, 'A Study of the Persona in Selected Works of Arthur Schnitzler', in *Modern Austrian Literature. Journal of the International Arthur Schnitzler Research Association*, vol. 2, no. 4, winter 1969.

LÖFFLER, FRITZ, *Otto Dix. Leben und Werk*. Vienna and Munich: Anton Schroll, 1967.

LORCA, FEDERICO GARCÍA, 'Lorca Discusses His Plays', in *Drama Review*, vol. 7, no. 2, winter 1962.

LYNCH, BOHUN, *A History of Caricature*. London: Faber and Gwyer, 1926.

MALRAUX, ANDRÉ, *The Voices of Silence*. Translated by Stuart Gilbert. New York: Doubleday, 1953; London: Secker & Warburg, 1954.

MACPHARLIN, PAUL, *A Repertory of Marionette Plays*. New York: Viking, 1929.

MEYER, CONRAD FERDINAND. *Sämtliche Werke*. Munich and Zurich: Droemersche Verlagsanstalt Th. Knaur Nachf., 1959.

MOORE, HENRY, *Henry Moore on Sculpture*. A Collection of the Sculptor's Writings and Spoken Words with an Introduction by Philip James. London: Macdonald, 1966.

— MOTHERWELL, ROBERT, ed., *The Dada Painters and Poets: an Anthology*. New York: Wittenborn, Schultz, 1951.

NATAN, ALEX, ed., *Swiss Men of Letters. Twelve Literary Essays*. London: Oswald Wolff, 1970.

NEUMANN, ERICH, *Depth Psychology and a New Ethics*. Translated by Eugene Rolfe. New York: G. P. Putman's Sons for the Carl Gustav Jung Foundation for Analytical Psychology, 1969.

NICOLL, ALLARDYCE, *The World of Harlequin. A Critical Study of the Commedia dell' Arte*. Cambridge: Cambridge University Press, 1963.

NICOLL, ALLARDYCE, *Stuart Masques and the Renaissance Stage*. London: Harrap, 1937; New York: Harcourt, Brace, 1938.

NICOLL, ALLARDYCE, *The Development of the Theatre*. London: Harrap, 1937; New York: Harcourt, Brace, 1957.

NICOLL, ALLARDYCE, *Masks, Mimes and Miracles*. London and New York: Harrap and Harcourt, Brace, 1931.

NIETZSCHE, FRIEDRICH, *Friedrich Nietzsches Werke*. Edited by Giorgio Colli and Mazzino Montinari. Berlin: Walter de Gruyter, 1958.

NIETZSCHE, FRIEDRICH, *Nietzsches Briefwechsel mit Franz Overbeck*. Leipzig: Insel Verlag, 1966.

NIKOLAIS, ALWIN, 'Nick. A Documentary'. Edited and introduced by Marcia Siegel in *Dance Perspectives*, New York, no. 48, winter 1971.

NOLDE, EMIL, *Das eigene Leben*. Berlin: Bard, 1931.

NOVERRE, JEAN-GEORGES, *Letters on Dancing and Ballets*. Translated by Cyril Beaumont. London: C. W. Beaumont, 1930; New York: Dance Horizons, 1970.

OKAKURA, KAKUZO, *The Book of Tea*. New York: Fox, Duffield, 1906; Rutland, Vt, and Tokyo: Charles E. Tuttle, 1957.

OLIVER, WILLIAM I., 'Lorca: The Puppist and the Artist', in *Drama Review*, vol. 7, no. 2, winter 1962.

O'NEILL, EUGENE, 'Memoranda on Masks', in the *American Spectator*, November 1932.

O'NEILL, EUGENE, *Nine Plays*. Selected by the author. Introduction by Joseph Wood Krutch. New York: Garden City Publishing Co., 1940.

PEPYS, SAMUEL, *Diary and Correspondence of Samuel Pepys*. New York: Dodd, 1884.

PIERRET, MARC, 'Genet's New Play: *The Screens*' in *Tulane Drama Review*, vol. 7, no. 3, spring 1963.

— PIRANDELLO, LUIGI, *Naked Masks*. Edited by Eric Bentley. New York: E. P. Dutton, 1952.

PIRANDELLO, LUIGI, 'On Humor'. Translated by Teresa Novel in *Tulane Drama Review*, vol. 10, no. 3, spring 1966.

PIRCHAN, EMIL, *Harald Kreutzberg. Sein Leben und seine Tänze*. Vienna: Wilhelm Frick Verlag, 1950.

PODACH, ERICH, *Friedrich Nietzsche und Lou Salomé. Ihre Begegnung 1882*. Zurich and Leipzig: Max Niehaus Verlag, no date.

POE, EDGAR ALLAN, *The Poems of Edgar Allan Poe*. Edited by Floyd Stovall. Charlottesville: University Press of Virginia, 1965.

POUND, EZRA, and FENOLLOSA, ERNEST, *The Classic Noh Theatre*. New York: New Directions, 1959.

— PUFF, WILHELM, *Maske und Metapher*. Nuremberg: Verlag Hans Carl, 1965.

RAMUZ, CHARLES-FERDINAND, *Souvenir sur Igor Stravinsky*. Lausanne: Mermod, 1946.

— RILEY, OLIVE L., *Masks and Magic*. London: Thames and Hudson, 1955.

RUBIN, WILLIAM S., *Dada, Surrealism, and Their Heritage*. New York: Museum of Modern Art, 1967.

RUSKIN, JOHN, *The Works of John Ruskin*. Edited by E. T. Cook and Alexander Weddenburn. London: George Allen, 1904.

SACHS, KURT, *World History of the Dance*. Translated by Bessie Schönberg. New York: W. W. Norton, 1937.

SARTRE, JEAN-PAUL, 'Saint Genet: Actor and Martyr'. Translated by Bernard Frechtman in *Tulane Drama Review*, vol. 7, no. 3, spring 1963.

SASTRI, K. S. RAMASWAMY, *The Indian Concept of the Beautiful*. Madras: University of Travancore, 1947.

SCHEYER, ERNST, 'The Shapes of Space: The Art of Mary Wigman and Oskar Schlemmer', in *Dance Perspectives*, New York, no. 41, spring 1970.

— SCHNEIDER-LENGYEL, ILSE, *Die Welt der Maske*. Munich: R. Piper Verlag, 1934.

SCHNITZLER, ARTHUR, *Die dramatischen Werke*. Frankfurt-am-Main: S. Fischer Verlag, 1962.

SCHUMANN, PETER, 'The Bread and Puppet Theatre'. Interview with Helen Brown and Jane Seitz in *Drama Review*, vol. 12, no. 2, winter 1968.

SELZ, PETER, 'Introductory Note', in *Alberto Giacometti*. New York: Museum of Modern Art, 1965.

SHAW, GEORGE BERNARD, *Shakes versus Shav. A Puppet Play*. Stratford-upon-Avon: Waldo S. Lanchester, no date.

SIMONSON, LEE, *The Stage Is Set*. New York: Harcourt, Brace, 1932.

SORELL, WALTER, *Hanya Holm. The Biography of an Artist*. Middletown, Conn.: Wesleyan University Press, 1969.

SUZUKI, D. T., *Zen Buddhism. Selected Writings of D. T. Suzuki*. Edited by William Barrett. New York: Anchor Books, Doubleday, 1956.

TAPER, BERNARD, *Balanchine. A Biography*. New York: Harper & Row, 1963; London: Collins, 1964.

TODD, ARTHUR, 'What Went Wrong?' in *Dance Magazine*, no. 8, August 1962.

VASARI, GIORGIO, *Lives of the Most Eminent Painters, Sculptors and Architects*. Edited by William Gaunt. London and New York: J. M. Dent and E. P. Dutton, 1963.

VITTORINI DOMENICO, *The Drama of Luigi Pirandello*. Philadelphia: University of Pennsylvania Press, 1935.

WARDLE, IRVING, 'East-West Ritual' in *The Times* (London), 17 September 1970.

WERNER, ALFRED, *Modigliani the Sculptor*. New York: Arts, 1962; London: Peter Owen, 1965.

WIGMAN, MARY, *The Language of Dance*. Translated by Walter Sorell. Middletown, Conn.: Wesleyan University Press, 1966.

YEATS, W. B., *The Collected Plays*. London: Macmillan, 1934; New York: Macmillan Co., 1953.

YOUNG, STARK, *The Theatre*. New York: Hill and Wang, 1954.

List of Illustrations

236

Index

References to works of literature and art are listed under their creators